BLADE RUNNER 2049

INTERLINKED – THE ART

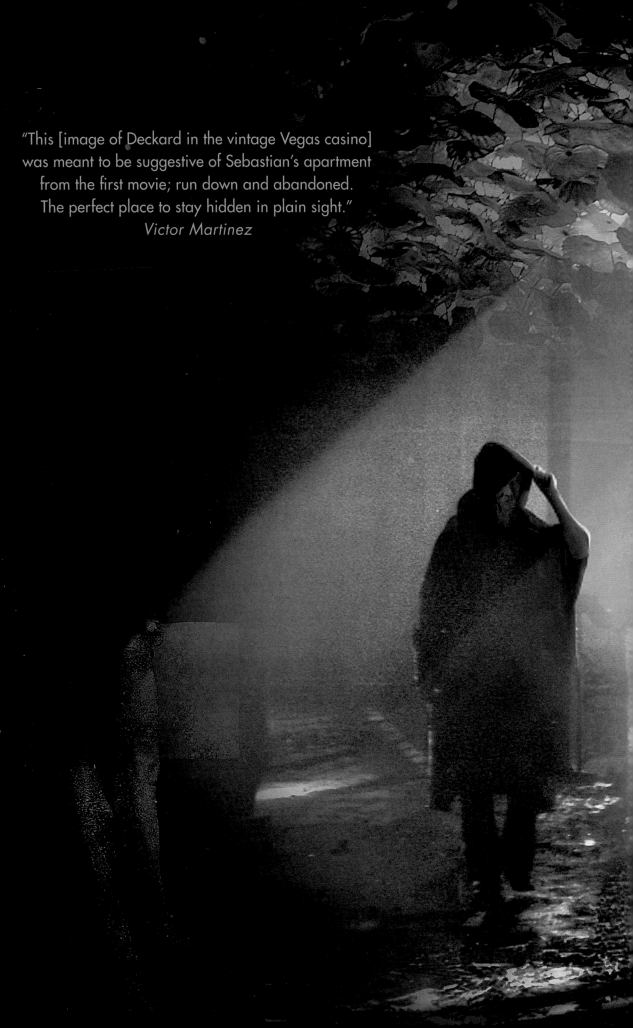

"This [image of Deckard in the vintage Vegas casino] was meant to be suggestive of Sebastian's apartment from the first movie; run down and abandoned. The perfect place to stay hidden in plain sight."

Victor Martinez

BLADE RUNNER 2049: INTERLINKED – THE ART
ISBN: 9781789092110

Published by Titan Books (in partnership with Alcon Publishing)
A division of Titan Publishing Group Ltd
144 Southwark Street
London
SE1 0UP

www.titanbooks.com

First edition: June 2020

2 4 6 8 10 9 7 5 3 1

Did you enjoy this book? We love to hear from our readers. Please e-mail us at: readerfeedback@titanemail.com or write to Reader Feedback at the above address.

To receive advance information, news, competitions, and exclusive offers online, please sign up for the Titan newsletter on our website: **www.titanbooks.com**

Printed and bound in China.

ALCON PUBLISHING, LLC

BLADE RUNNER 2049

INTERLINKED – THE ART

Tanya Lapointe

TITAN BOOKS

ALCON
PUBLISHING®

CONTENTS

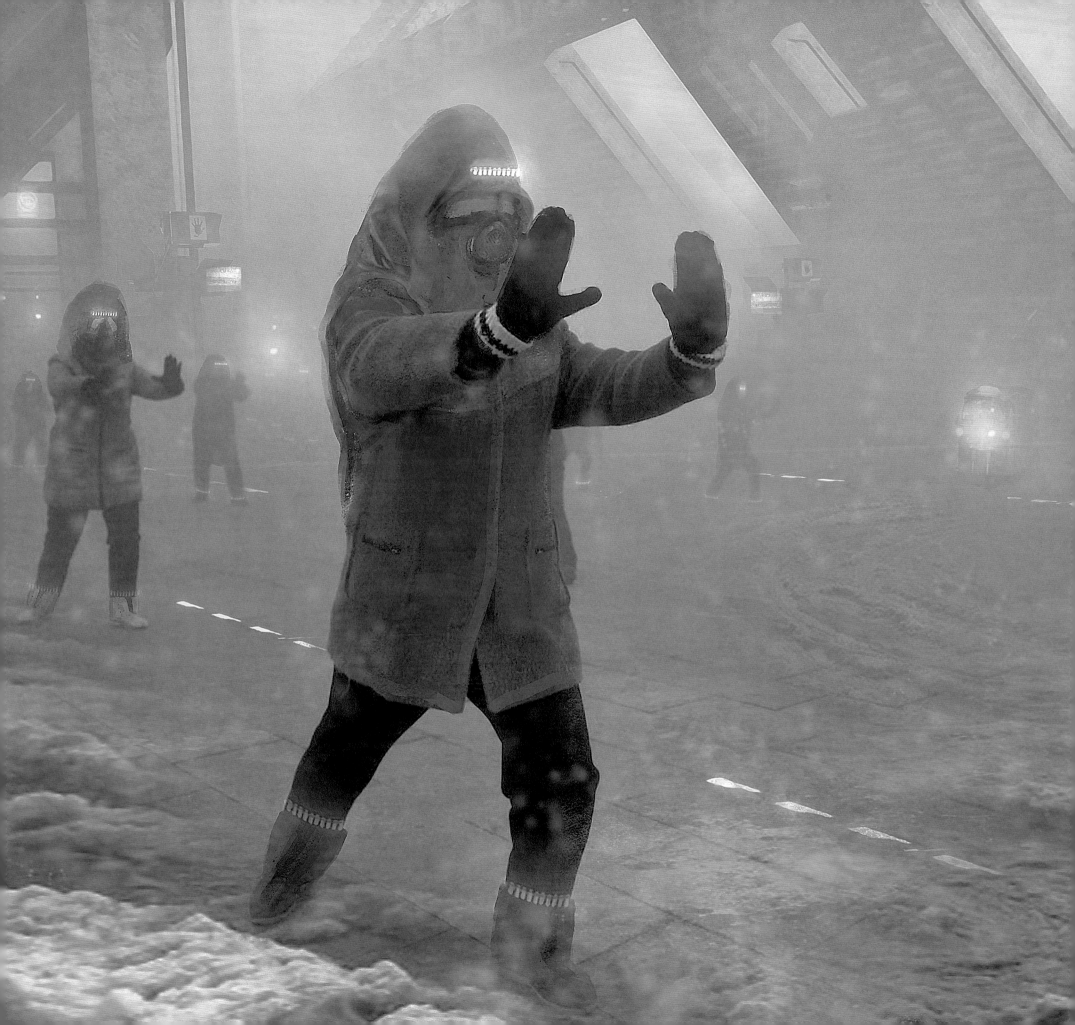

INTRODUCTION
WITHIN CELLS INTERLINKED

It's no secret that decades after Ridley Scott's *Blade Runner* was released in 1982, it became a cult film and the baseline for the sci-fi genre. The original movie's cyberpunk dystopian style and Syd Mead's futuristic design were repurposed countless times on the silver-screen, making it next to impossible to direct a sequel without falling prey to replication. Yet, thirty years later, filmmaker Denis Villeneuve took on the challenge, knowing he had to reinvent a world that was both iconic and revered.

Blade Runner 2049 was released in October 2017 to critical acclaim, succeeding in staying true to Ridley Scott's cinematic DNA. It also lived up to the hardcore fan's expectations, because it expanded the world, while having its own unique identity. Villeneuve managed to push the boundaries between the past and the future, but he did not do it alone. The creative process started in 2015 with a small team he called the "early dreamers."

"It all began with an early outline of the script and an empty room," explains production consultant Aaron Haye. He was tasked with putting together the core creative team that was made up of researcher Allison Klein, senior conceptual designer George Hull, concept artist Scott Lukowski, concept designer Victor Martinez and concept illustrator Emmanuel Shiu, as well as WETA Workshop artist Steve Jung. "We called it 'The Nest,' because it was a comfortable place where everyone could express their ideas," recalls Haye. The biggest challenge was finding the perfect equilibrium between nostalgia and innovation. "The film

"For me, the original *Blade Runner* ignited my passion for film design and this career that I love. Working on the sequel, I felt a huge burden to live up to the talents of the original creators. I started by doing extensive research about the original film. Then I studied every film by Denis Villeneuve and saturated my brain with his aesthetic, color palettes, compositions, etc. I got started with Aaron Haye as part of the crew of early dreamers. While Denis was finishing his film *Arrival*, Aaron and I felt free to imagine the world that we would want to see in a sequel. We both felt strongly that fans would loathe a departure that didn't feel like a close evolution of the original. I never had specific instruction on how far to push the boundaries, only a personal taste to keep the same DNA."

George Hull

needed to take place thirty years in the future of the original *Blade Runner* world, not thirty years in our future. Nothing built between 1983 and 2016 could be included in our movie. This world had to have its own architecture, technology, and design."

"Denis Villeneuve is such a talented and visionary director. It really was a pleasure to work with him, even though most of the time was spent communicating from a distance, [as] Denis was deep into prep on *Arrival* at that time, so could only fly in occasionally to see the work in person. We went over ideas on his first visit and I got a good sense of the feeling he was trying to convey with the film. After this we would speak remotely virtually every weekend. We would create images during the week and I would send these works in progress to him, usually on a Friday night. He would then have Saturday to digest it and we would talk on Sunday. He would give me his thoughts and any notes would be incorporated in the next version. I count the six months I spent creating the world of *Blade Runner 2049* with my small team as some of the most challenging and fulfilling days of my career."
Aaron Haye

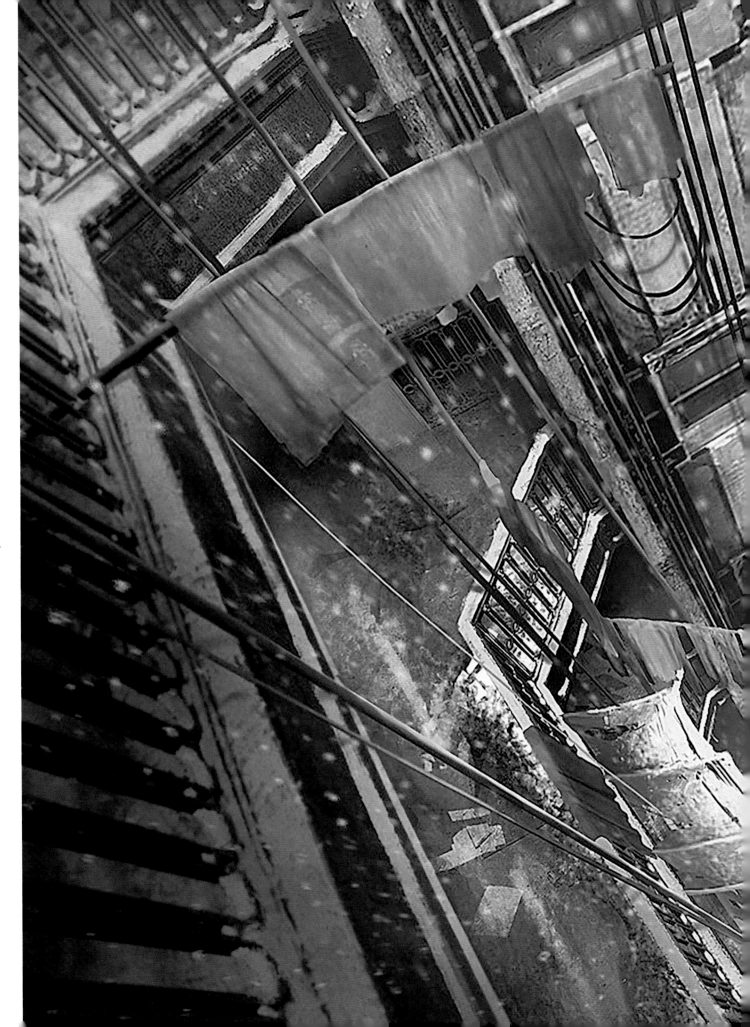

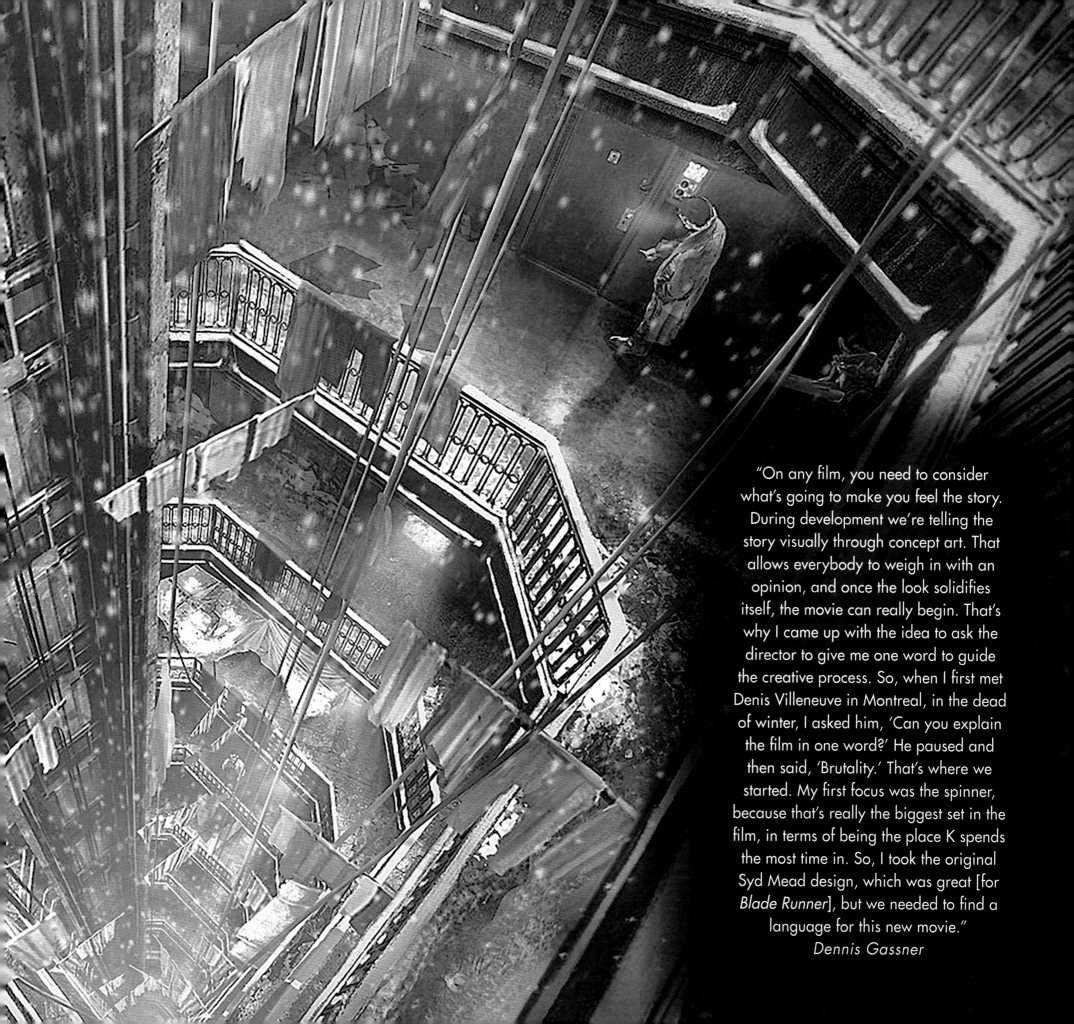

"On any film, you need to consider what's going to make you feel the story. During development we're telling the story visually through concept art. That allows everybody to weigh in with an opinion, and once the look solidifies itself, the movie can really begin. That's why I came up with the idea to ask the director to give me one word to guide the creative process. So, when I first met Denis Villeneuve in Montreal, in the dead of winter, I asked him, 'Can you explain the film in one word?' He paused and then said, 'Brutality.' That's where we started. My first focus was the spinner, because that's really the biggest set in the film, in terms of being the place K spends the most time in. So, I took the original Syd Mead design, which was great [for *Blade Runner*], but we needed to find a language for this new movie."
Dennis Gassner

Among the many ways in which the *Blade Runner* universe evolves in the second movie is through climate change. Denis Villeneuve transformed Ridley Scott's rainy environments into snowy landscapes. Early visual explorations featured Los Angeles streets covered in snow, with characters in hazmat suits practicing tai chi. "It was a bizarre vision of the future," remembers Martinez. "The challenge in revisiting this world was stripping away everything that pulled us to the first film, but still paying homage to it."

In the fall of 2015, Dennis Gassner joined the *Blade Runner 2049* team after having worked on three James Bond movies, *Quantum of Solace*, *Skyfall*, and *Spectre*. "I felt comfortable doing this film, because I'd already done these Bond films, which are [also] homages," explains the Oscar-winning production designer. "I was mining twenty-some Bond films, but I didn't do it specifically, only in the feeling." The process would be similar with the world of Replicants. It was fitting that *Blade Runner 2049*'s central theme is memory, more specifically what endures and what evolves.

With Villeneuve, Gassner developed a cinematic solution to express Los Angeles' thirty-year growth and transformation. "The advantages we had over the first film were technology, finances, and the ability to create larger scale. It was the metaphor that helped to create Wallace's world." It was a crucial ingredient to tell the story of Eldon Tyrell's megalomania, of the original movie, being surpassed by Niander Wallace's messianic ambition.

This book is a companion piece to *The Art and Soul of Blade Runner 2049*, published in 2017. It is a journey into the creative process, which includes early concept art and visual explorations, as well as discarded ideas. I interviewed many artists who worked on this project and who have generously shared their stories. They will guide you through the *Blade Runner* universe with stories, too often left unheard. It takes a team to bring a world together and these artists were interlinked within one vision.

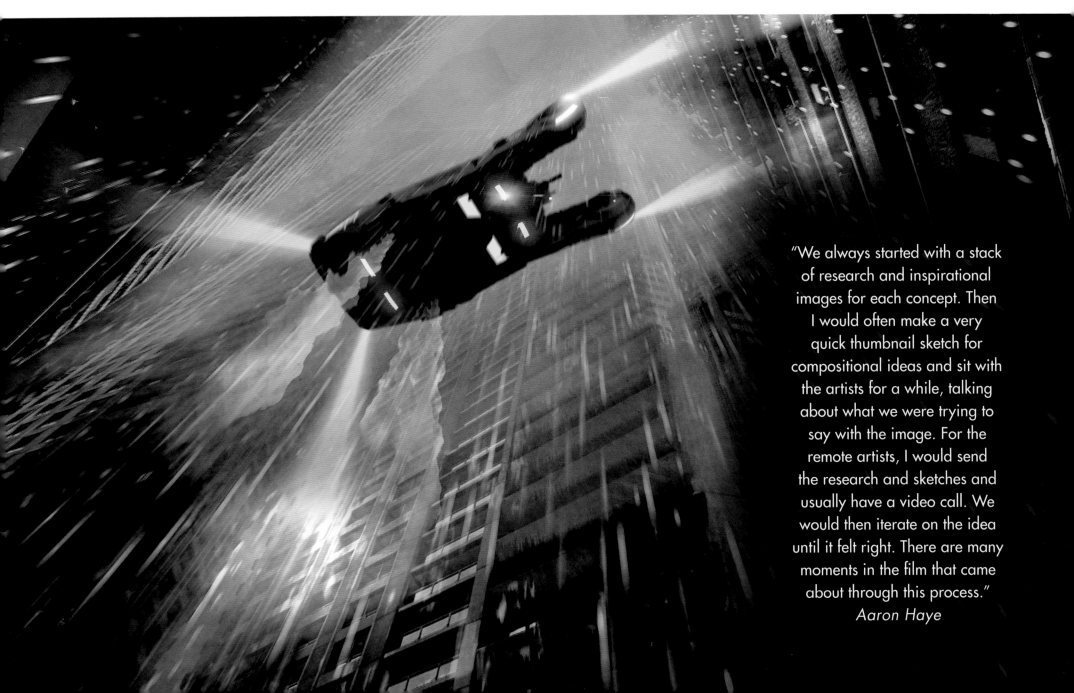

"We always started with a stack of research and inspirational images for each concept. Then I would often make a very quick thumbnail sketch for compositional ideas and sit with the artists for a while, talking about what we were trying to say with the image. For the remote artists, I would send the research and sketches and usually have a video call. We would then iterate on the idea until it felt right. There are many moments in the film that came about through this process."
Aaron Haye

POST-TRAUMATIC BASELINE TEST

OFFICER KD6-3.7
30TH JUNE 2049

INTERVIEWER: Officer KD6-dash-3-dot-7. Let's begin. Ready?

K: Yes, sir.

I: Recite your baseline.

K. "And blood-black nothingness began to
spin / A system of cells interlinked
within / Cells interlinked within cells
interlinked / Within one stem.
And dreadfully distinct / Against the
dark, a tall white fountain played."

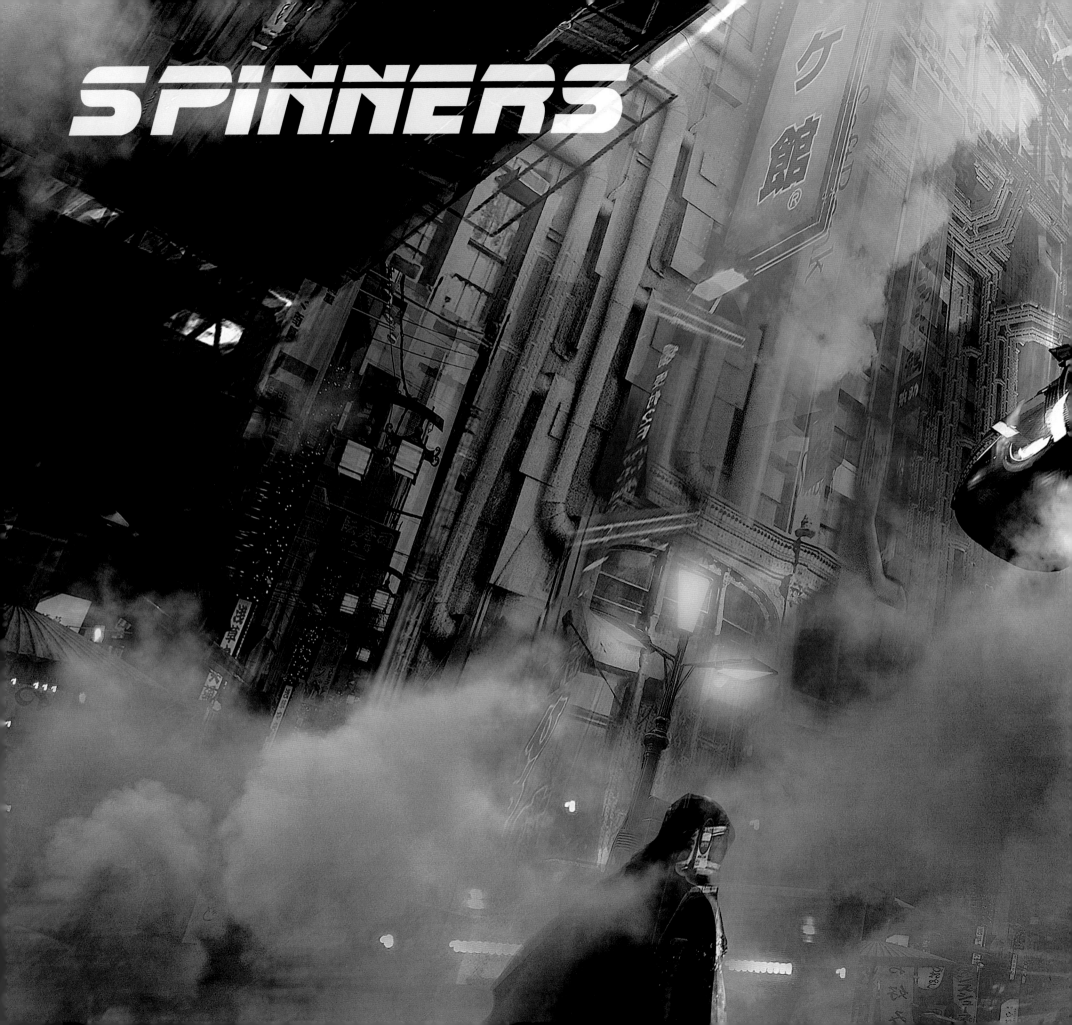

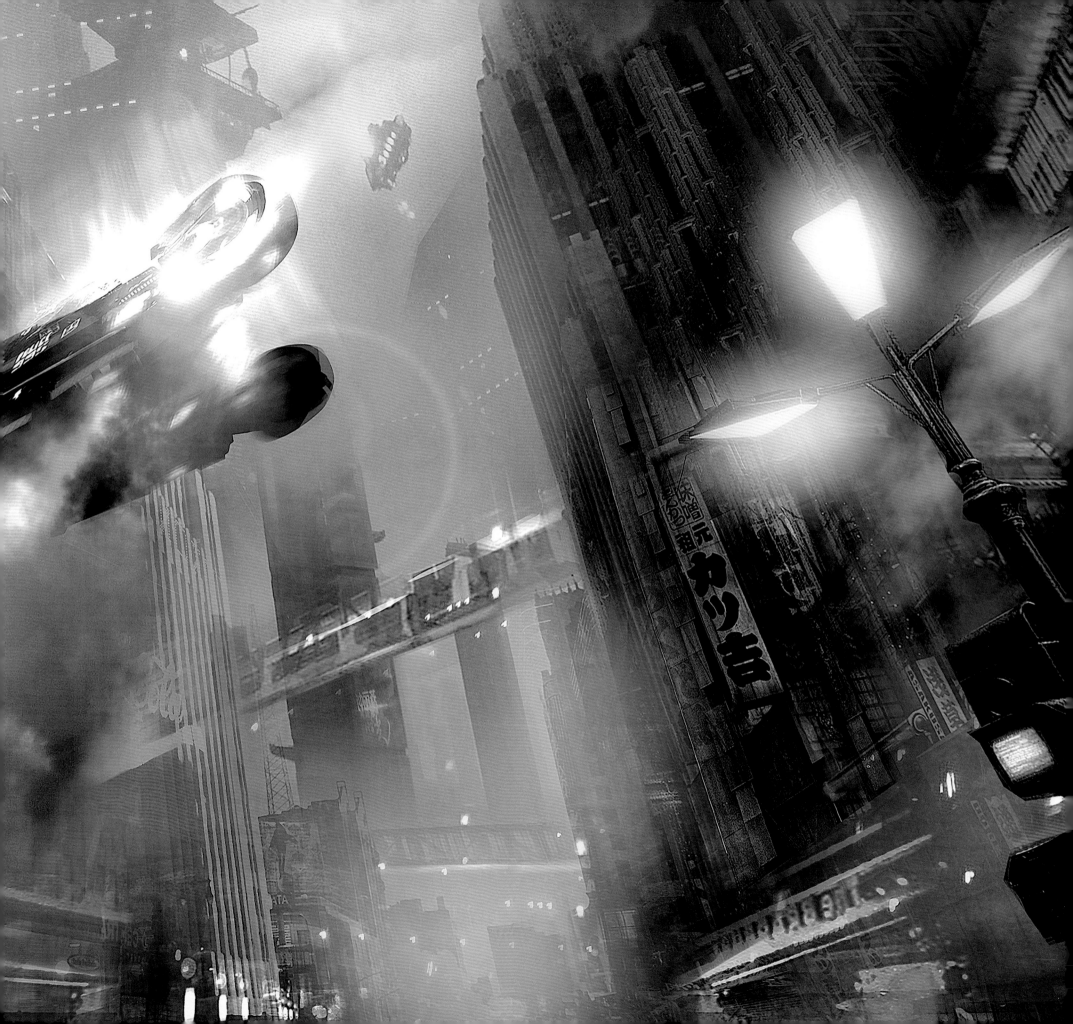

"My spinner designs took cues from the script and notes from Denis Villeneuve. Because the world of *2049* is even more dystopian than *Blade Runner* – colder from climate change and darker following the blackout – the new spinners are more protected, insulated, and armored. I wanted the changes to feel like a functional upgrade. The script only required a rooftop drone [for the police spinner], and I believe some weapons, too. After I created my designs, the project went on hold, and I started on another film. When *2049* picked back up in the UK and Hungary, the look of K's spinner separated from the LAPD's, so that K could have a vehicle that could blend into the background and be more covert for investigations. My design was then used for the police, while K's spinner kept evolving with Dennis Gassner and Dan Walker."

George Hull

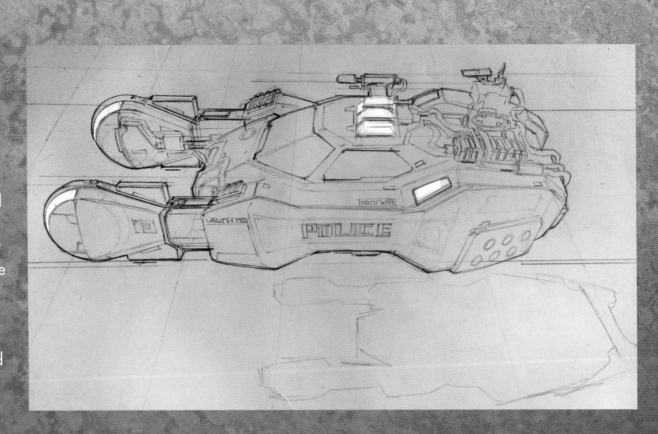

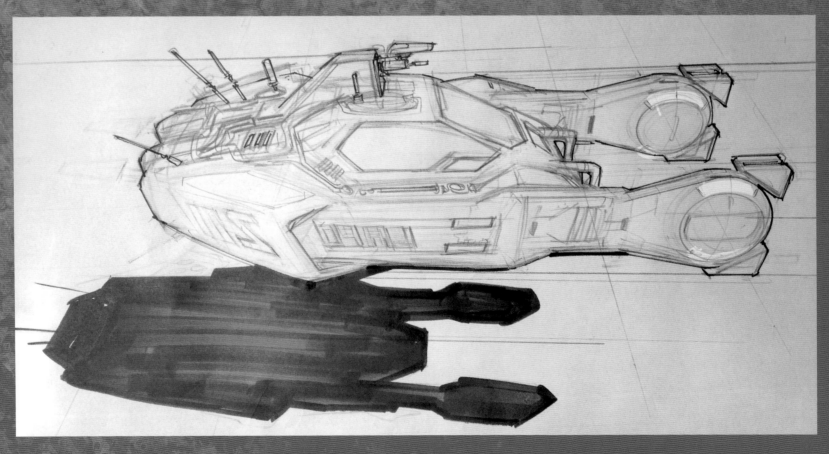

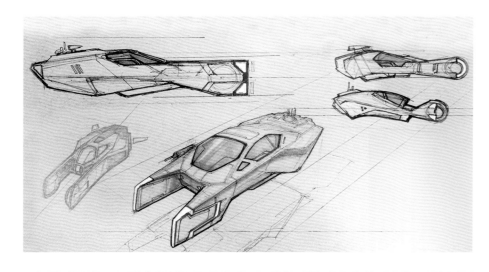

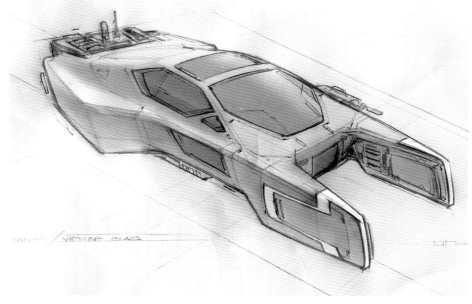

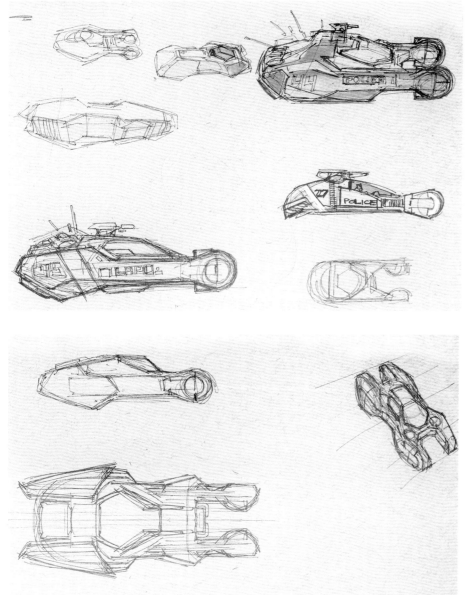

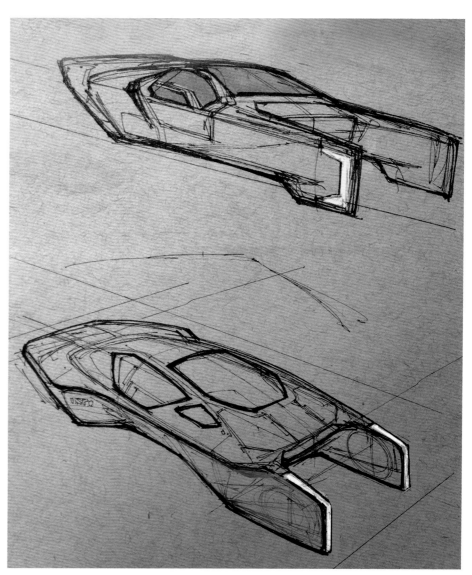

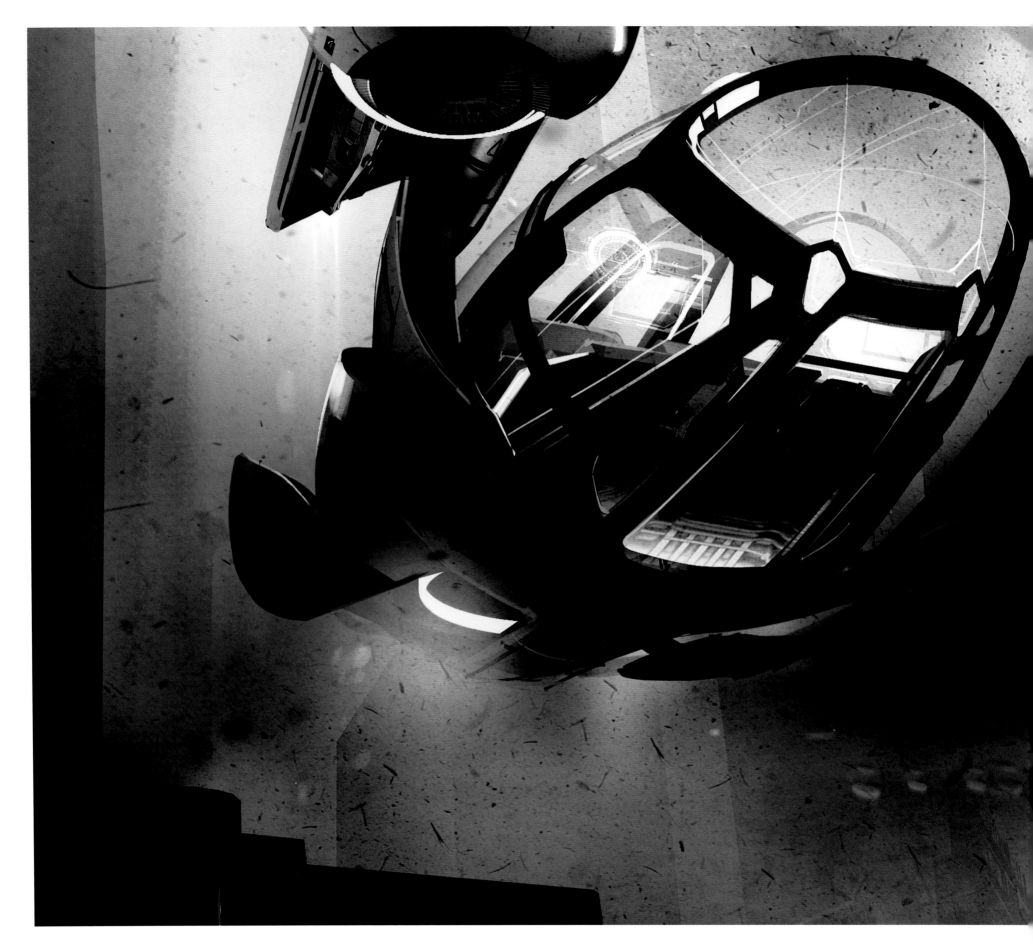

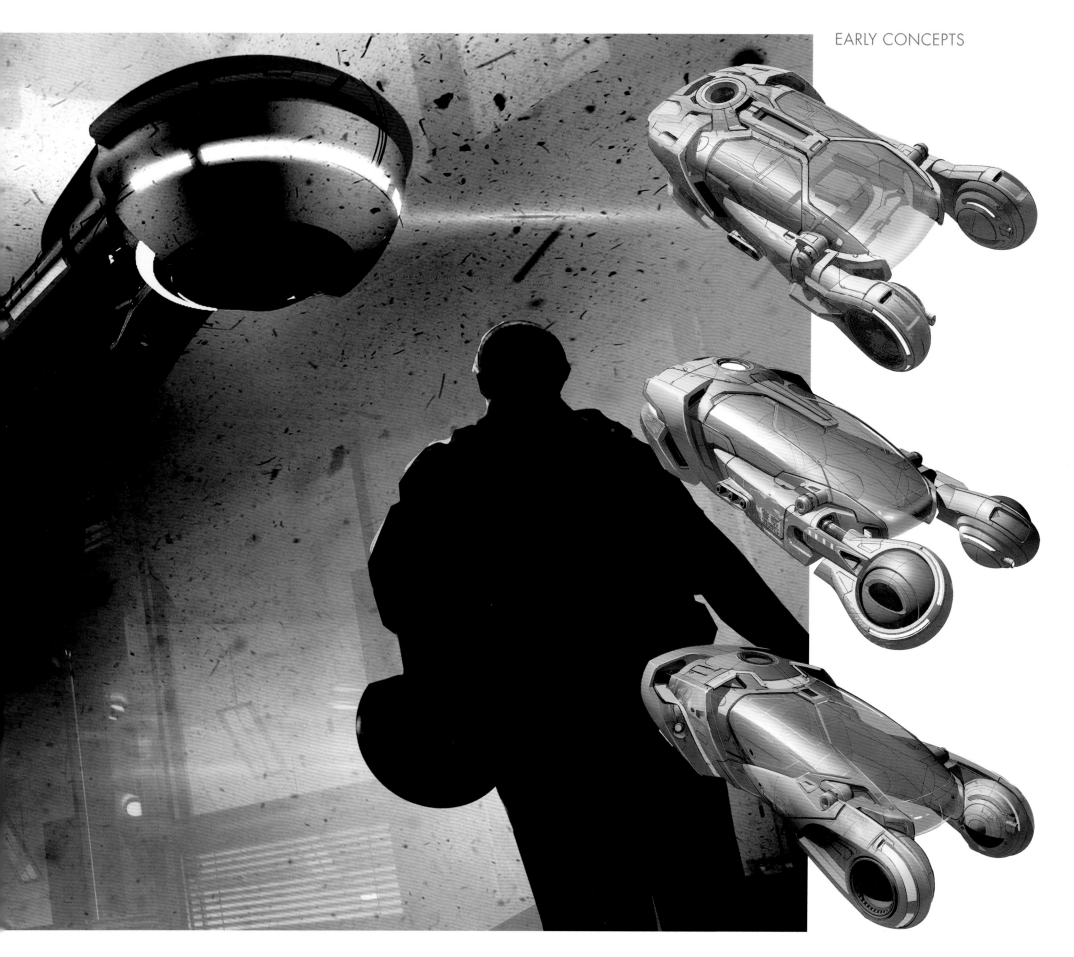

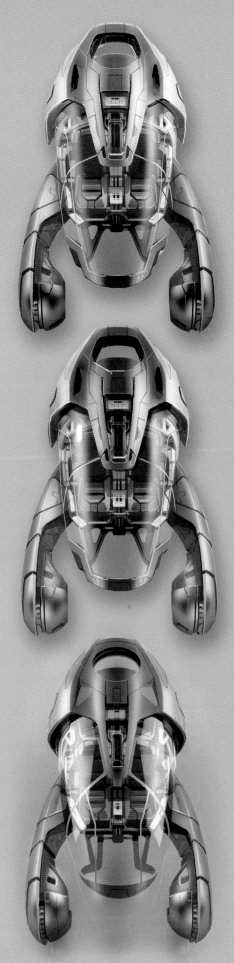
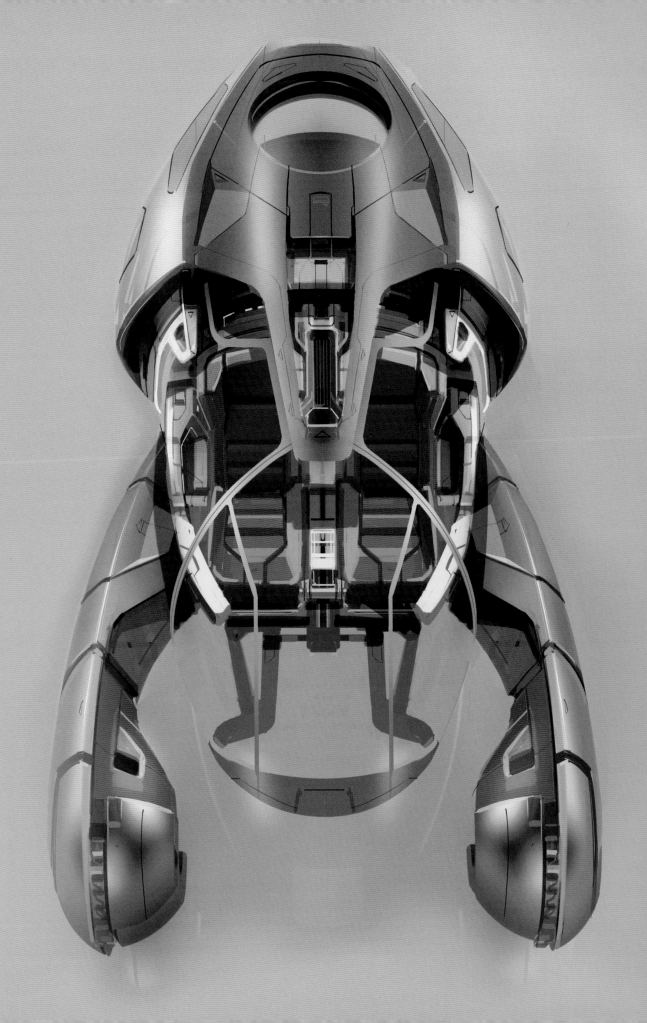

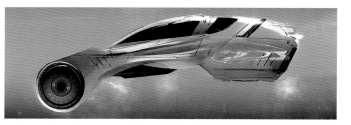
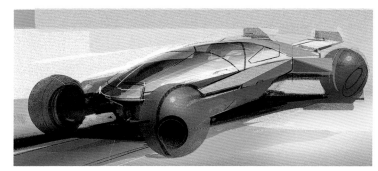
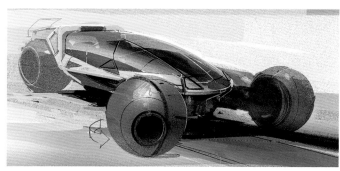
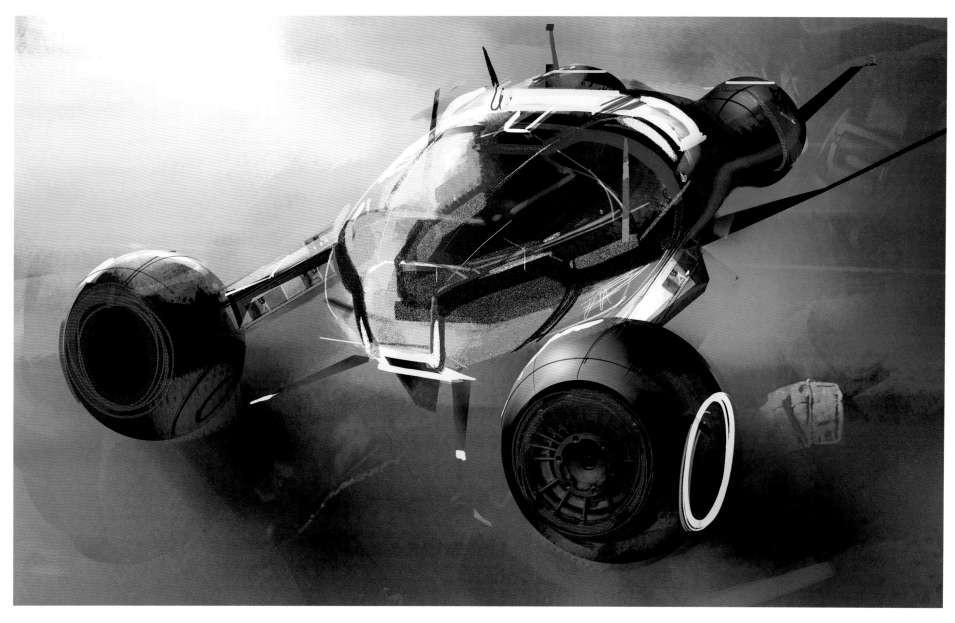

PILOT FISH

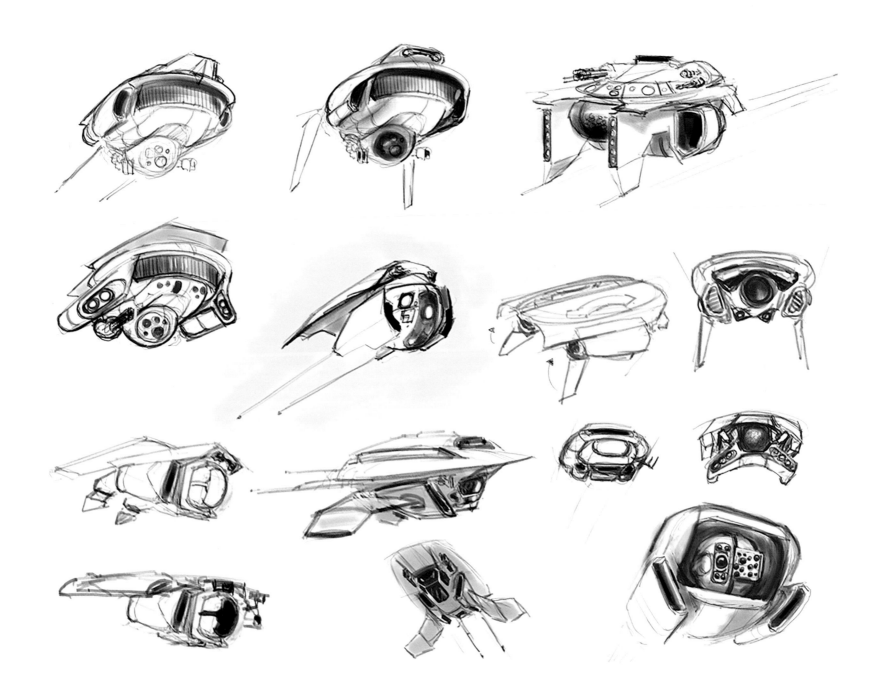

"This is a good example of a brainstorm study for the pilot fish. I would often do this kind of exploration with Denis Villeneuve to discover what works and what doesn't. This stepping stone was based on the idea that it had to be a flat-topped drone with a multi-lensed eye. These drawings are some of many that funneled toward the idea that it should be a more utilitarian 'traffic camera with wings' within the tradition of the 'walk/don't walk' signs of *Blade Runner*. It was an experimental process of elimination, based on research into various technologies, along with ideas about how they might eventually be animated in flight."

Sam Hudecki

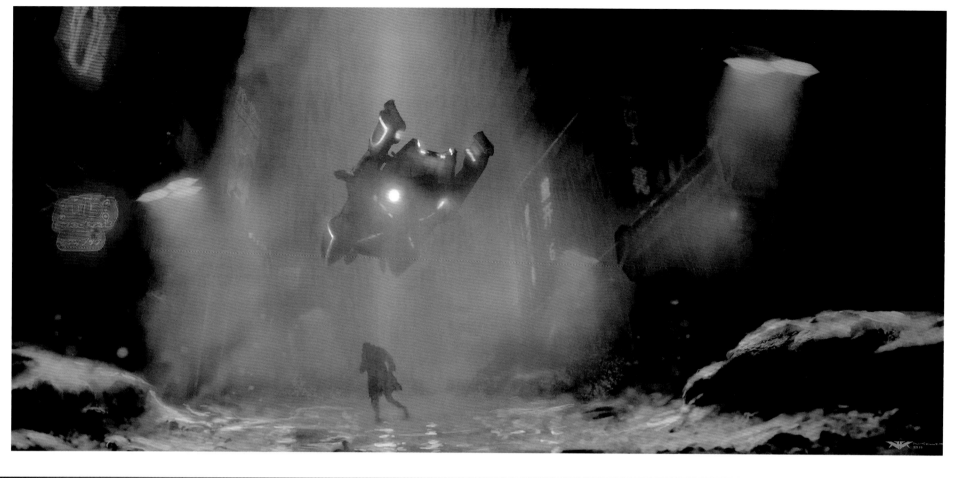

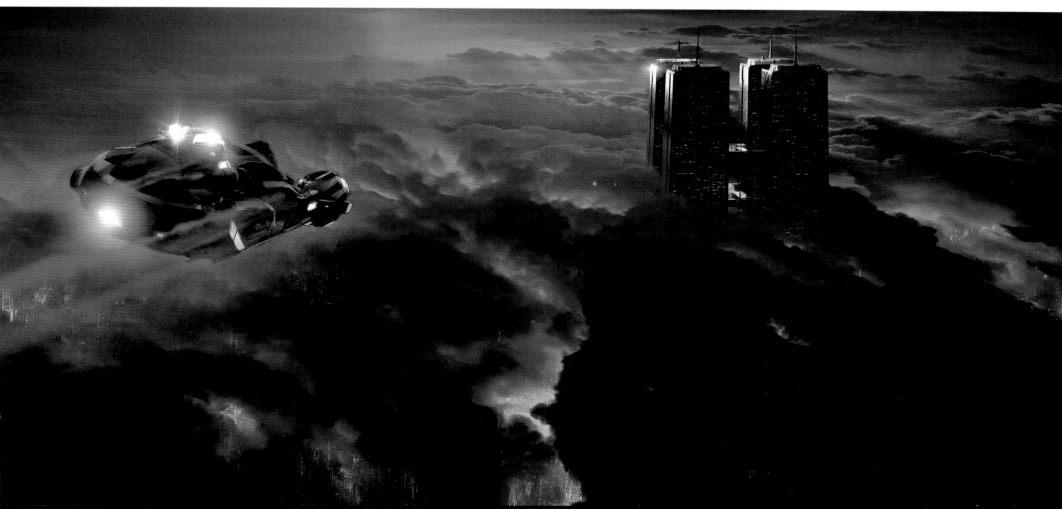

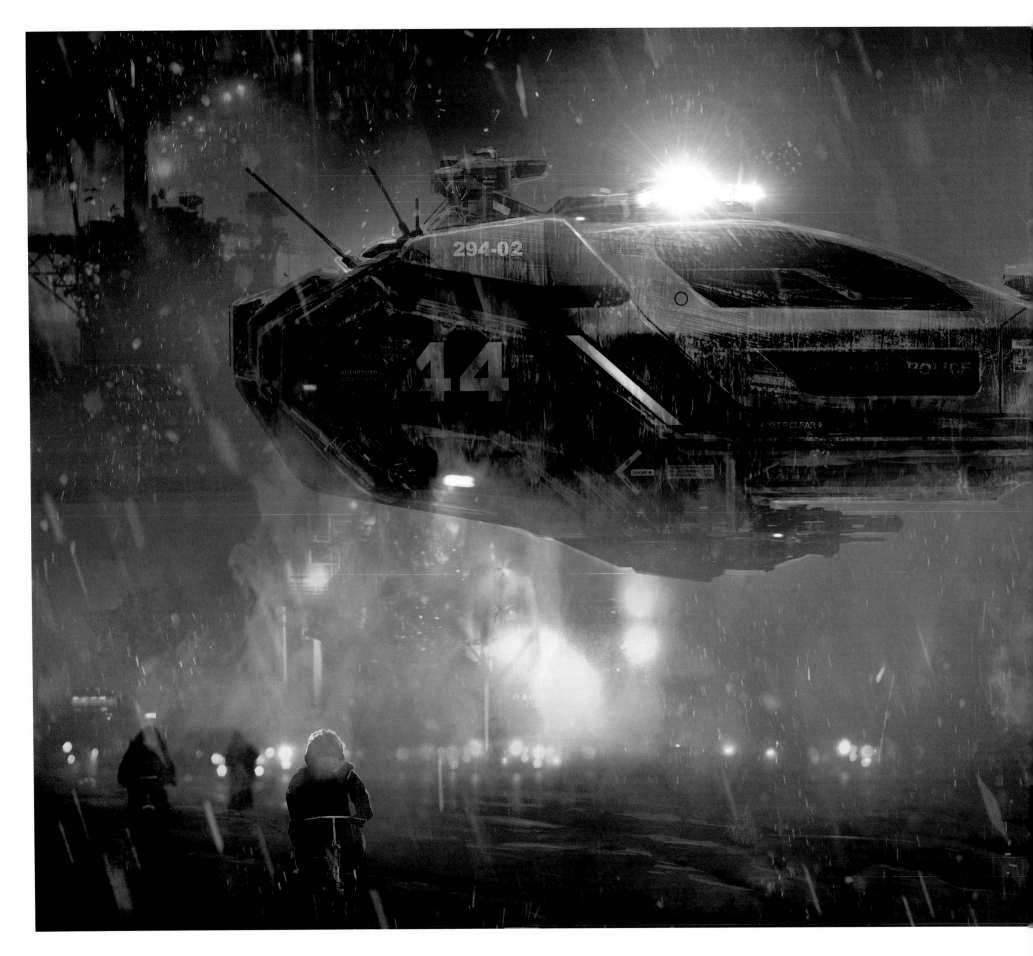

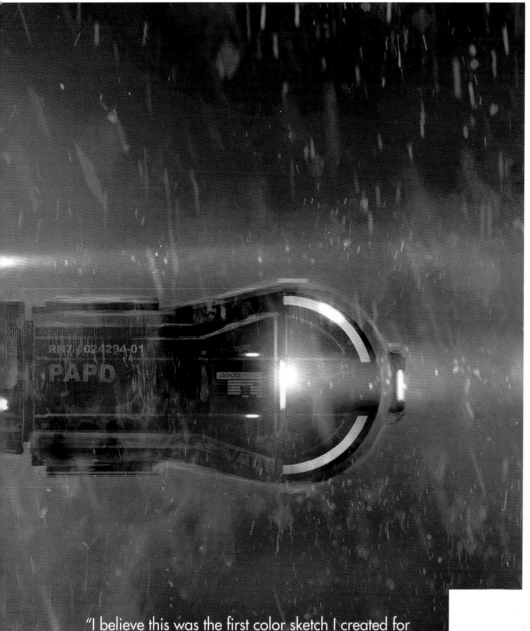

"I like to think through a concept like an engineer. My degree is in industrial and automotive design, so I instinctually think in a form-follows-function mentality. I start with the needs of the script and any notes from the director and production designer. At the time of this illustration, we discussed how to apply Denis Villeneuve's key word 'Brutal.' So I came up with technical details, imagining that the new spinners would have to melt ice and need heavy duty pollution filters and sensors to navigate within the thick smog."

▼ *George Hull*

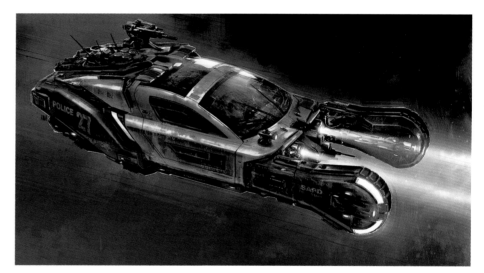

"I believe this was the first color sketch I created for K's spinner, drawn around March 2015. I wanted to be respectful of Syd Mead's design, so this was meant to keep the basic shapes, but depict a more armored shell and changes to the door glass and rear. For the mood, I was looking at a lot of photography from China of streets thick with pollution. Having a bicycle was important to me, as I loved the original film's use of old and new technology existing simultaneously. These little details are so helpful when trying to invent a future that still seems grounded."

George Hull

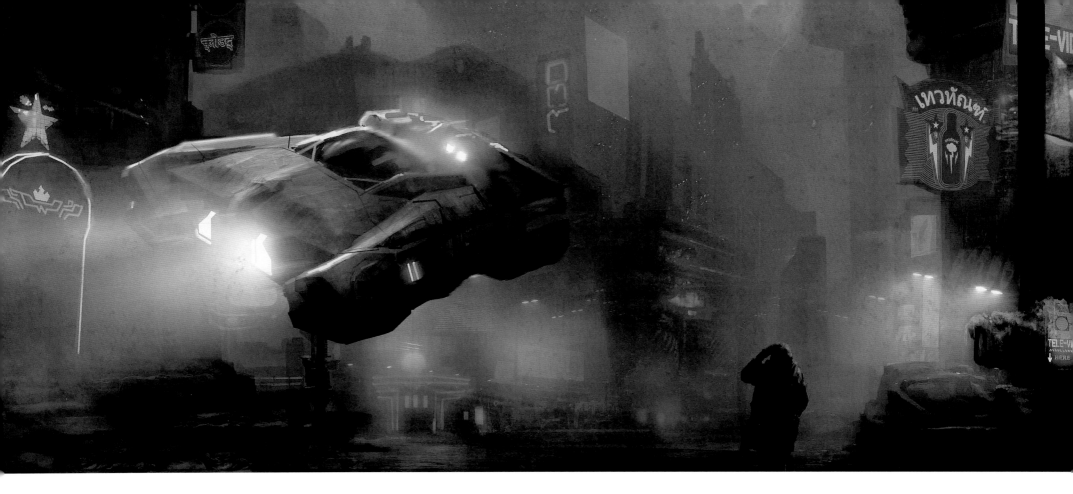

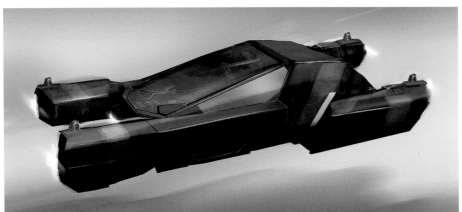

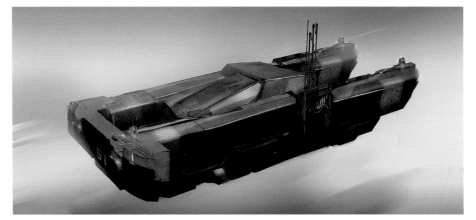

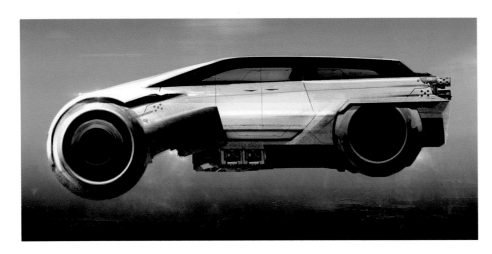

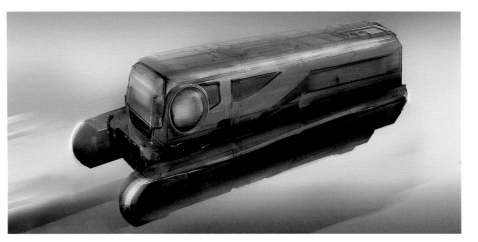

"We treated the spinner as a character itself. There is a fine line between a futuristic car and a 'flying car' fantasy. Denis Villeneuve and I made sure our vehicles would own the credibility of a real car and added features from existing vehicles that people are already familiar with. A final pass included aging and use-wear marks from previous owners. The design process involved many designers and followed a winding path from the curved shapes of a Bugatti to the boxy exterior of the Lotus Esprit. It was Dan Walker who eventually shaped the look of the vehicle and pushed it in a new direction. Zsolt Tarnok was the one who crafted the interior and exterior with the knowledge of a real automotive designer."
Peter Popken

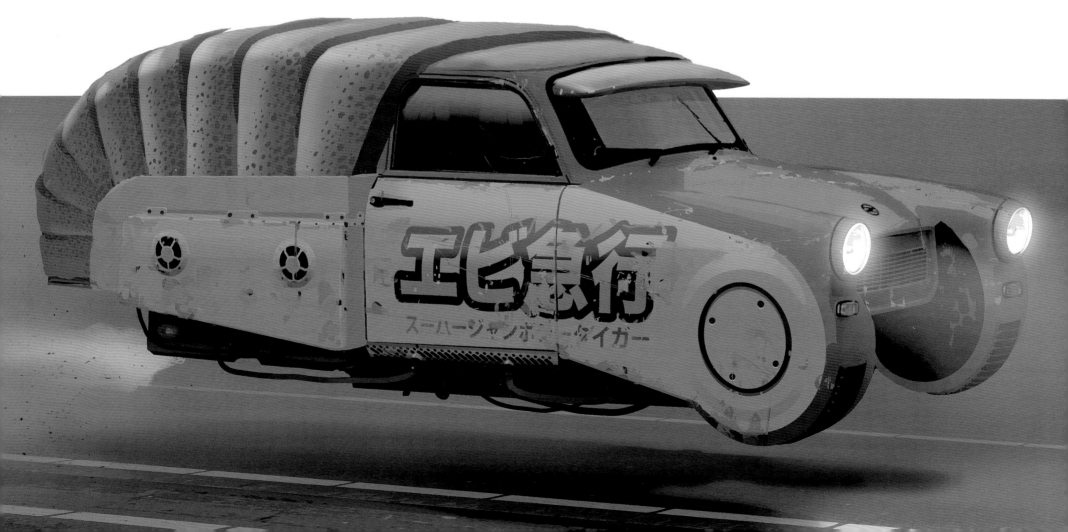

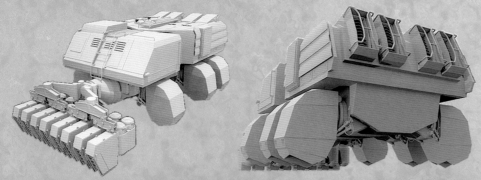

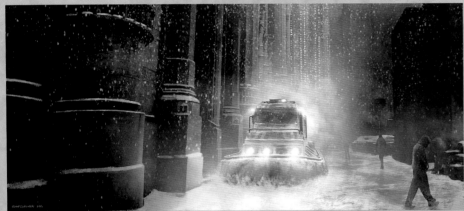

"Dennis Gassner asked me to develop an unmanned municipal A.I. vehicle that would plow the streets at night. The sweeper was to have a Brutal and heavy architecture, yet be able to hover above the street as it extracts the snow. My initial approach was to research military hovercraft; practical design with a menacing visual language. As the vehicle evolved, my inspiration included mine sweepers and other utility vehicles, while trying to maintain ties with the aesthetics from the original film. My final design was composed of multiple forward inhalation gates that would collect the snow, vaporize it, and ventilate the steam through twin aft turbines. The sweeper is levitated and propelled by six adjustable vertical-lift engines. An articulating mid-joint allows the larger design of the vehicle to maneuver through confined streets. For visibility during extreme weather conditions the snow sweeper is equipped with hazard beacons, multiple high-beam lamps, and lined with a scrolling 'Caution' banner."

◄▼ *Scott Lukowski*

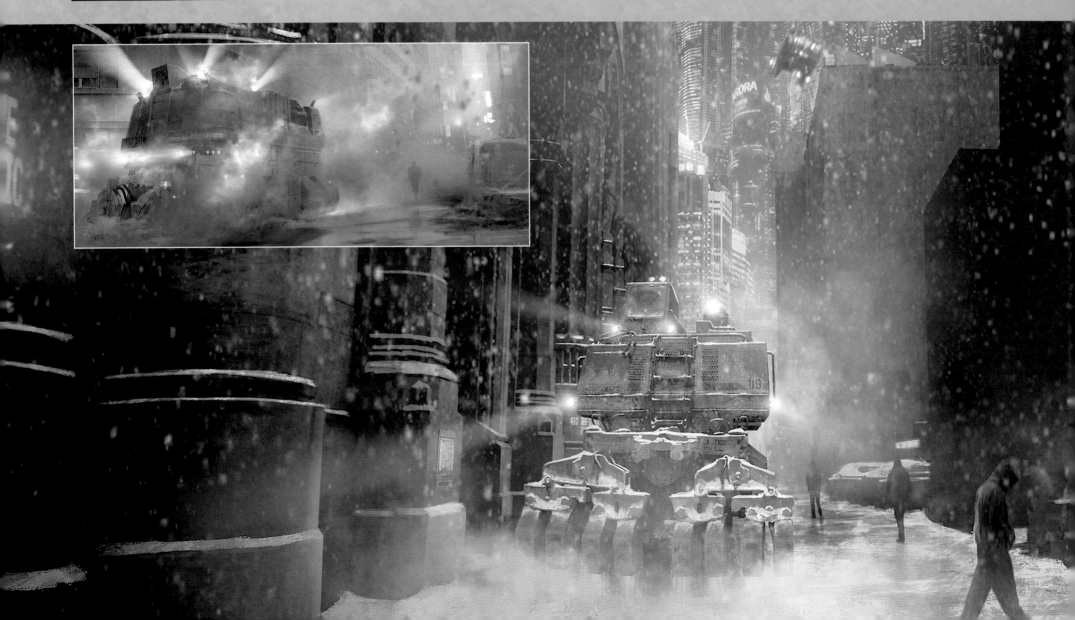

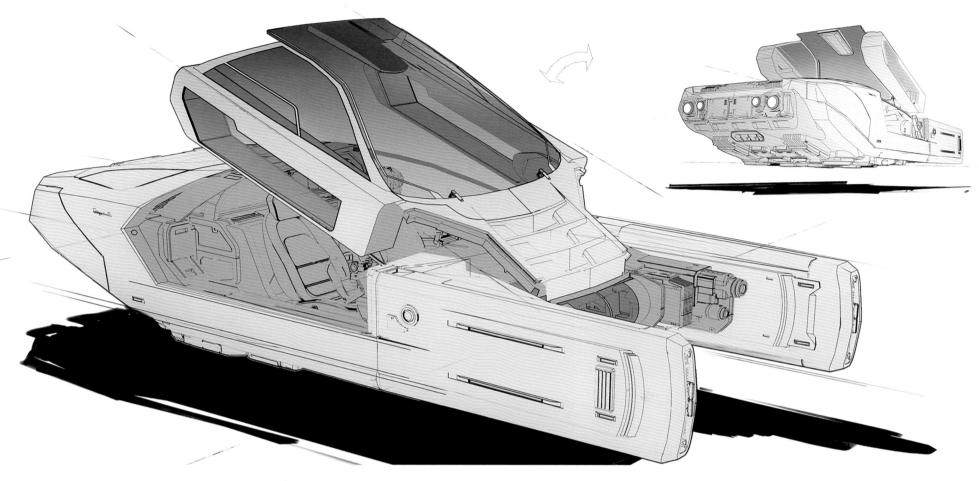

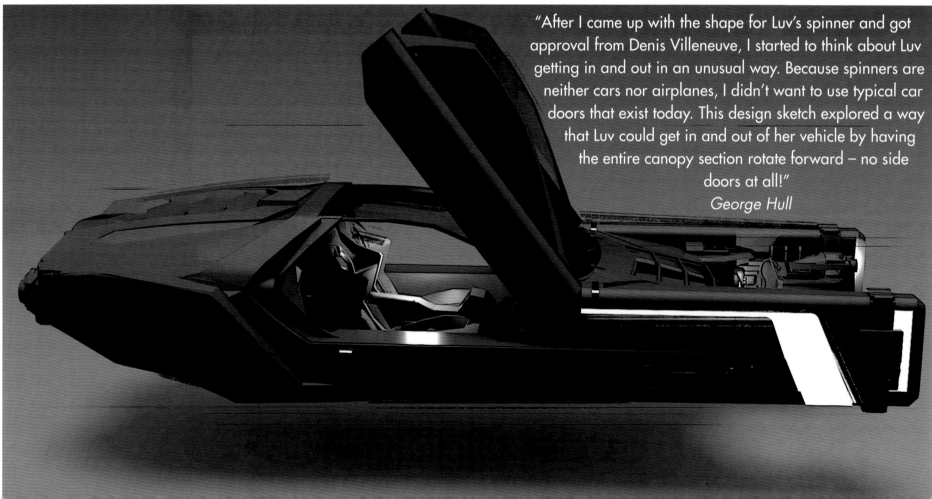

"After I came up with the shape for Luv's spinner and got approval from Denis Villeneuve, I started to think about Luv getting in and out in an unusual way. Because spinners are neither cars nor airplanes, I didn't want to use typical car doors that exist today. This design sketch explored a way that Luv could get in and out of her vehicle by having the entire canopy section rotate forward – no side doors at all!"

George Hull

"Since Luv is the main antagonist for the Wallace Corporation, I used keywords like 'elite,' 'aggressive,' 'luxury,' and 'sexy' to start my design sketches. For an elite feel, I took cues from the 1965 Lincoln Continental, with its iconic blunt front fenders. This is the type of car that presidents were driven in, so it felt authoritative to me. I was asked to round the front fenders by Dennis Gassner, to make it a touch more feminine. The copper color hues were my idea to evoke a luxury quality and add a retro-futuristic feeling that I love from the original film."

George Hull

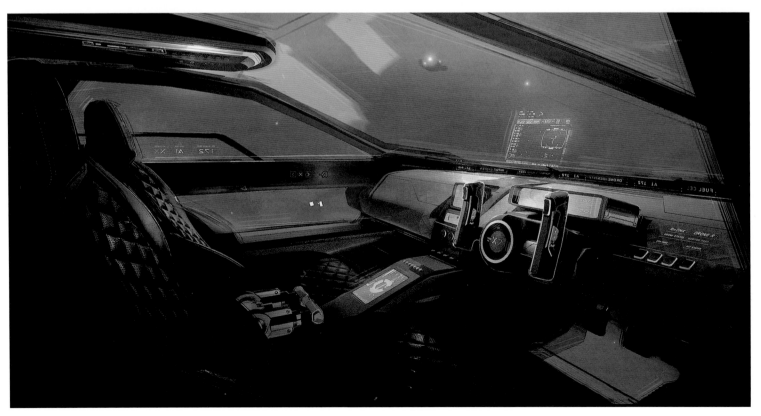

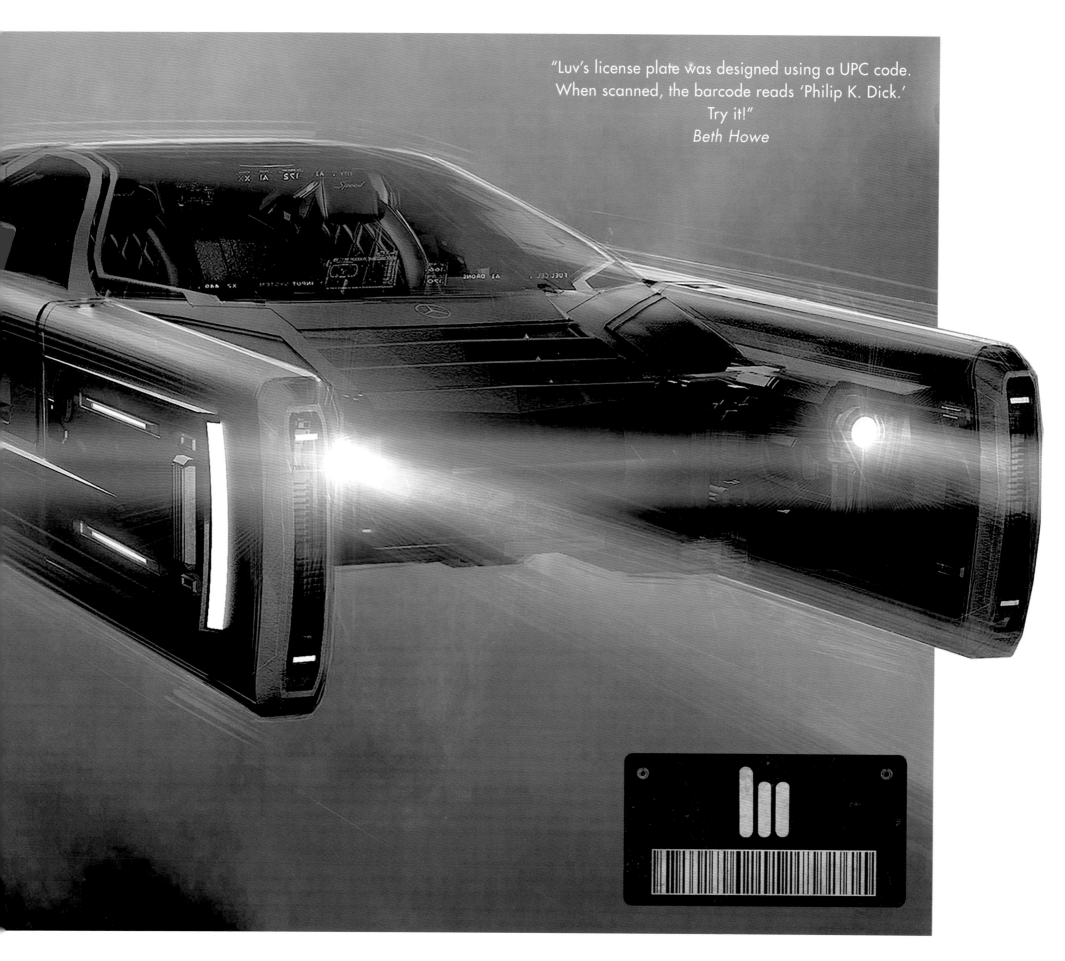

"Luv's license plate was designed using a UPC code. When scanned, the barcode reads 'Philip K. Dick.' Try it!"
Beth Howe

"In [an early version of the script] there was an action sequence involving a 'Wallace transport spinner' carrying Deckard to an off-world launch site. It was described as a van, but I was determined to create something that had a more intersecting silhouette. I found inspiration watching airplane tow vehicles at the airport, which attach to the plane for docking, then disconnect. Similarly, this design imagines the cabin as a separate container that could get picked up from above by a driver who controls the flying section. The sequence eventually took place on the shoreline in a much simpler vehicle, but this design idea was repurposed for use as a garbage truck to add scale and scope to the trash mesa scene [see page 144]. It works perfectly as an industrial recycling vehicle with an interesting silhouette."
George Hull

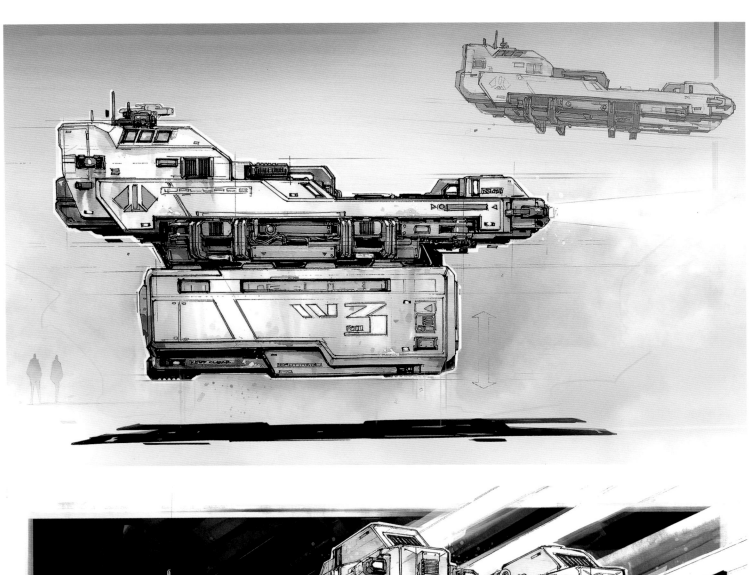

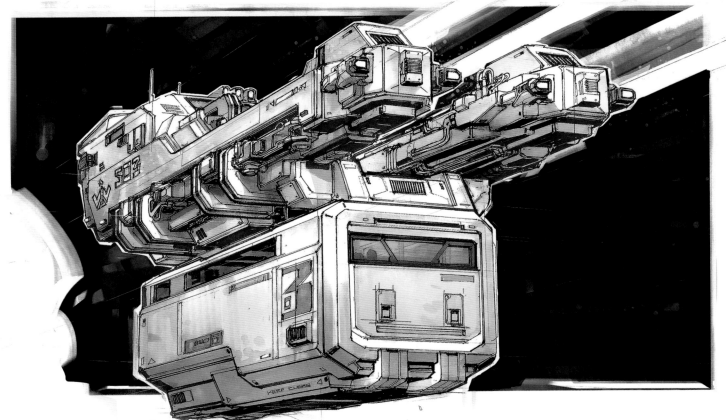

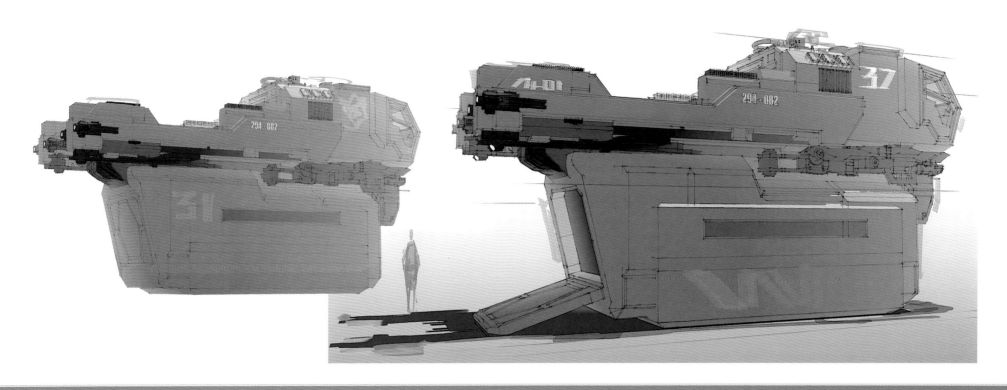

TRANSPORT SPINNER V1.-

CONCEPT: LIFT VEHICLE AND TRANPORT CABIN ARE SEPARATE FOR AN ATYPICAL SILHOUETTE - DIFFERENT THAN THE EXPECTED TRUCK OR VAN SHAPE.

WALLACE CORP. LIFT VEHICLE COULD TRANSPORT MANY DIFFERENT STYLES OF CABIN MODULES, PROVIDING A VARIETY OF LOOKS WITH ONE PRIMARY DESIGN.

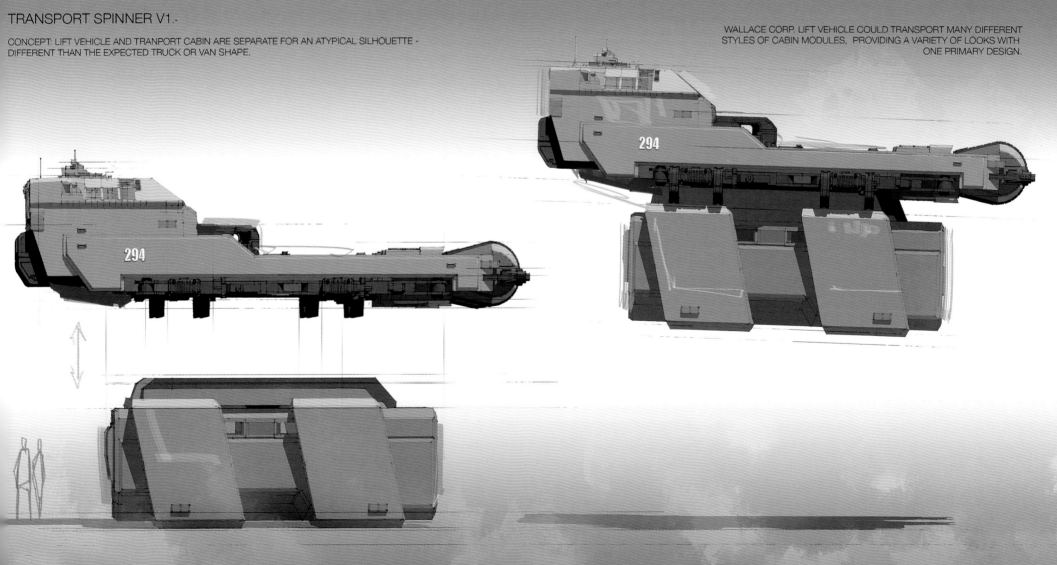

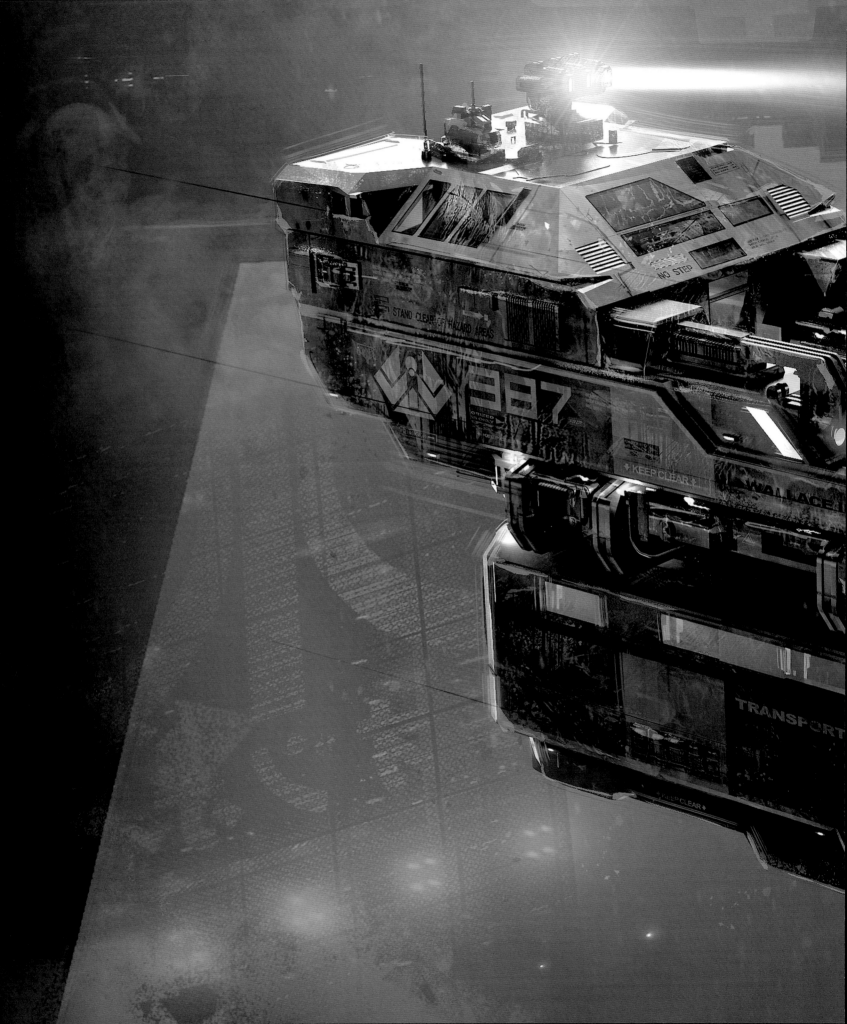

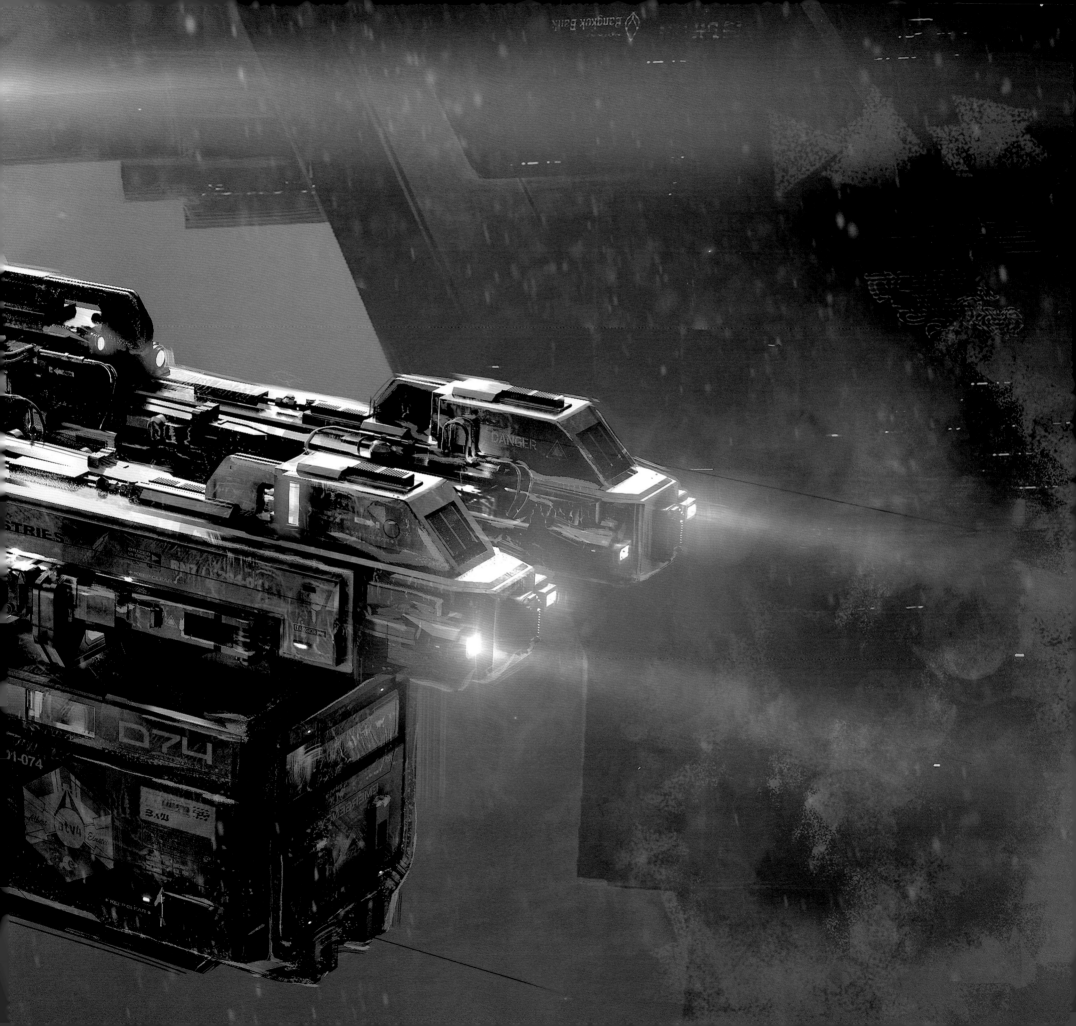

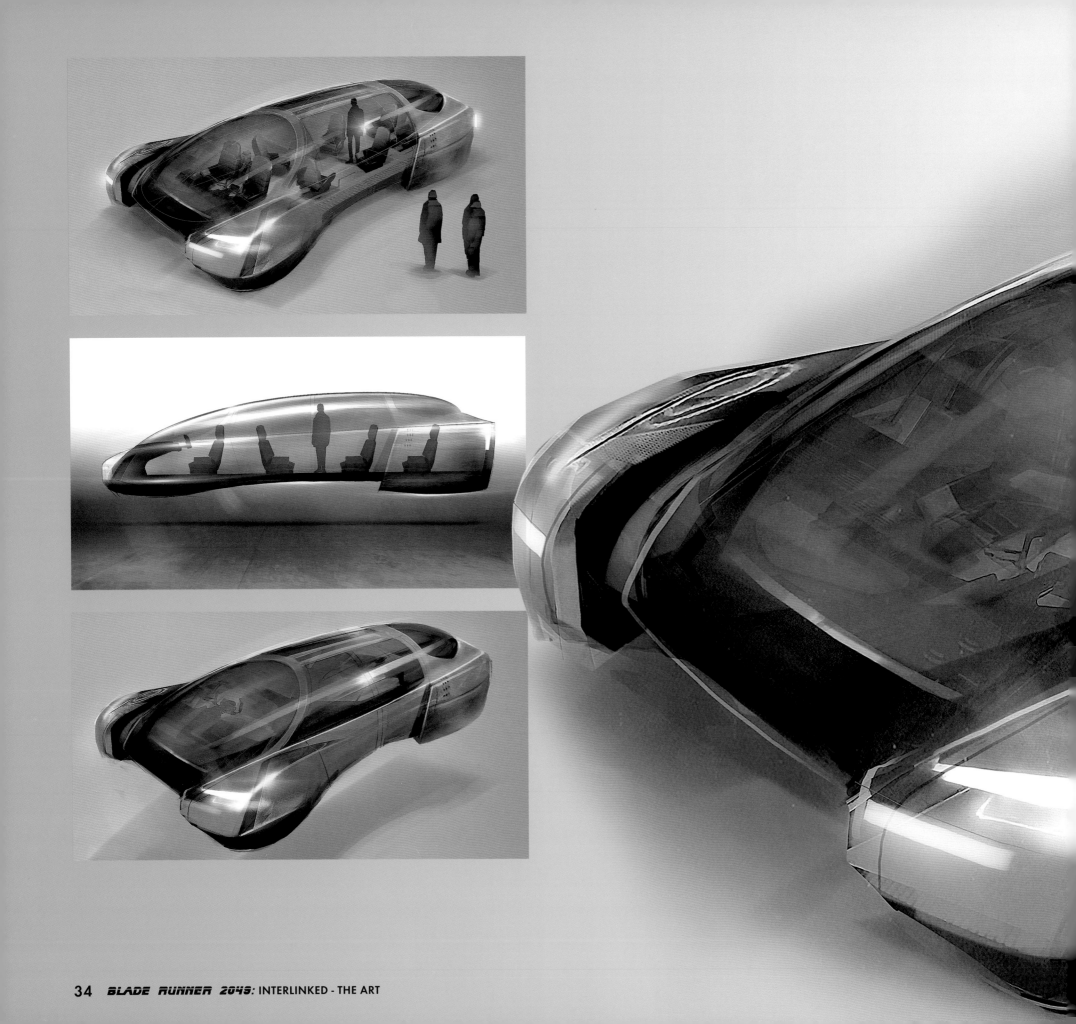

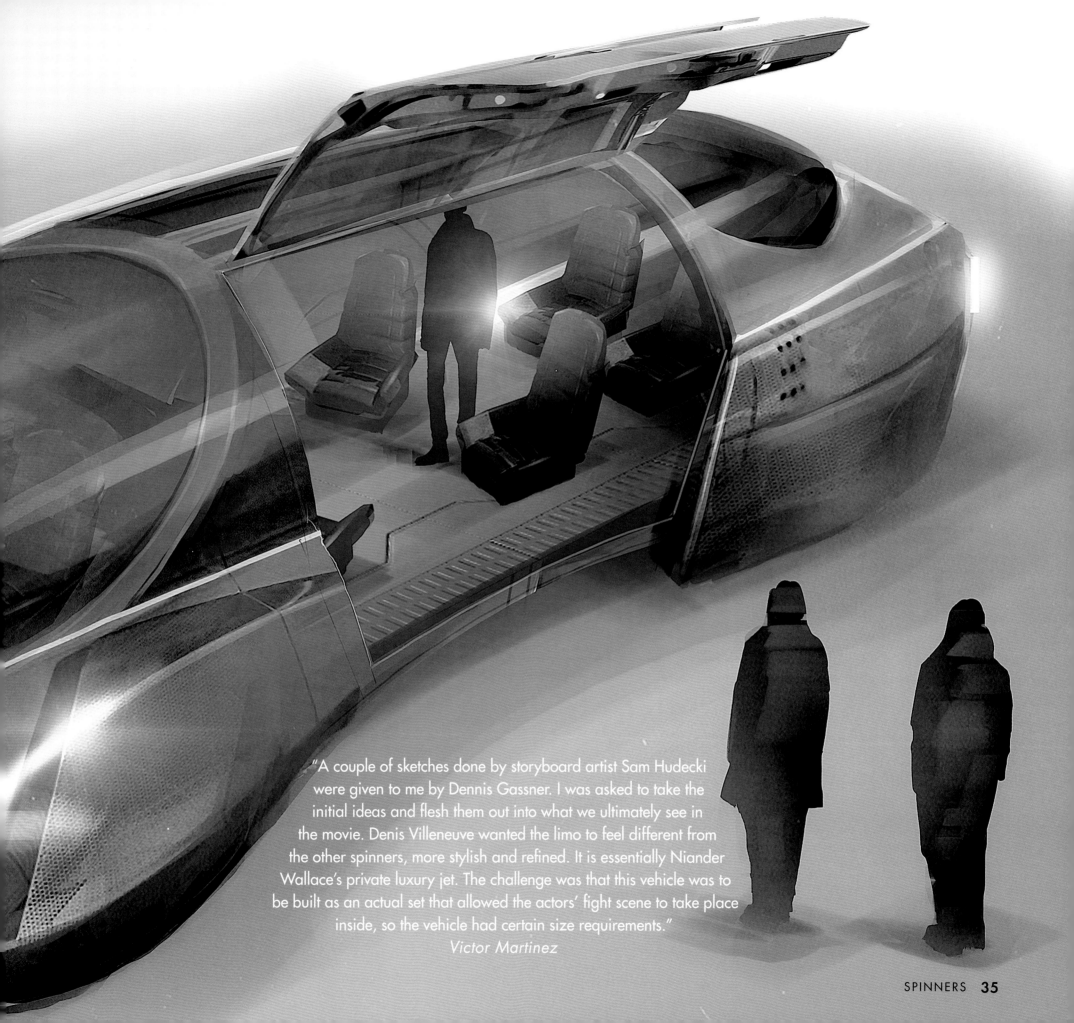

"A couple of sketches done by storyboard artist Sam Hudecki were given to me by Dennis Gassner. I was asked to take the initial ideas and flesh them out into what we ultimately see in the movie. Denis Villeneuve wanted the limo to feel different from the other spinners, more stylish and refined. It is essentially Niander Wallace's private luxury jet. The challenge was that this vehicle was to be built as an actual set that allowed the actors' fight scene to take place inside, so the vehicle had certain size requirements."
Victor Martinez

BLASTERS

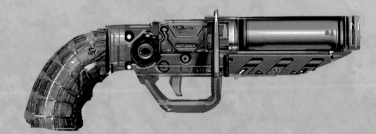

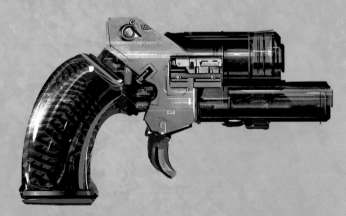

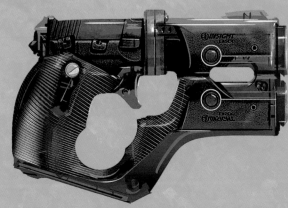

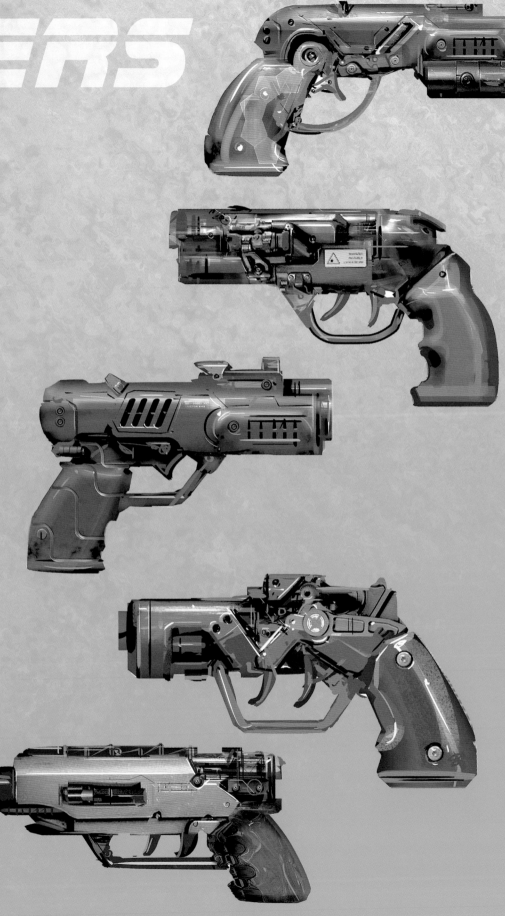

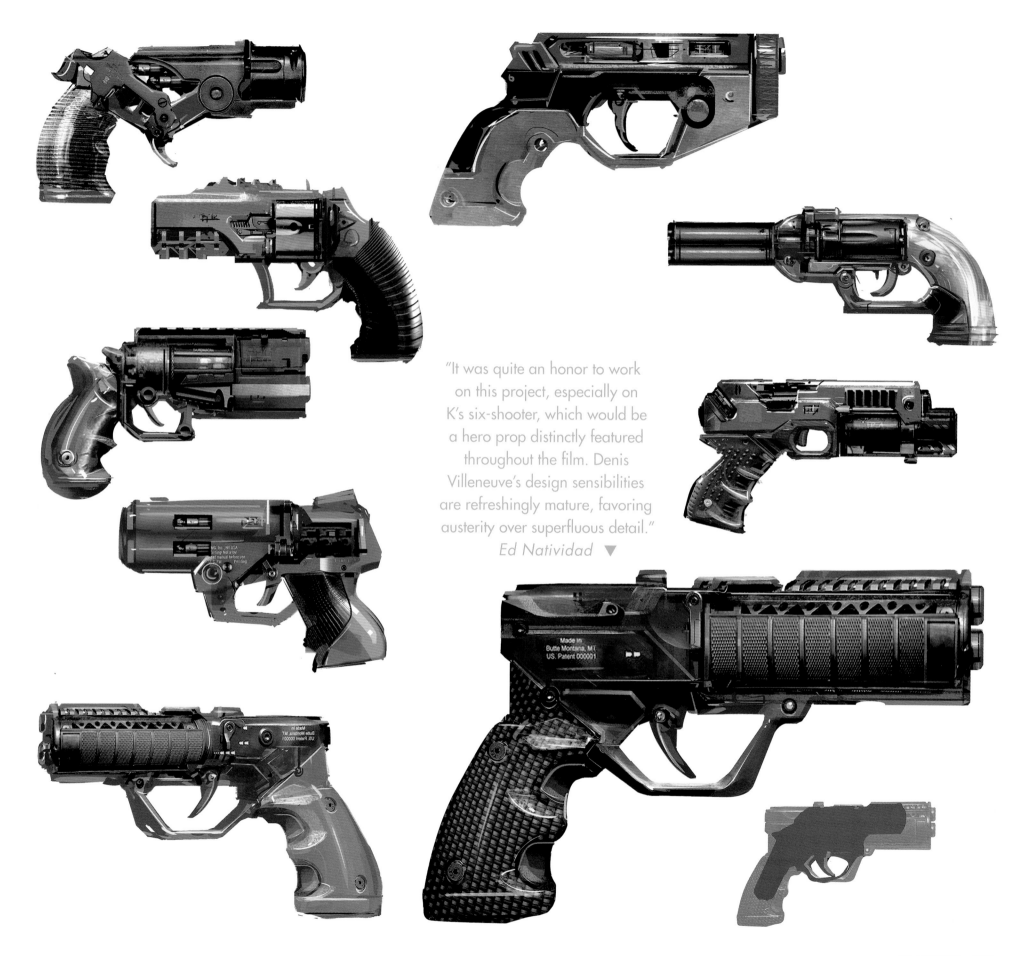

"It was quite an honor to work on this project, especially on K's six-shooter, which would be a hero prop distinctly featured throughout the film. Denis Villeneuve's design sensibilities are refreshingly mature, favoring austerity over superfluous detail."

Ed Natividad ▼

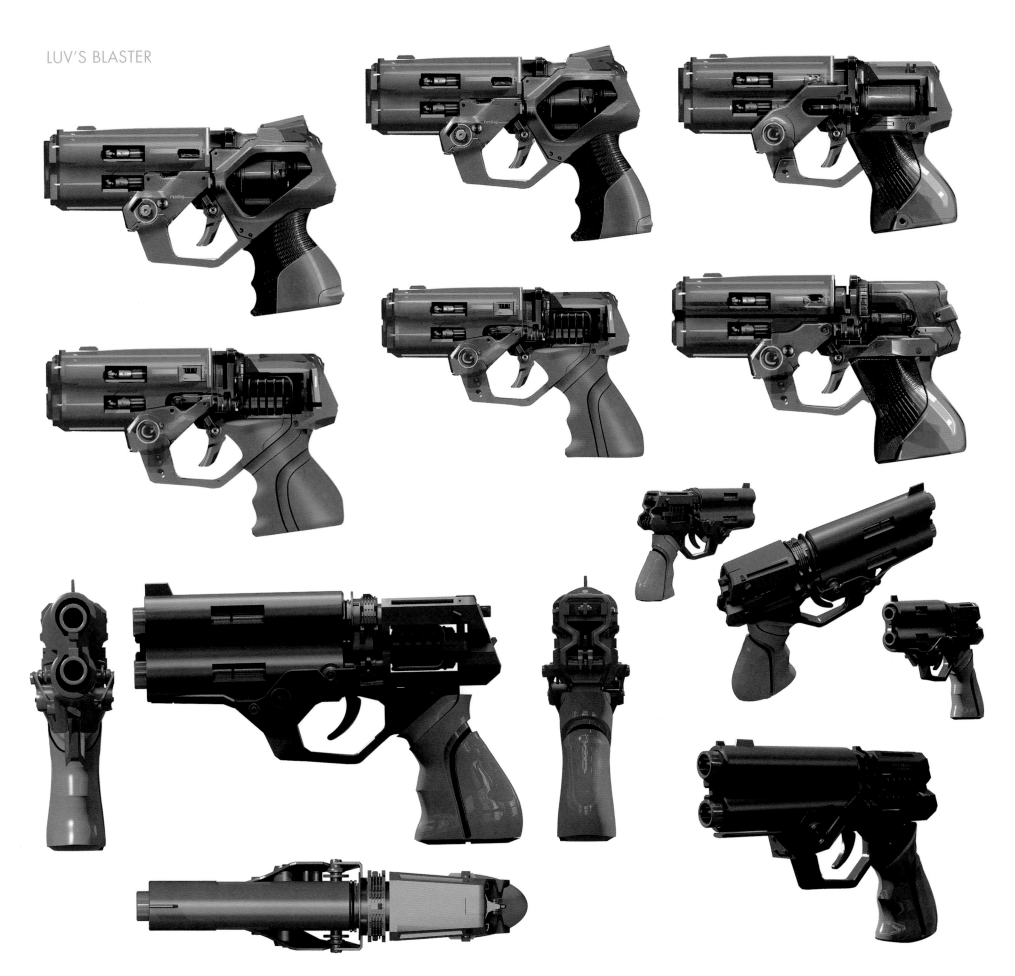

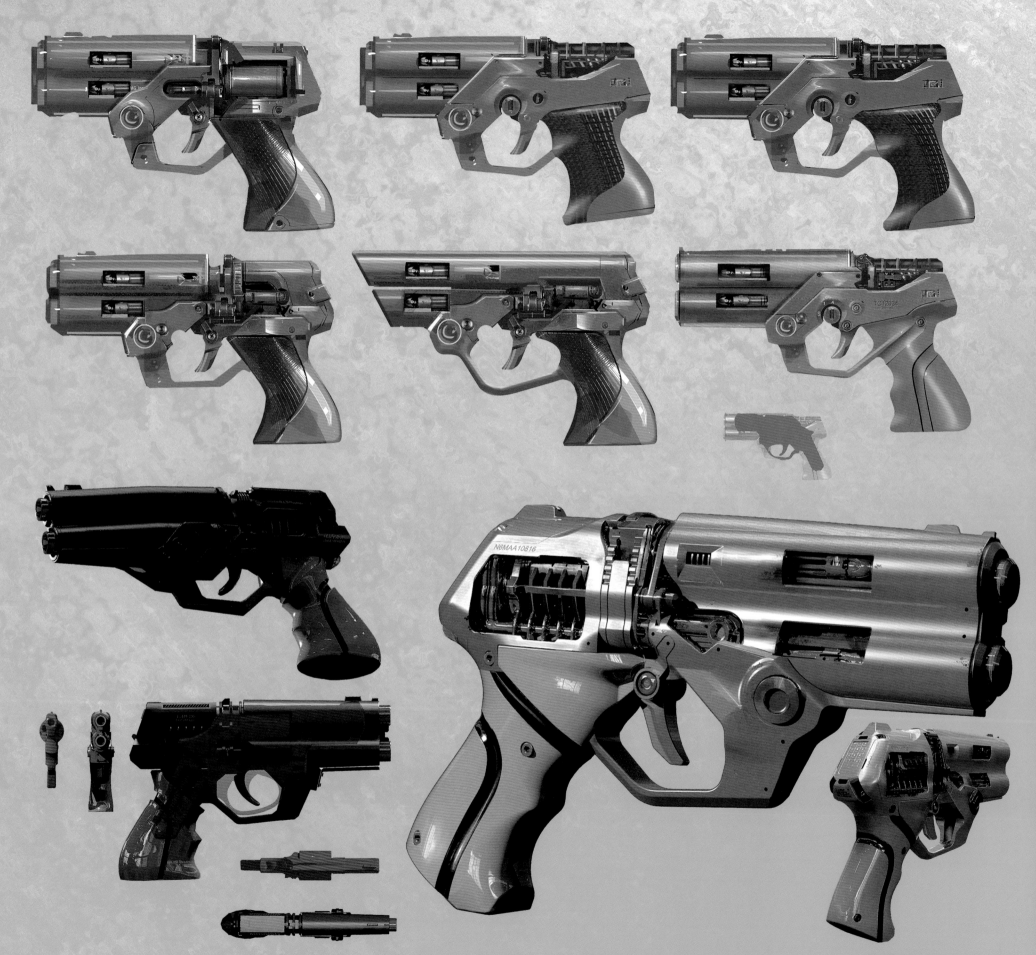

LOS ANGELES

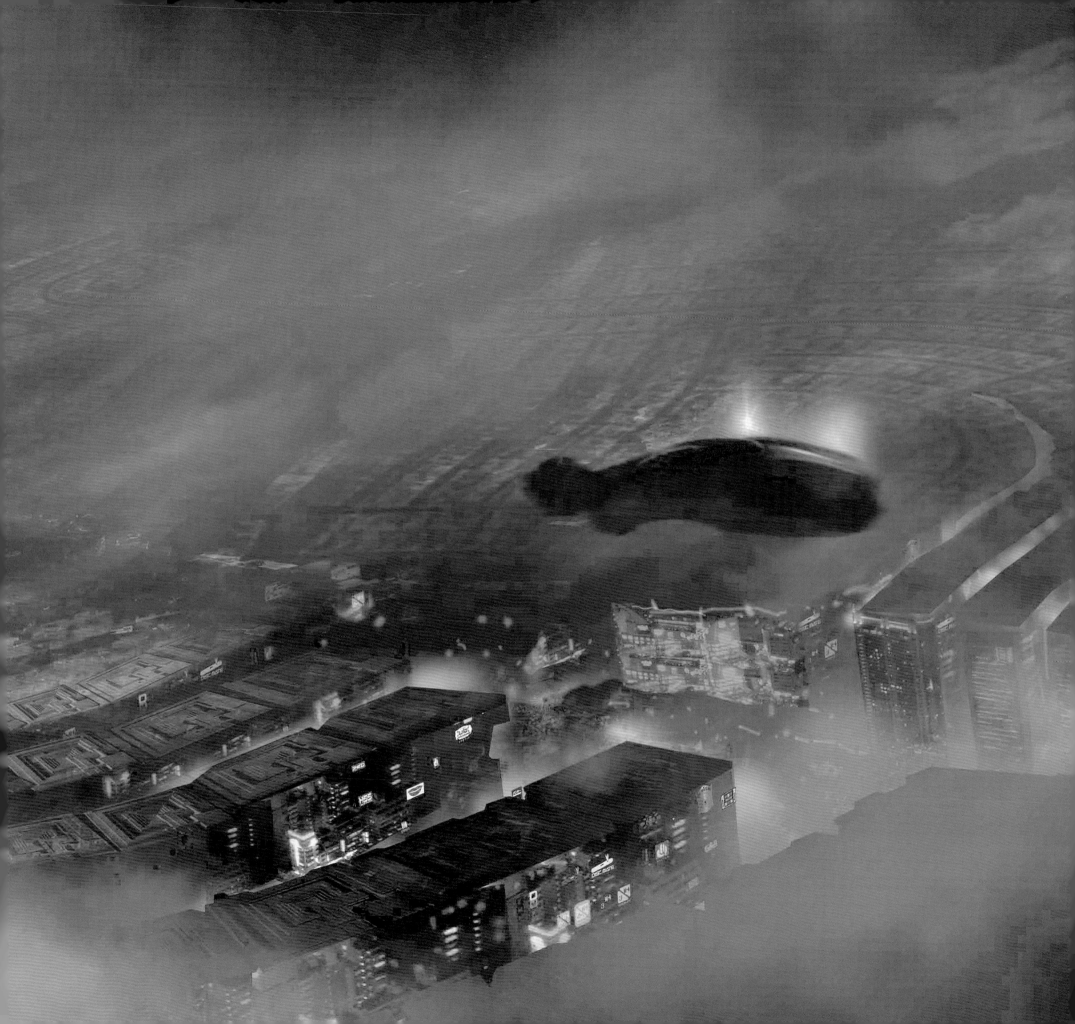

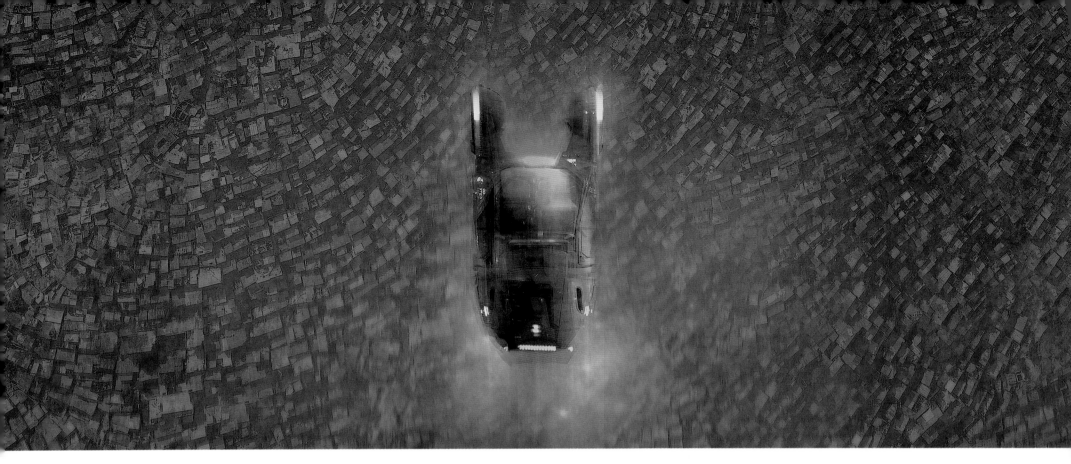

CITYSCAPE

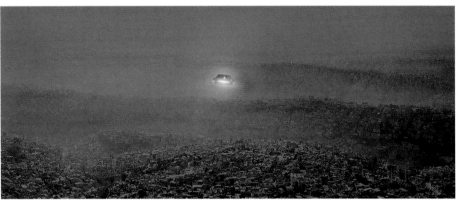

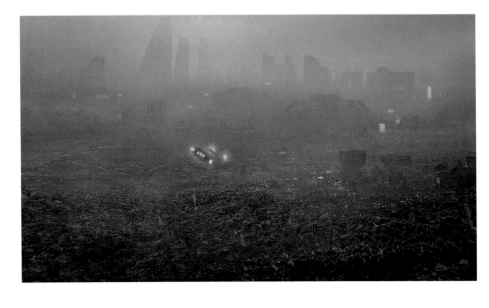

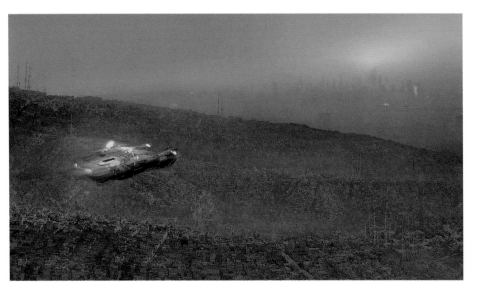

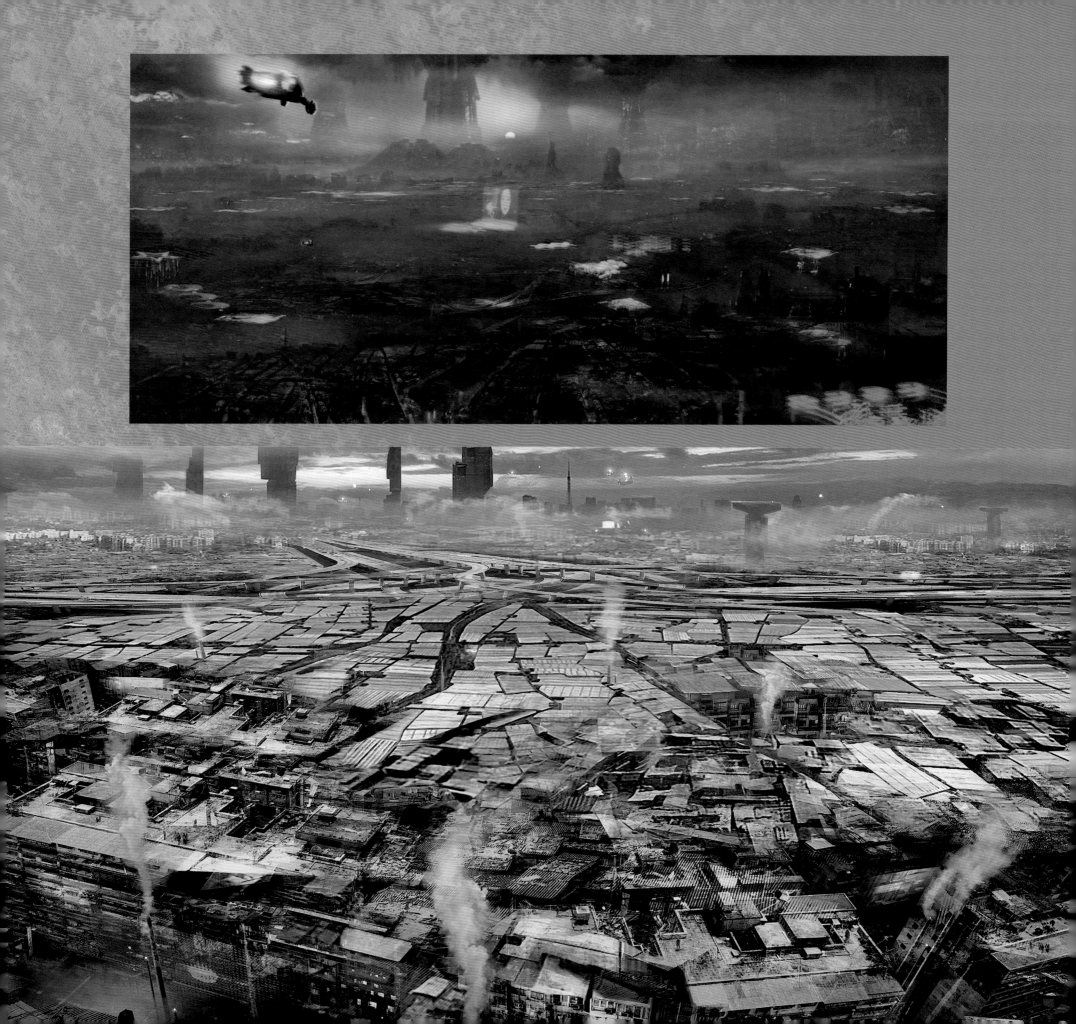

"The cityscape was an opportunity to do an homage to the first film. This was a first stab. So you can see where it went."
Victor Martinez

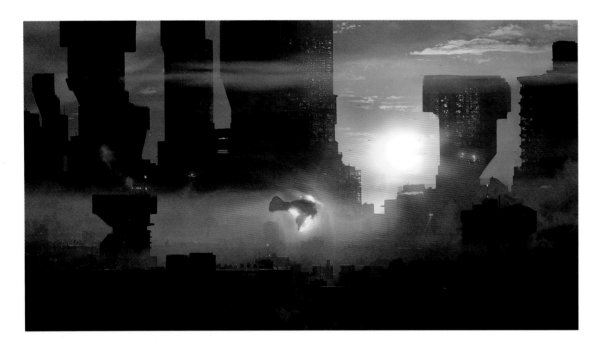

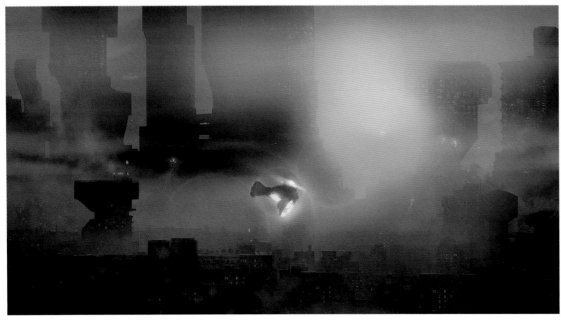

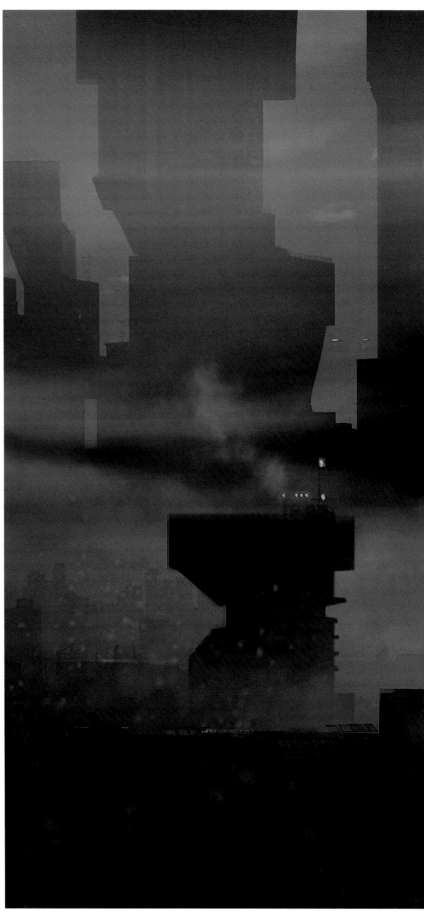

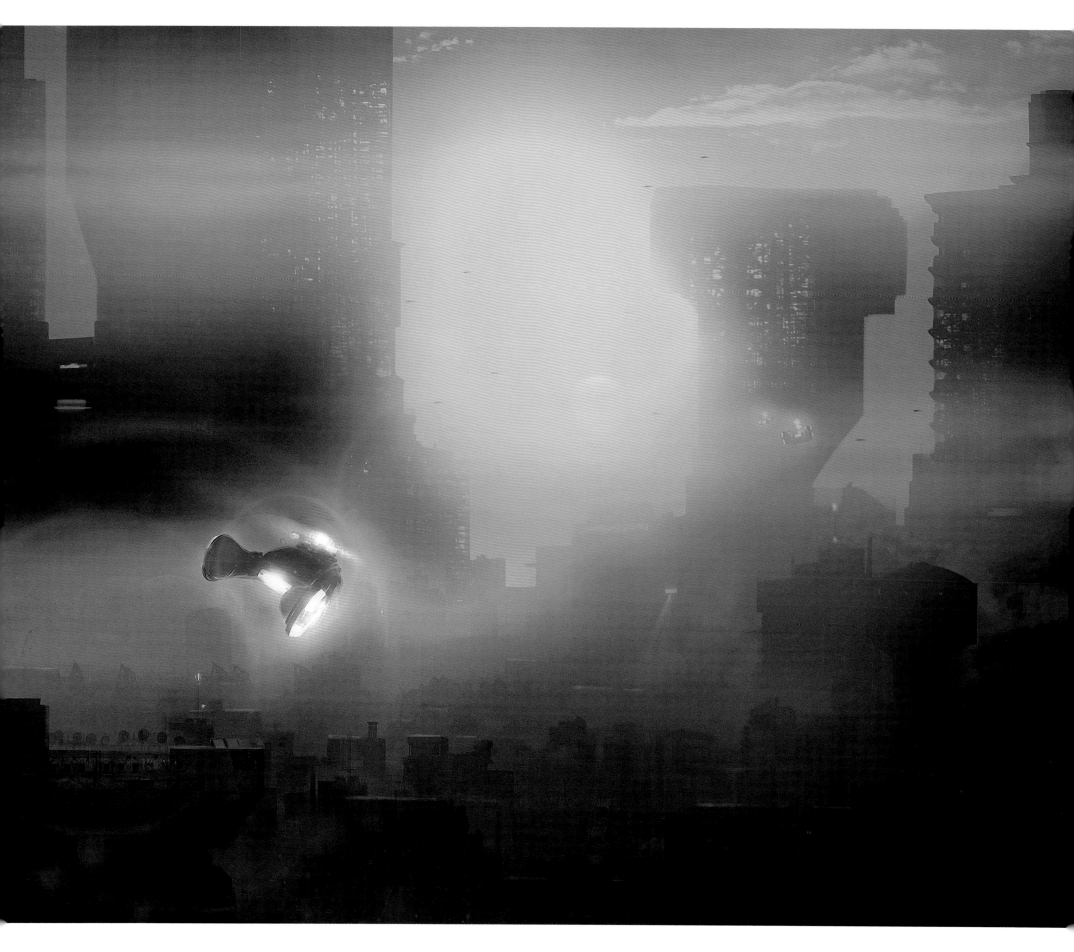

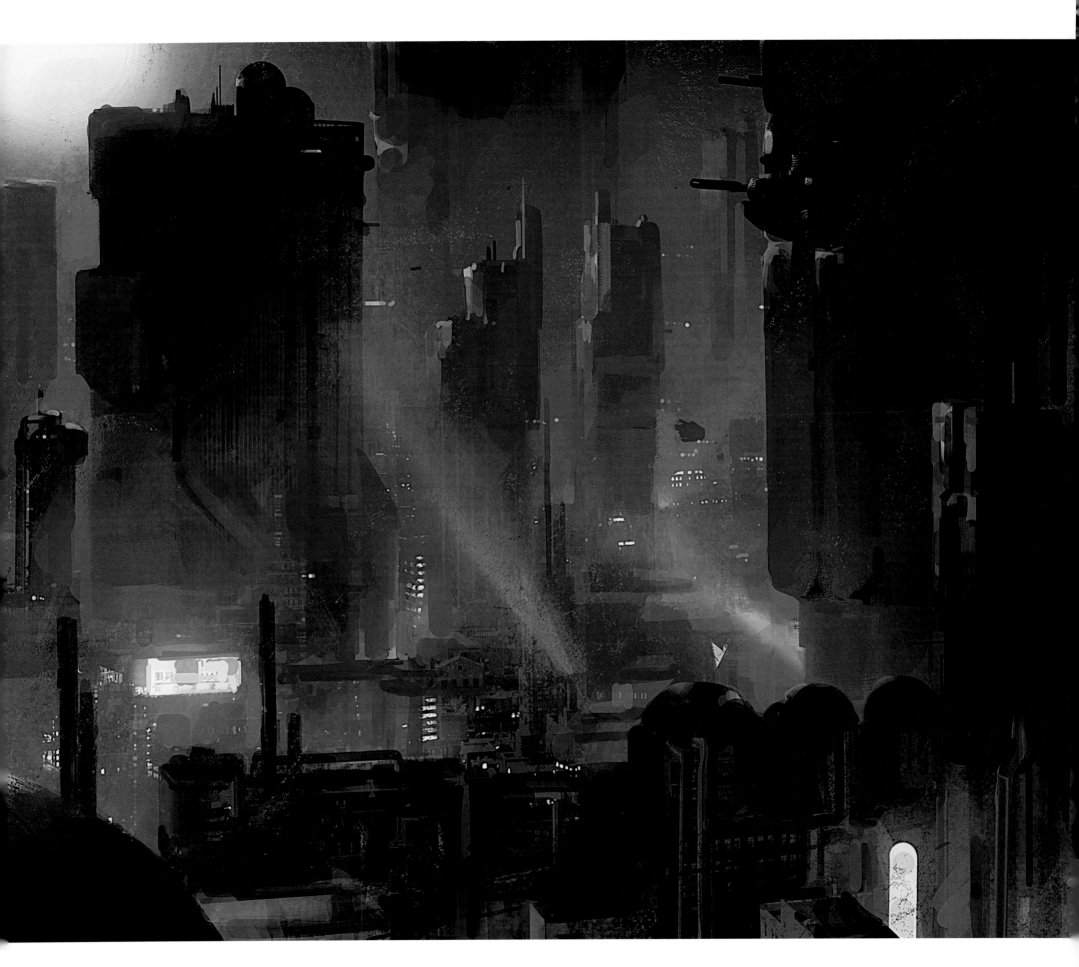

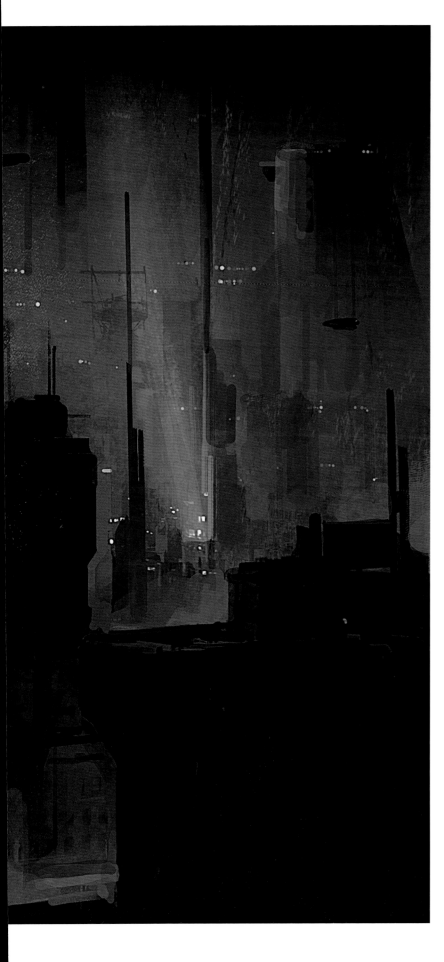

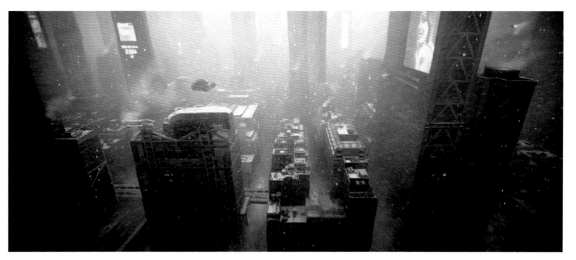

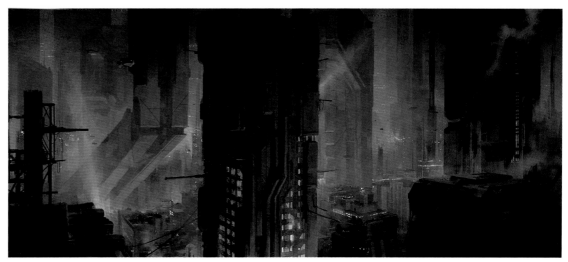

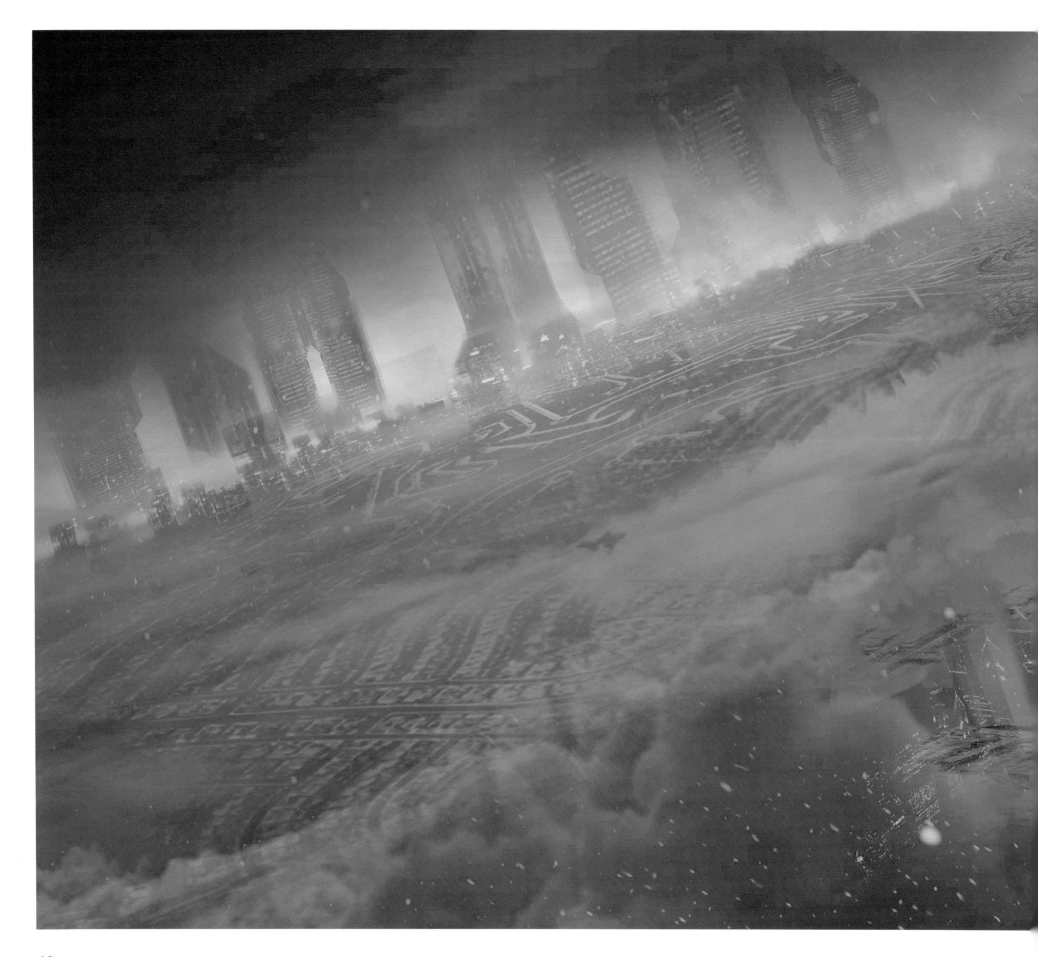

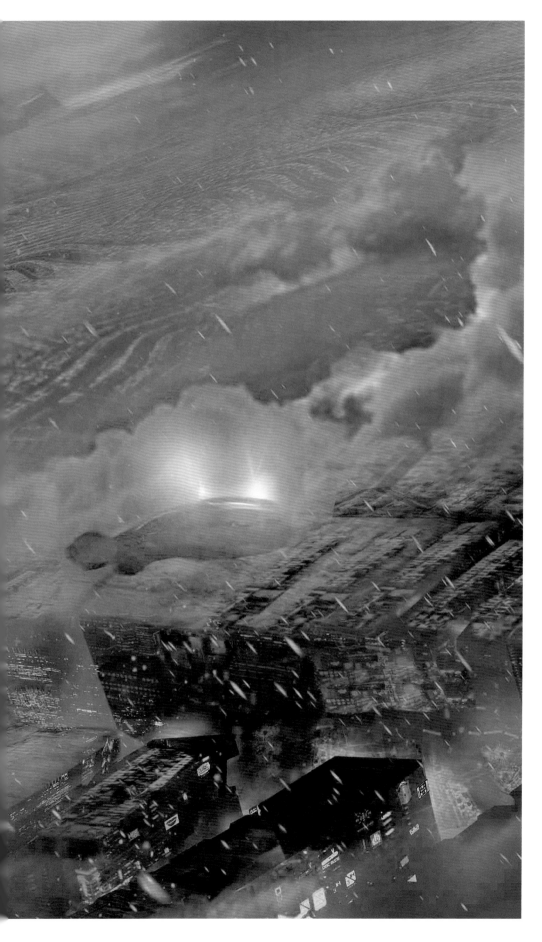
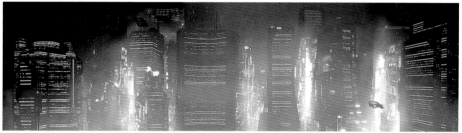
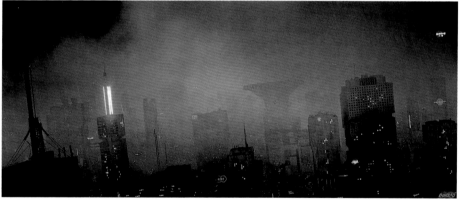
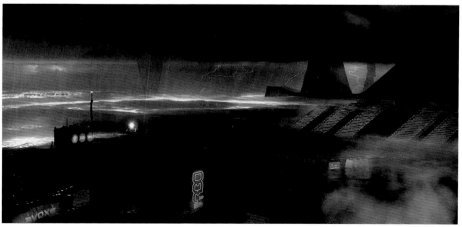

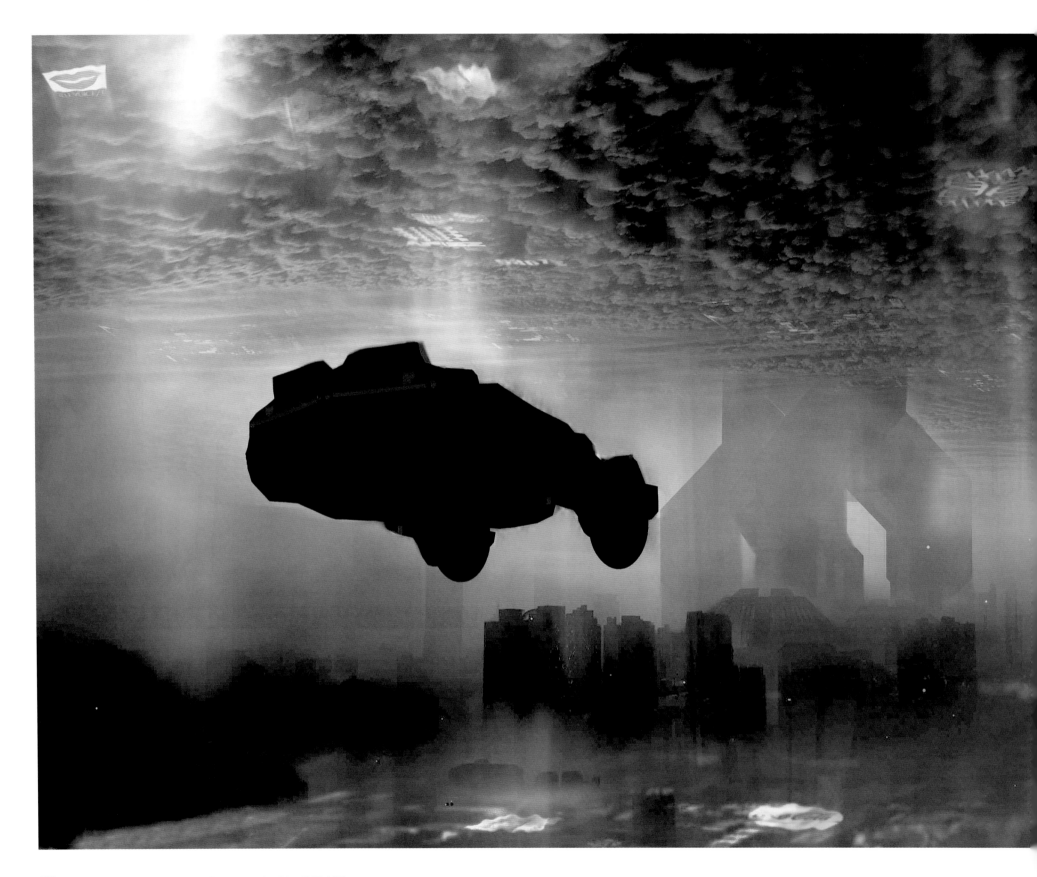

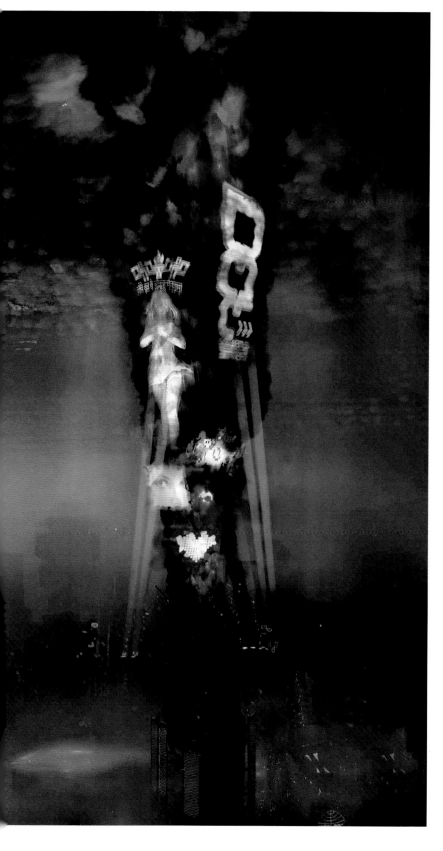
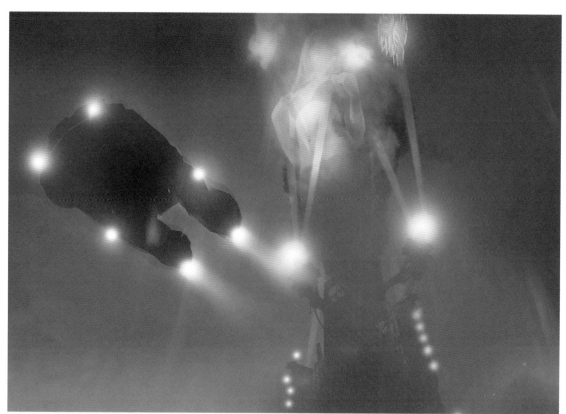
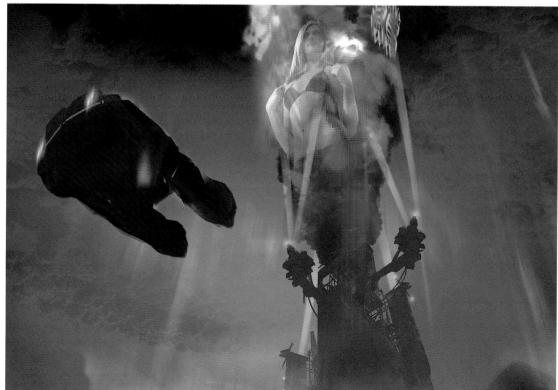

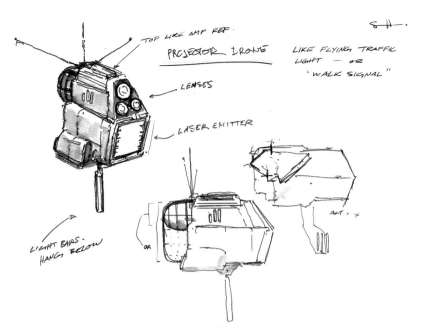

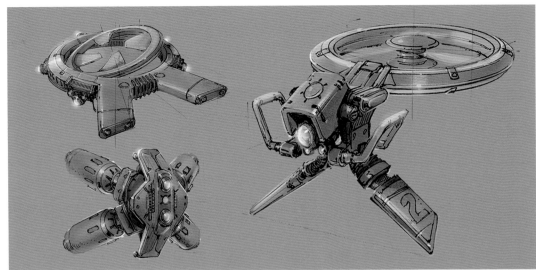

"This painting was done very early in the production as a proposal for both the architecture and projections on buildings. We talked about using a combination of logos from 1980s companies for a nostalgic feel, mixed in with something new. I thought it would be dramatic to have horizontal 'ceilings' of building architecture with giant advert screens looking down onto the streets from a mile up. Japanese signage was such a big part of *Blade Runner*, and as a person of Indian heritage, I selfishly took the opportunity to add projected logos from Indian companies here. A keen eye could spot my daughter's name in Hindi on the blimp, and obsessive *Blade Runner* fans might spot the same White Dragon Noodle Bar logo from the original film."

▼ *George Hull*

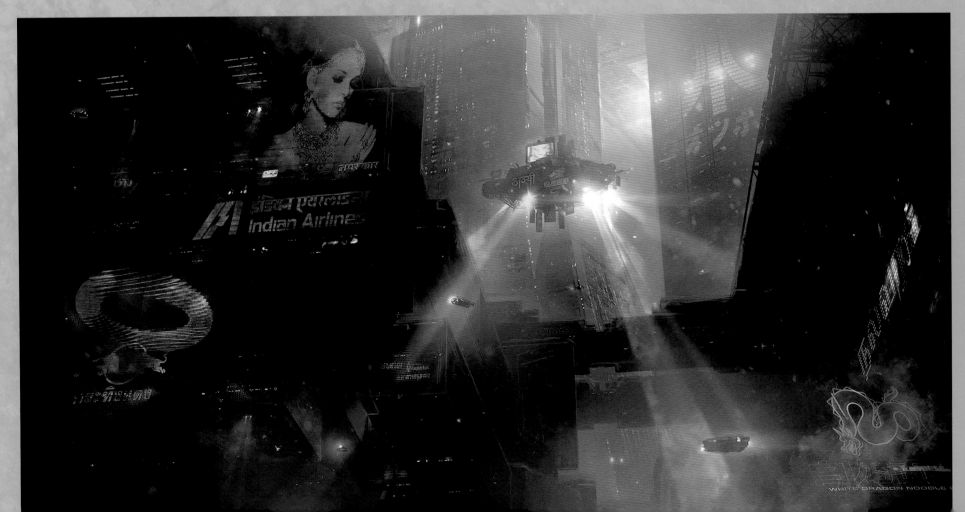

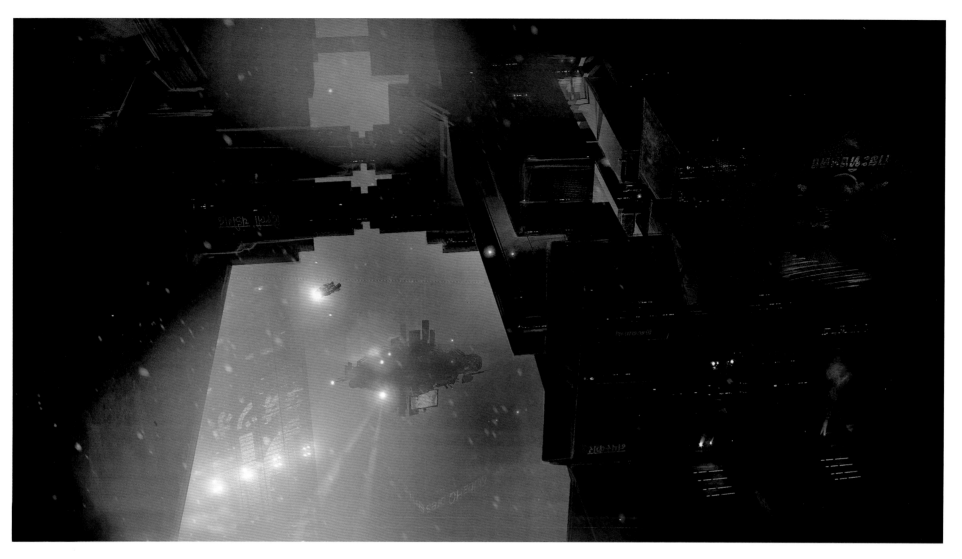

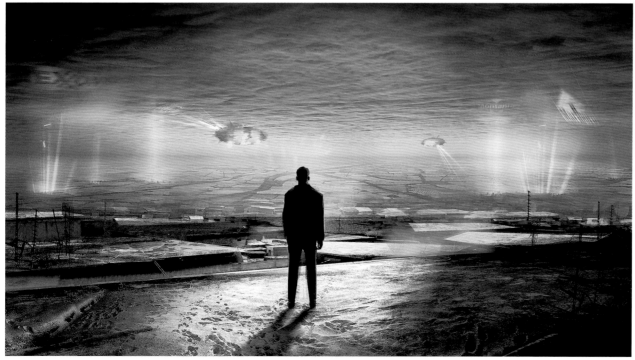

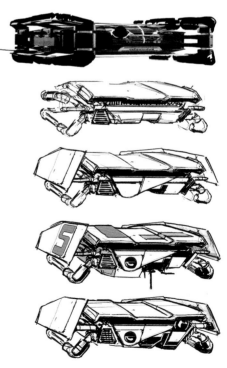

CURTAIN OF FOG
GLOW — PINK SILHOUETTE
 - SPREADS FOG LIKE CURTAIN

 - GHOSTED SHEE.

 - RHYTHM

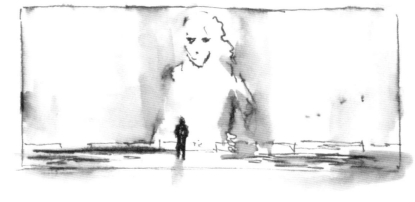

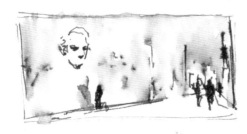

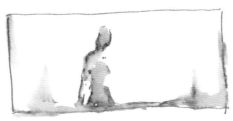

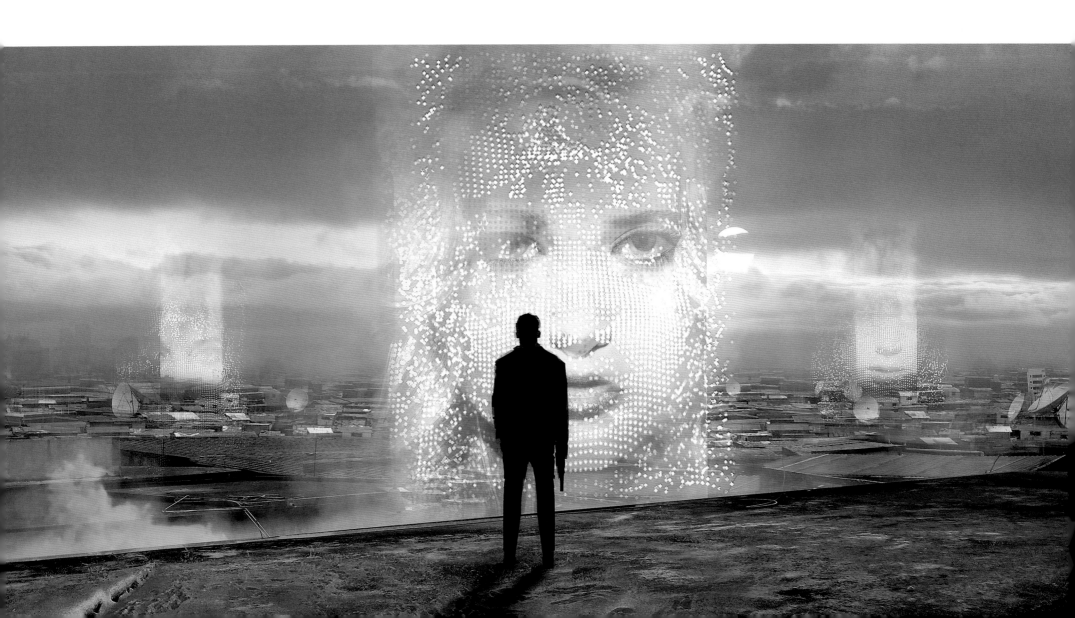

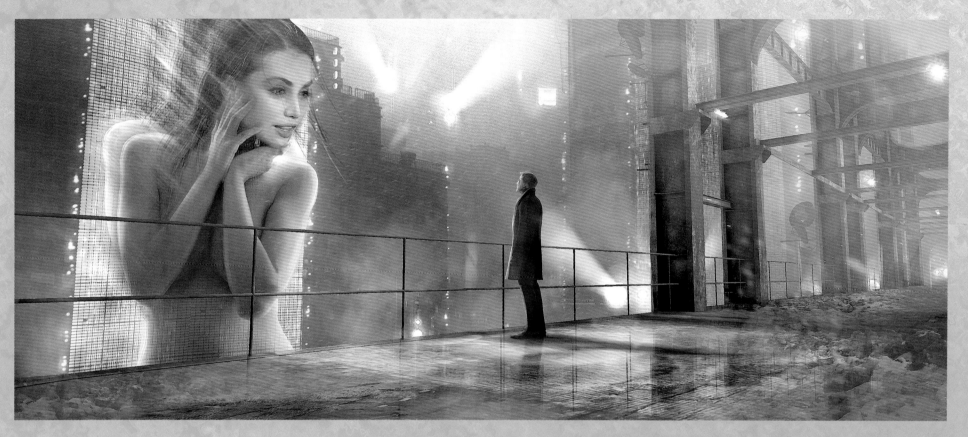

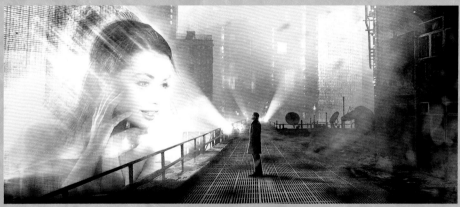

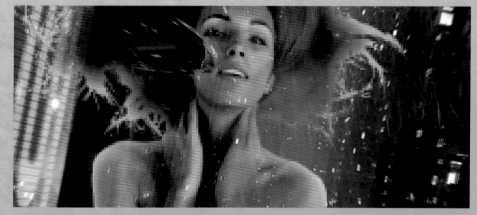

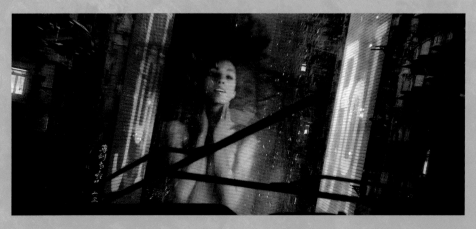

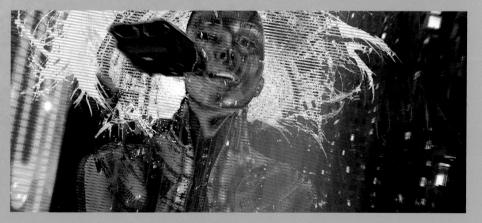

URBAN SNOW TRASH

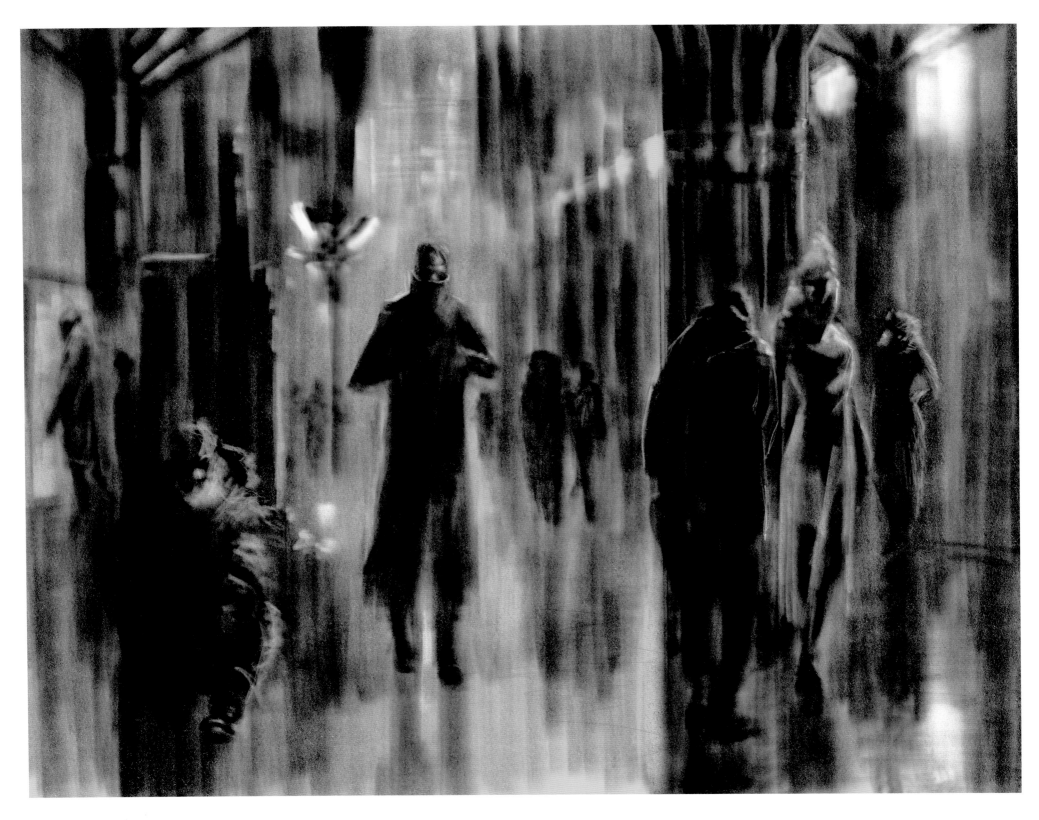

"Looking to our own world and environment for moments that felt strangely familiar yet dislocated fed the early creative process. There are some interesting things that happen when you juxtapose culture and tradition with an urban industrial environment that is in constant flux. Looking at how moments lost in time are reclaimed and take on a new life. I think these recycled and reinvented moments are what make the world of *Blade Runner* both foreign and vaguely familiar at the same time. The idea here came from an image that Aaron Haye found early on, of people doing tai chi in the thick smog of Fuyang, China. It was that perfect juxtaposition of ancient tradition amongst modern chaos. It resonated with everyone and seemed to encapsulate what our world would be. So, I put our *Blade Runner 2049* spin on it."

▶ *Victor Martinez*

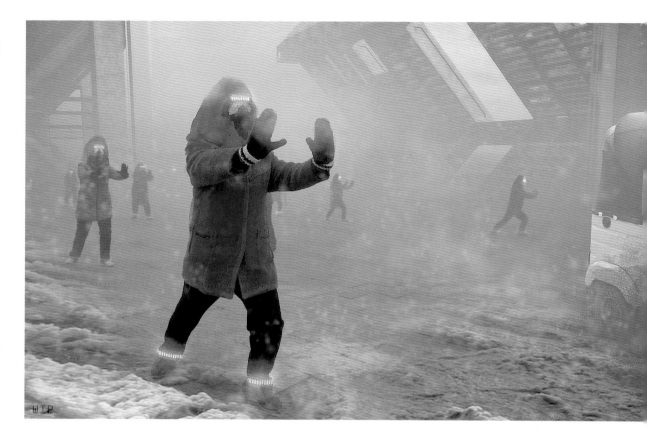

"This was the first piece I did for the film. Aaron Haye was still trying to feel out Denis Villeneuve and what he wanted, so he asked me to do a future image based in LA, trying to keep the 'vibe' of the first film. I thought it would be cool to show some kind of atmospheric processor plant in dirty snow. I wanted to stay away from the rain and cool palette of *Blade Runner*, so I changed up the palette and content, substituting rain with snow."

▼ *Emmanuel Shiu*

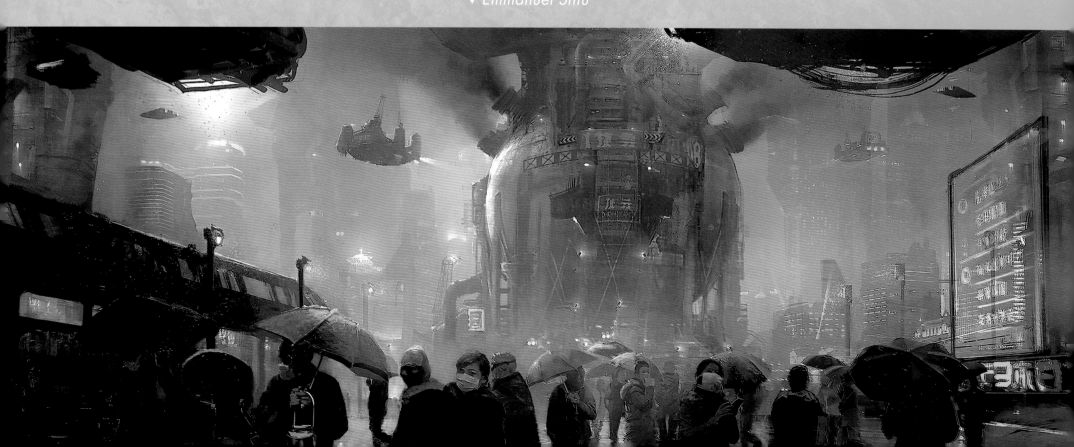

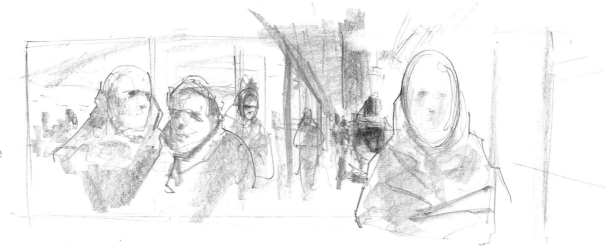

"Sam Hudecki coined the term 'Urban Snow Trash' to describe the lifestyle in *Blade Runner 2049*. It reflects the underlying philosophy that we should enjoy life despite the complete absence of hope for the future."
Tanya Lapointe

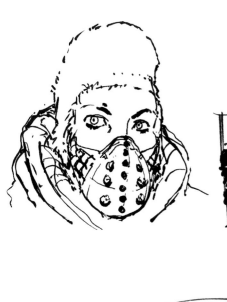

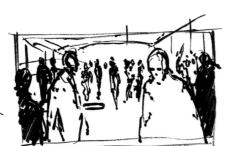

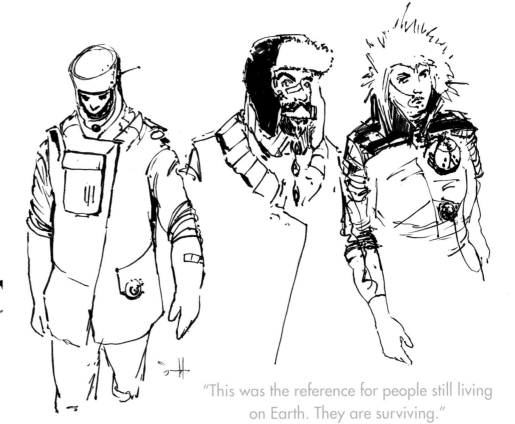

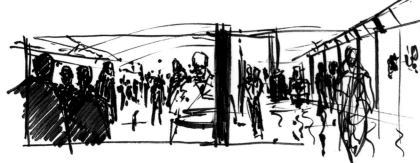

"This was the reference for people still living on Earth. They are surviving."
Sam Hudecki

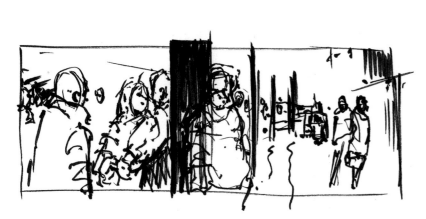

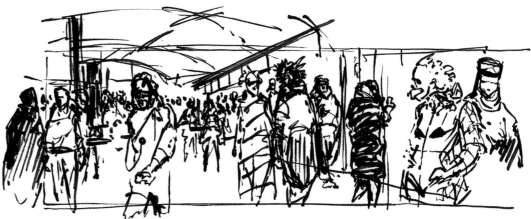

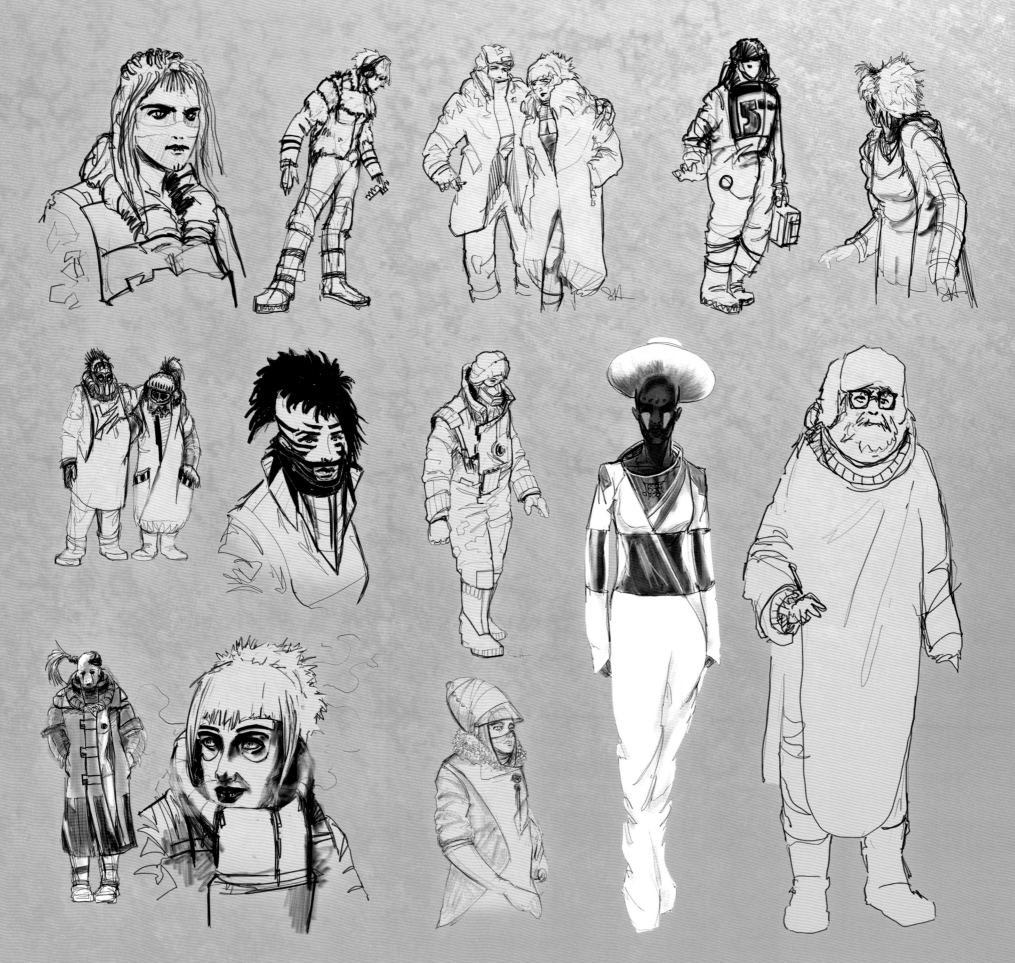

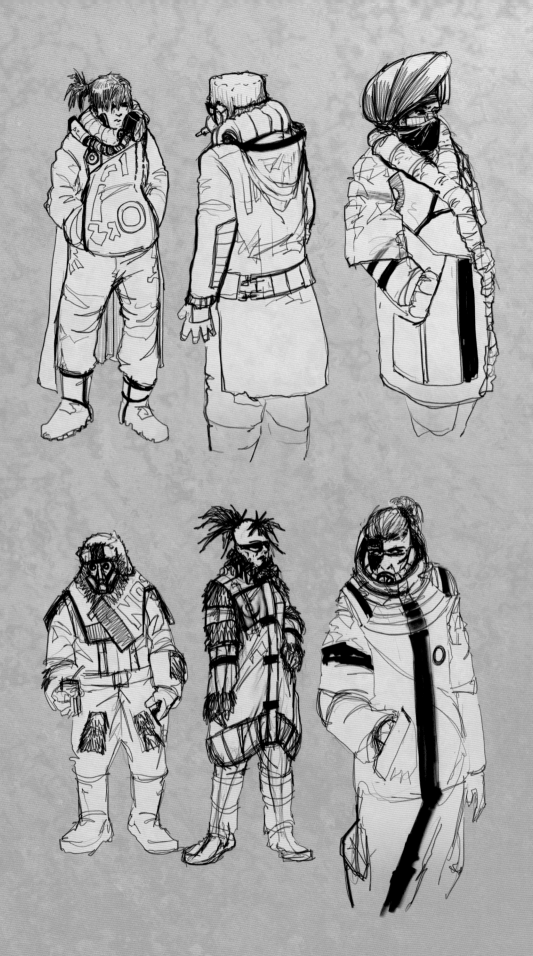

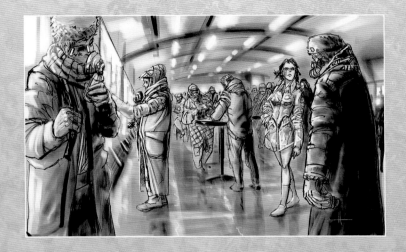

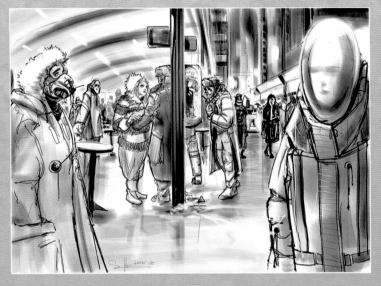

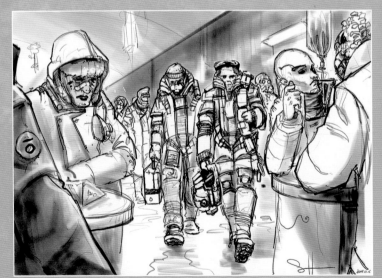

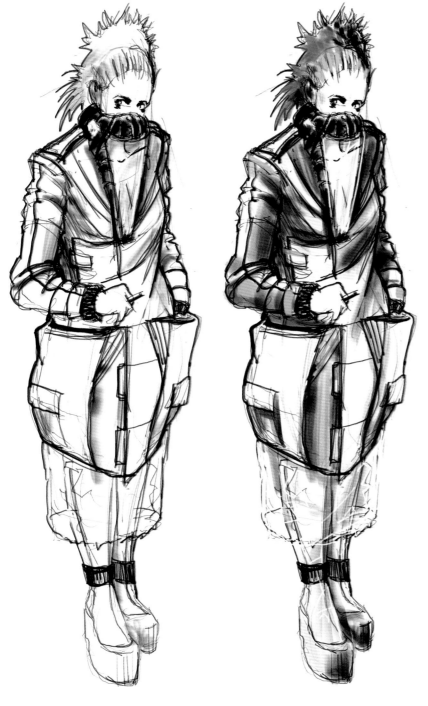

"The work I do is very quick. It's the research that takes the most time."
Sam Hudecki

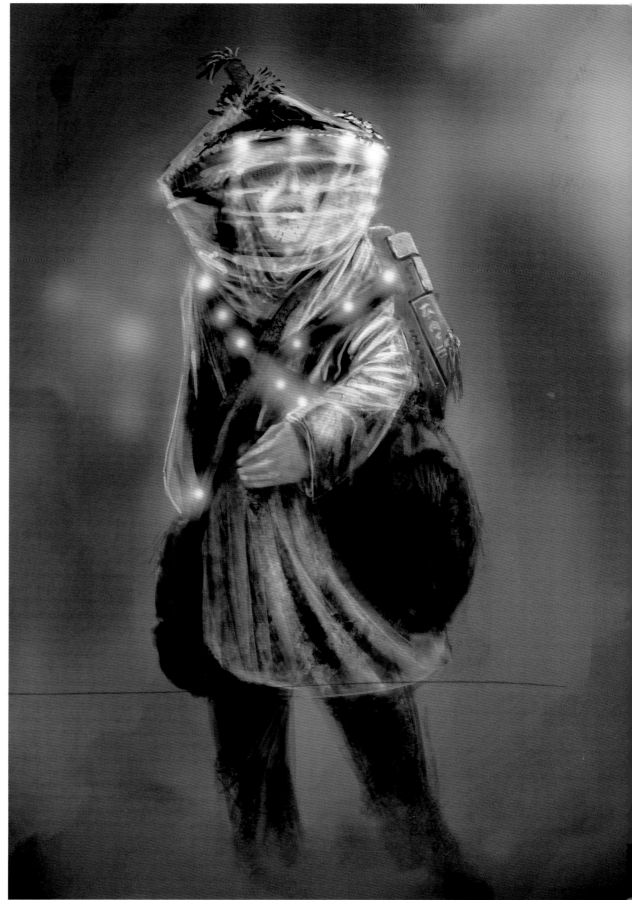

"Bibi's Bar and marketplace was the connective tissue between this movie and the first one, with the neon lights and the bizarre people walking around. It was a strange and scary world, but we oddly all wanted to be there and see more of it."

Victor Martinez

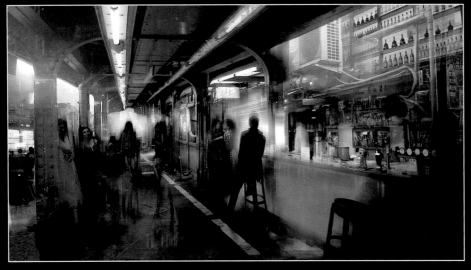

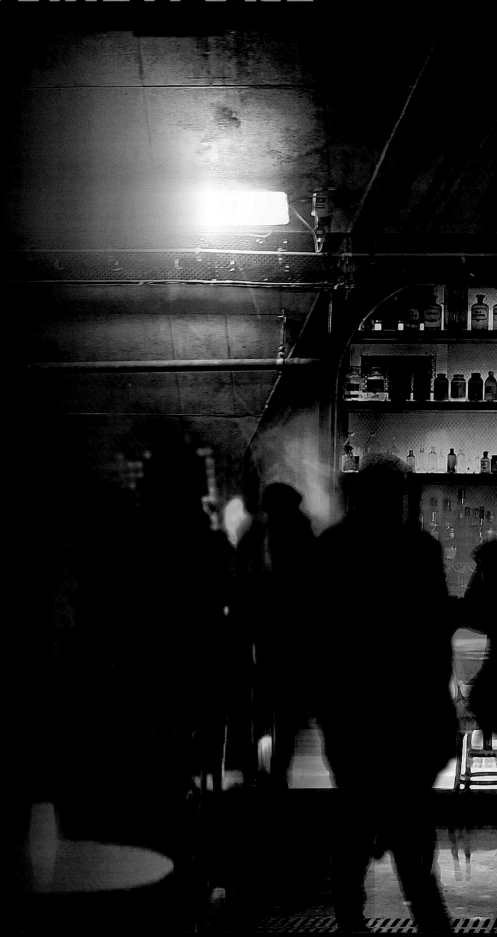

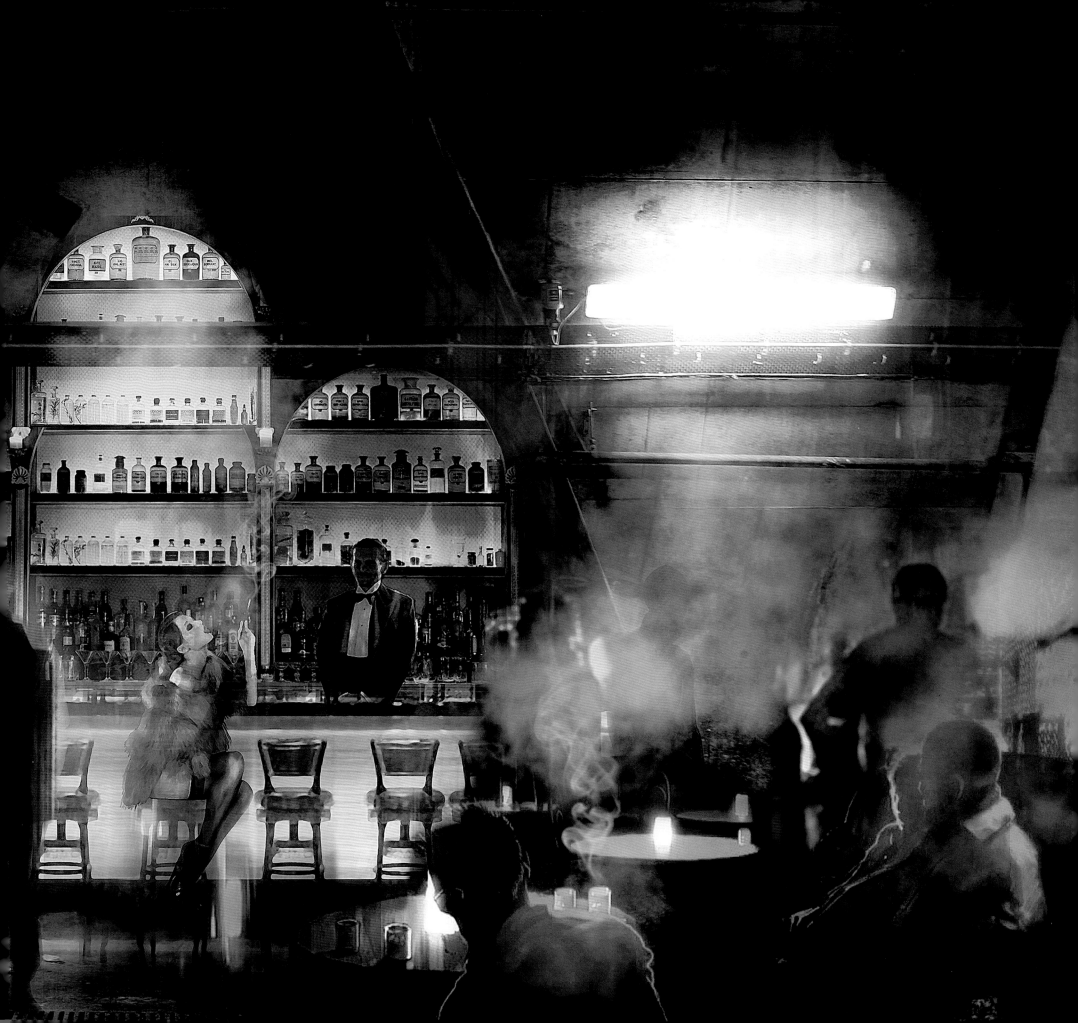

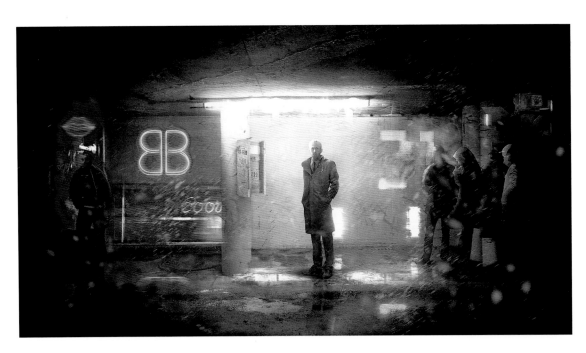

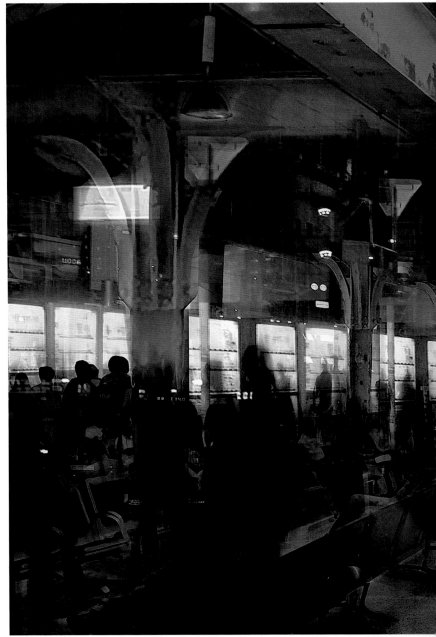

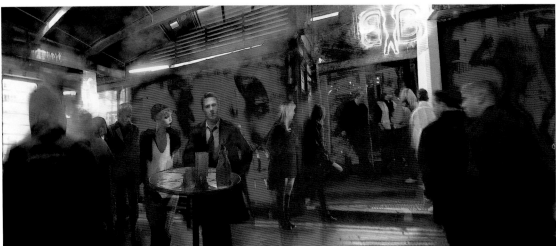

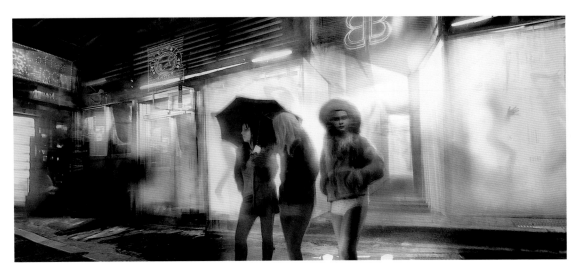

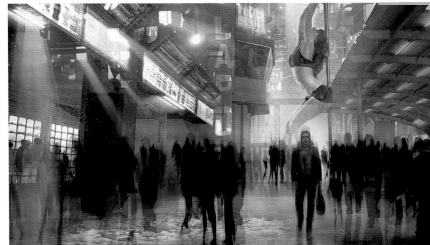

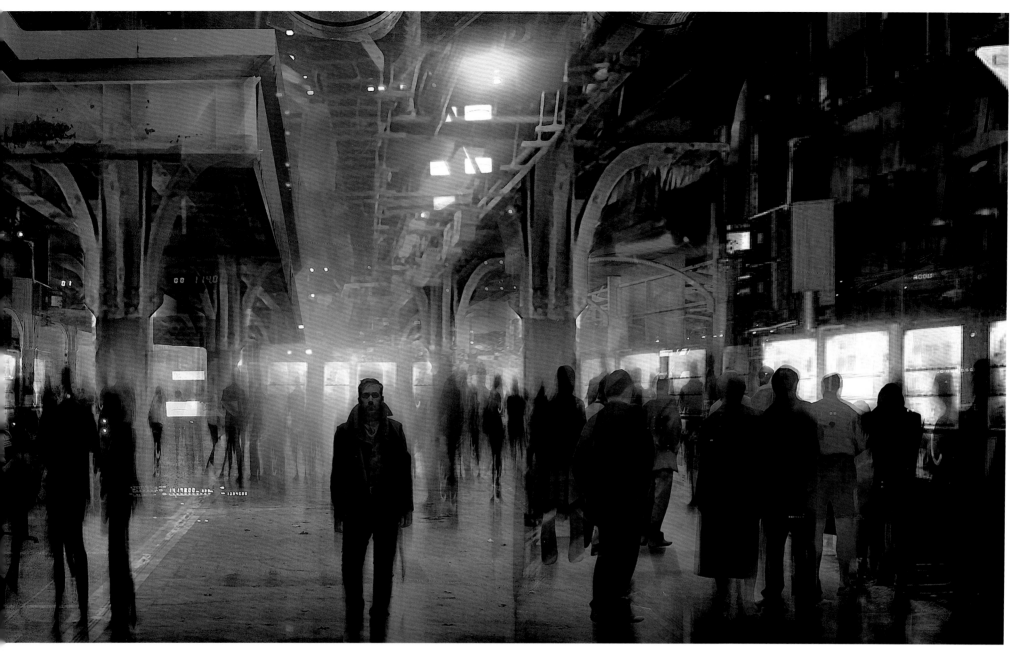

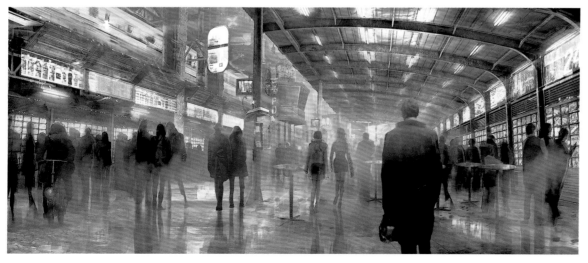

"I worked very closely with Dennis Gassner and [supervising art director] Paul Inglis on the design. Starting loose with ideas of an open marketplace covered with some sort of industrial canopy, like being in an airport. I wanted to blur the notions of a street and how these people navigate and occupy public spaces with a space that has now been completely commercialized and the individual commodified."

Victor Martinez

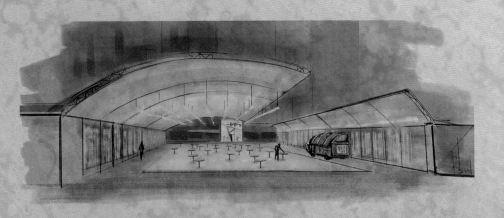

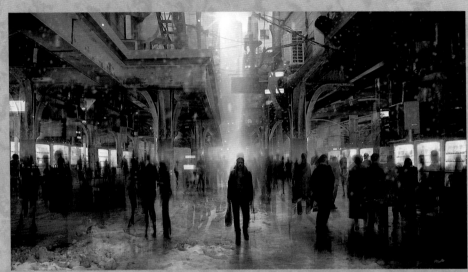
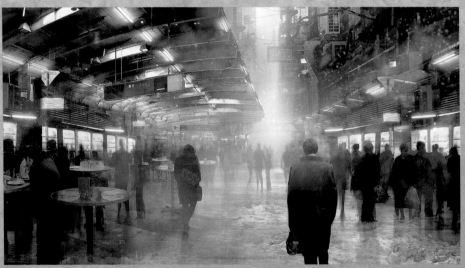

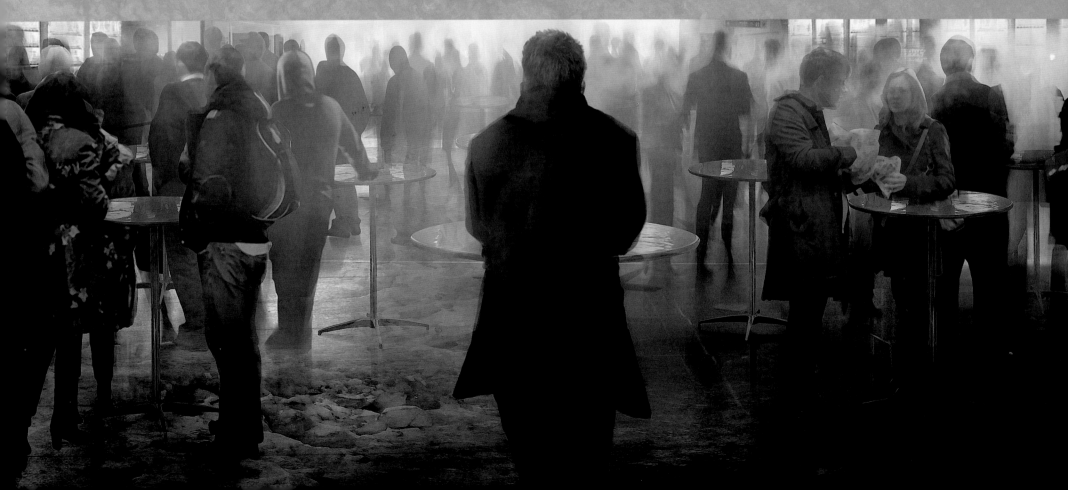

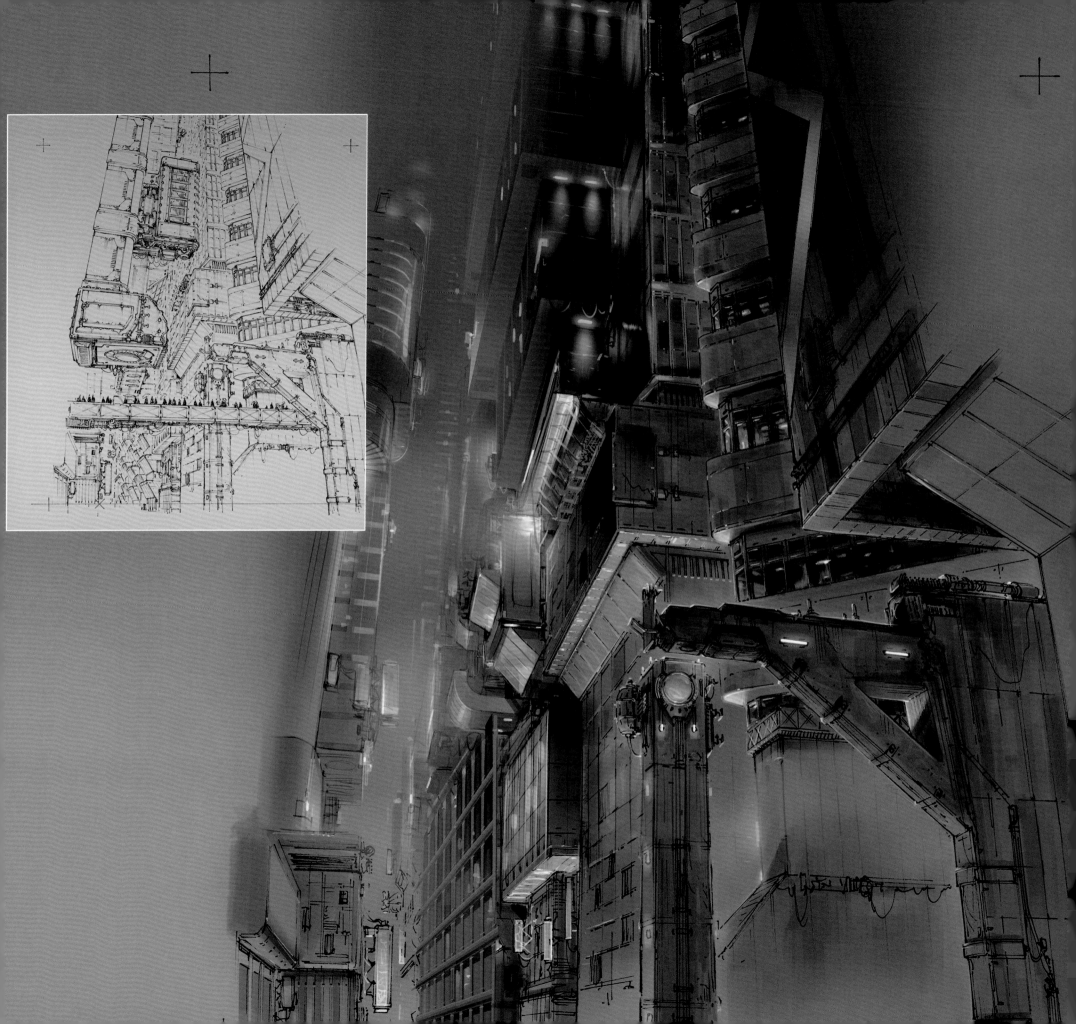

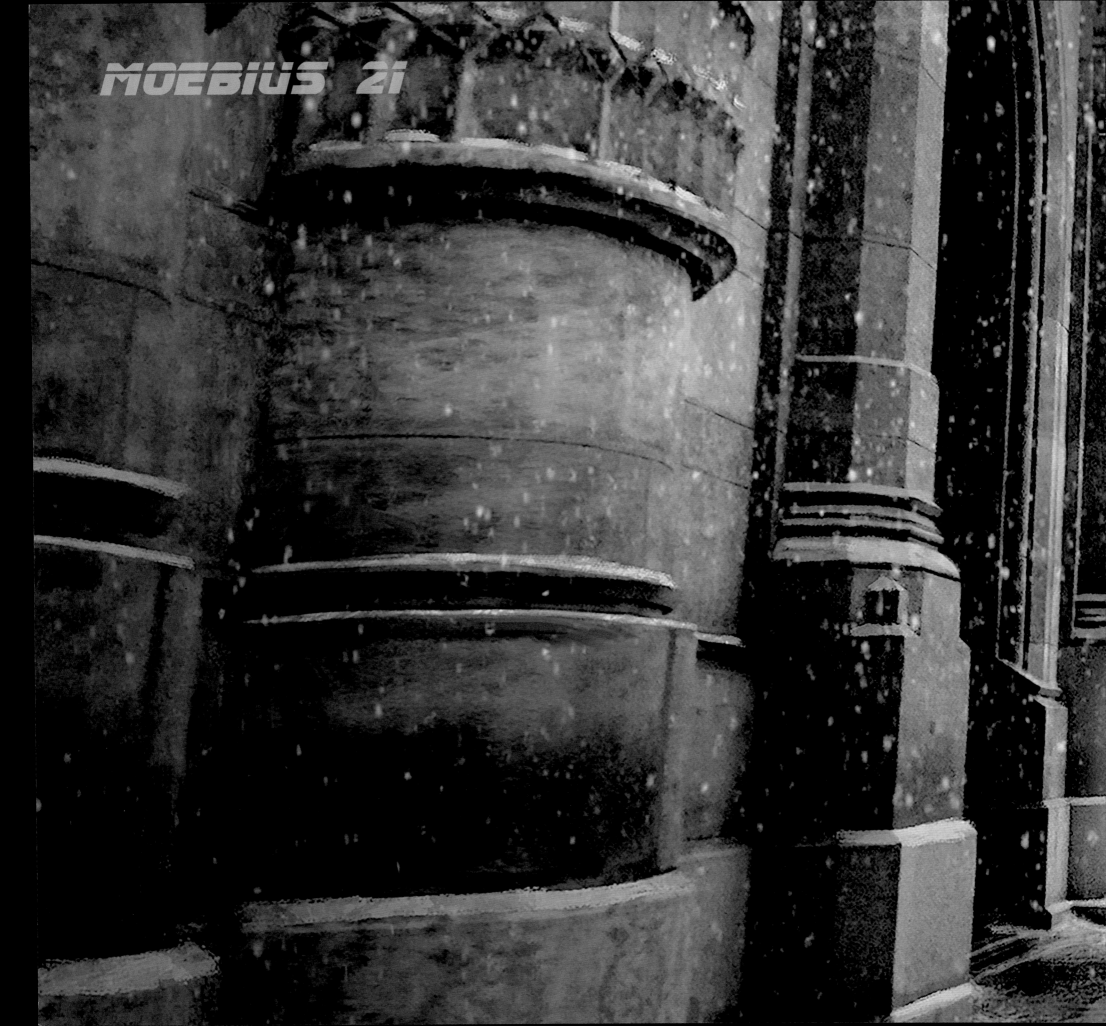

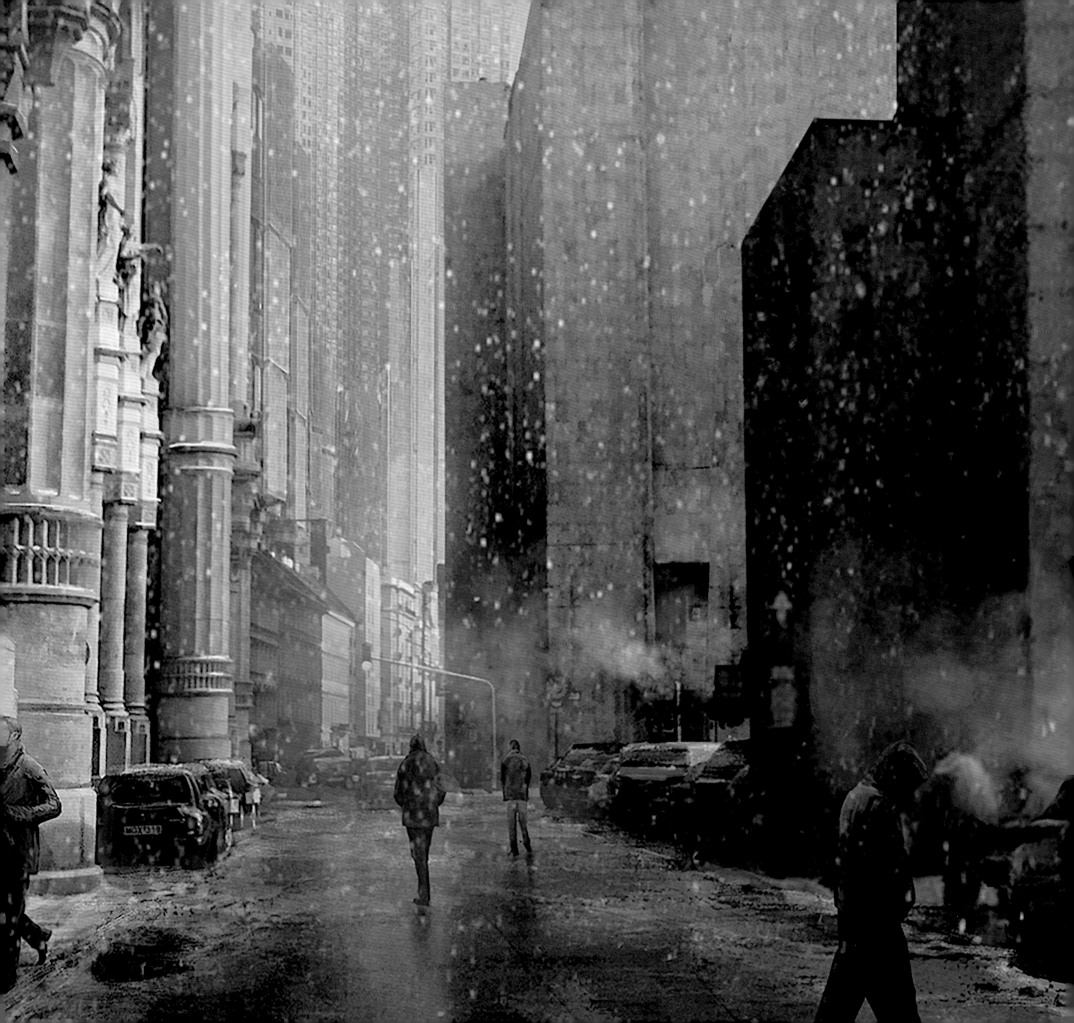

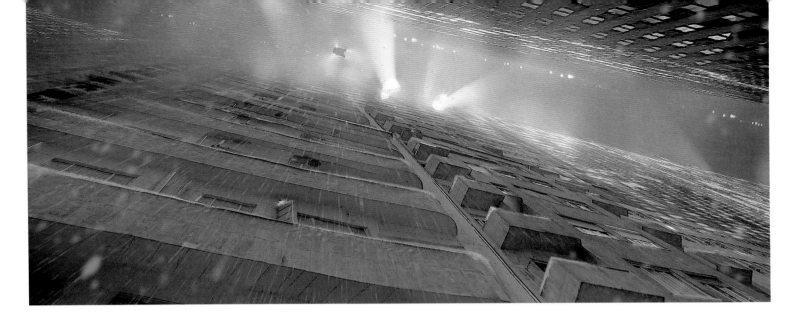

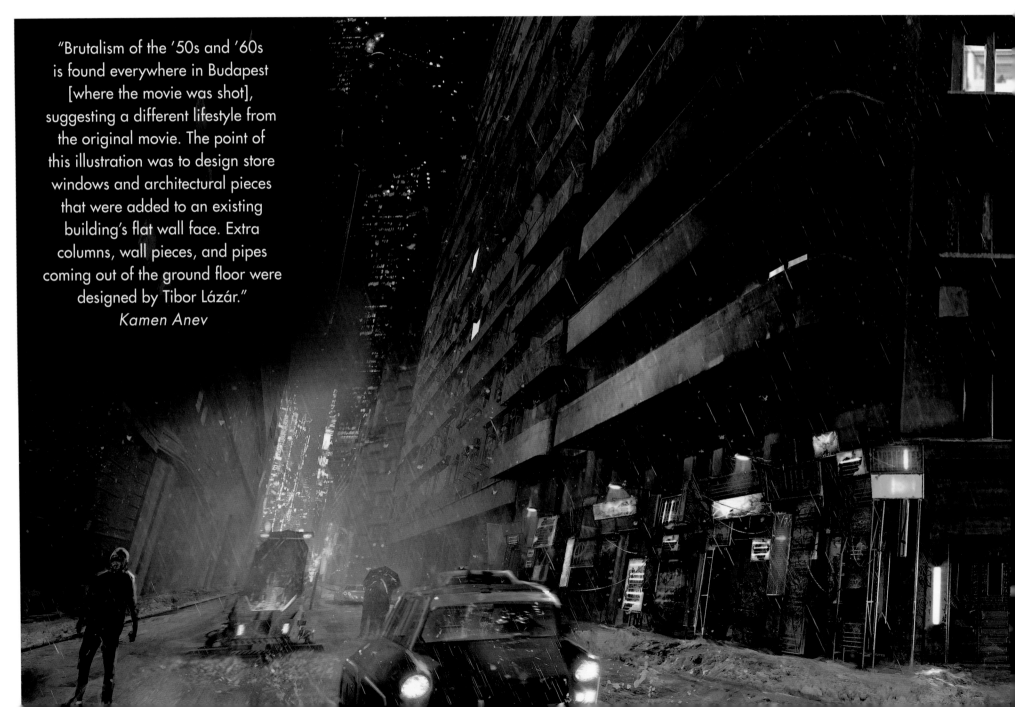

"Brutalism of the '50s and '60s is found everywhere in Budapest [where the movie was shot], suggesting a different lifestyle from the original movie. The point of this illustration was to design store windows and architectural pieces that were added to an existing building's flat wall face. Extra columns, wall pieces, and pipes coming out of the ground floor were designed by Tibor Lázár."
Kamen Anev

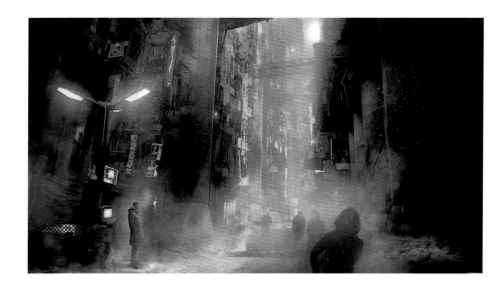
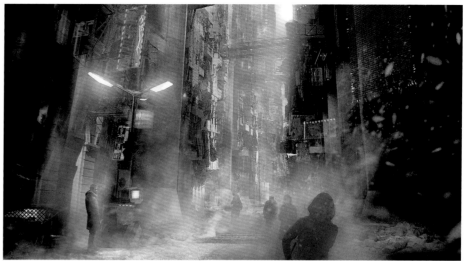
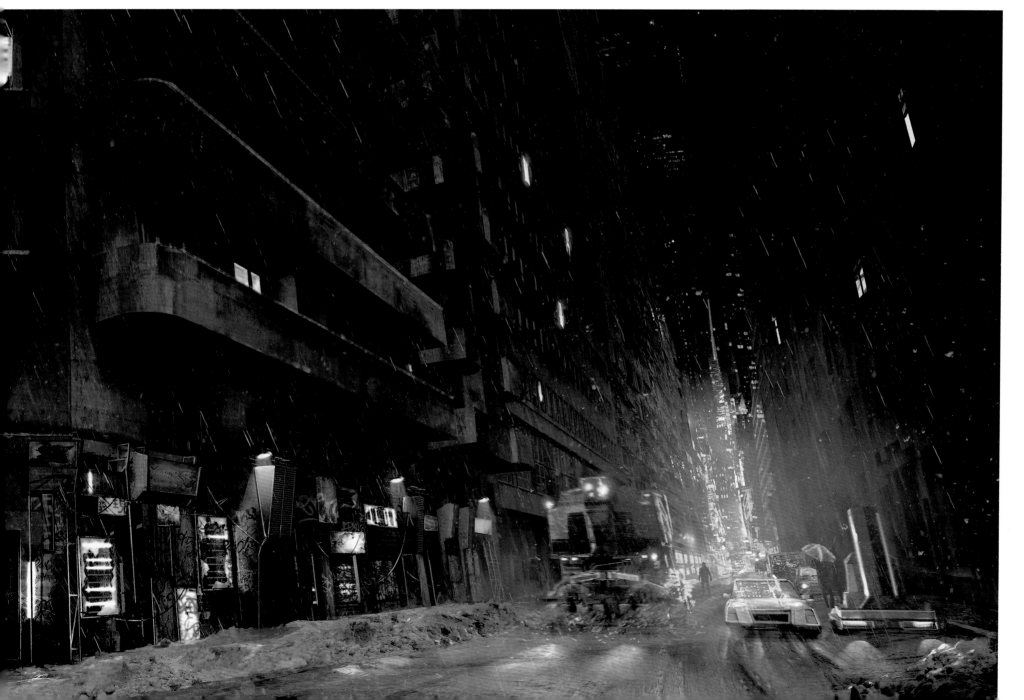

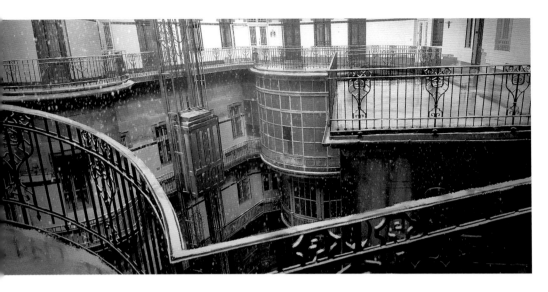

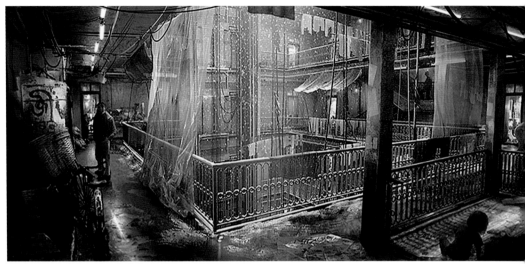

"The overall tone and atmospheric layers of the original *Blade Runner* were the foundation for this iteration of K's apartment complex. The idea was to keep a derelict building alive in an impoverished and over-populated district. Clotheslines and canopies are draped across a central court that extends into an abyss below. Above us, out of view, is a decayed glass aperture open to the elements, allowing the snowfall in."

Scott Lukowski

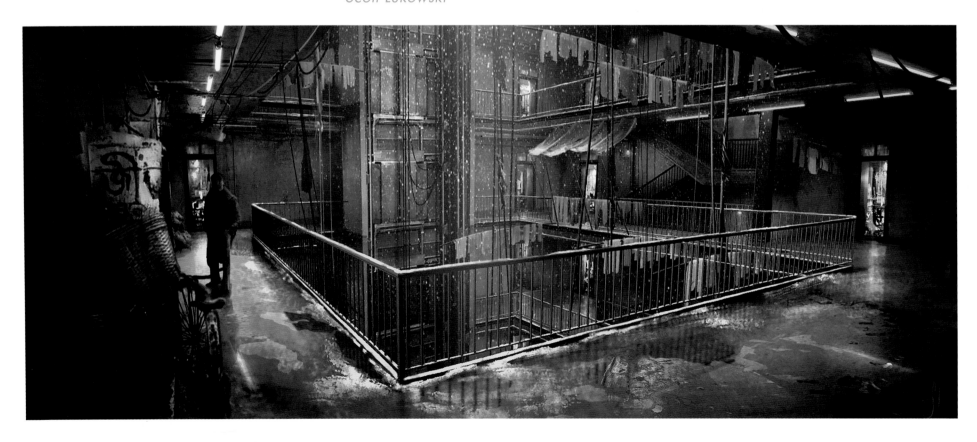

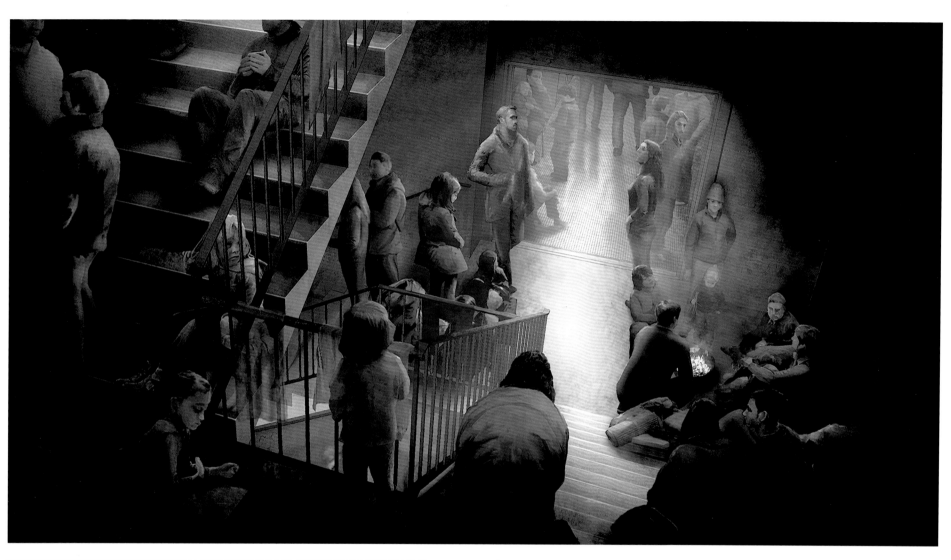

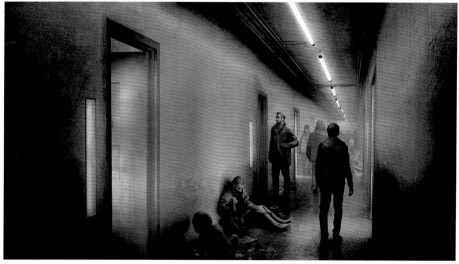

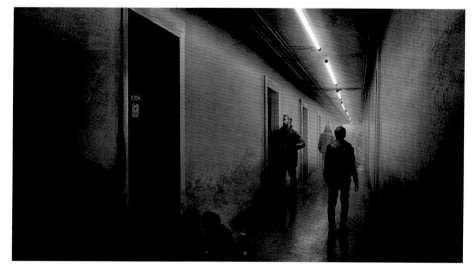

K'S APARTMENT

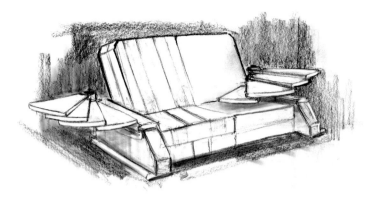

"[Denis Villeneuve and I] spent a lot of time talking about what K's apartment would look like. We were inventing a bed-chair for it – something minimalistic."

Sam Hudecki

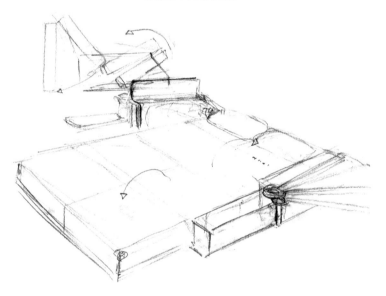

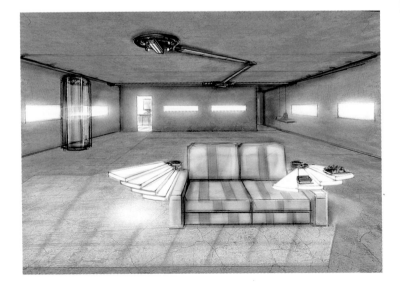

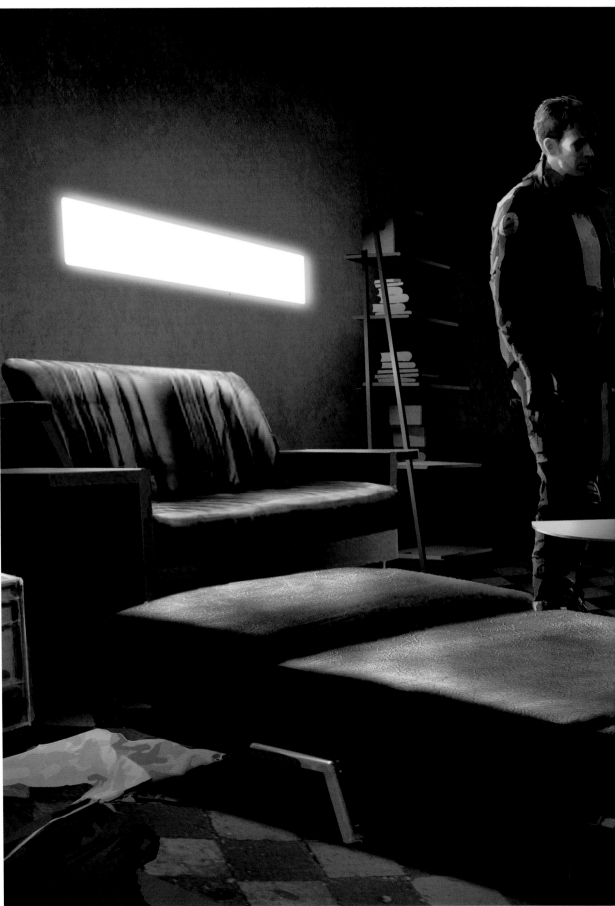

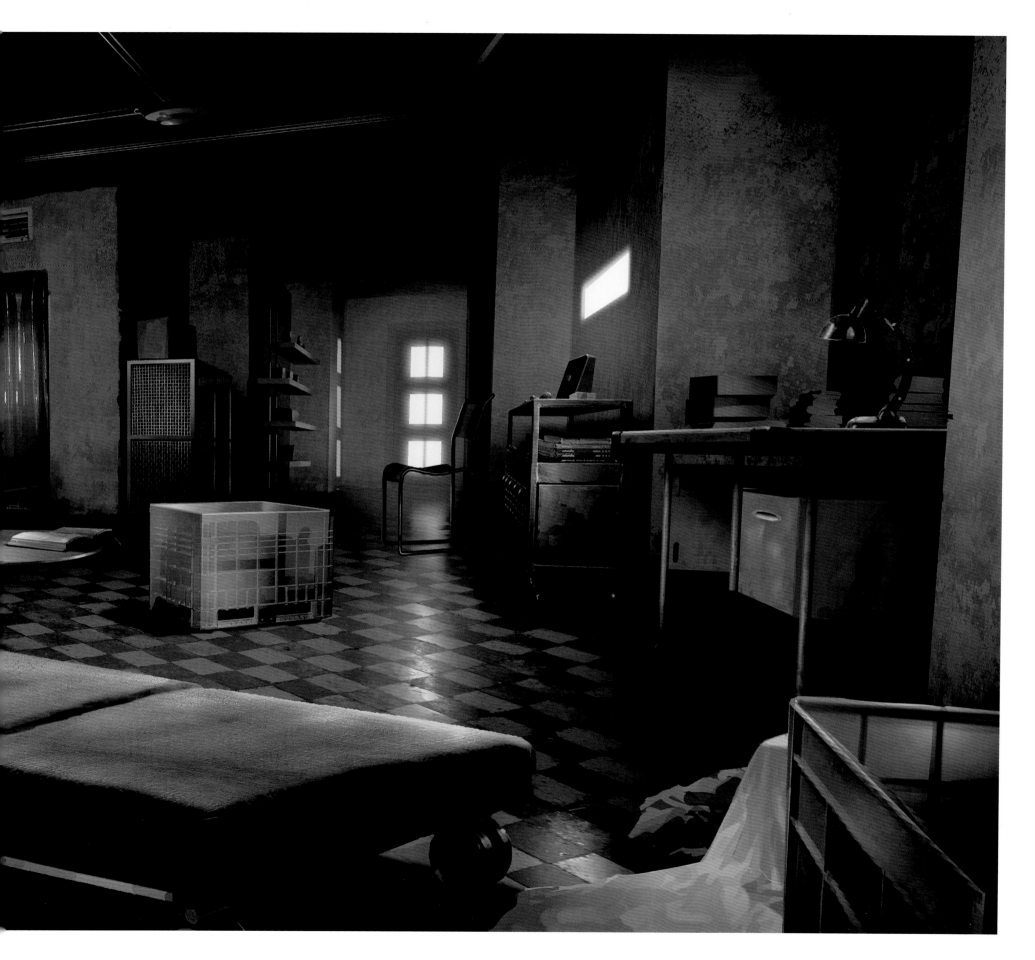

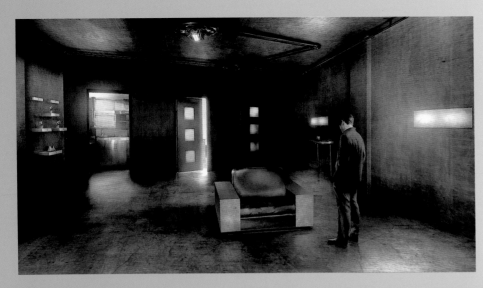
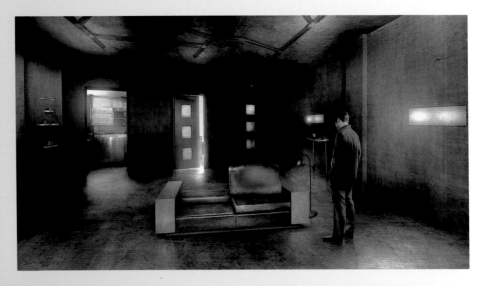
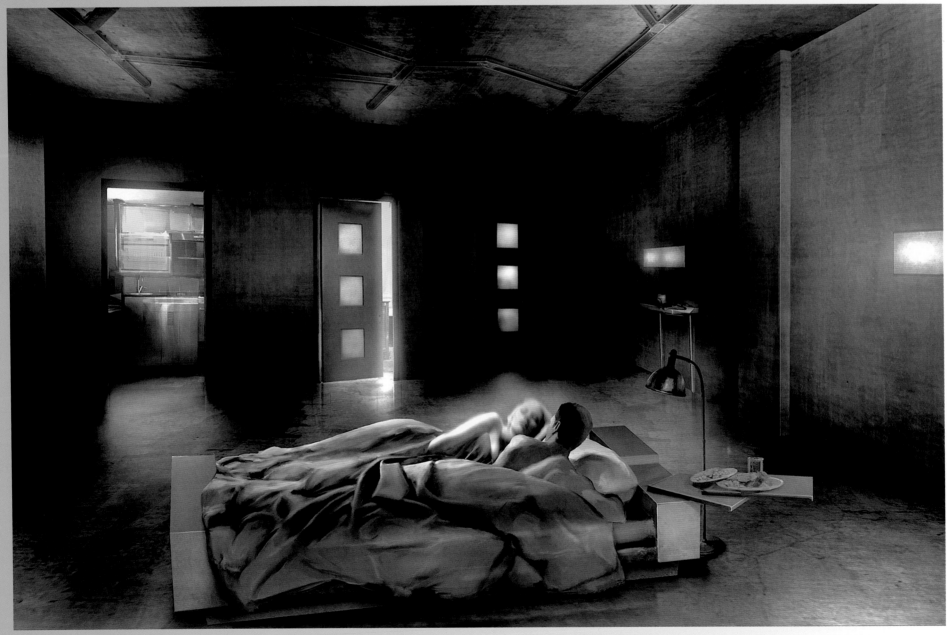

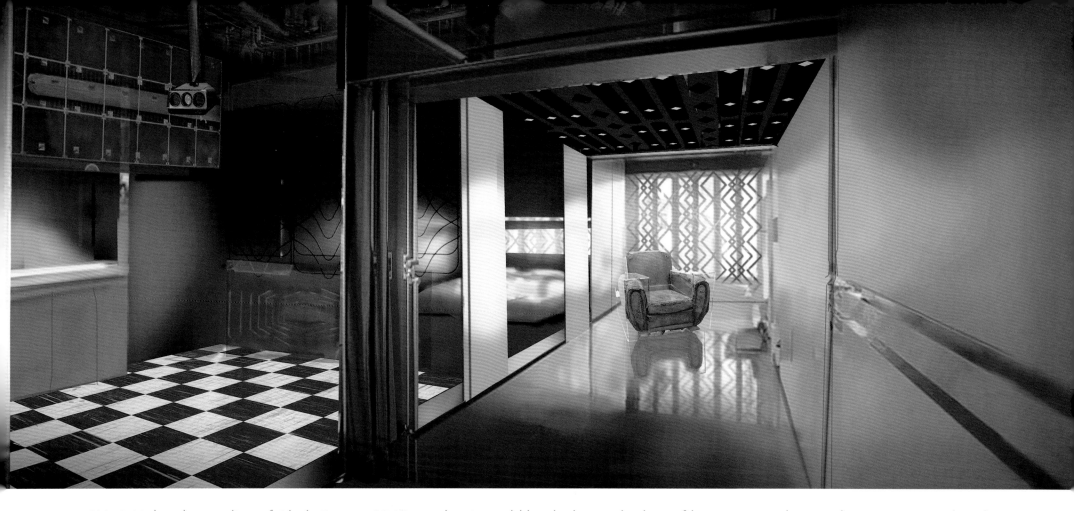

"My initial understanding of *Blade Runner 2049* was that it would be dealing with ideas of humanism, isolation, aloneness. K is reduced to coming home from work and finding mental solace in his relationship with a[n augmented-reality] girlfriend. I was trying to reinforce a sort of world where apartments/furniture/architecture/appliances are like ghosts of a bygone past, tired and worn. The only thing that would really matter to K was when his 'woman' would be there. Also, early on, when searching for reference imagery, I came across an art installation where someone had enclosed a beautiful, but old and worn, leather armchair in a shape-fitted, heavy Plexiglas encasement. I liked the idea of the juxtaposition of old soft-form analog leather trapped by a squared plastic form. I felt like the metaphor helped support the ideas in the film."

▲ *Leri Greer*

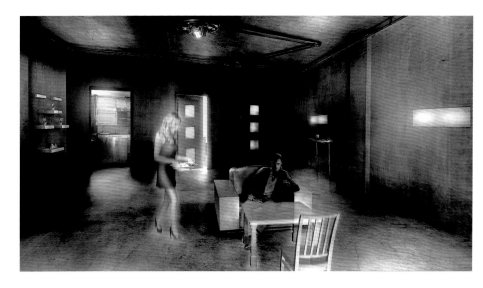 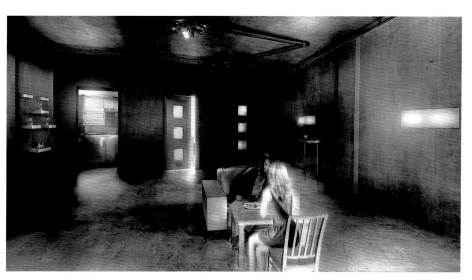

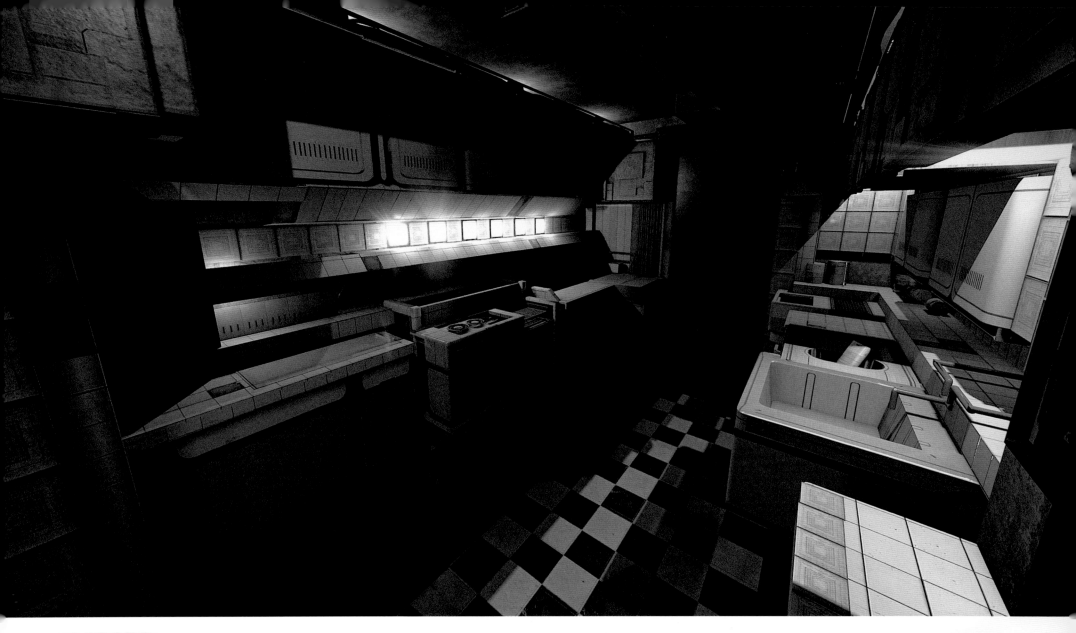

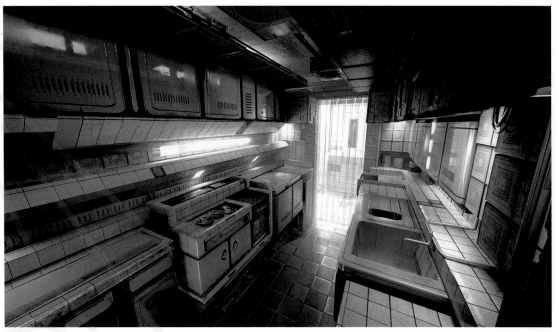

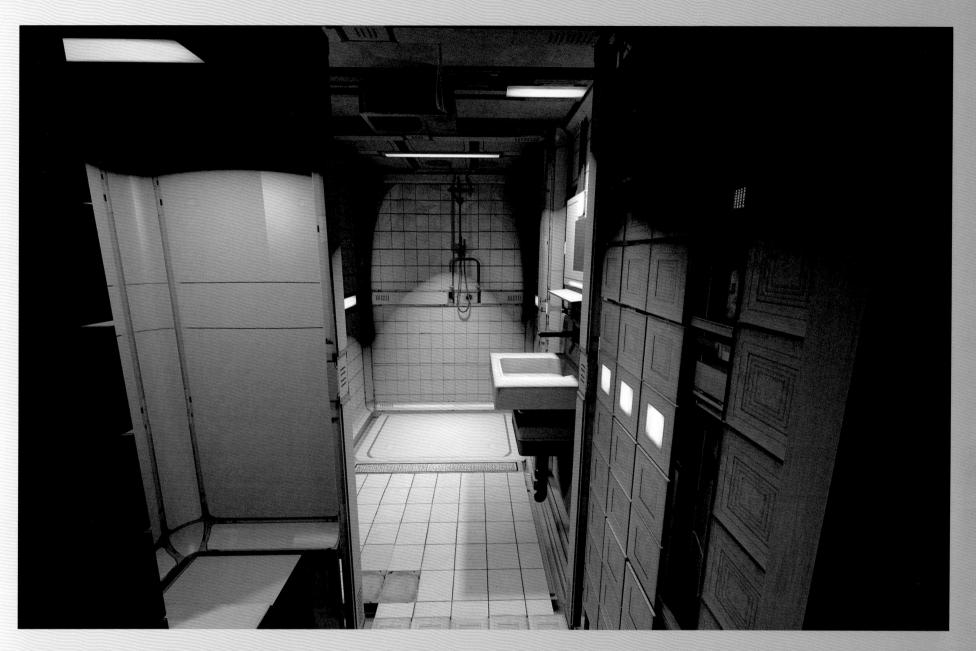

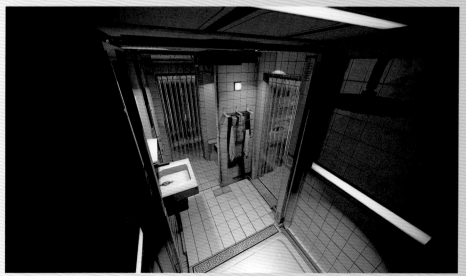

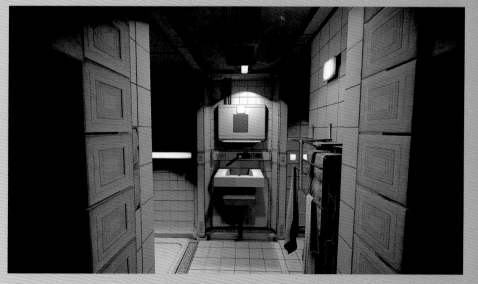

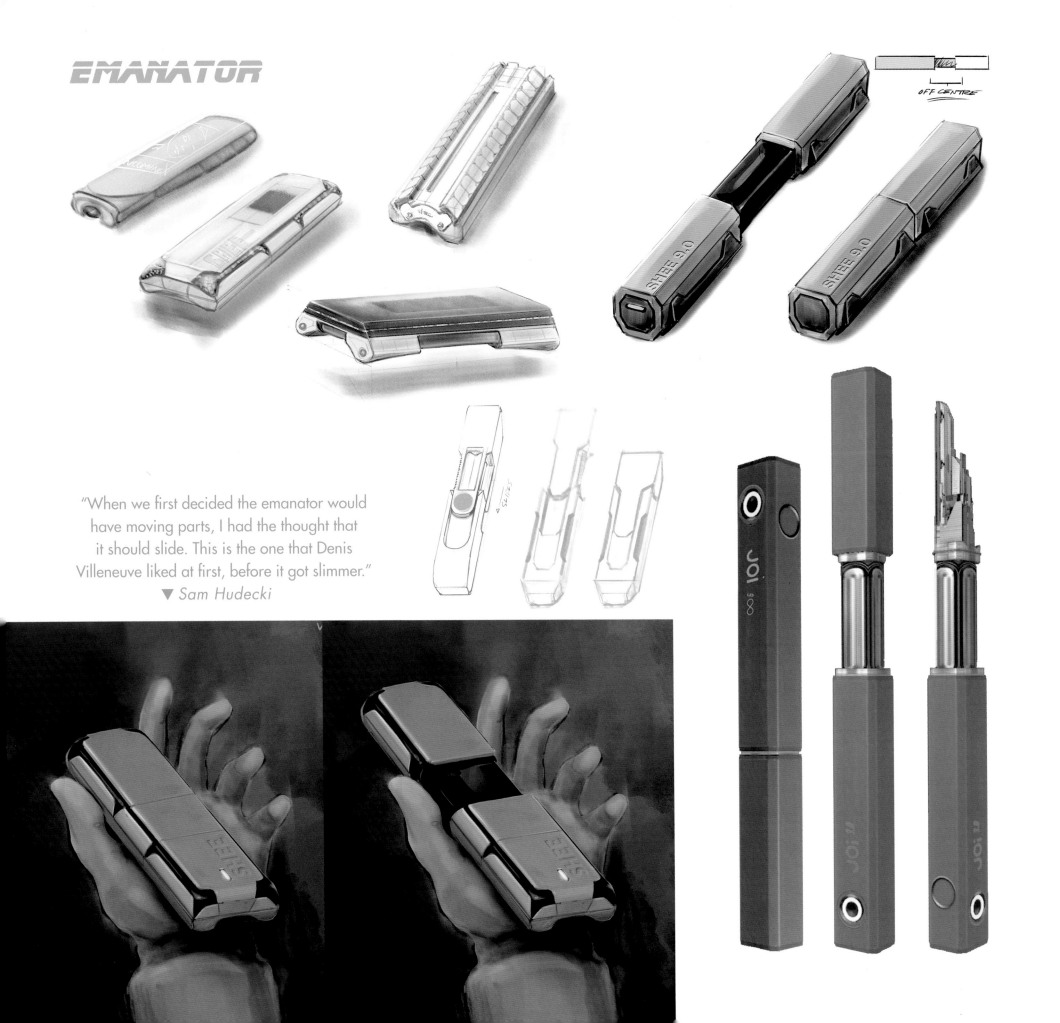

EMANATOR

OFF CENTRE

SHEE 9.0

SHEE 9.0

"When we first decided the emanator would have moving parts, I had the thought that it should slide. This is the one that Denis Villeneuve liked at first, before it got slimmer."
▼ Sam Hudecki

JOi 9∞

JOi 9∞

JOi 9∞

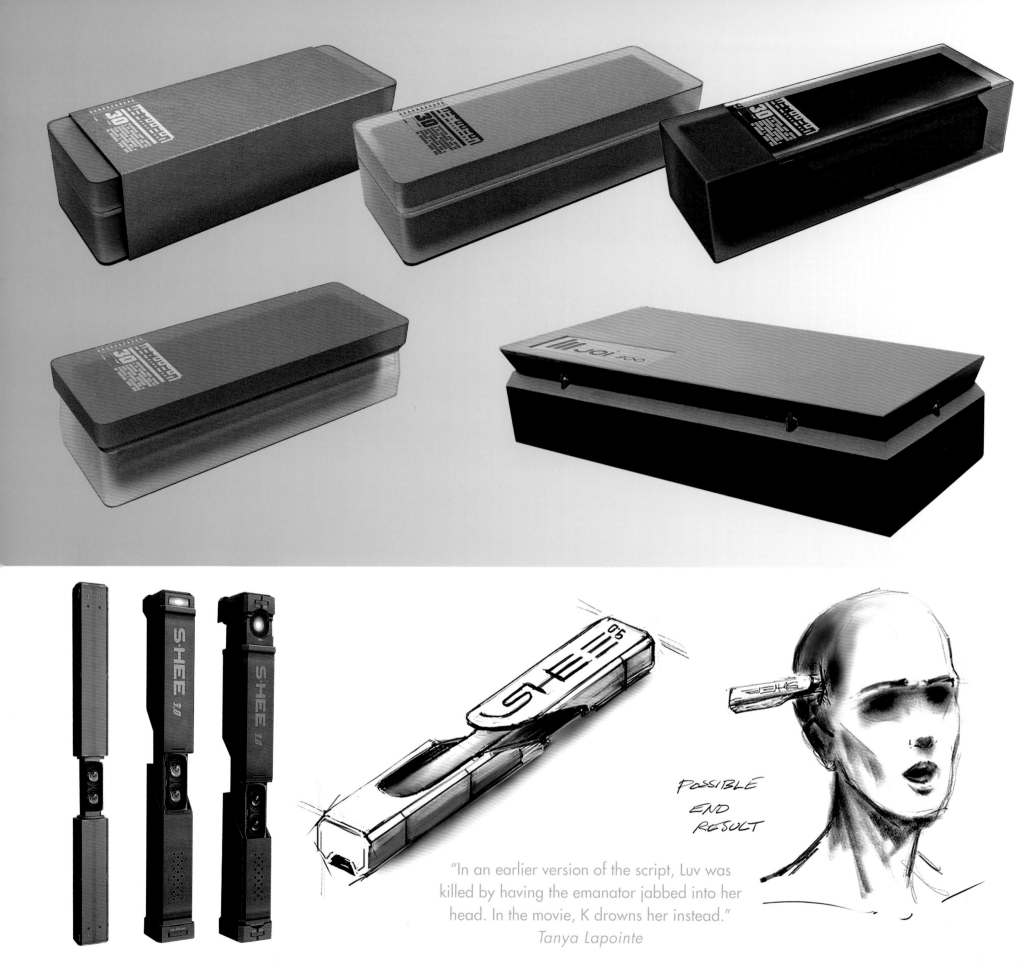

"In an earlier version of the script, Luv was killed by having the emanator jabbed into her head. In the movie, K drowns her instead."
Tanya Lapointe

POSSIBLE END RESULT

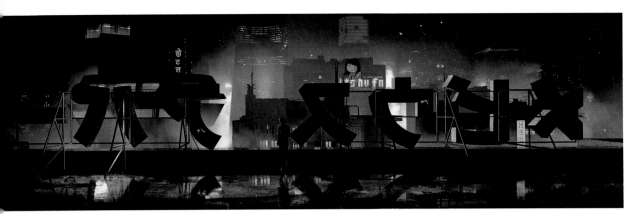

ROOFTOP

"This sequence of images were about trying to describe the moment when Joi becomes real. She's in her 'body' and experiences the outside for the first time in her life. Rain literally sizzles as it passes through her electrostatic 'skin.' Then later, we see K glancing up at a much larger than life version of Joi as she steps out of a billboard, her eyes black and void of all life, soulless. We're left wondering if K is just as doubtful of his own experience."

Victor Martinez ▶

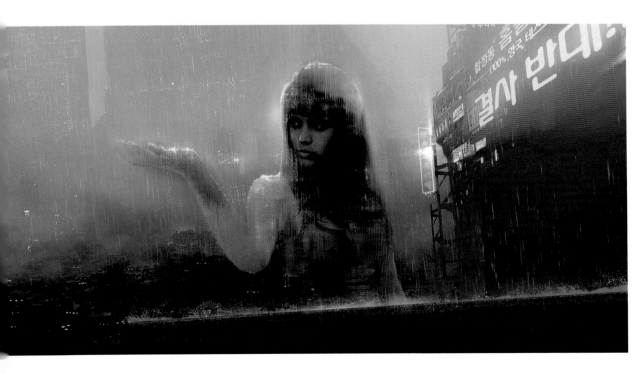

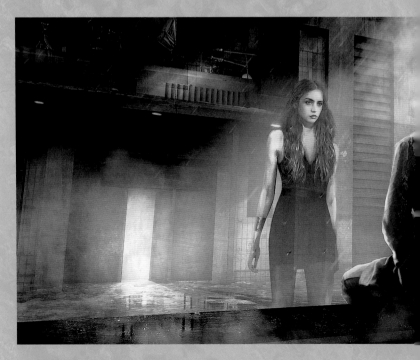

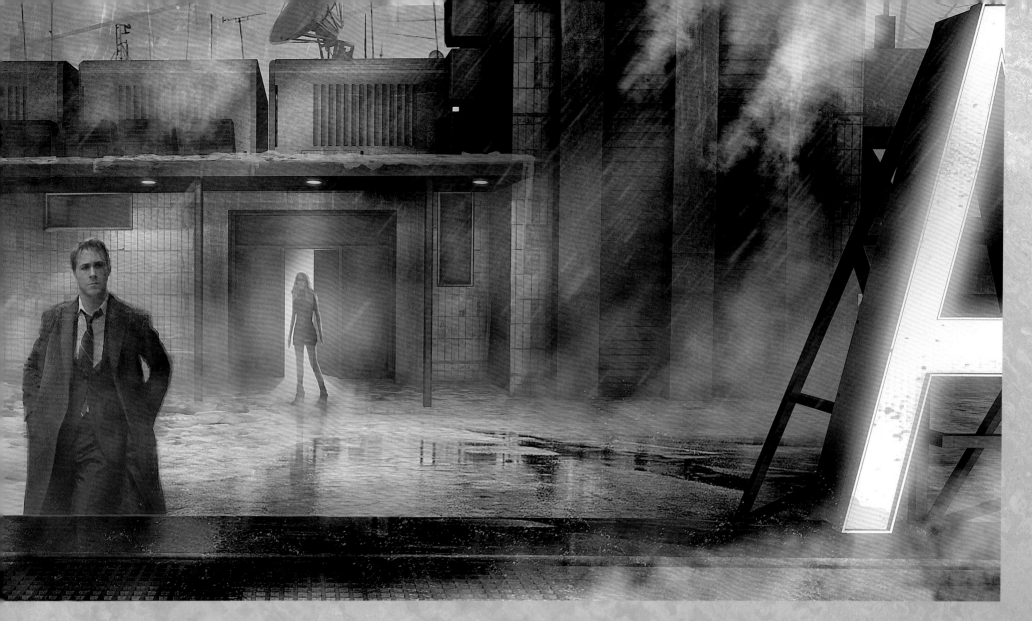

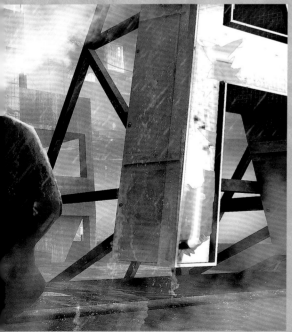

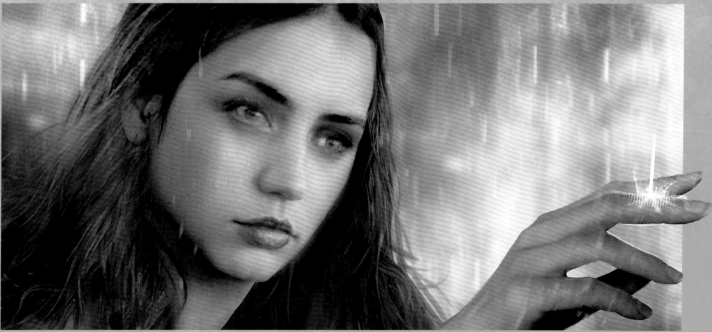

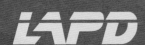

"Very early on, Denis Villeneuve had worked out the hammerhead shape that became the LAPD building, based on a photo of an unfinished freeway overpass, which created an interesting monolithic structure that rose above the urban environment. We then looked at buildings like the Marina Bay Sands resort in Singapore and Brutalist structures for further inspiration."
▼ *Victor Martinez*

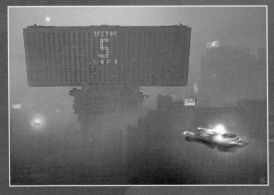

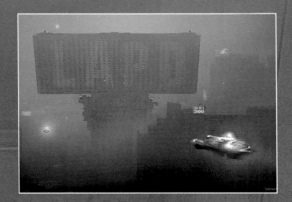

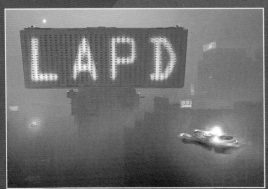

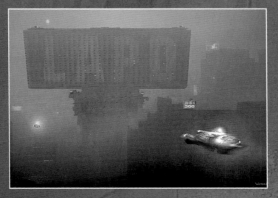

"The LAPD building design evolved over time. Denis Villeneuve had a very specific idea of what it should be and we chiseled away at it. He has very strong ideas, even dreams."
Sam Hudecki

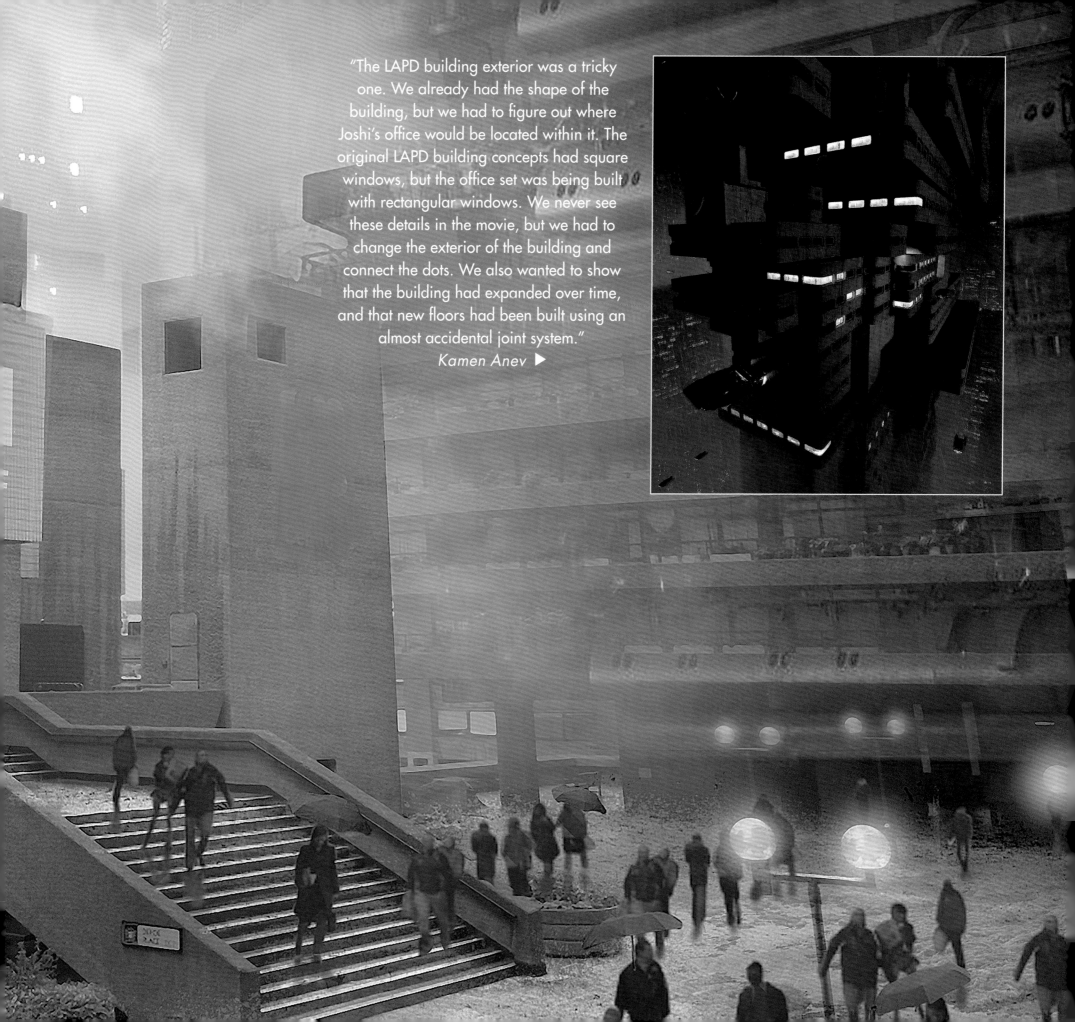

"The LAPD building exterior was a tricky one. We already had the shape of the building, but we had to figure out where Joshi's office would be located within it. The original LAPD building concepts had square windows, but the office set was being built with rectangular windows. We never see these details in the movie, but we had to change the exterior of the building and connect the dots. We also wanted to show that the building had expanded over time, and that new floors had been built using an almost accidental joint system."

Kamen Anev ▶

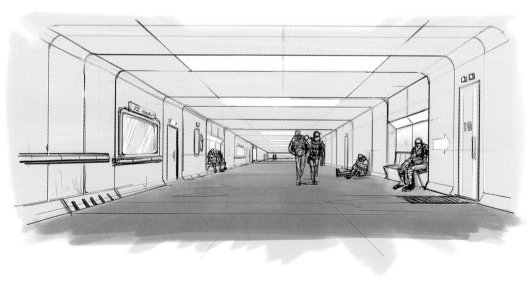

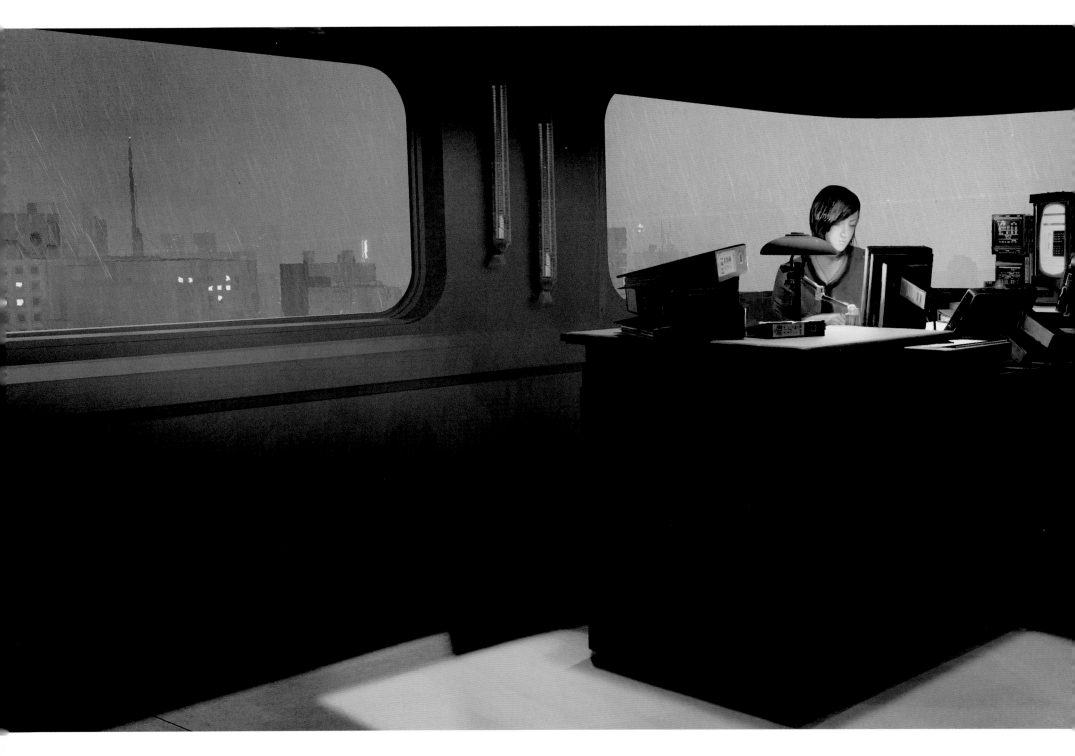

"It's a cold world, so we figured they should have heat lamps in the offices. There was also something sinister about that."
Sam Hudecki ▶

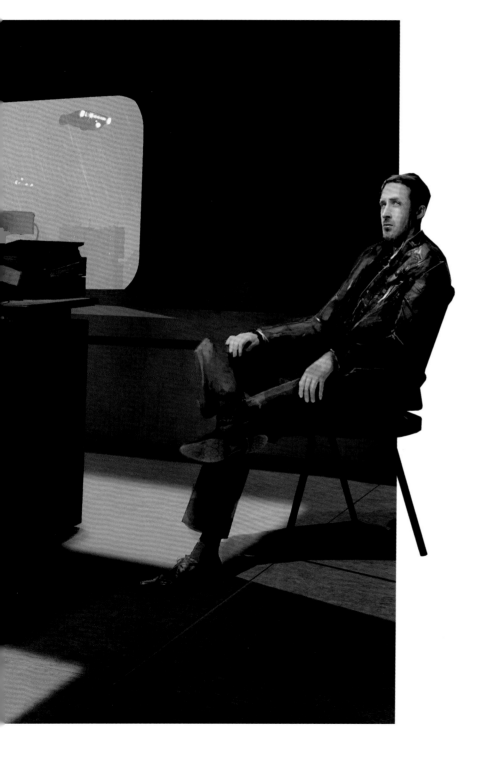

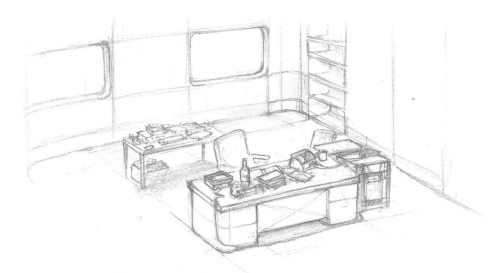

JOSHI CONCEPT ROUGH - FEB 1

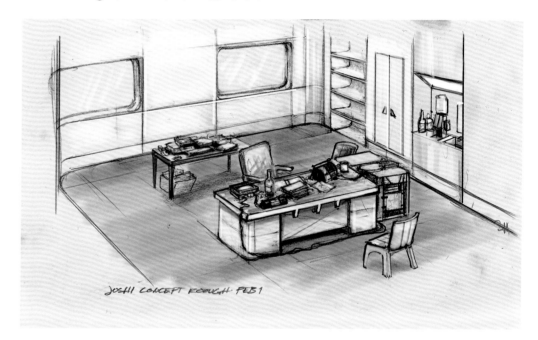

JOSHI CONCEPT ROUGH - FEB 1

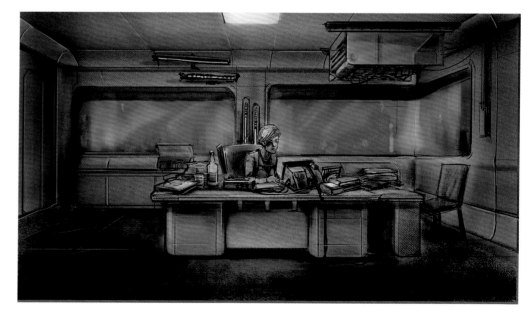

MORGUE

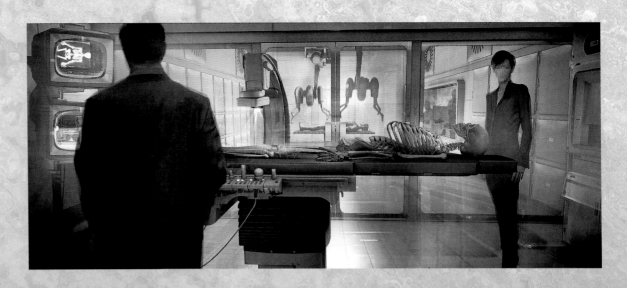

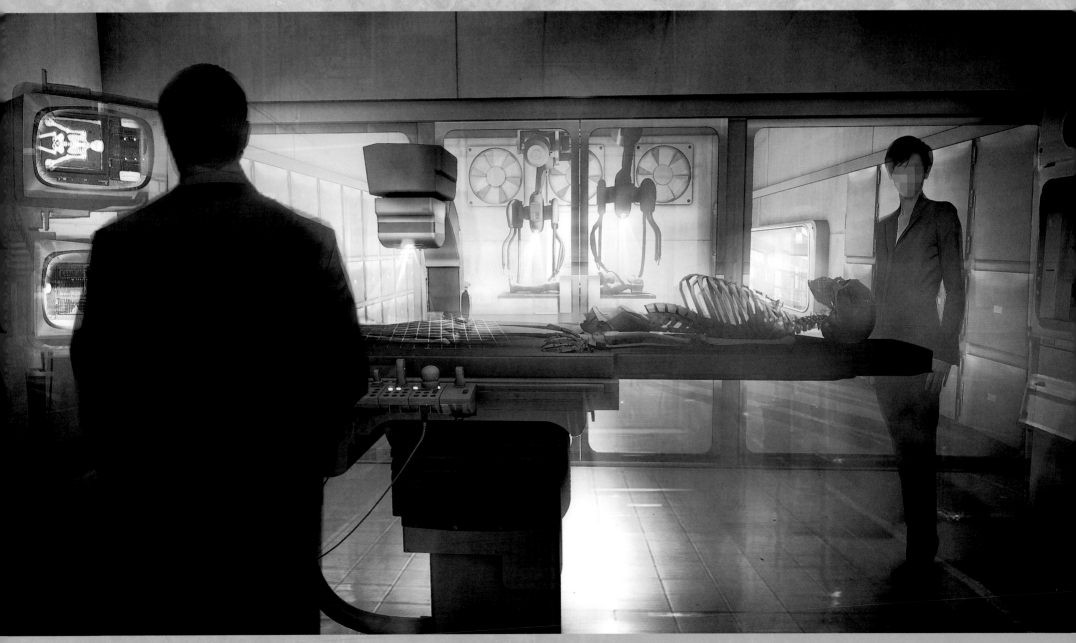

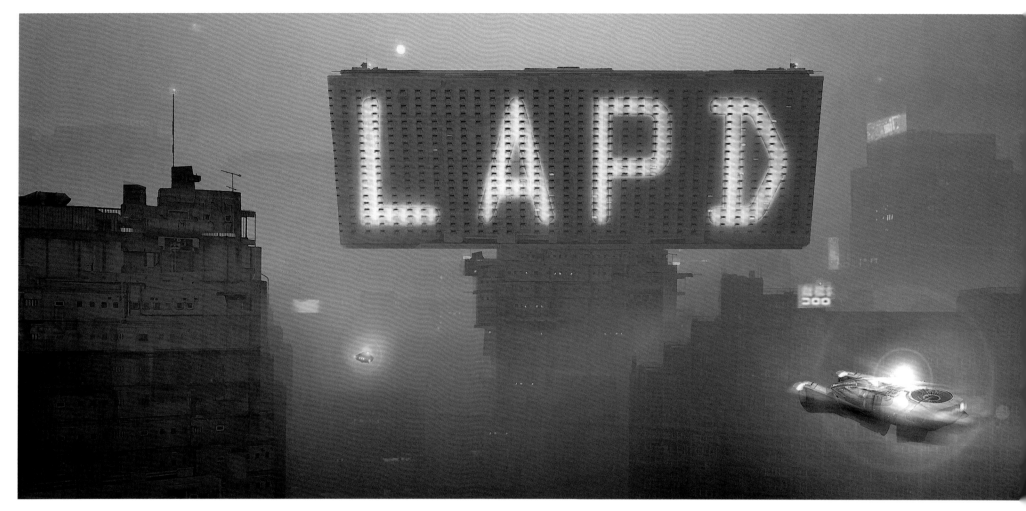

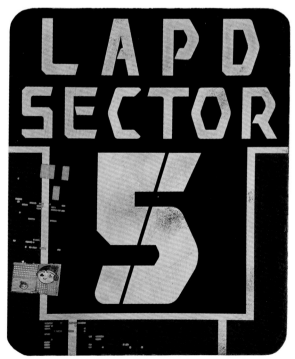

"Initially, we did a number of other designs using established commercial fonts, but we quickly realized that although LAPD is a universally recognized acronym, we needed to come up with something that was entirely unique to our world. I started with a standard sans-serif font and began to pull apart and chop into it. We ended up with something that is recognizable and readable, but Brutal and mechanized, reflective of our dystopian world. Dennis Gassner was very involved at every level. He gave a concise brief at the beginning of the process and then let us run, giving guidance and support throughout. Three designs were presented, giving Denis Villeneuve the final choice."

Laura Dishington

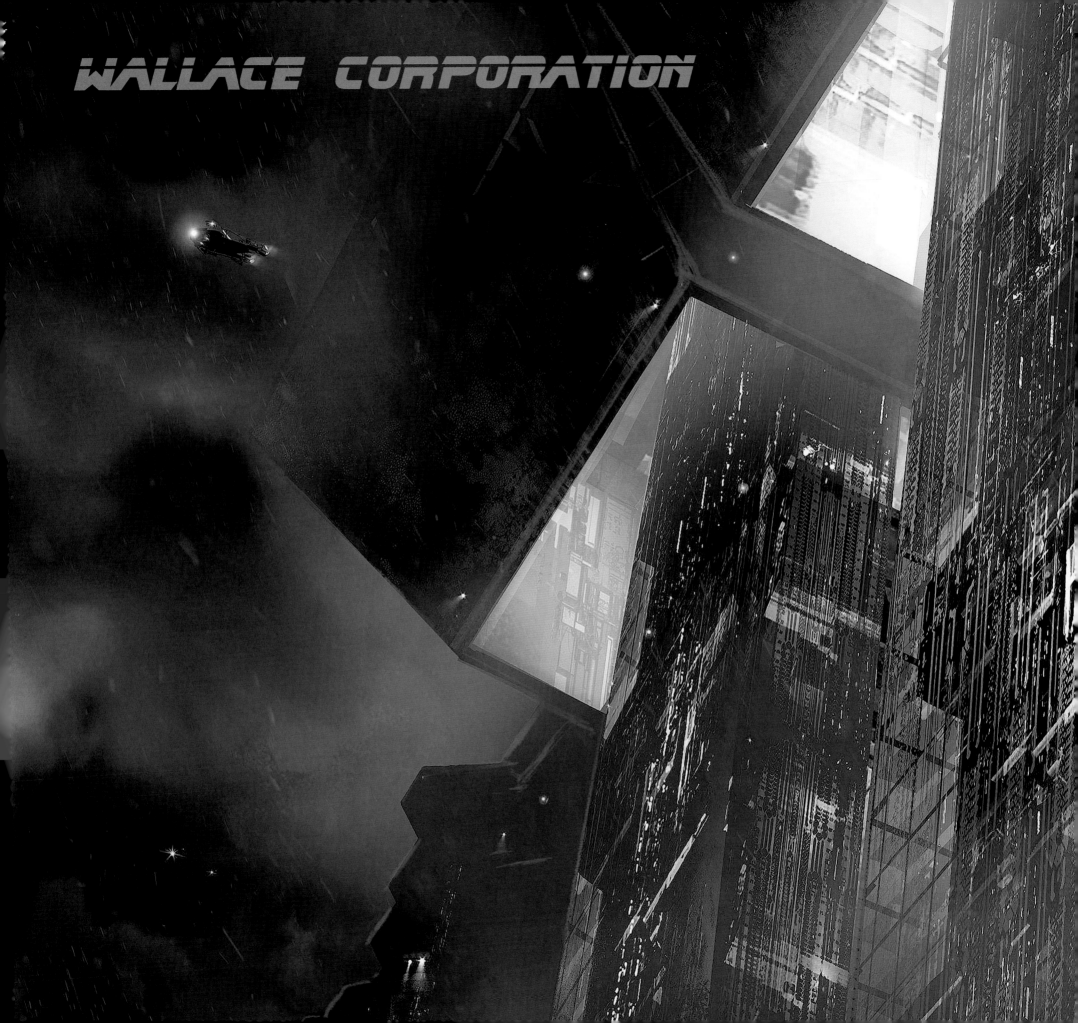

WALLACE LOGO

"Logos are ubiquitous in modern society, and branding is literally on everything in our consumer-driven economy, so if a science fiction property is going to be taking place in a possible/likely future with a capitalist advertising paradigm, then logos and brands will have to be everywhere in order to ground things in reality/hyper-reality. Usually, I try to hone in on a couple things: What will read really strong with high-impact for the film audience and what tone is the commercial entity attempting to communicate within the film. Wallace is a very powerful, personality-driven corporation, with a bent towards technology, so I tried to blend power, tech, and a bit of hubris, and then the letter W is very strong. It's symmetrical, with angles that naturally create visual energy. Plus, anything that has three points, or three of anything, is also very strong – in the West we have a subconscious bias for things that come in threes."

Leri Greer

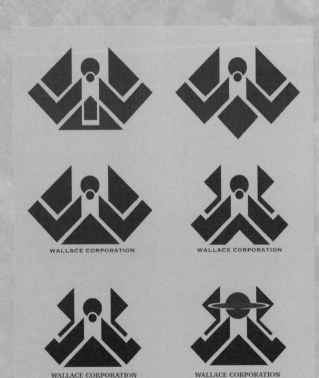

WALLACE

WALLACE CORP.

WALLACE

WALLACE

WALLACE

WALLACE

WALLACE

WALLACE

WALLACE

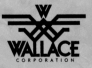
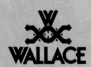

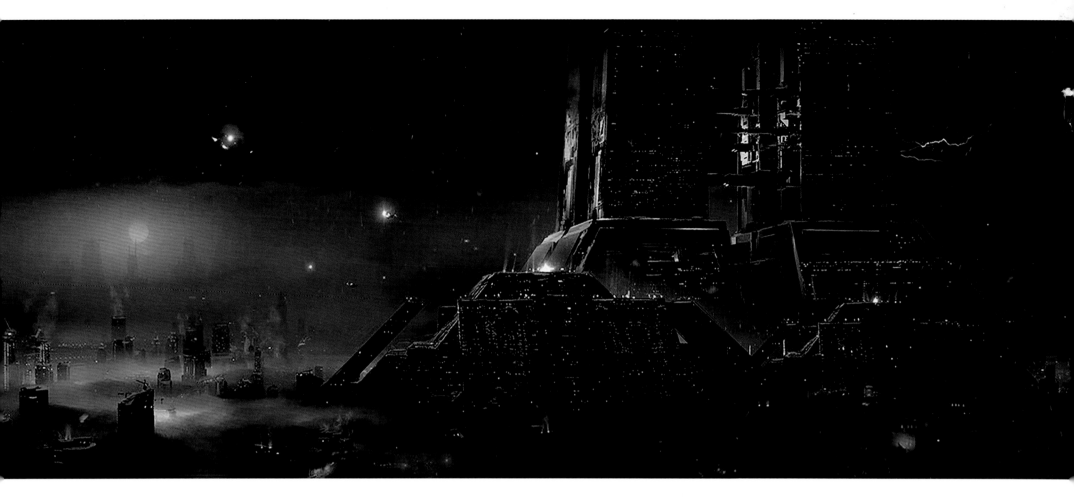

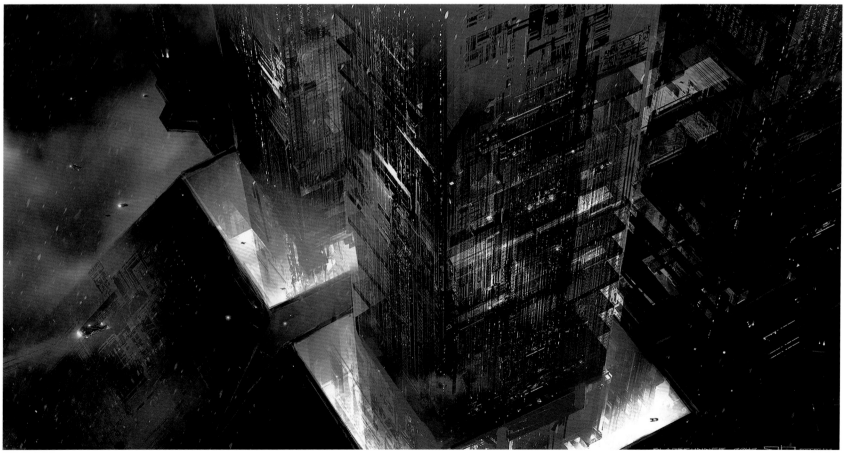

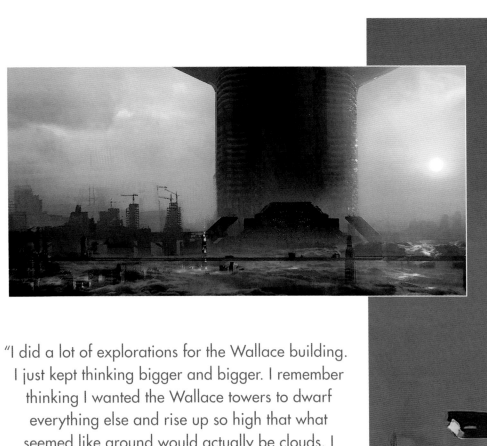

"I did a lot of explorations for the Wallace building. I just kept thinking bigger and bigger. I remember thinking I wanted the Wallace towers to dwarf everything else and rise up so high that what seemed like ground would actually be clouds. I played with a lot of shapes, but decided not to do a pyramid building, as that would be too similar to what was done already. I gave Aaron Haye a bunch of thumbnails and he went with the sunset one and asked me to finish it off."
Emmanuel Shiu

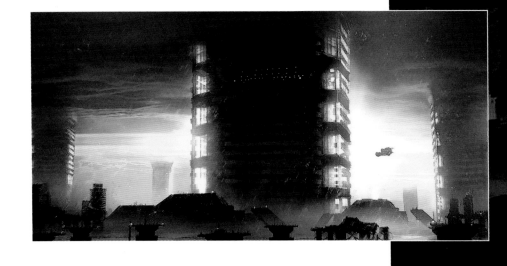

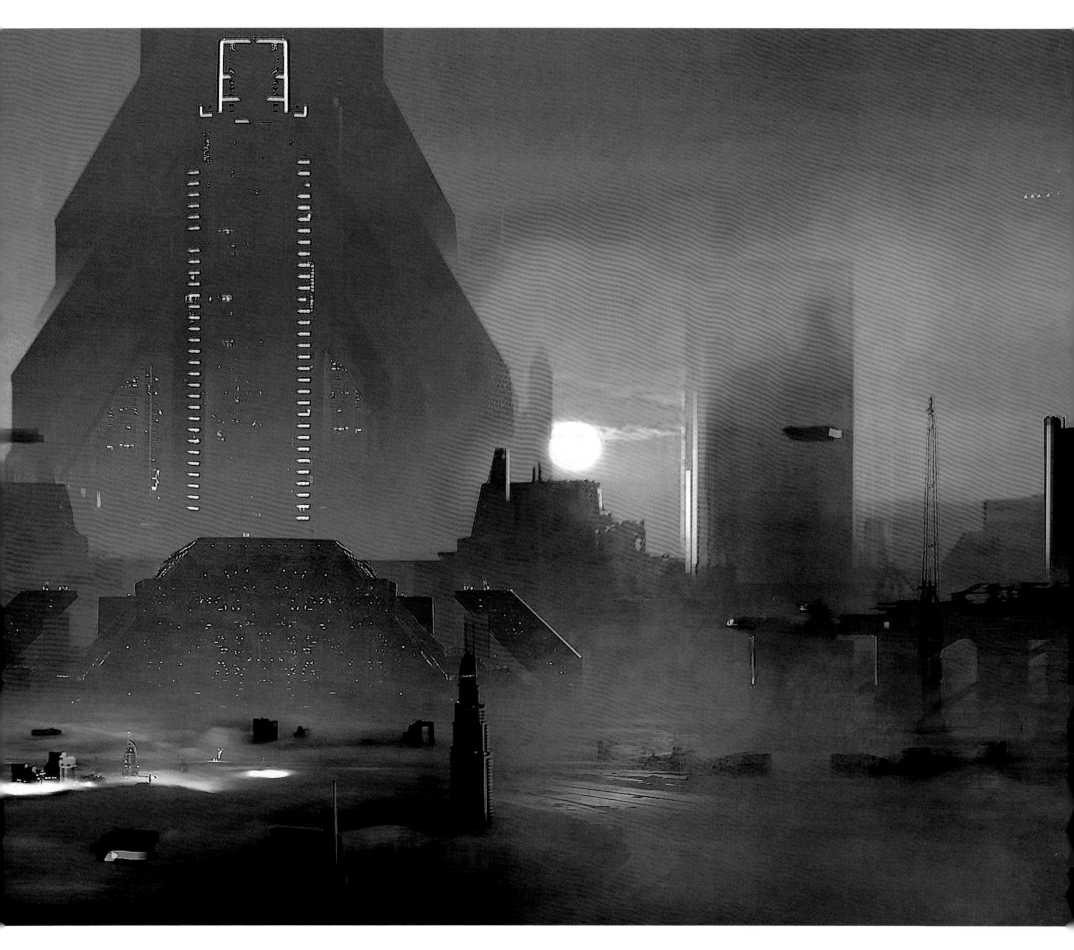

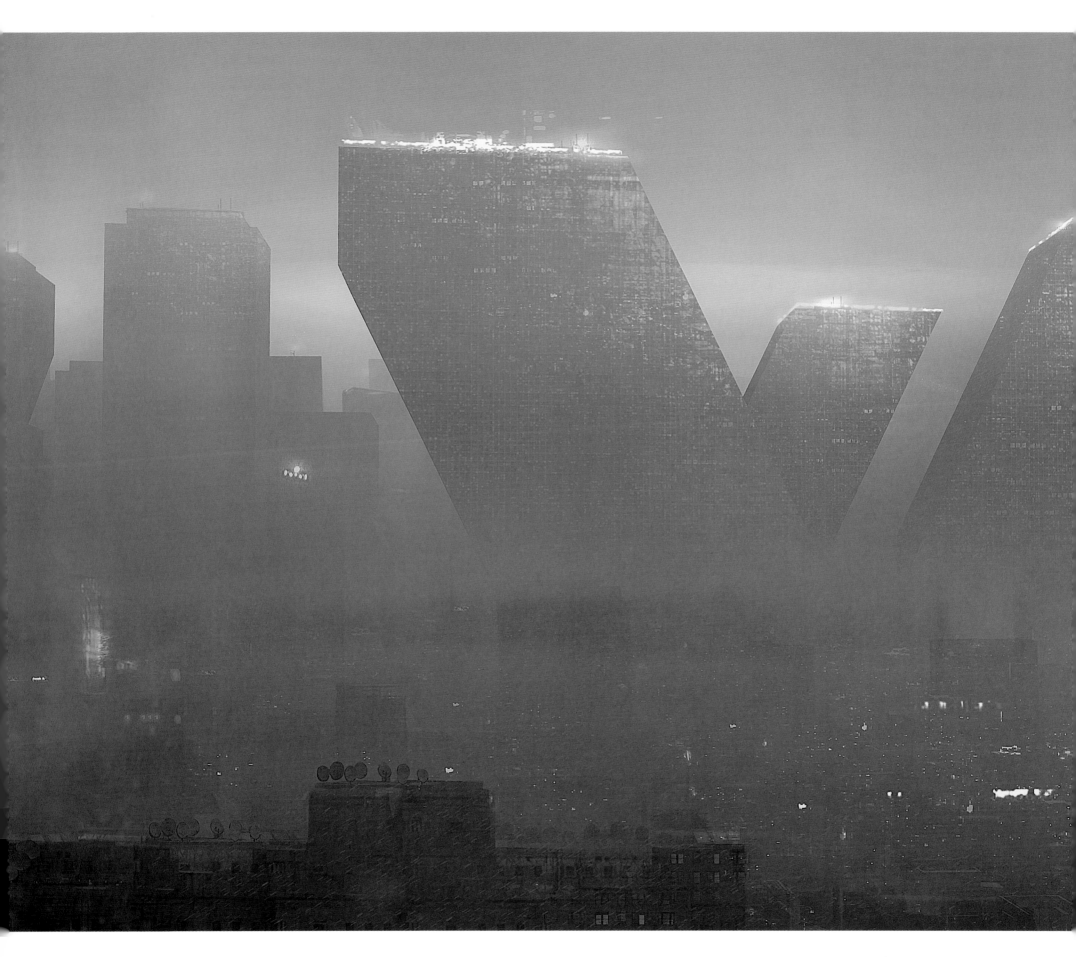

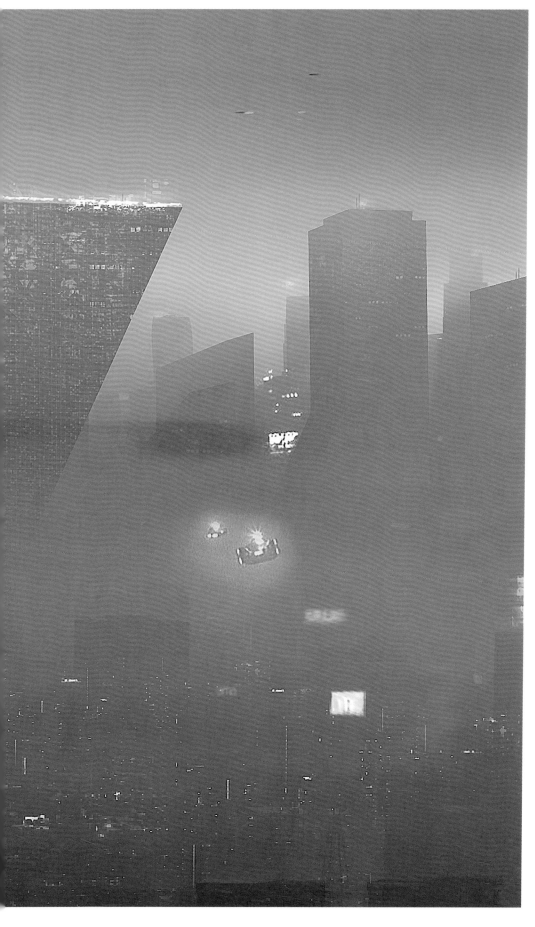

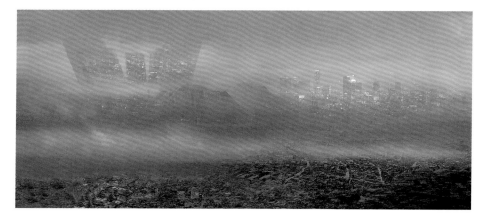

"The Wallace towers were meant to evoke the same type of awe and presence that the Tyrell building had in the first film, but on an even larger scale. A megastructure that grew tall into the haze, like some acropolis in which Wallace reigned like a god, and Luv rained thunderbolts from above. The shape was an early idea that when flying around the three towers, they would align to form a W for Wallace. It later evolved into the final version we see in the movie."
Victor Martinez

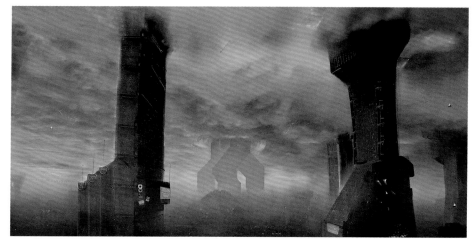

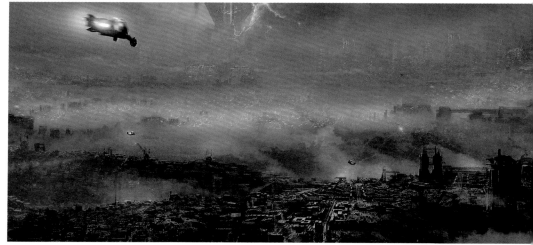

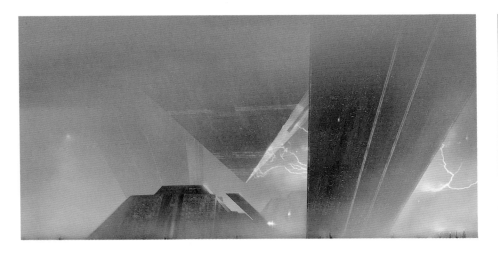
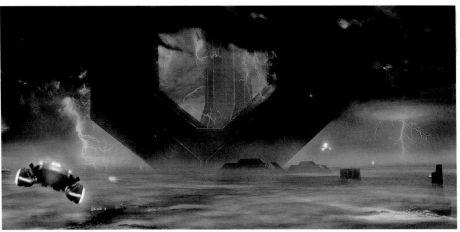
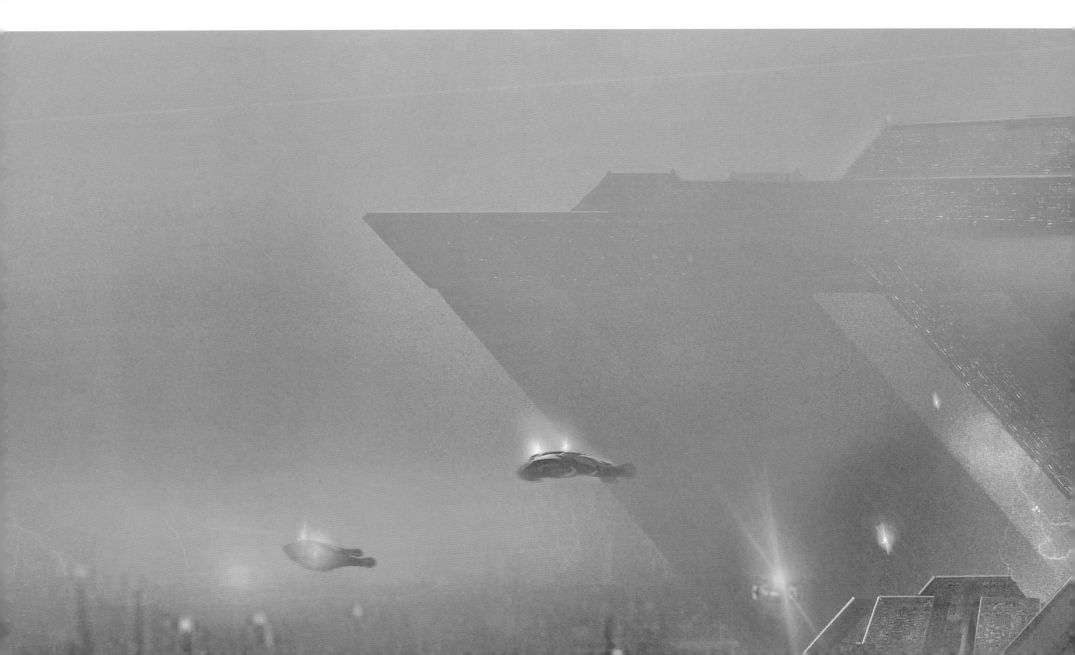

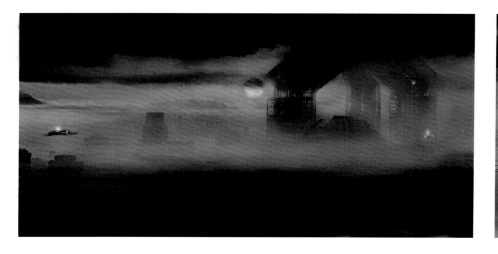
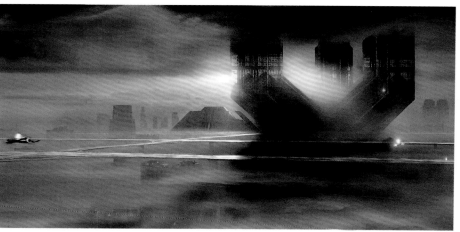
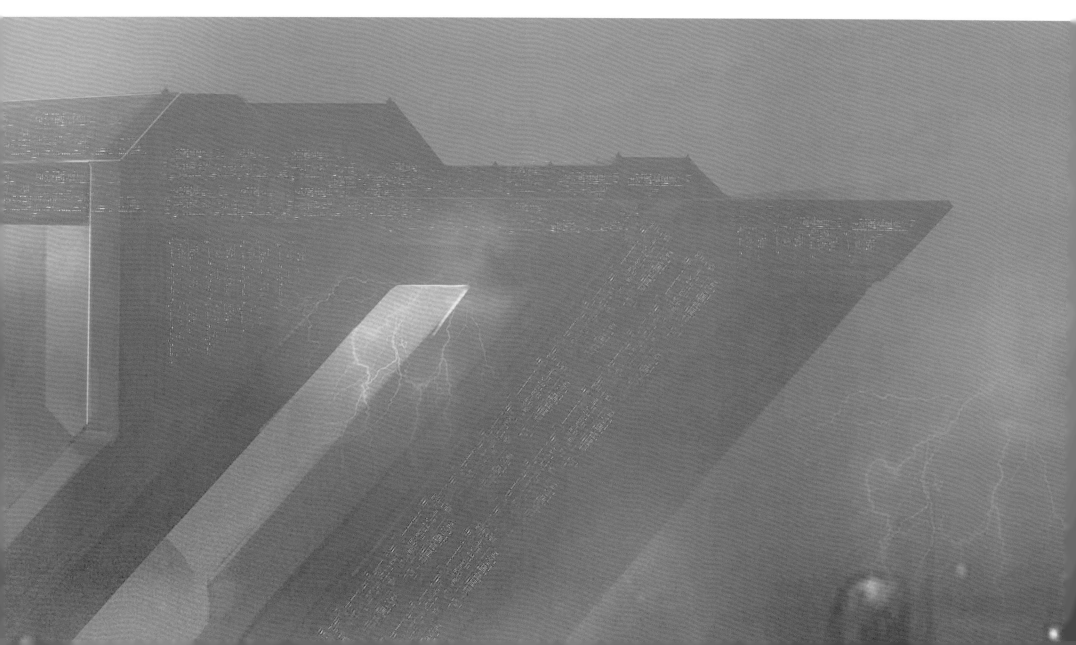

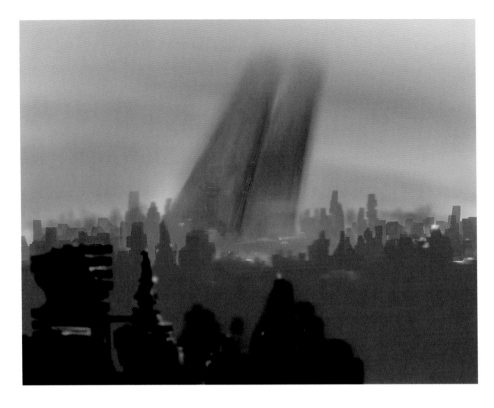

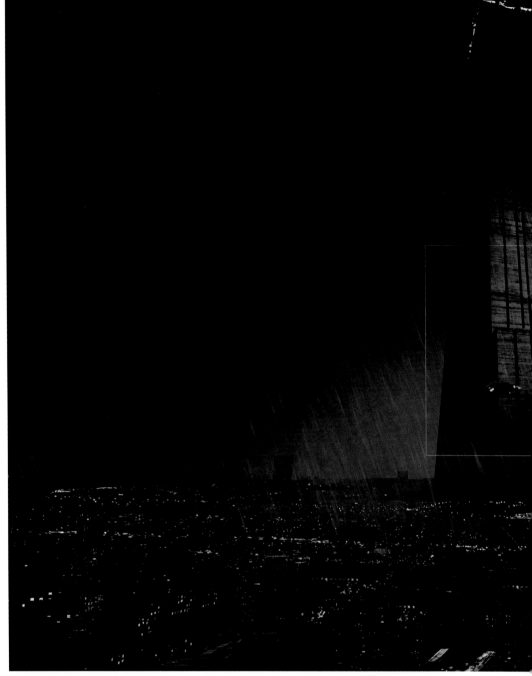

"Working with Denis Villeneuve means that all the visual solutions are defined by logic and the natural flow of the script. There is no place for solutions that are there only for the sake of visual spectacle, if it's not part of the natural evolution of the world. I would say less is more. In the end, the connecting bridges between the Wallace towers [seen from above] felt unnecessary, and disappeared after putting the building in context. [The side-on images] were a couple of days later. It felt much stronger with the three independent 'blades.' It was probably a bit forced to emphasize that this was one building, and not three individual ones. The height and the style told that story without the connecting bridges."

Kamen Anev ▶

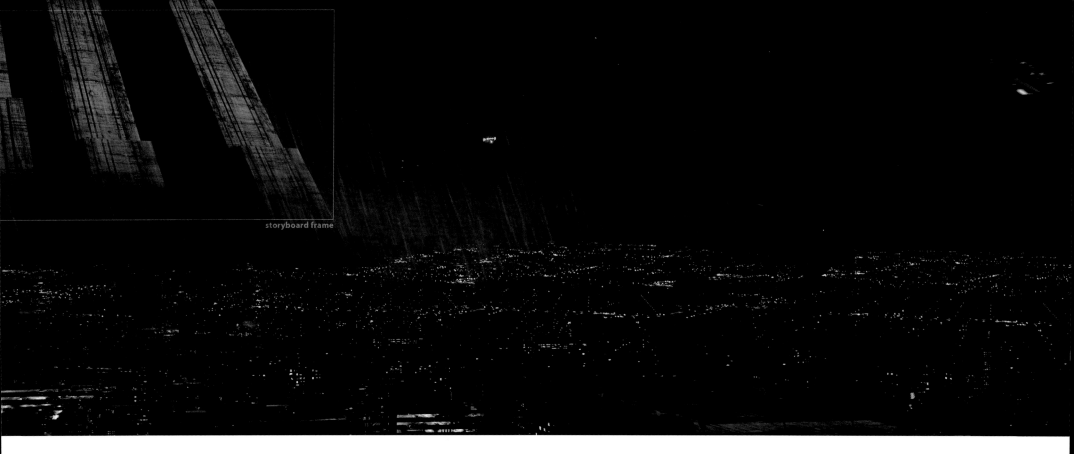

storyboard frame

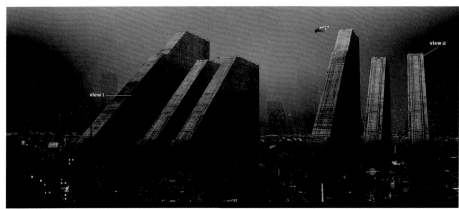

view 1
view 2

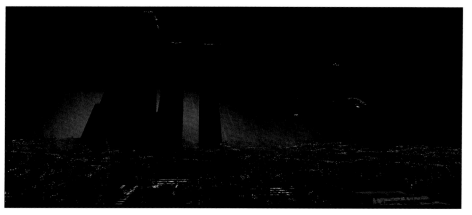

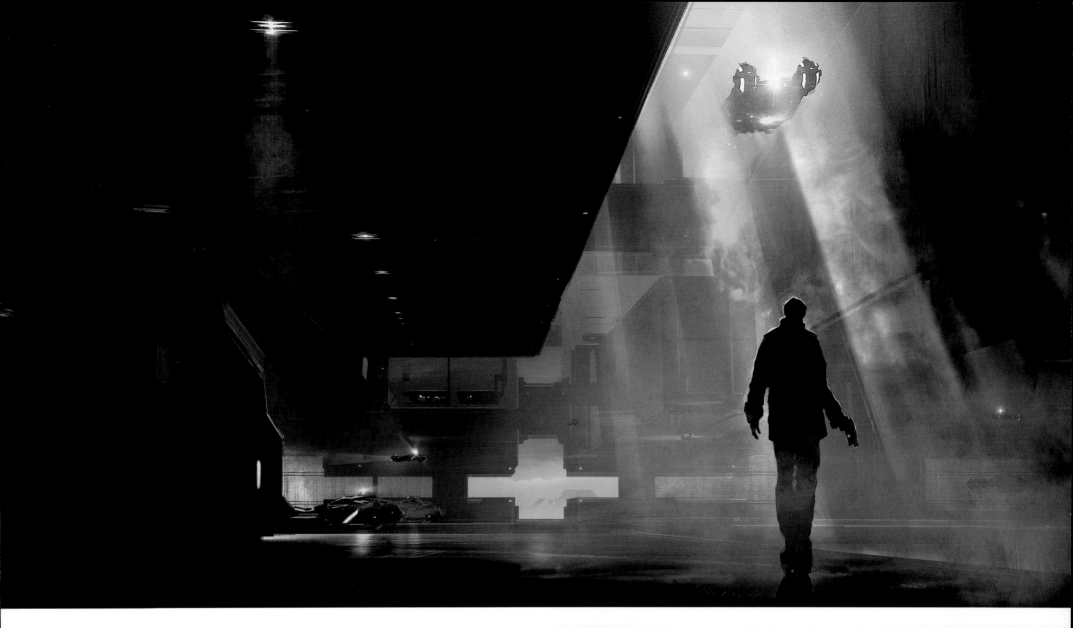

"I feel proud of this illustration as I believe it contributed to the color palette and cinematography of the Wallace interior shots. In the summer of 2015, I had a lot of freedom to imagine what a Denis Villeneuve *Blade Runner* film could look like. I set out to paint a lighting design keyframe that combined the compositions that I loved from Denis and Roger Deakins's work together, plus the gorgeous lighting from the original film. Starting from the script, it read that K needed to travel to Wallace's tower for his investigation. At this point nothing had been drawn yet for this setting, so I took cues from the original film, specifically the scene with Rachael sitting in Tyrell's office and the shafts of light cutting out her silhouette. Denis also works in strong silhouettes. I chose to use such a saturated yellow sunlight in the dark dystopian world to show that Wallace's wealth granted him access to the sun."

▲ *George Hull*

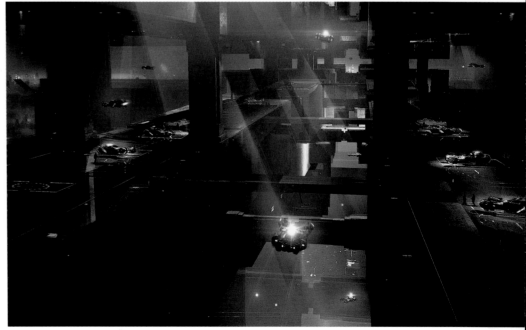

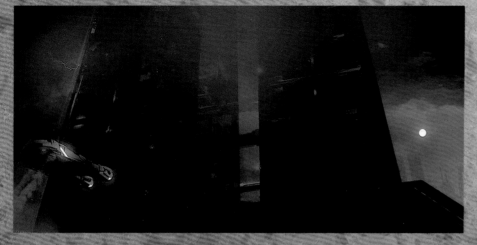 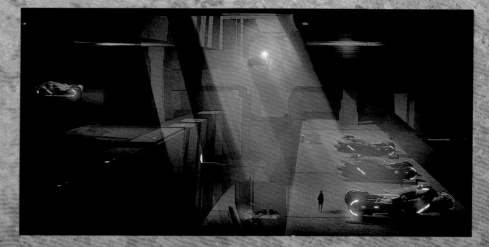

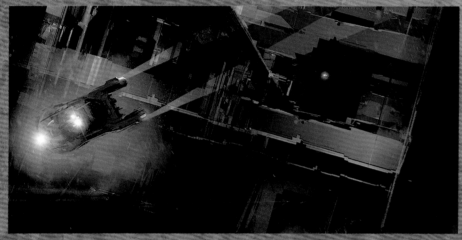 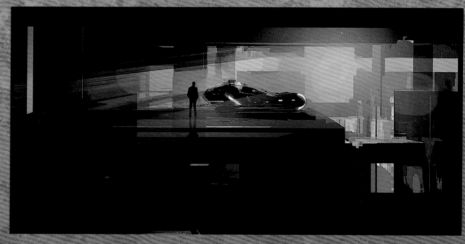

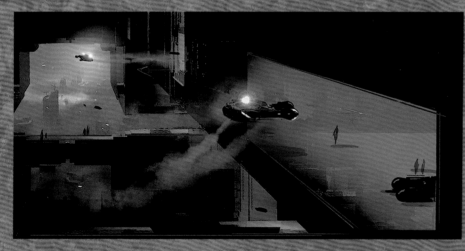 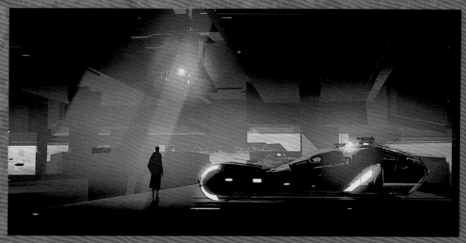

"One of my favorite scenes in movie history is Deckard traveling to Tyrell's pyramid in *Blade Runner*. The scale of the architecture, the light and mood, all had a profound effect on my imagination as a young adult. So, when I read the script scene of agent K flying his spinner to the Wallace Corporation's headquarters, my eyes lit up. These sketches are the earliest composition ideas for the framing, light, and mood for the sequence. In support of the script, I wanted to show Wallace's wealth through the scale of his tower and the beauty of natural (or artificial) sunlight streaming into the building. The art deco shapes here are a nostalgic nod to Deckard's apartment tiles."
George Hull

WALLACE'S OFFICE

"An early concept for Wallace's office (even though it looks like it could have been an early take on the records library with the Nexus chambers). This design was developed to display Wallace's opulence. The room integrates numerous monolithic chambers populated with natural exotic marine life. And the oblique walls, active with cascading water, are divided by a now-extinct species of tree."
Scott Lukowski

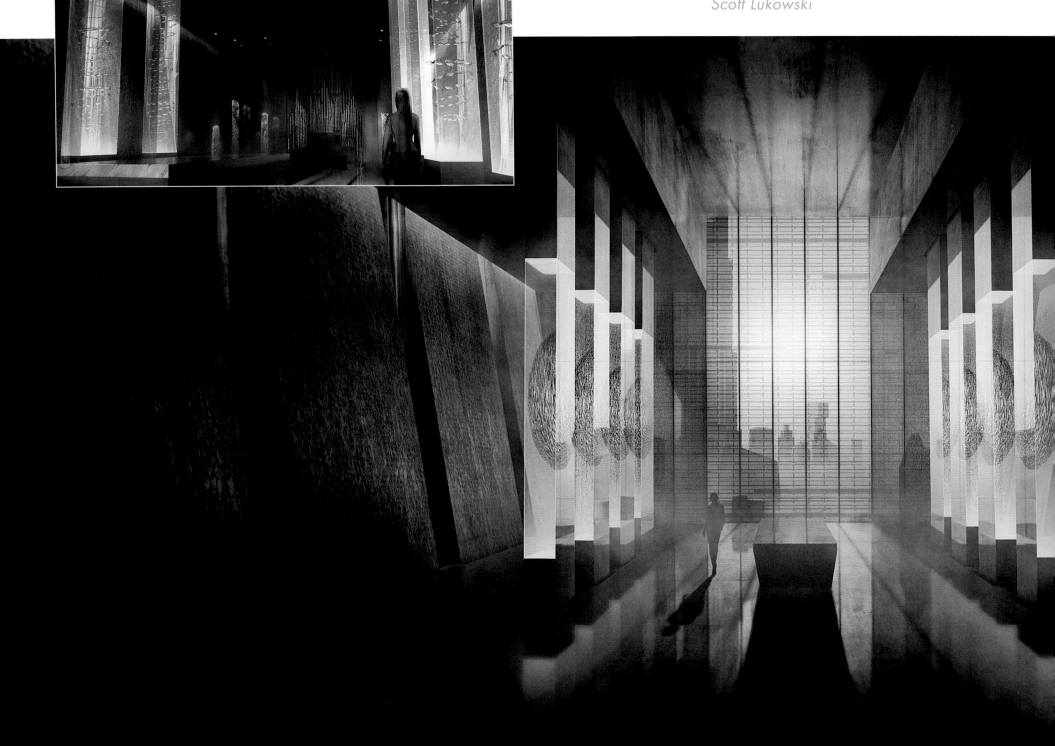

"The set was already designed from some beautiful paintings by Peter Popken. Then our set decorator Alessandra Querzola asked me to put her furniture in the space, which was a good opportunity to do one image of the set myself."
▼ *Kamen Anev*

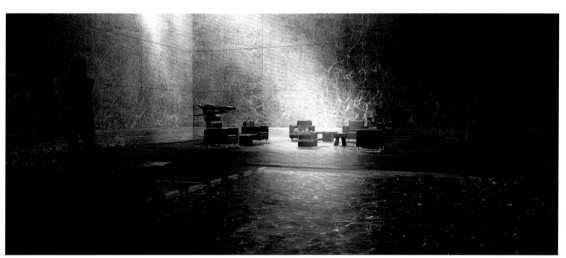

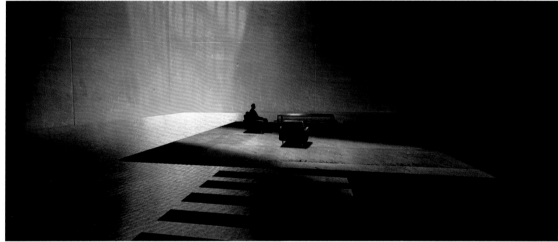

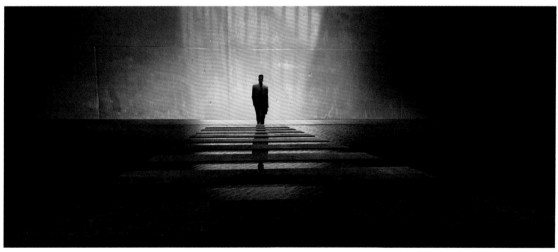

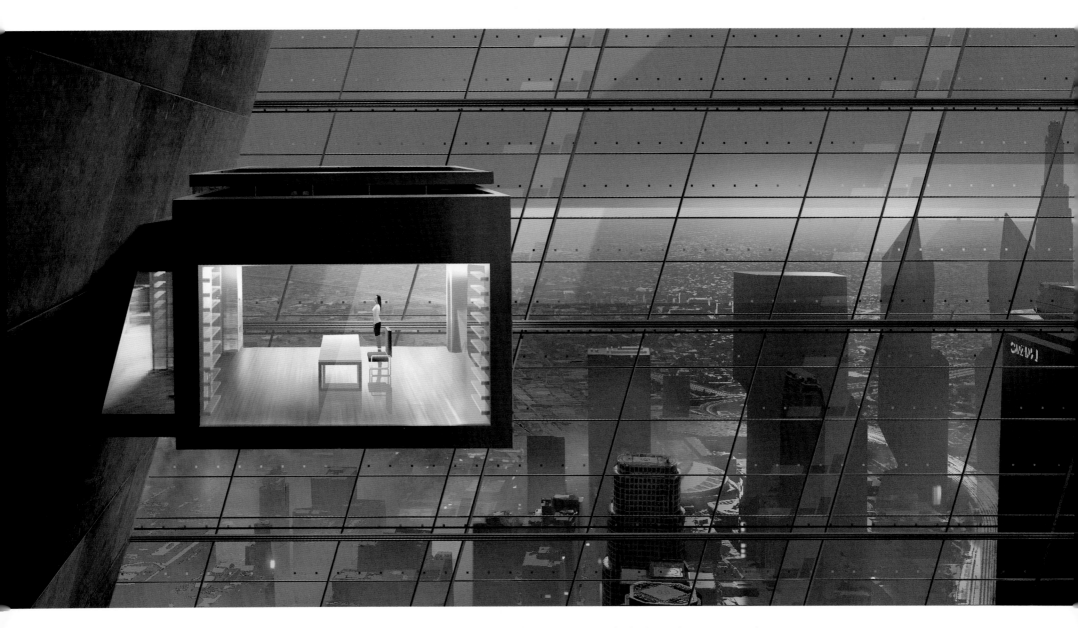

"In this early pass on Luv's office we wanted to show her exposed position and status in the Wallace Corporation. Soon we found out that the design did not blend in with the preceding scenes. Aside from that, the whole concept revealed itself only in a super-wide shot and started to tell a story of its own instead of supporting K's."

Peter Popken

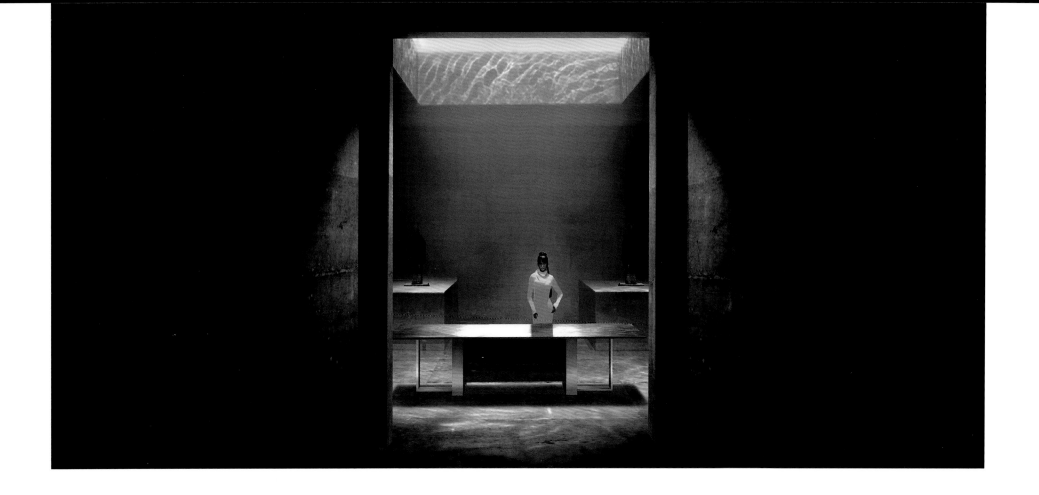

"Technically, Luv's office evolved as a consequence of Niander Wallace's office. We used the same shape, textures, quality of light, and minimalist design. The trick was to keep it simple – but not too simple. A great deal of work went into the details and perfecting of the surfaces. Production designer Dennis Gassner knew how each set could be tied in to the greater picture. For example, having established an interior moat of water surrounding Wallace's office, Dennis suggested that Luv's room could be located right underneath, so that we would see the water above her ceiling. With the light shining through the water from above we got the beautiful ripple effect on the floor."

Peter Popken

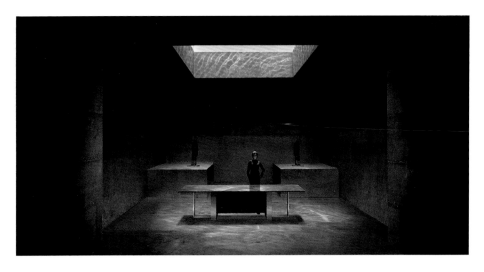
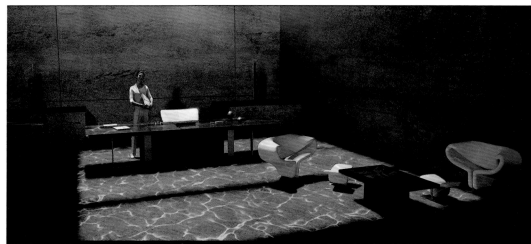

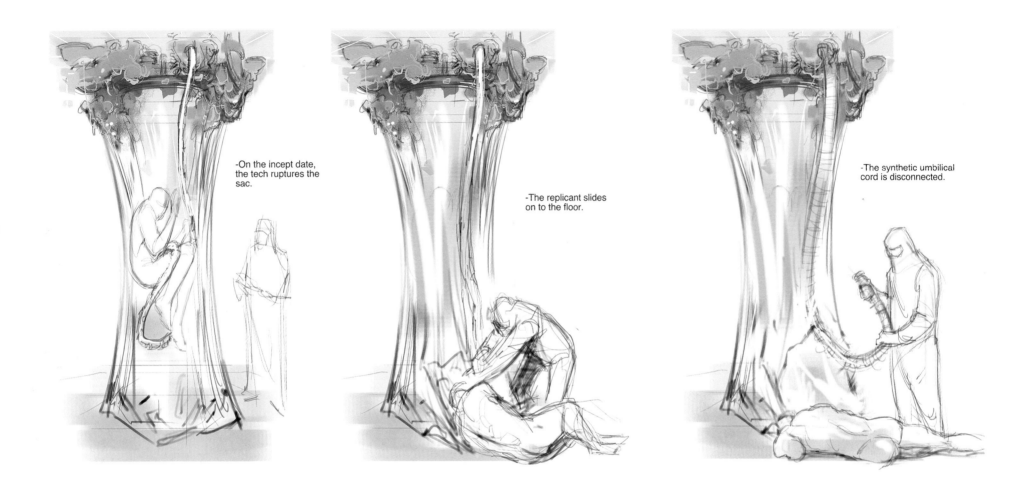

-On the incept date,
the tech ruptures the
sac.

-The replicant slides
on to the floor.

-The synthetic umbilical
cord is disconnected.

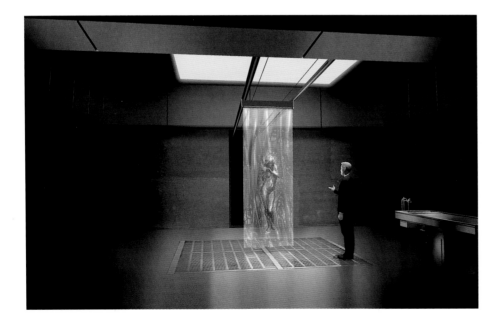

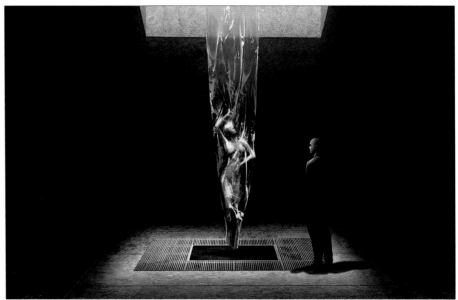

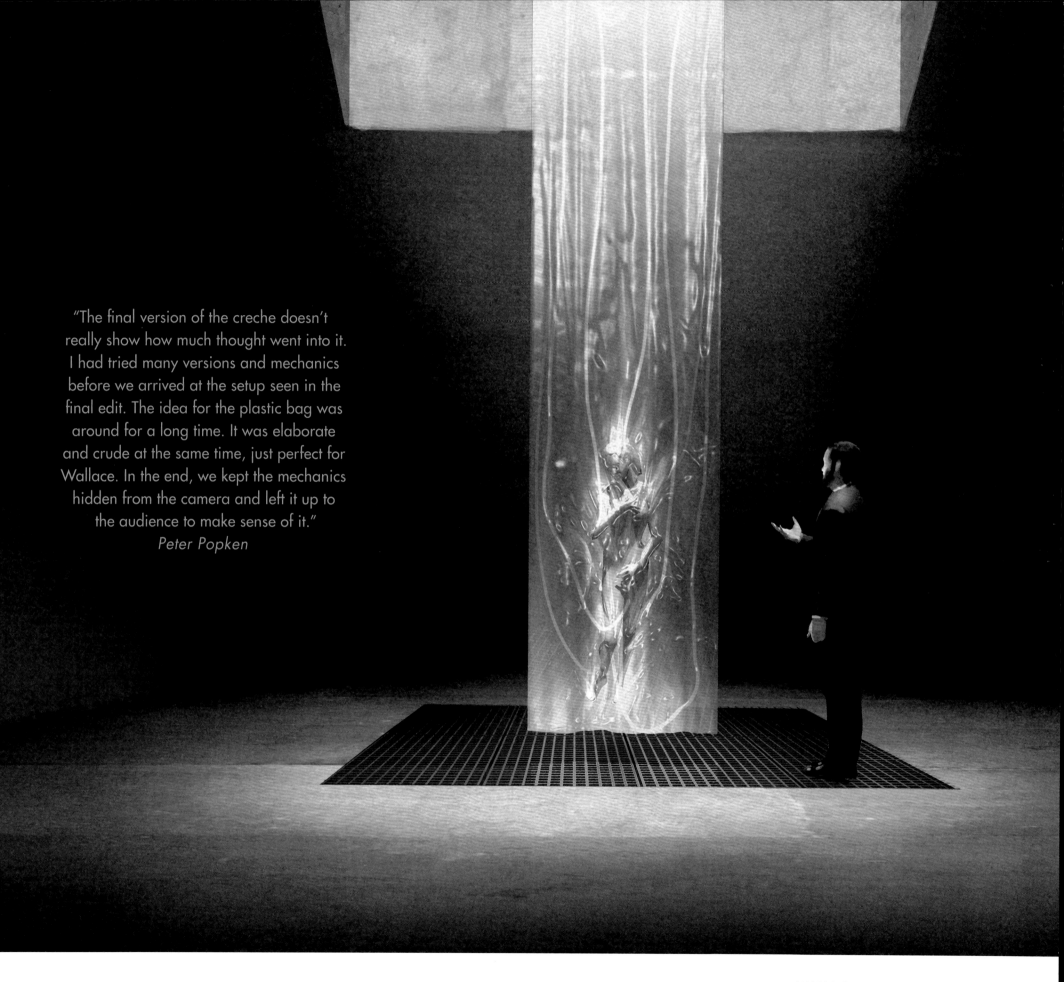

"The final version of the creche doesn't really show how much thought went into it. I had tried many versions and mechanics before we arrived at the setup seen in the final edit. The idea for the plastic bag was around for a long time. It was elaborate and crude at the same time, just perfect for Wallace. In the end, we kept the mechanics hidden from the camera and left it up to the audience to make sense of it."

Peter Popken

NEXUS RELIQUARY

"The Wallace inspiration came from various references. Roger Deakins had some very strong ideas about how light would move through this building and pyramid-like rooms. I did 3D models to see what these interiors would look like and that's exactly how the sets were built."
Sam Hudecki

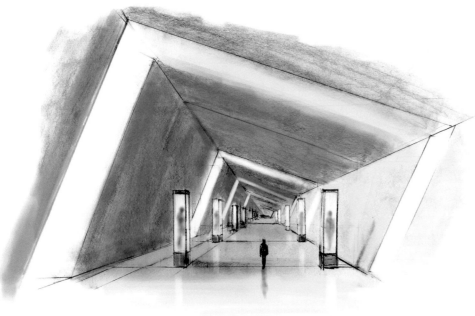

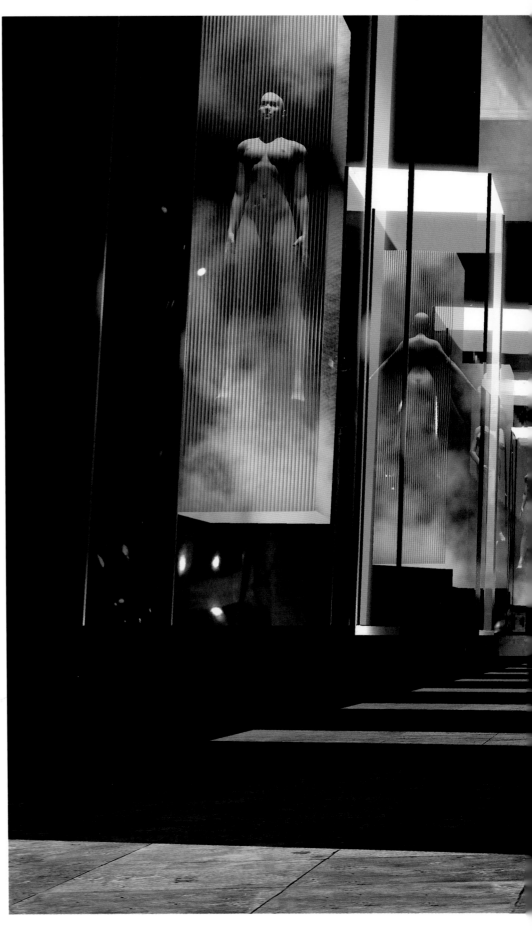

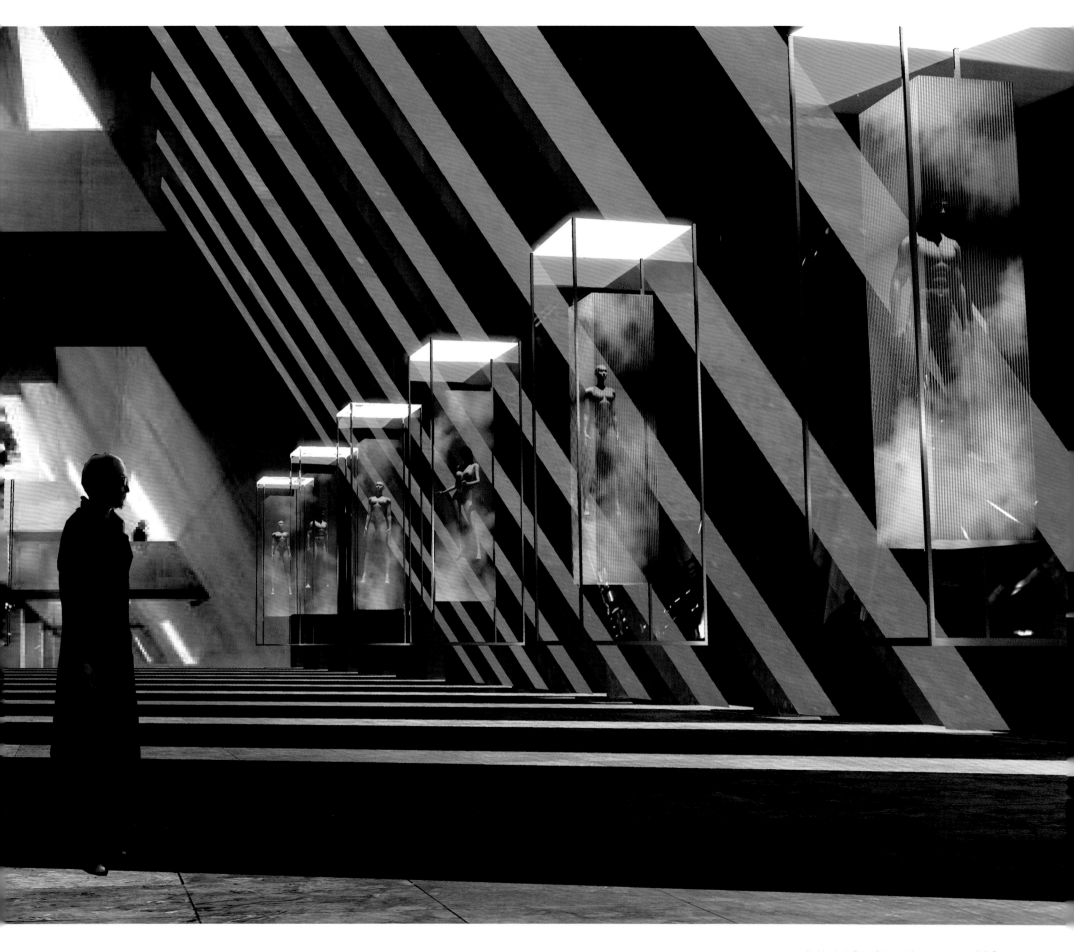

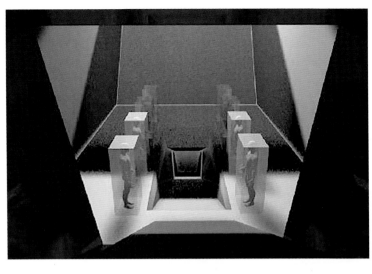

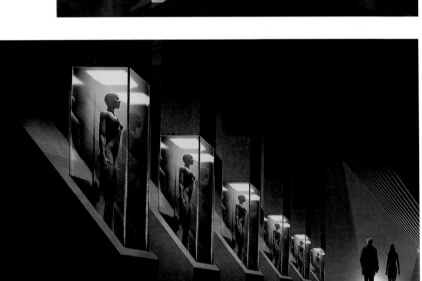

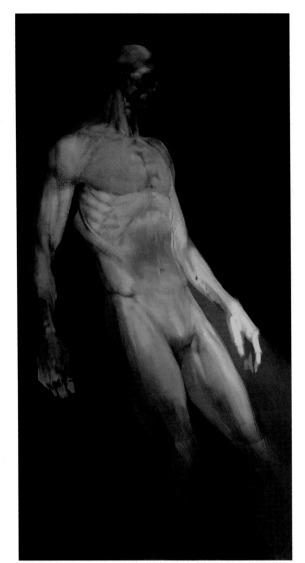

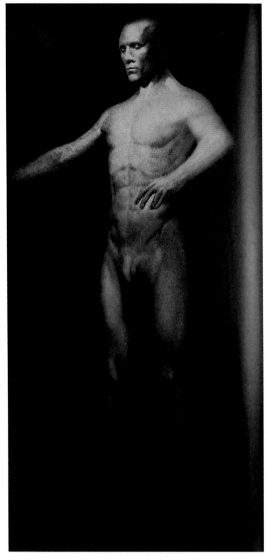

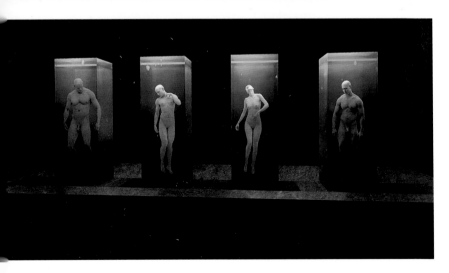

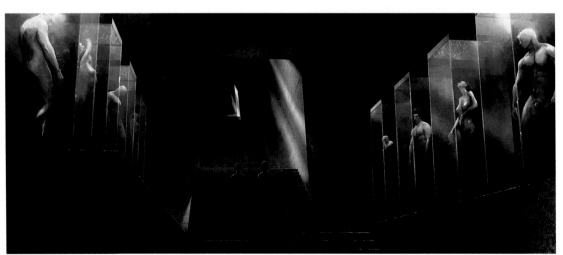

"I always tell the artists, 'Before you put your pencils to paper, make sure you know what you're doing.' The reason is someone is going to have to build it. So, know what you're doing before you start, and that means understanding the story and the essences of it."

Dennis Gassner

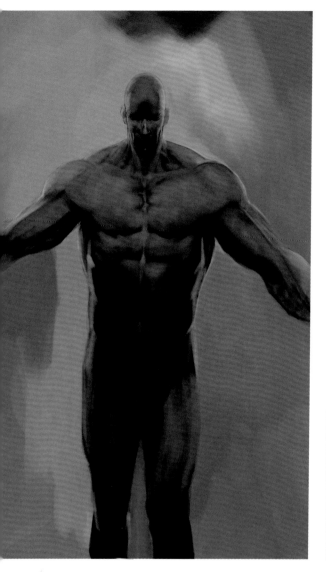

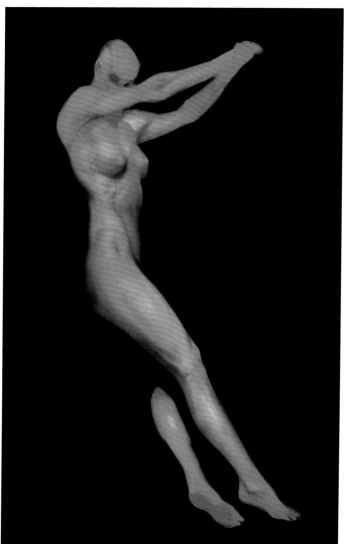

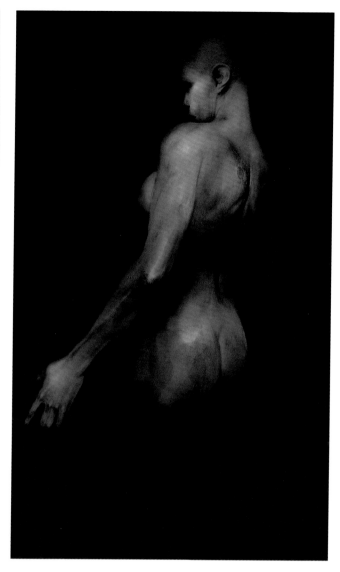

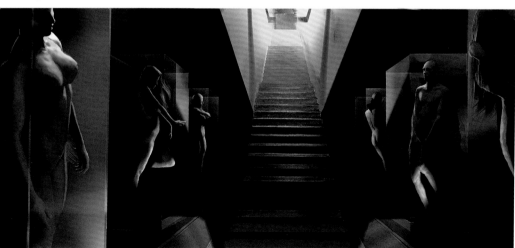

"Denis Villeneuve approached me with the idea that two characters would walk down an area where there would be older model Replicants on display. He wasn't sure how exactly we should show that they were different than humans, and I was allowed to play with it and pitch him some ideas. Knowing Denis's sensibilities from working with him on *Arrival*, I knew we were going to go subtle, so I approached it as if we were staging sculptures for viewing. I thought they should be in tanks of liquid, like amniotic fluid but not, metaphorically as if they were in wombs. I also streamlined the physiques of the figures, so they would seem artificial but not fake. I thought they should be almost-androgynous yet ideal at the same time, which is a contradiction, but it all helps to make them seem like something 'more human than human.'"

▲ *Carlos Huante*

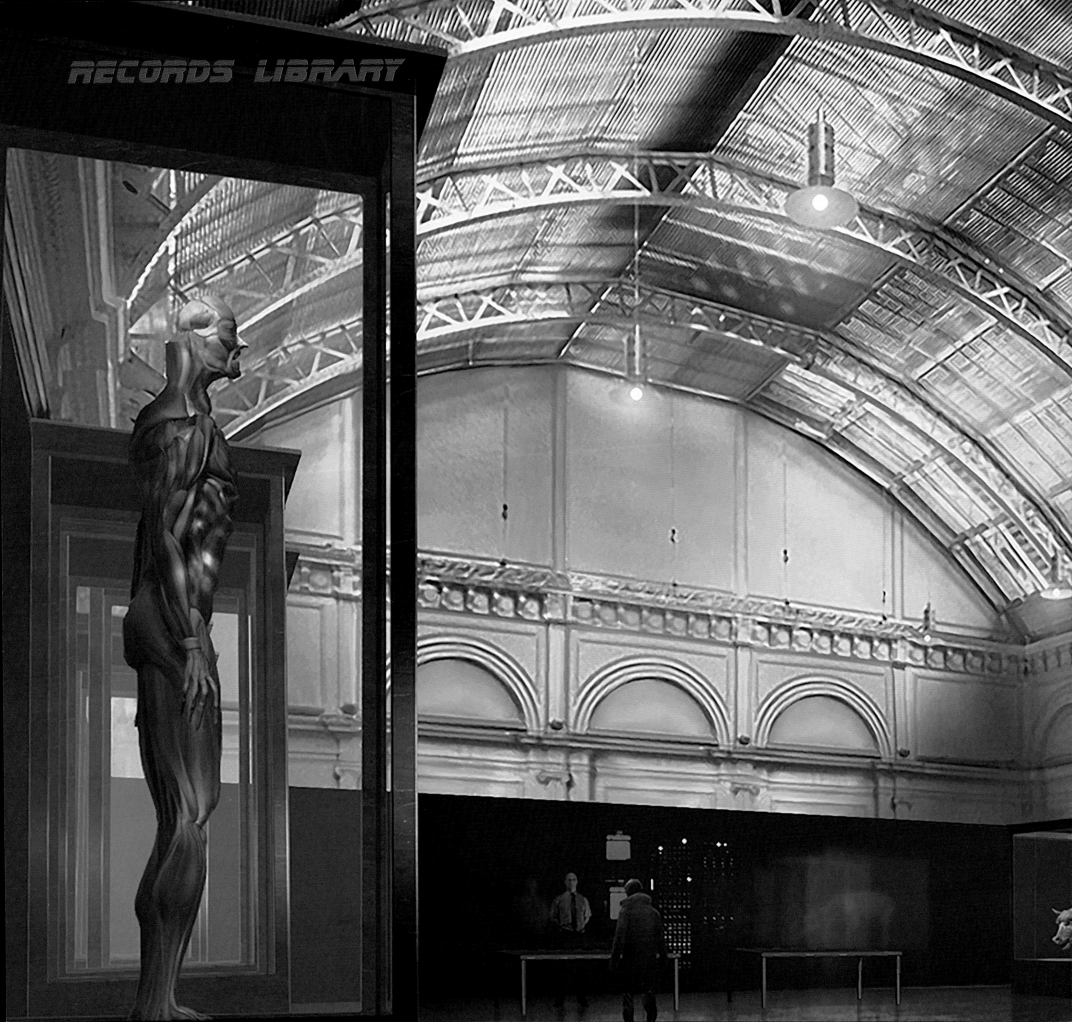

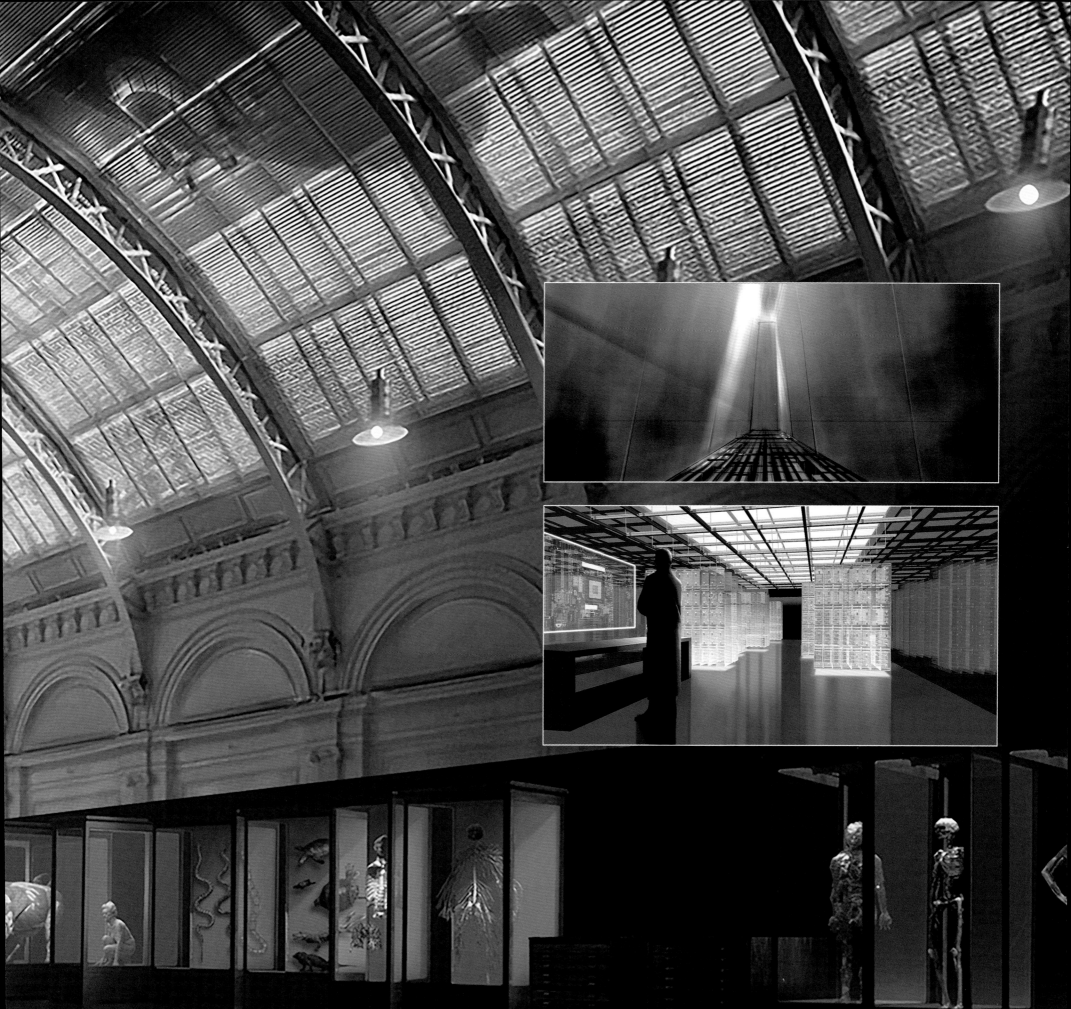

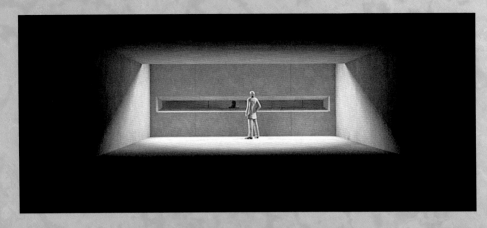
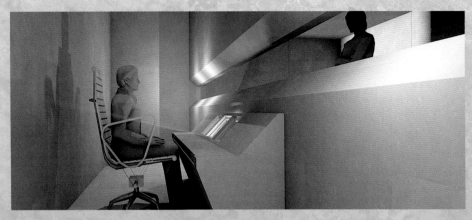
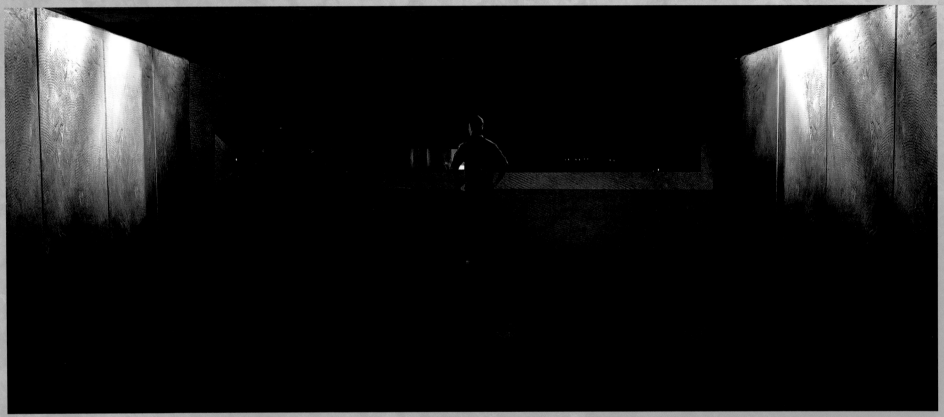
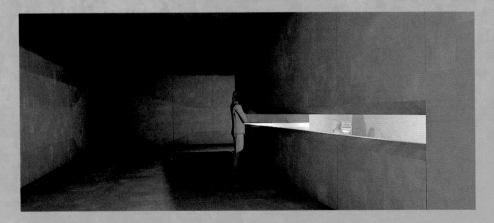
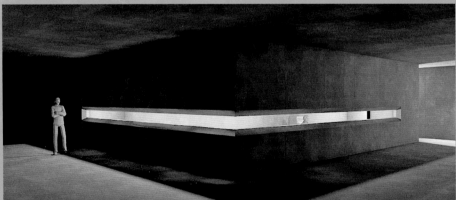

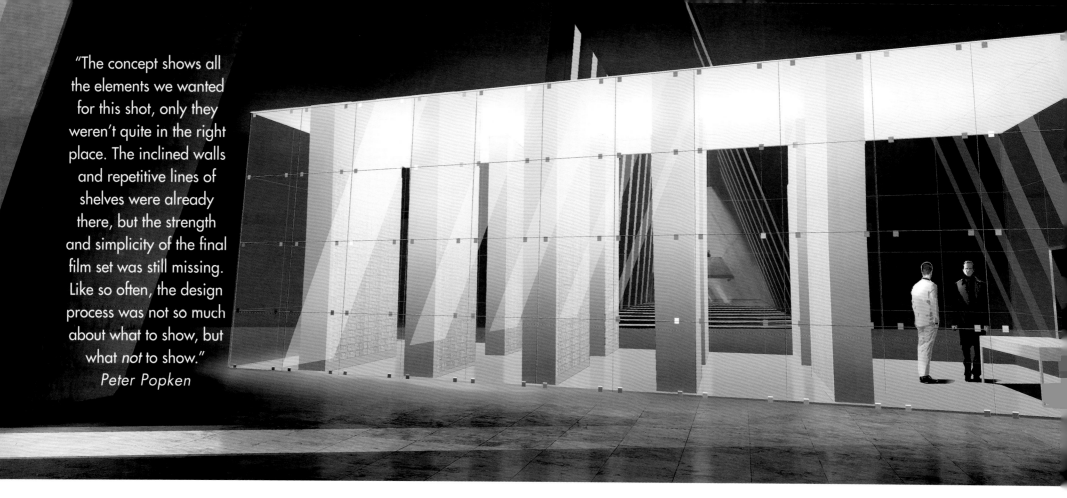

"The concept shows all the elements we wanted for this shot, only they weren't quite in the right place. The inclined walls and repetitive lines of shelves were already there, but the strength and simplicity of the final film set was still missing. Like so often, the design process was not so much about what to show, but what *not* to show."
Peter Popken

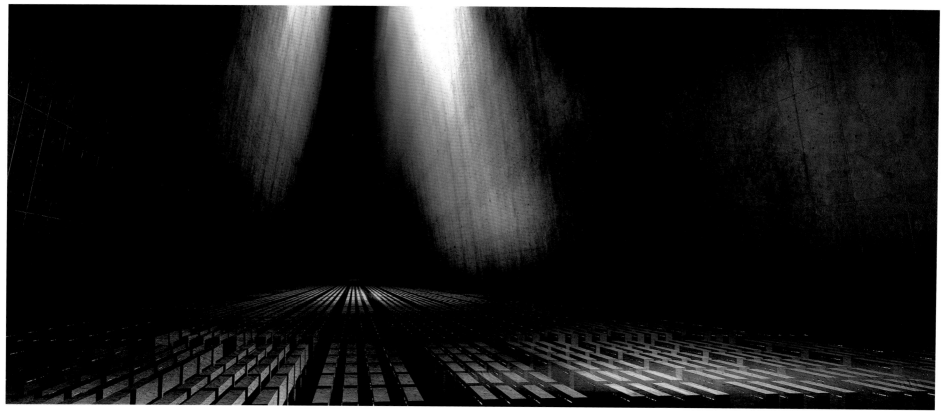

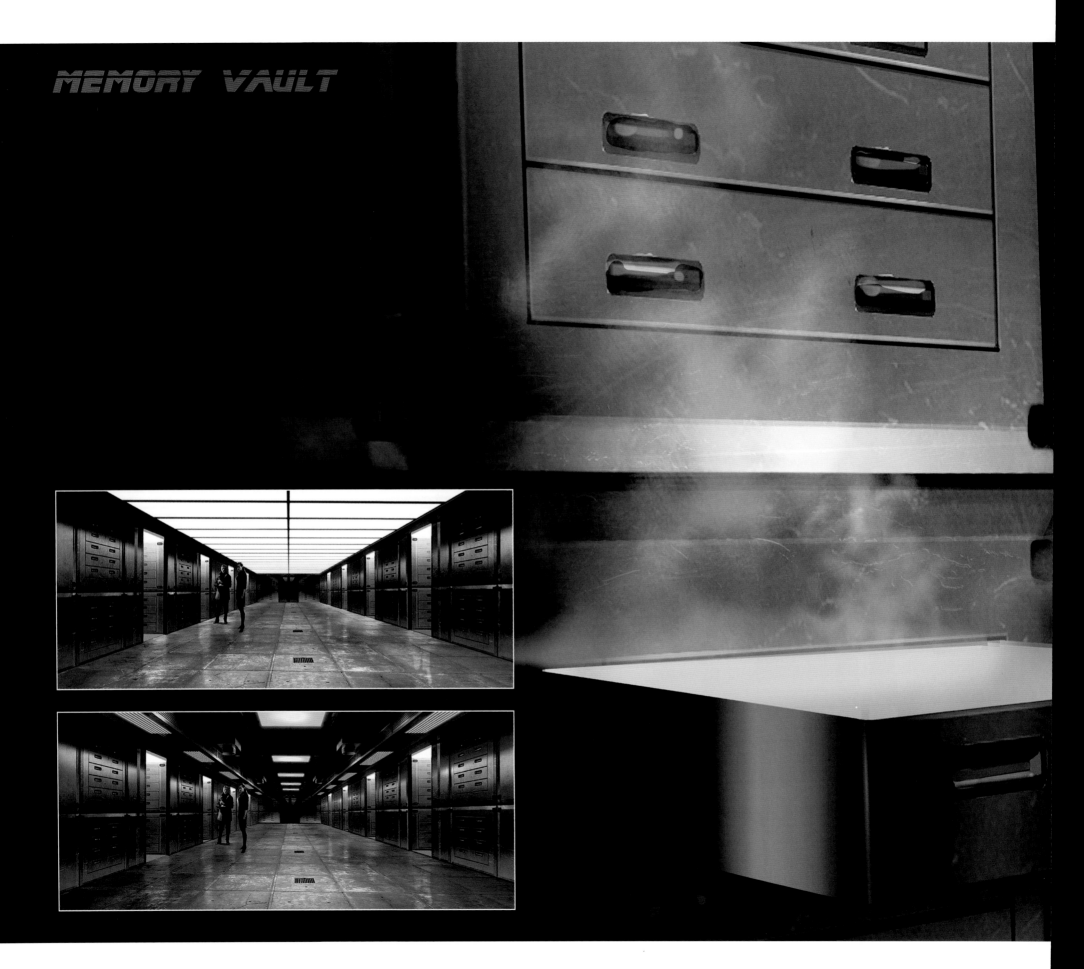

MEMORY VAULT

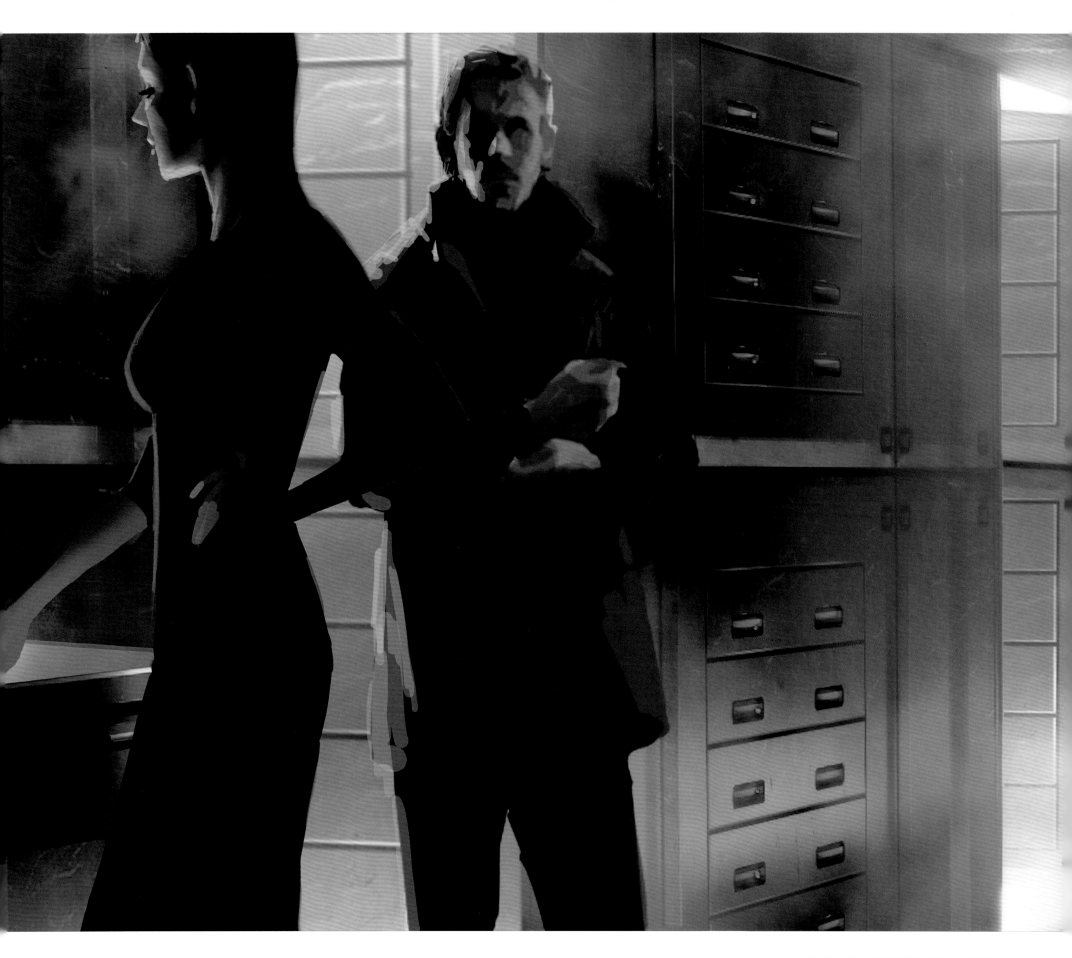

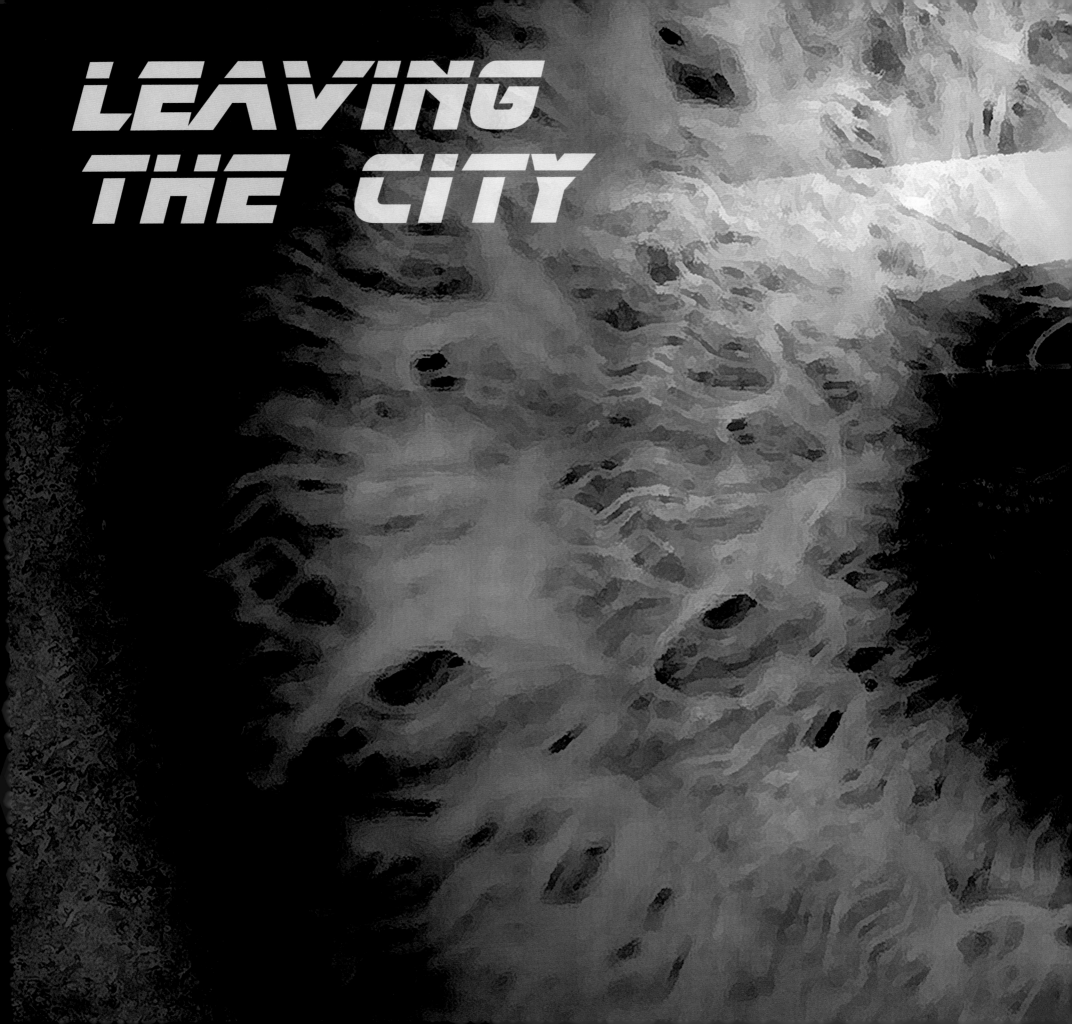

"The farmland opening of *Blade Runner 2049* is completely different from the original movie. It had to be. This is the first shot that takes you into the world. It had to have a particular feel and history to it. We had to find the right balance between being frightening and being reminiscent of '70s sci-fi. Playing around with those levels were fun challenges."
Sam Hudecki

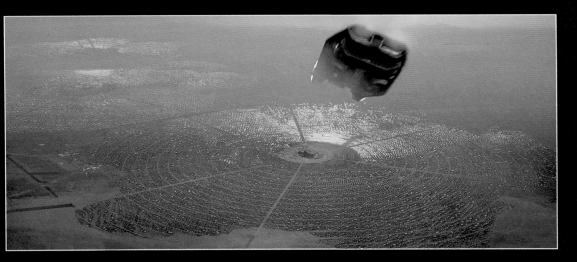

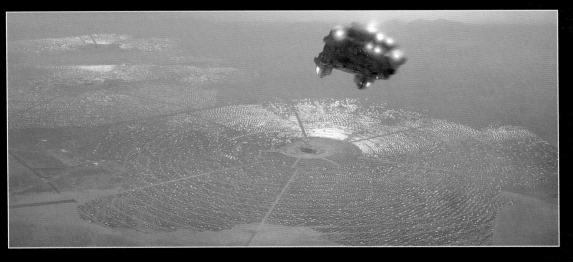

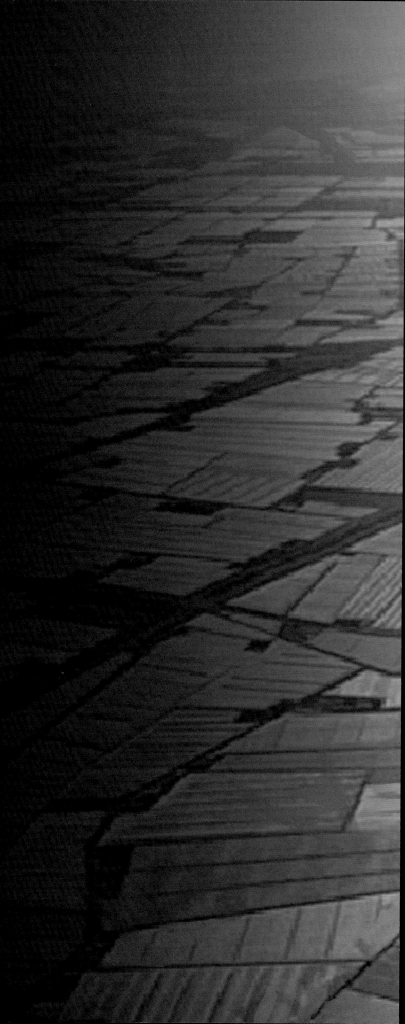

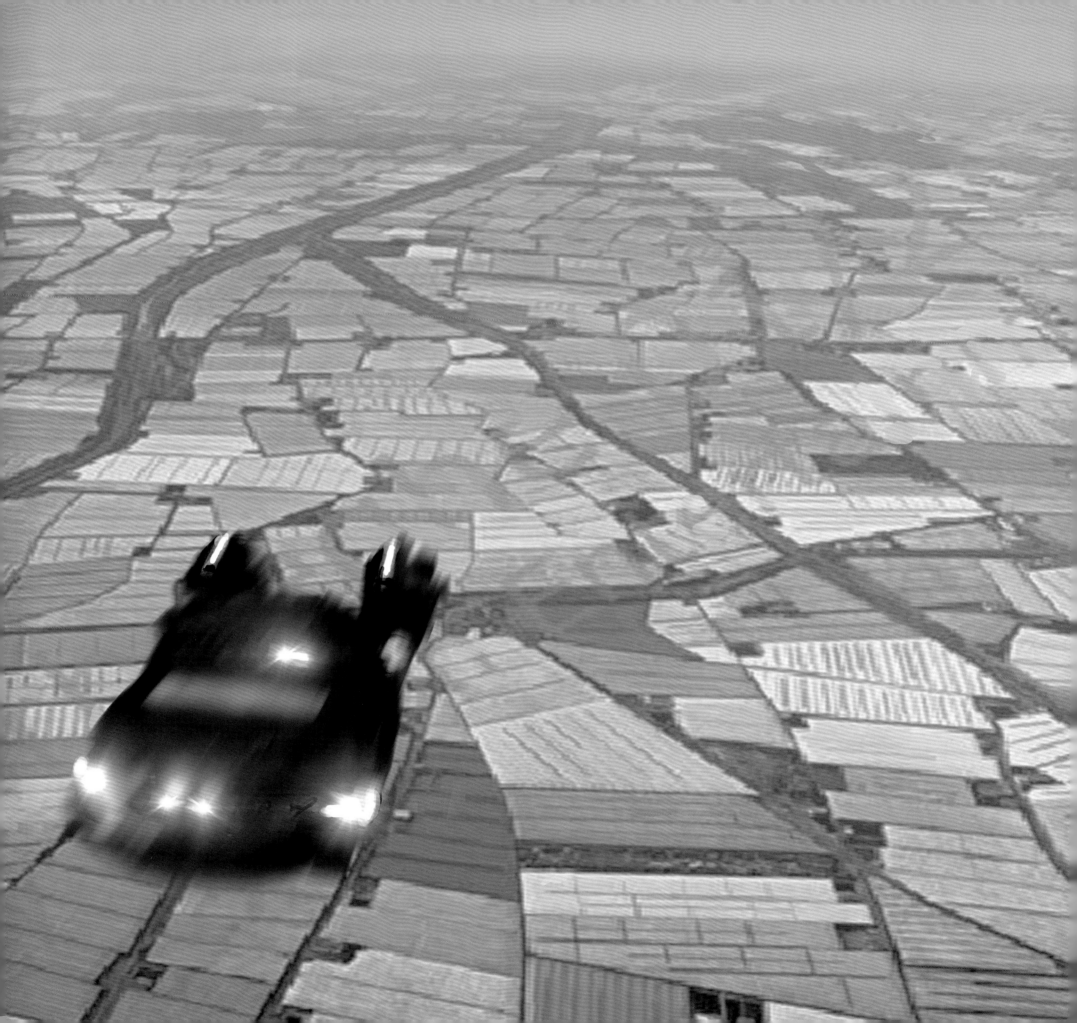

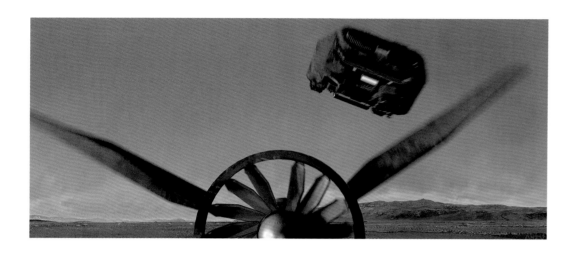

"This was to be K's first view from his spinner of Sapper's farm as it appeared through the dense haze. This angle shows the aging farm with multiple greenhouses in neglect."
▼ *Scott Lukowski*

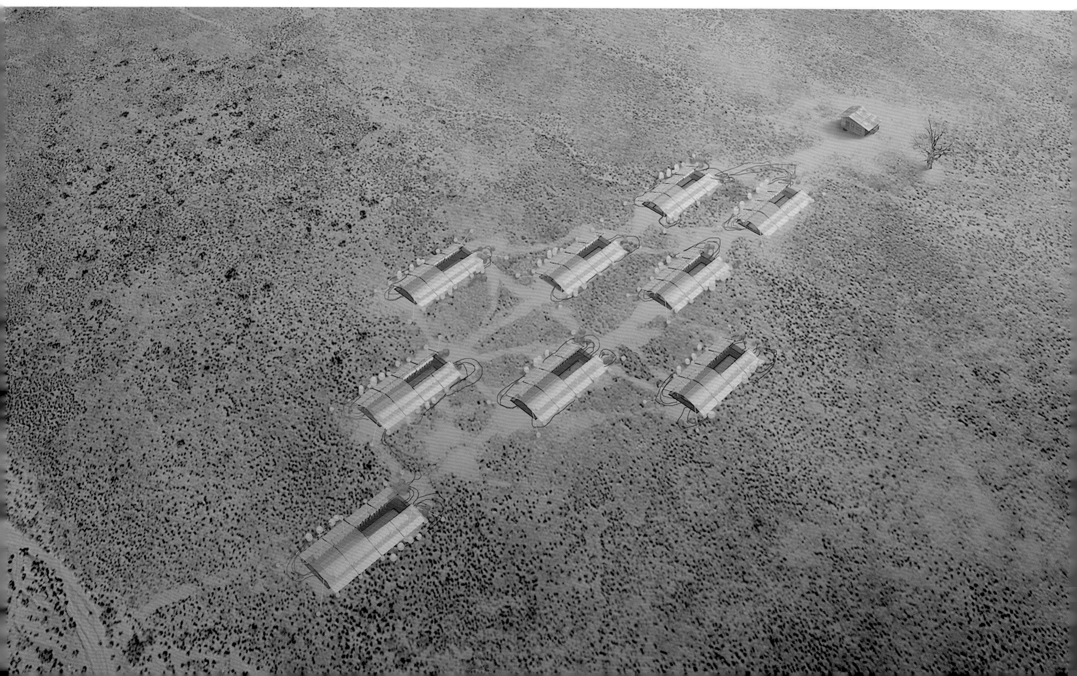

SAPPER MORTON'S FARM

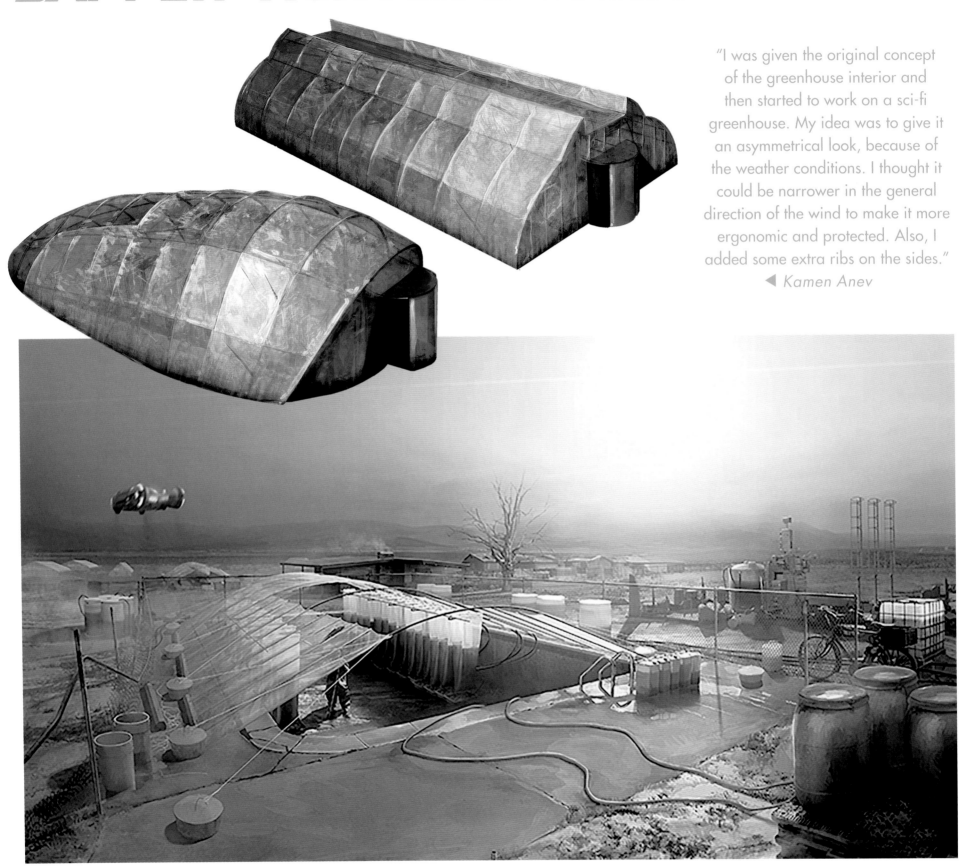

"I was given the original concept of the greenhouse interior and then started to work on a sci-fi greenhouse. My idea was to give it an asymmetrical look, because of the weather conditions. I thought it could be narrower in the general direction of the wind to make it more ergonomic and protected. Also, I added some extra ribs on the sides."
◄ Kamen Anev

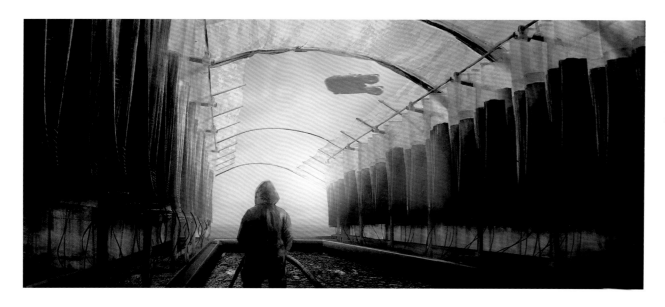

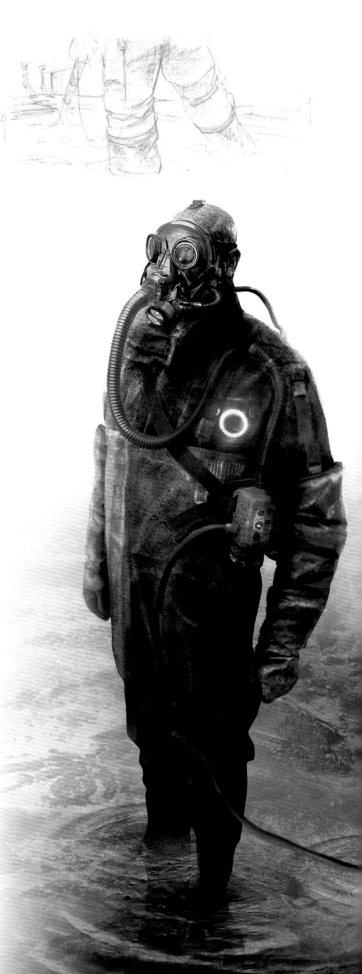

"I didn't want Sapper's farm to feel 'of our world.' He couldn't be cultivating corn. The idea of a nematode farm came from [screenwriter] Michael Green, and we wanted to find a way to make that a really compelling image. We found this wonderful photo of an algae bioreactor in a long plastic bag. I made a sketch that showed Sapper standing in a pool surrounded by these green bags and K's spinner flying overhead. That sketch turned into a beautiful illustration by Scott Lukowski, which was then very faithfully replicated in the final film."

▼ *Aaron Haye*

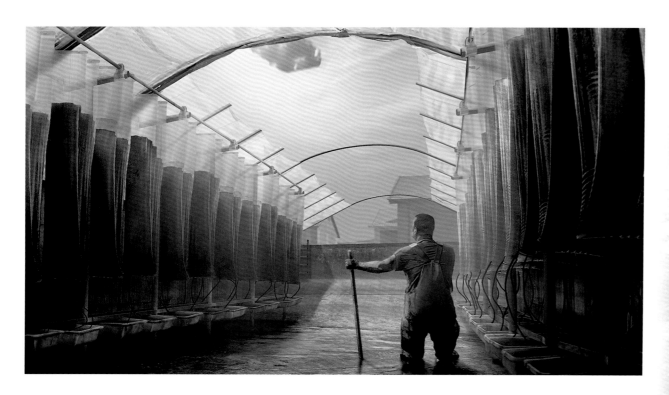

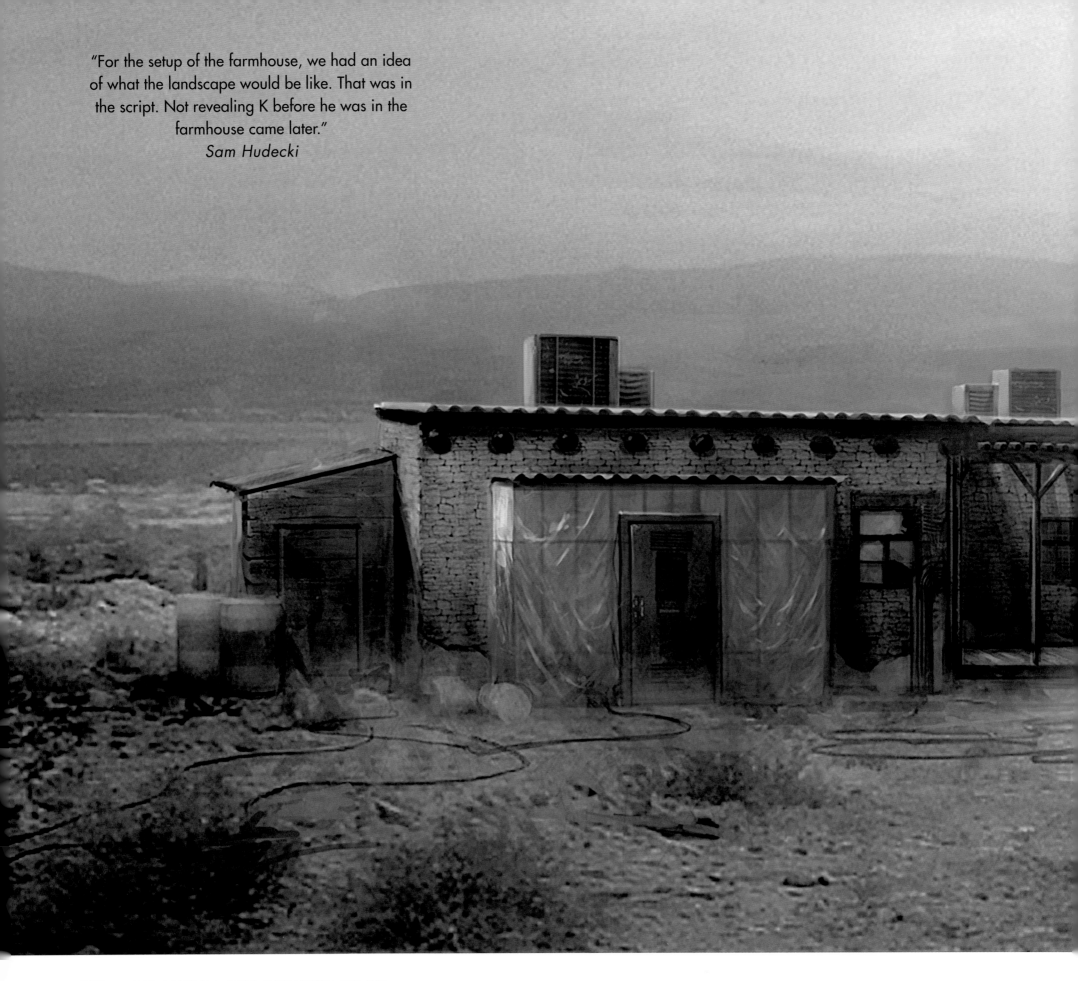

"For the setup of the farmhouse, we had an idea of what the landscape would be like. That was in the script. Not revealing K before he was in the farmhouse came later."
Sam Hudecki

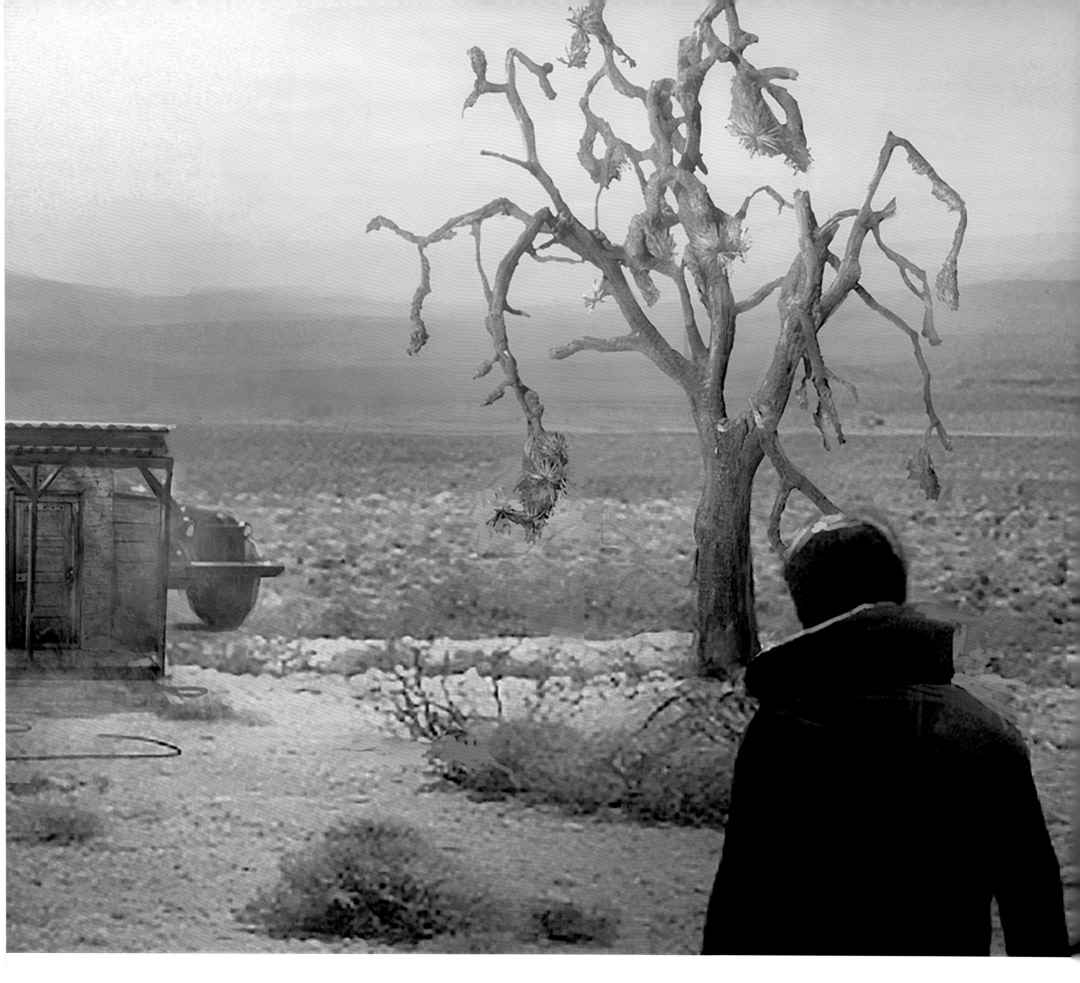

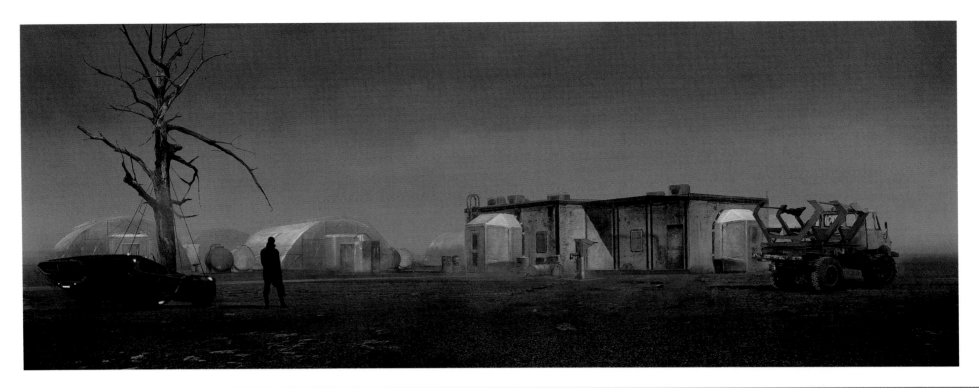

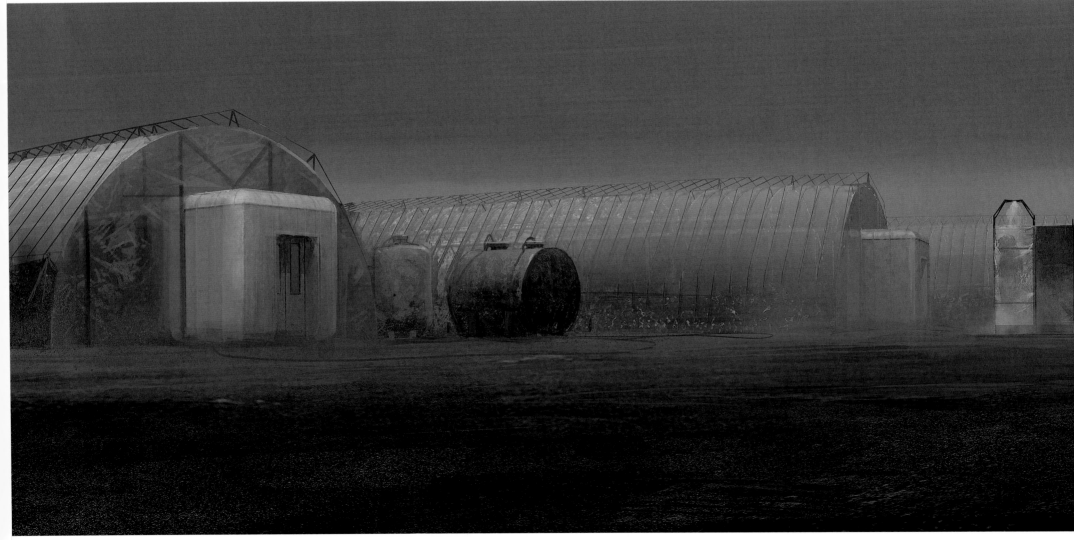

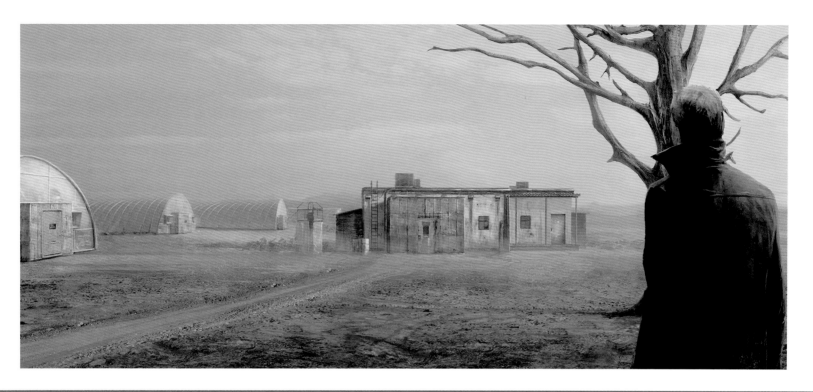

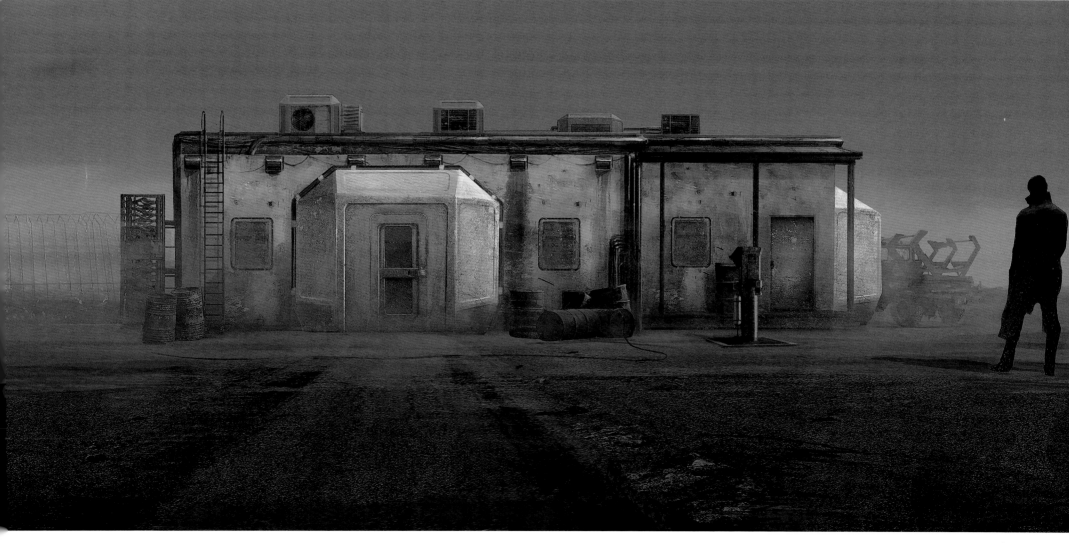

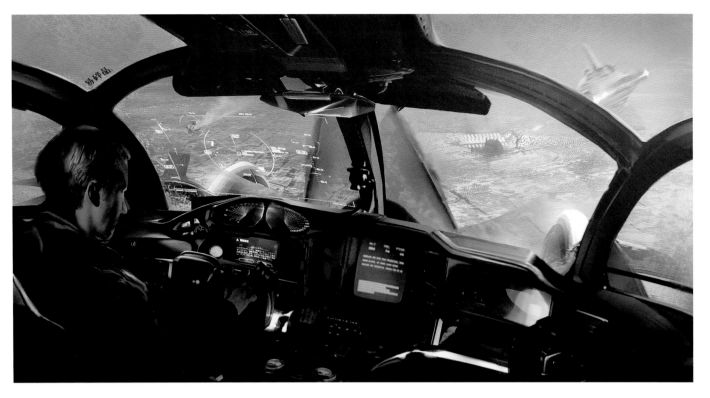

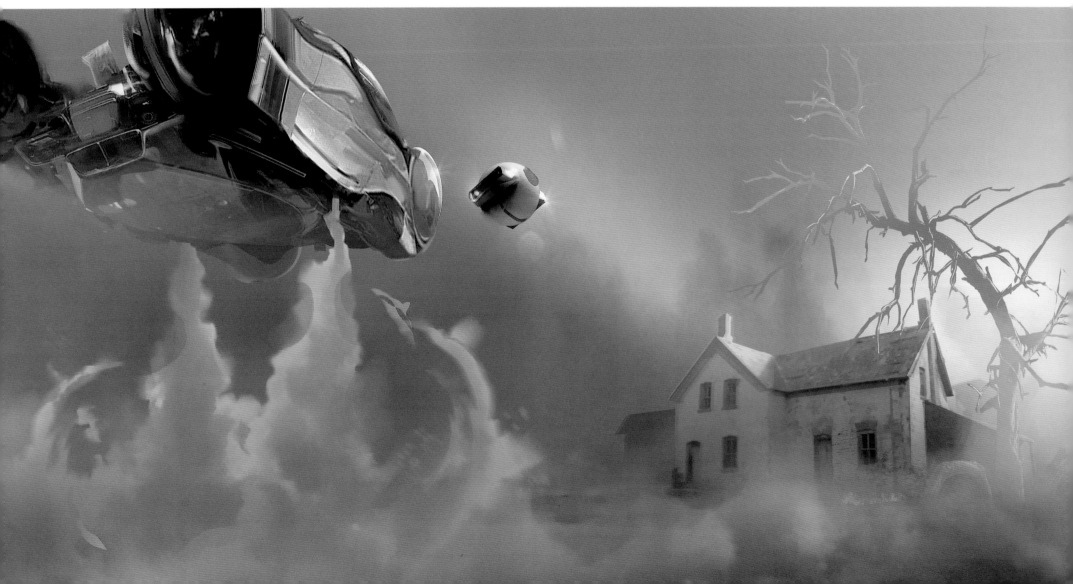

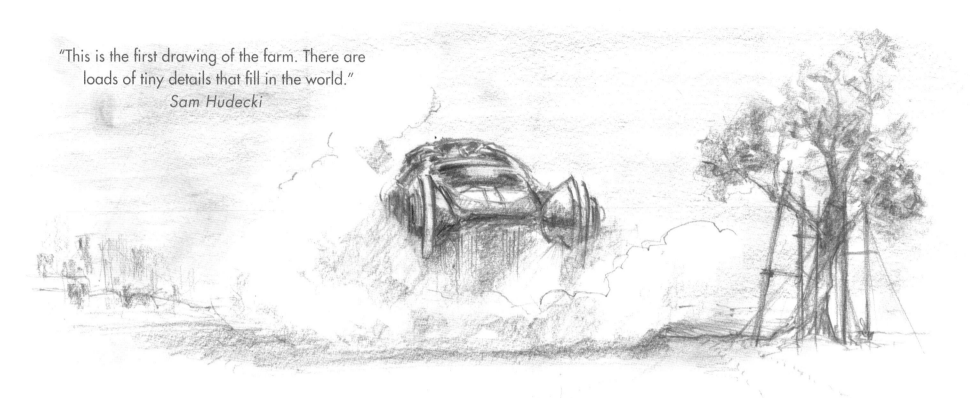

"This is the first drawing of the farm. There are loads of tiny details that fill in the world."
Sam Hudecki

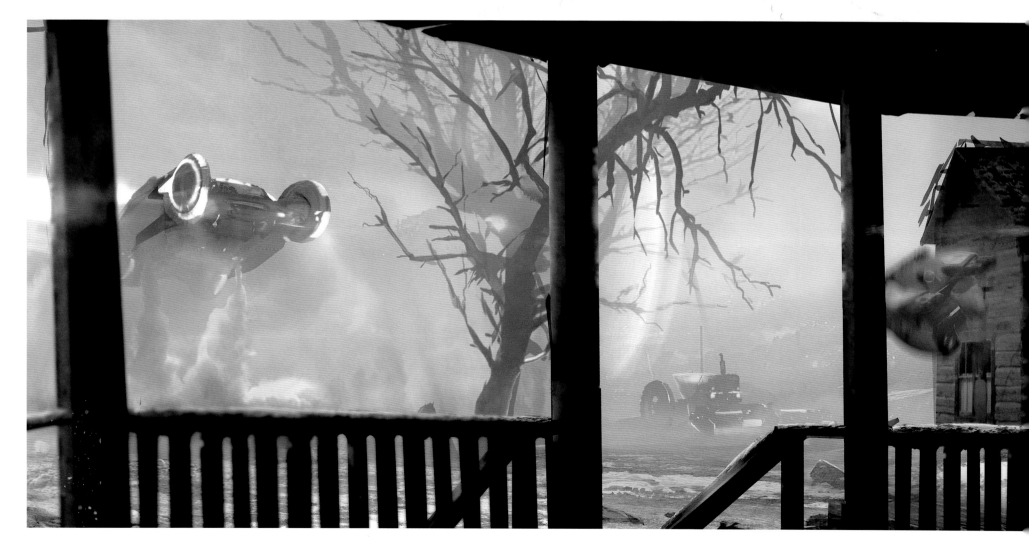

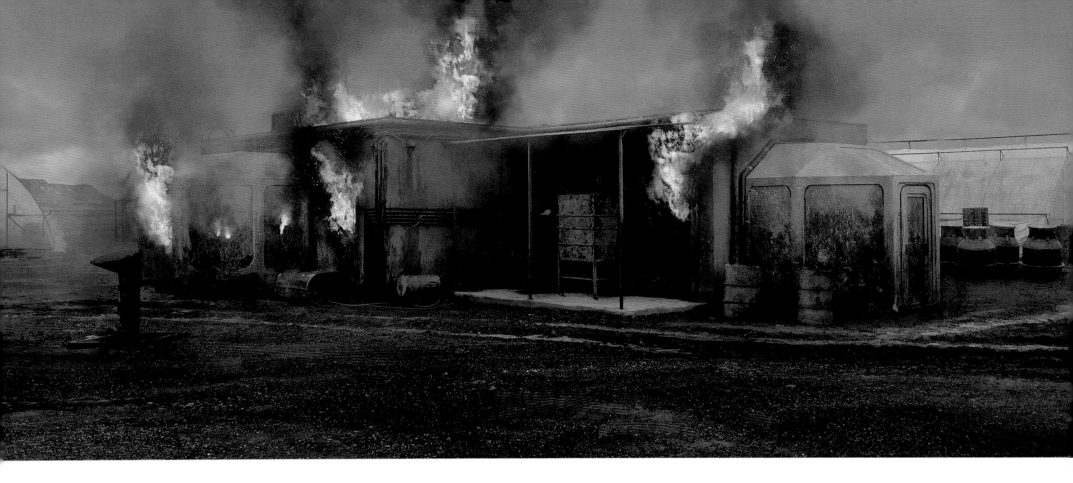

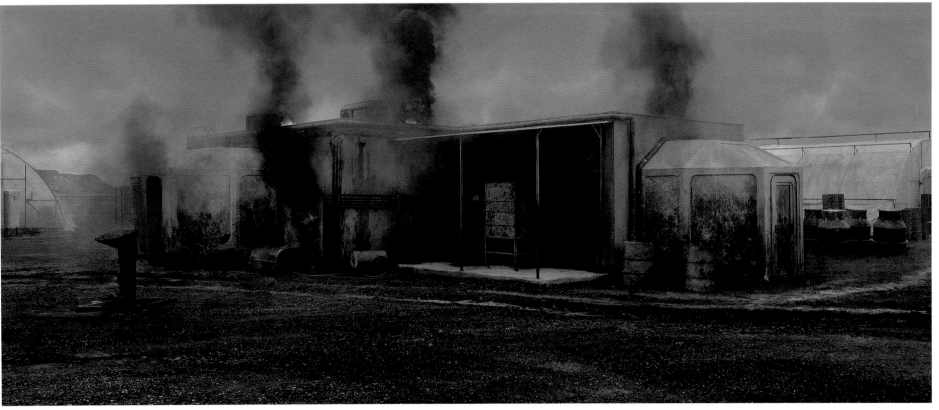

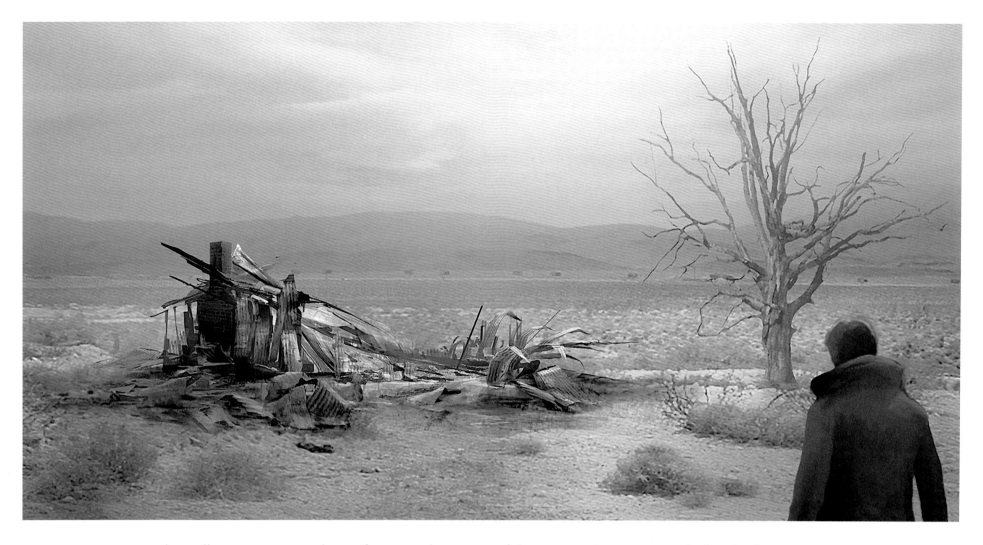

"These illustrations were drawn for an early version of the script [where K arrived after the farmhouse had burned down]. It was tricky to find a way to burn a brick building, but I had fun with the yellow plastic parts. What was important in the scene was to keep the piano relatively intact."
▼ *Kamen Anev*

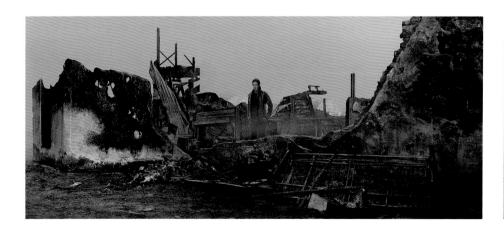 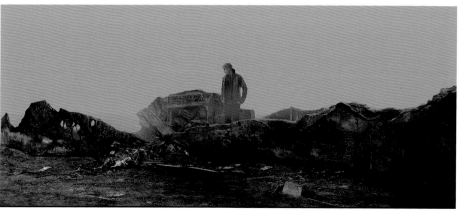

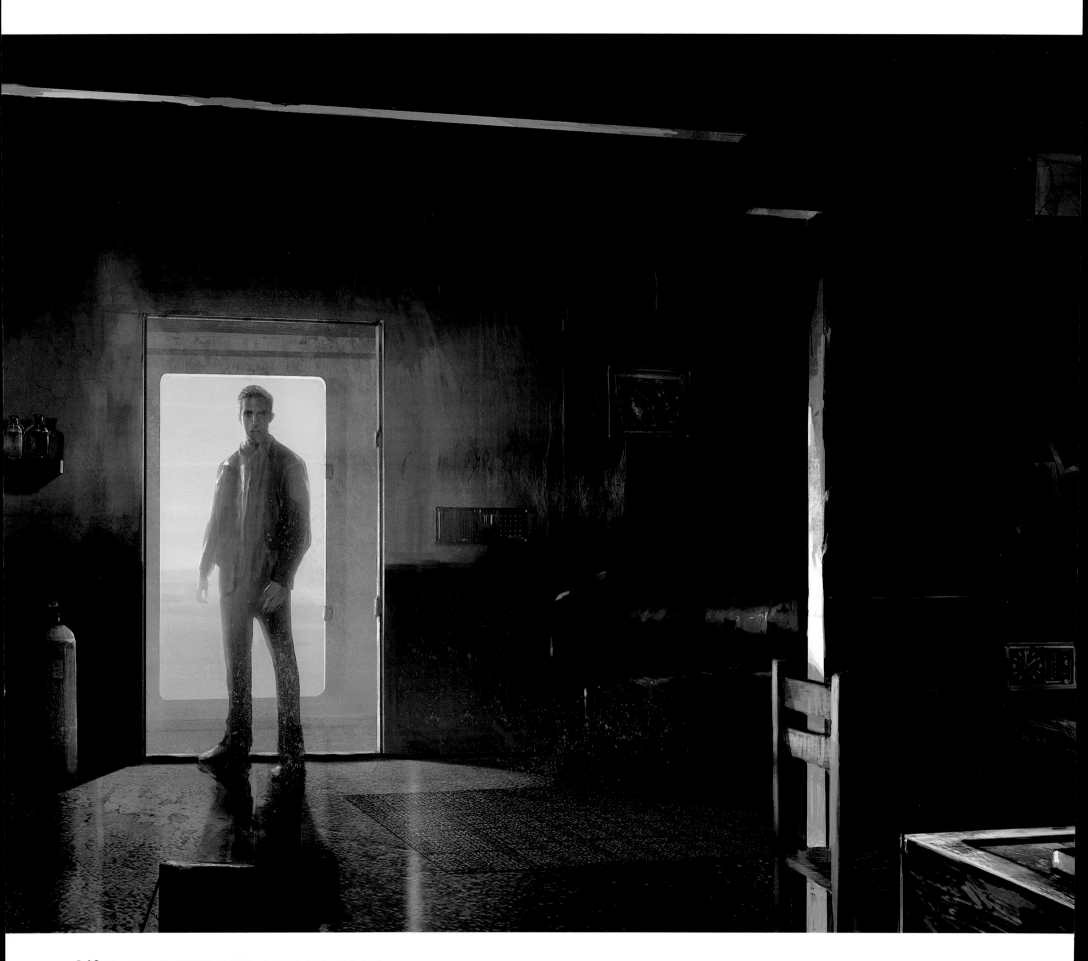

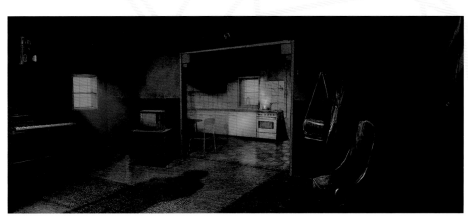

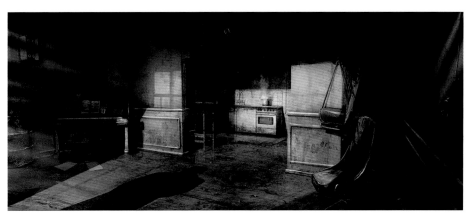

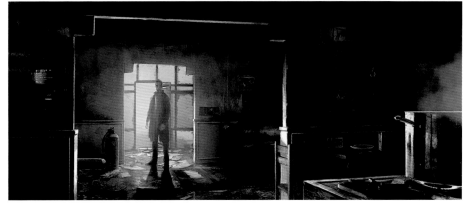

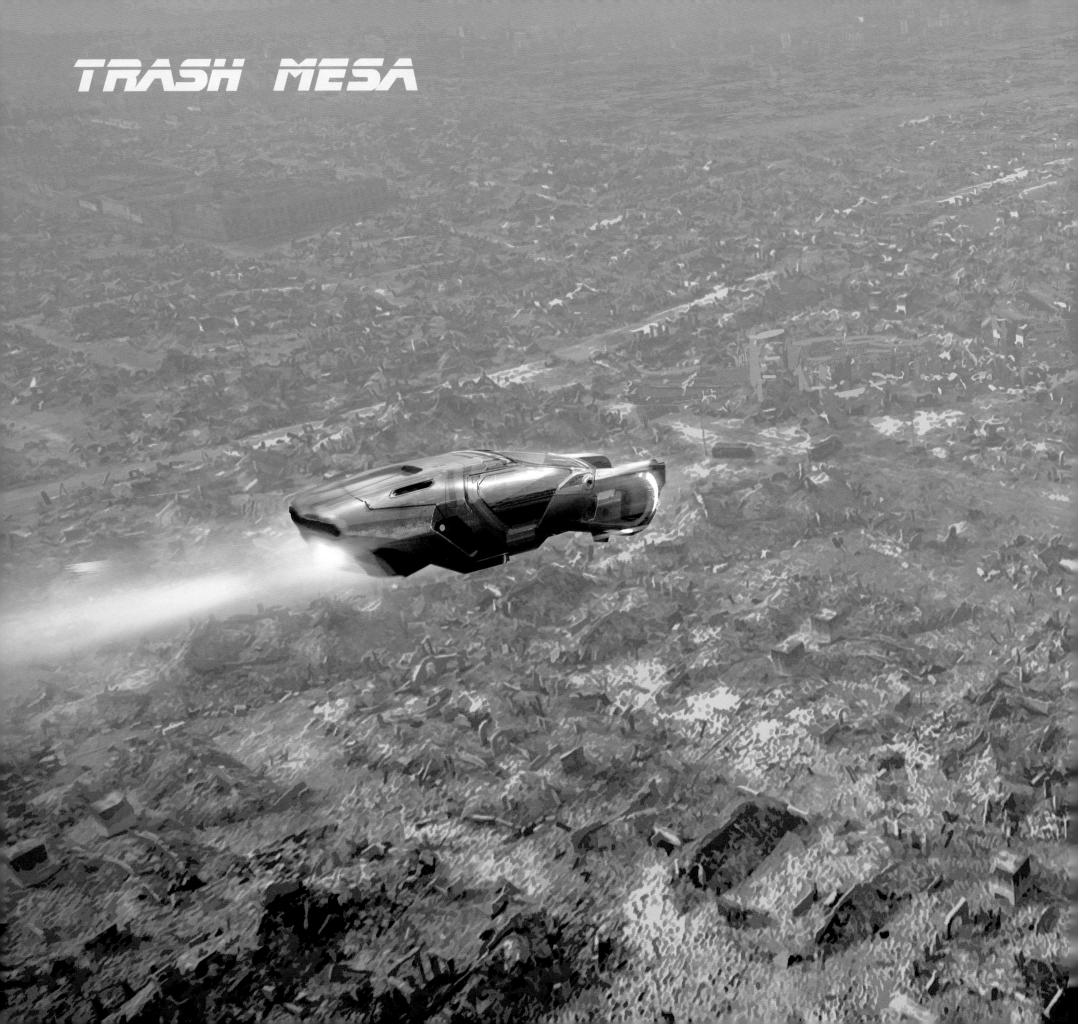

TRASH MESA

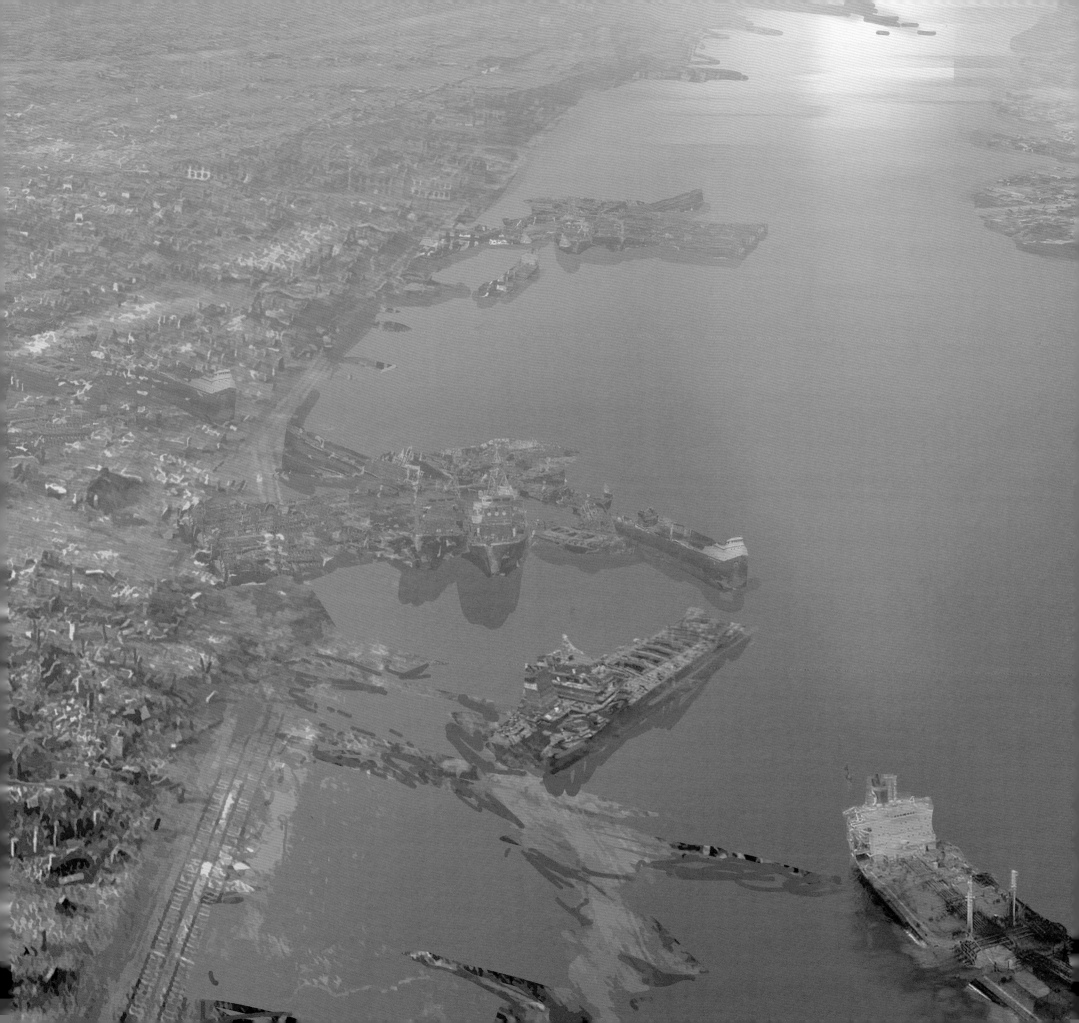

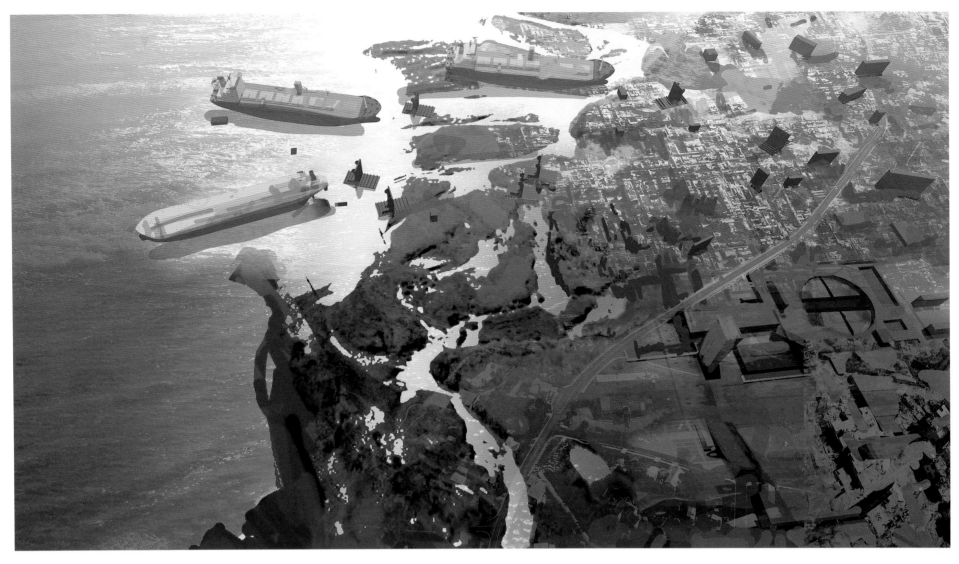

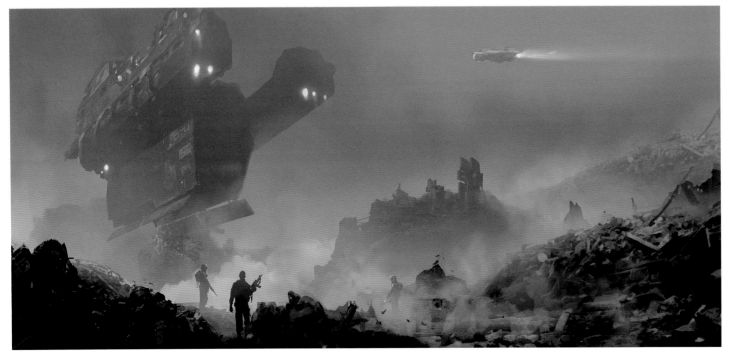

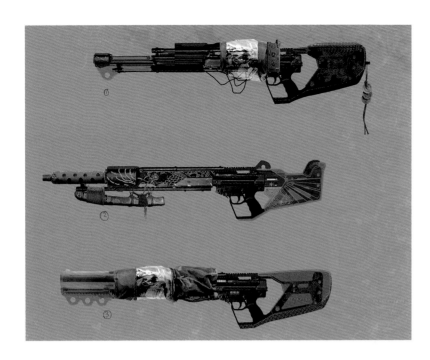

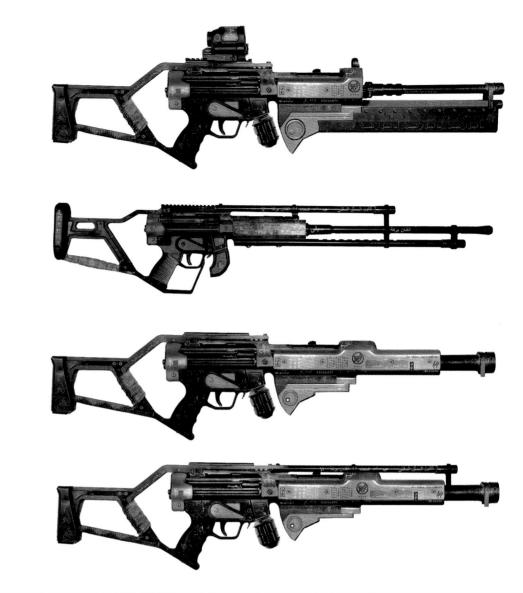

"The main idea [for the trash mesa] was to have a complex of compressed trash cubes that would be built up into a city of trash. I referenced the usual trash and scrap metal, but in the end I thought, *Why wouldn't they compact the trash in cubes and build whatever they wanted from those cubes? It would be like a trash city you could live in.* [To me] it just didn't seem efficient to have trash just laying around."
▼ *Emmanuel Shiu*

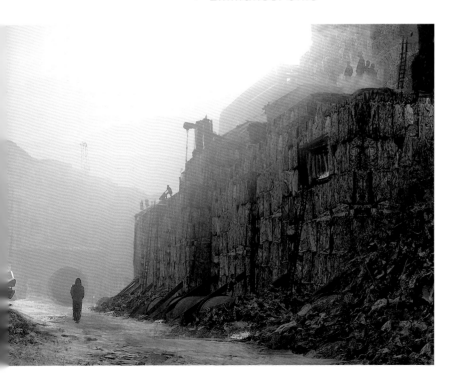

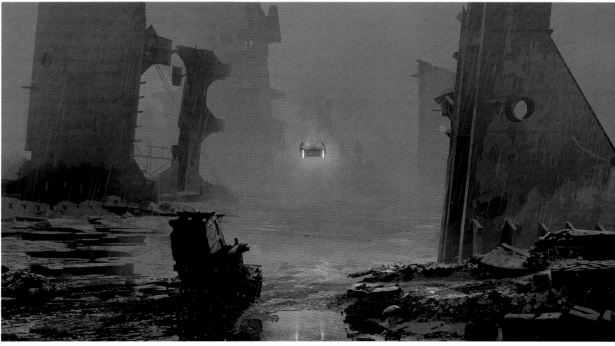

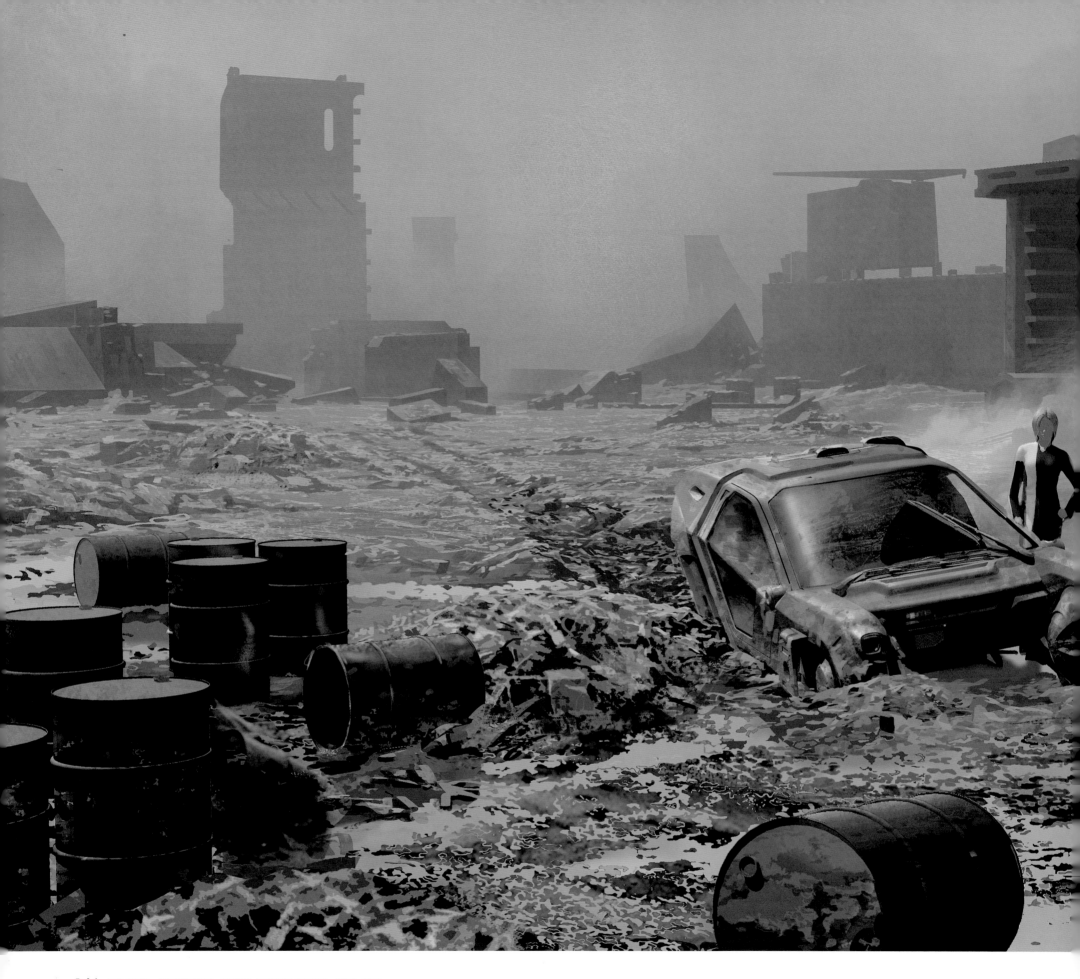

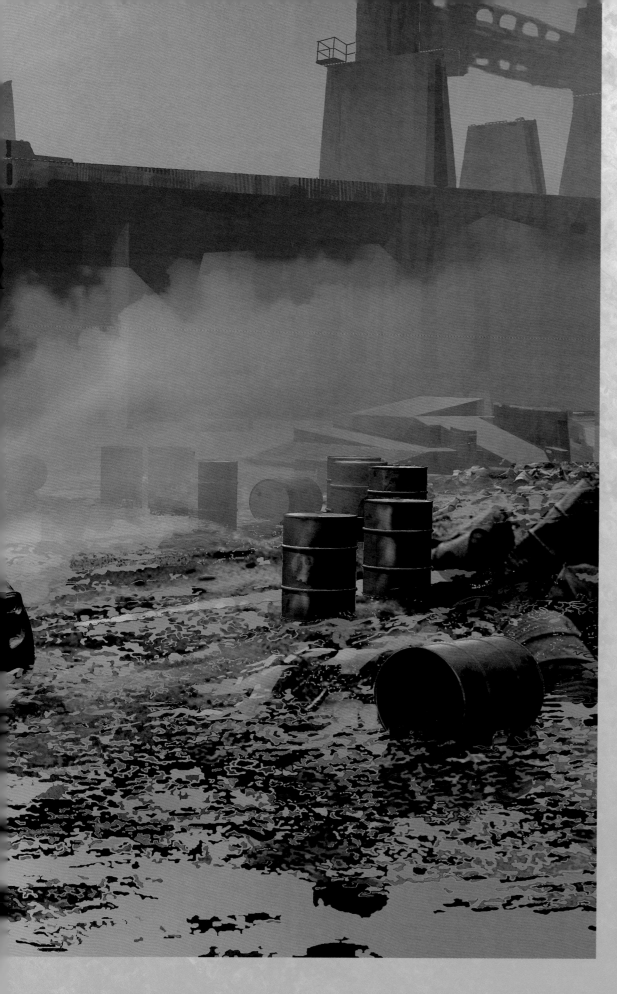

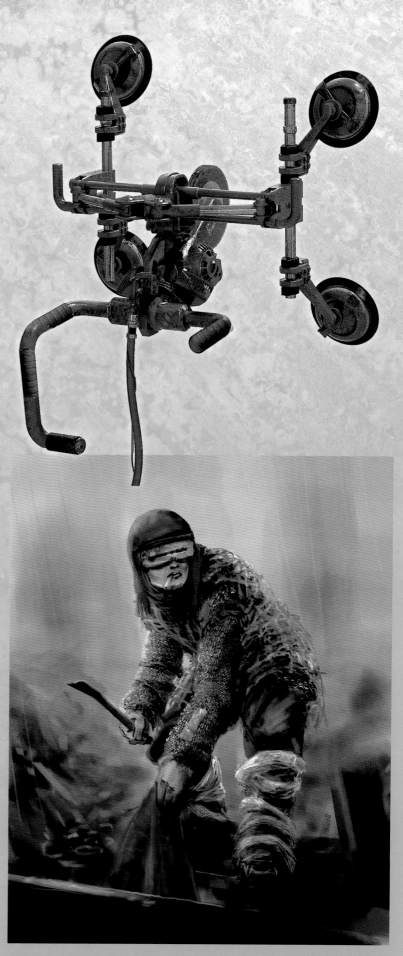

ORPHANAGE

"That was our first pass at the orphanage, with the idea of it being an overturned satellite dish. Some of this didn't change at all."
▼ *Sam Hudecki*

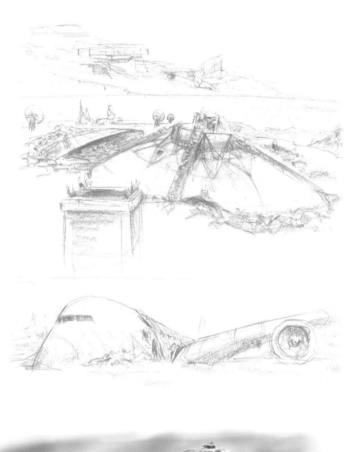

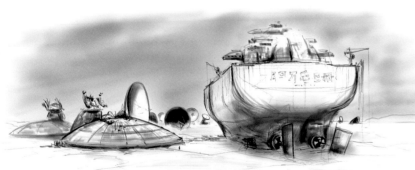

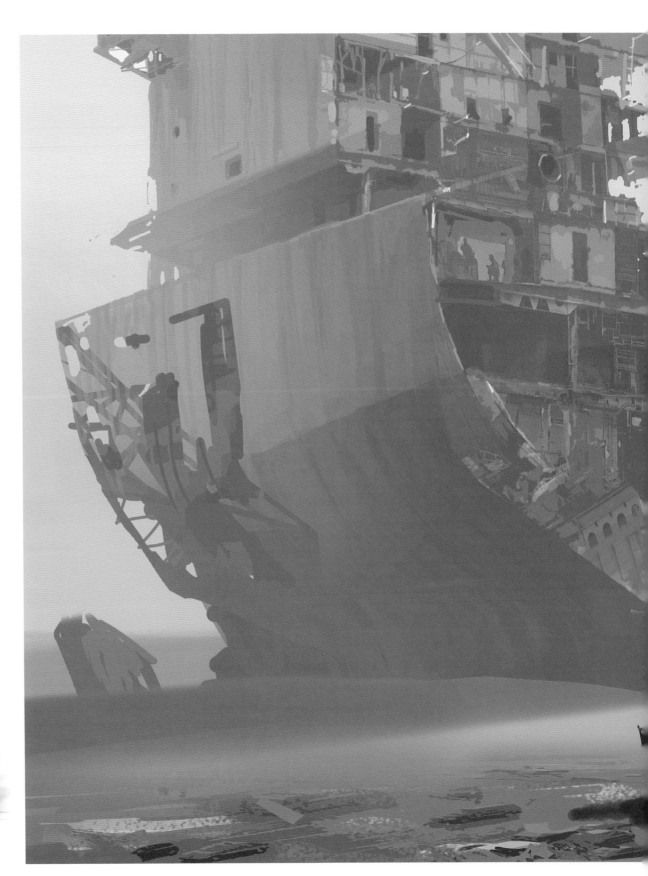

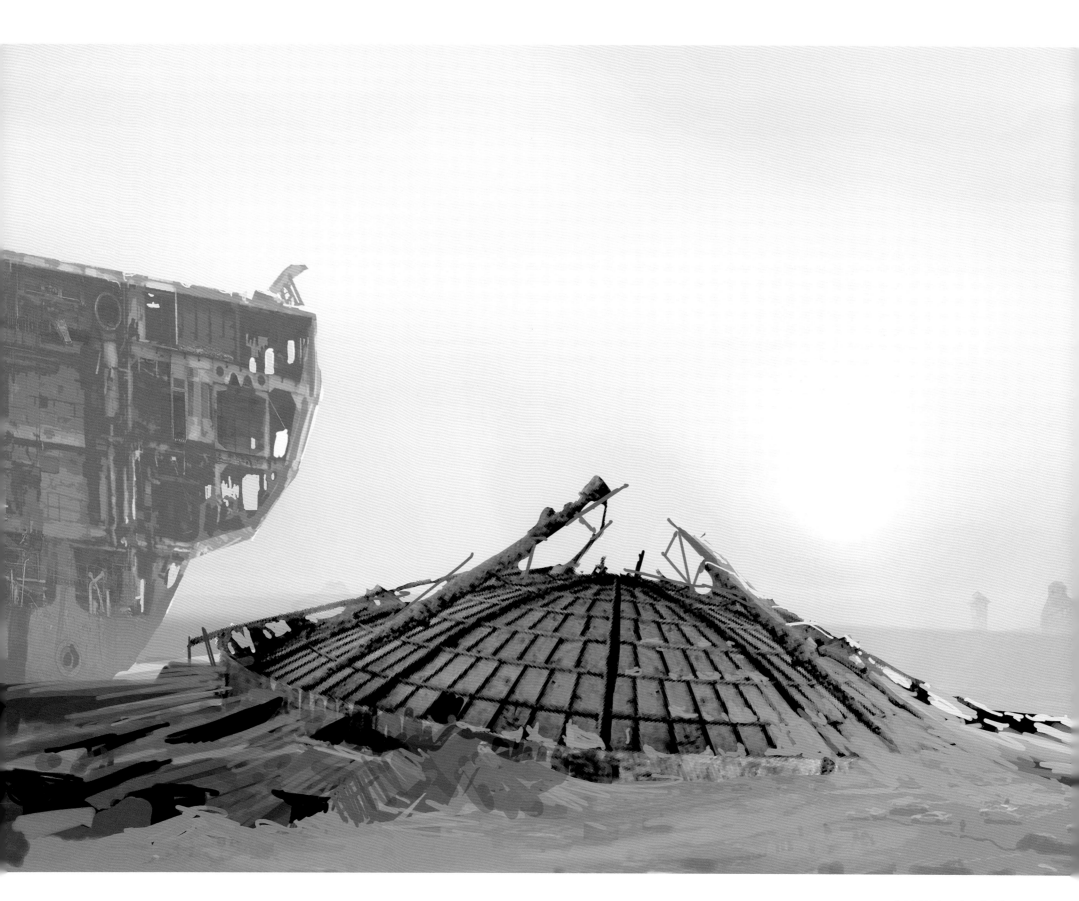

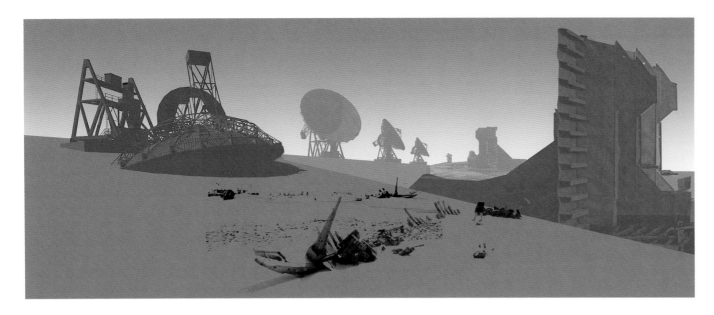
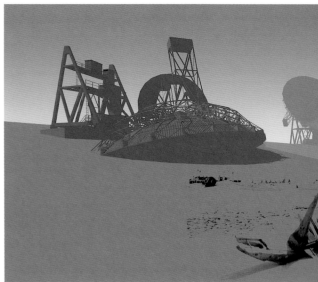

"These sketches were exploring more stylized and abstract set designs. Genres like film noir and the German Expressionists had been a source of inspiration. The scrapyard in the trash mesa sequence offered a variety of shapes and interesting angles for the cinematography."
▲ *Peter Popken*

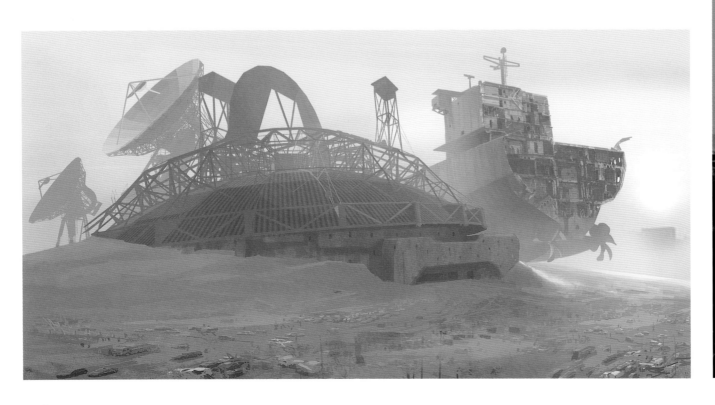
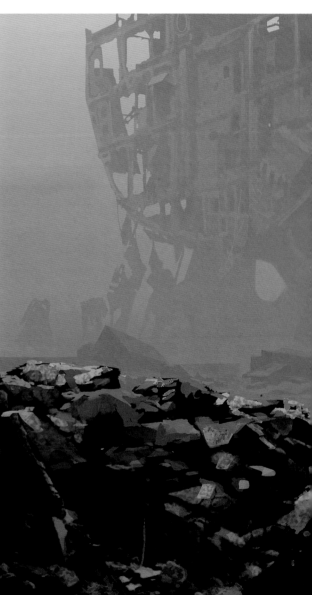

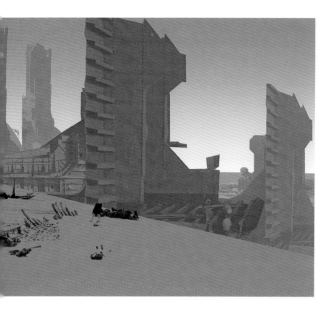
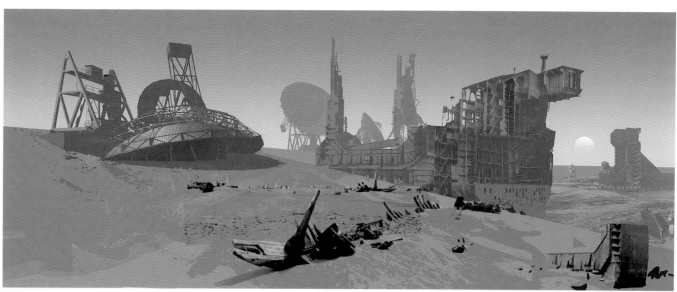
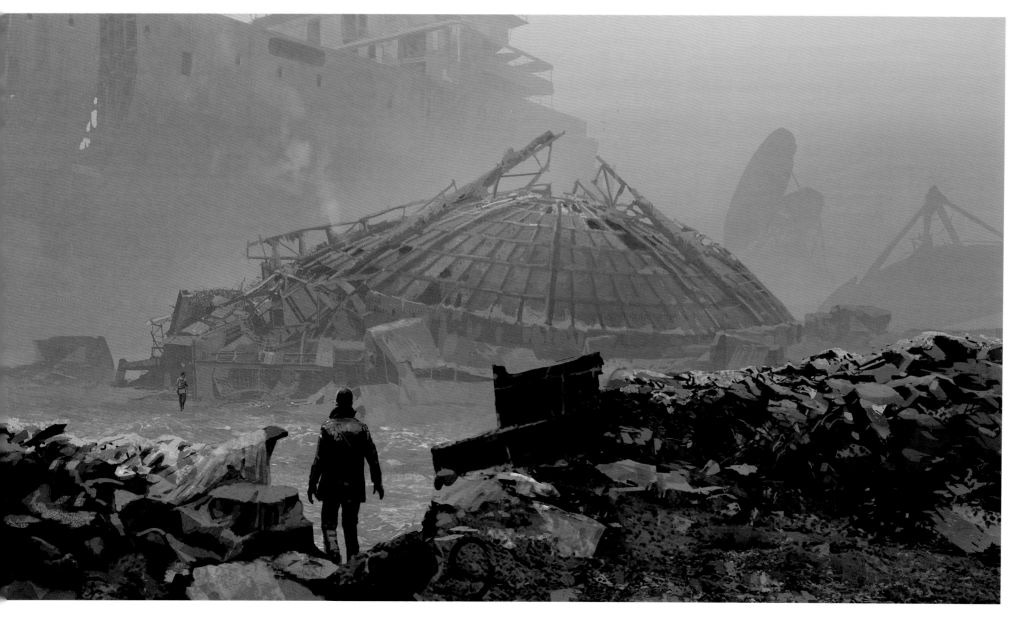

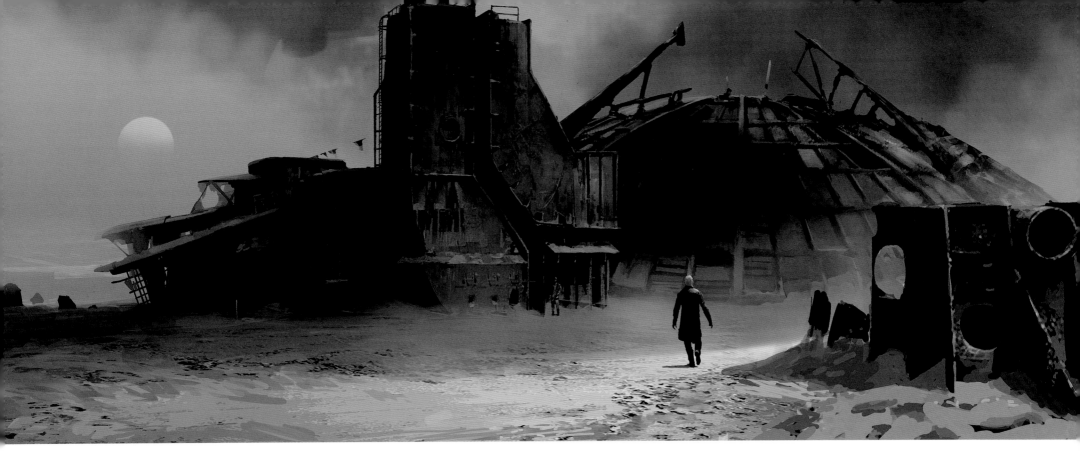

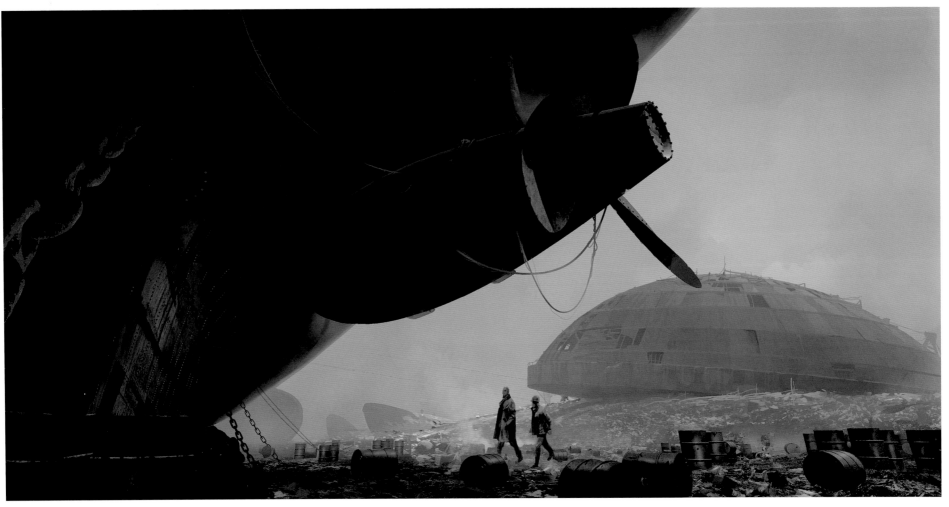

VESTIBULE AND SORTING ROOM

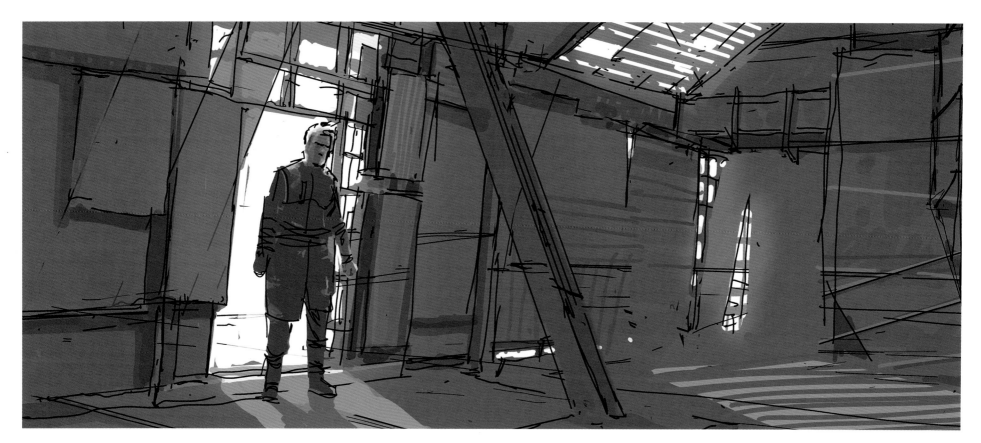

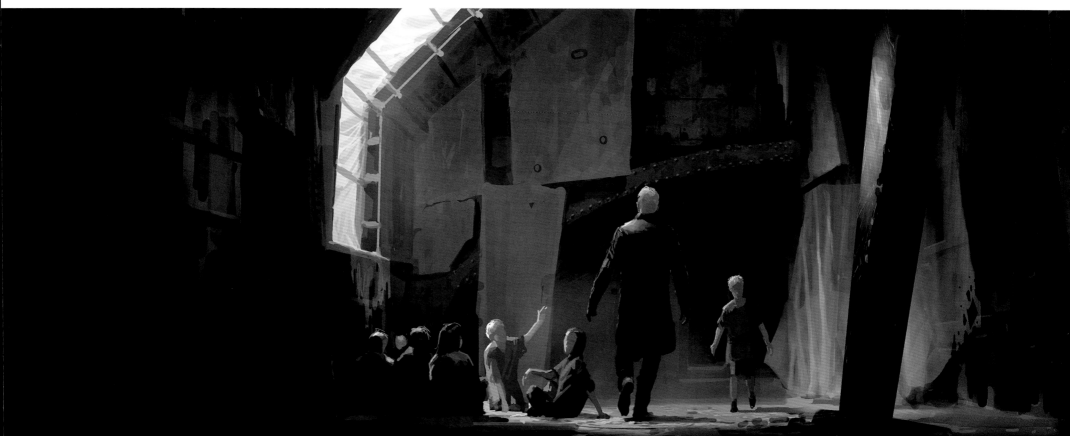

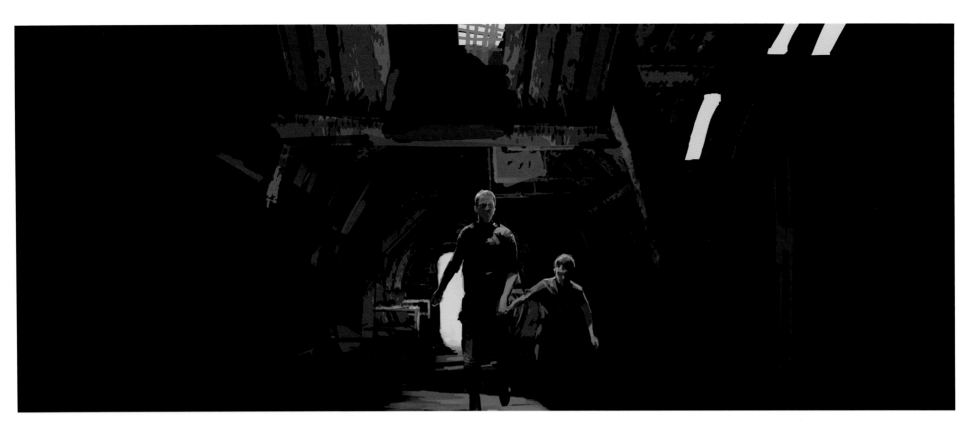

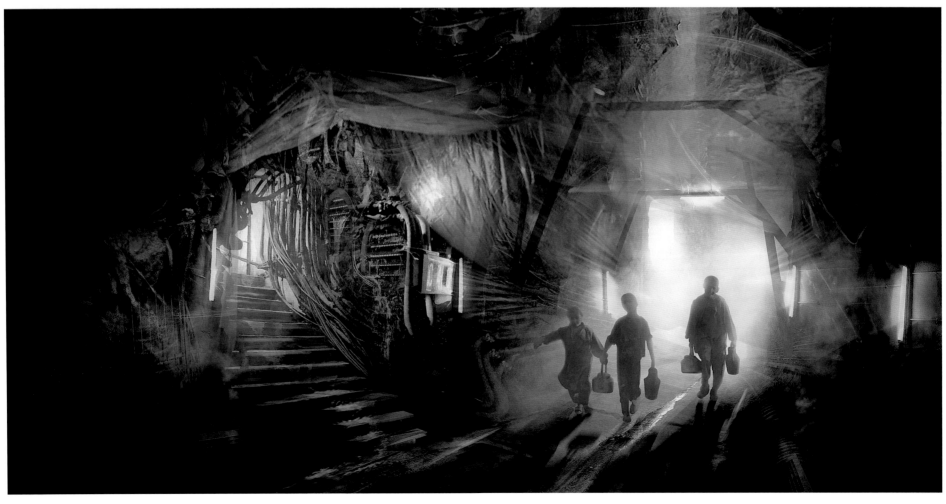

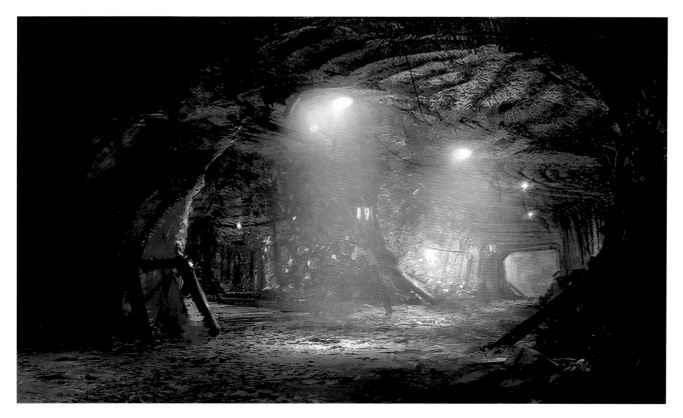

"Aaron Haye had asked me to come up with a cave and tunnel structure that had to feel claustrophobic and dirty. I researched salt mines and mines in general and incorporated a lot of that into the caves and tunnels, especially in the textural quality and scale. I made the tunnels cramped and dingy, and tried to open it up to give scale to the main 'cave.'"
Emmanuel Shiu

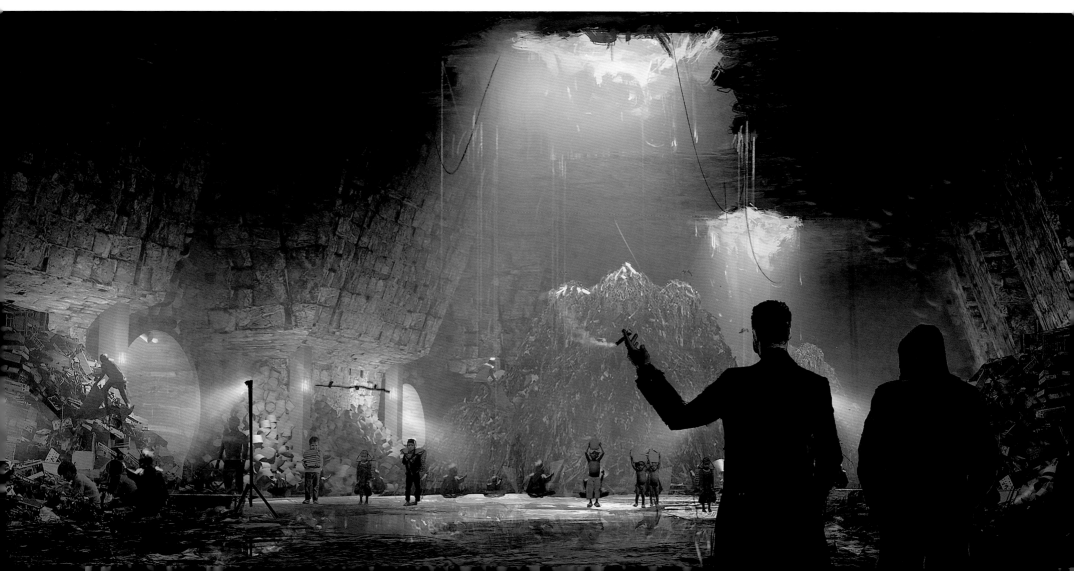

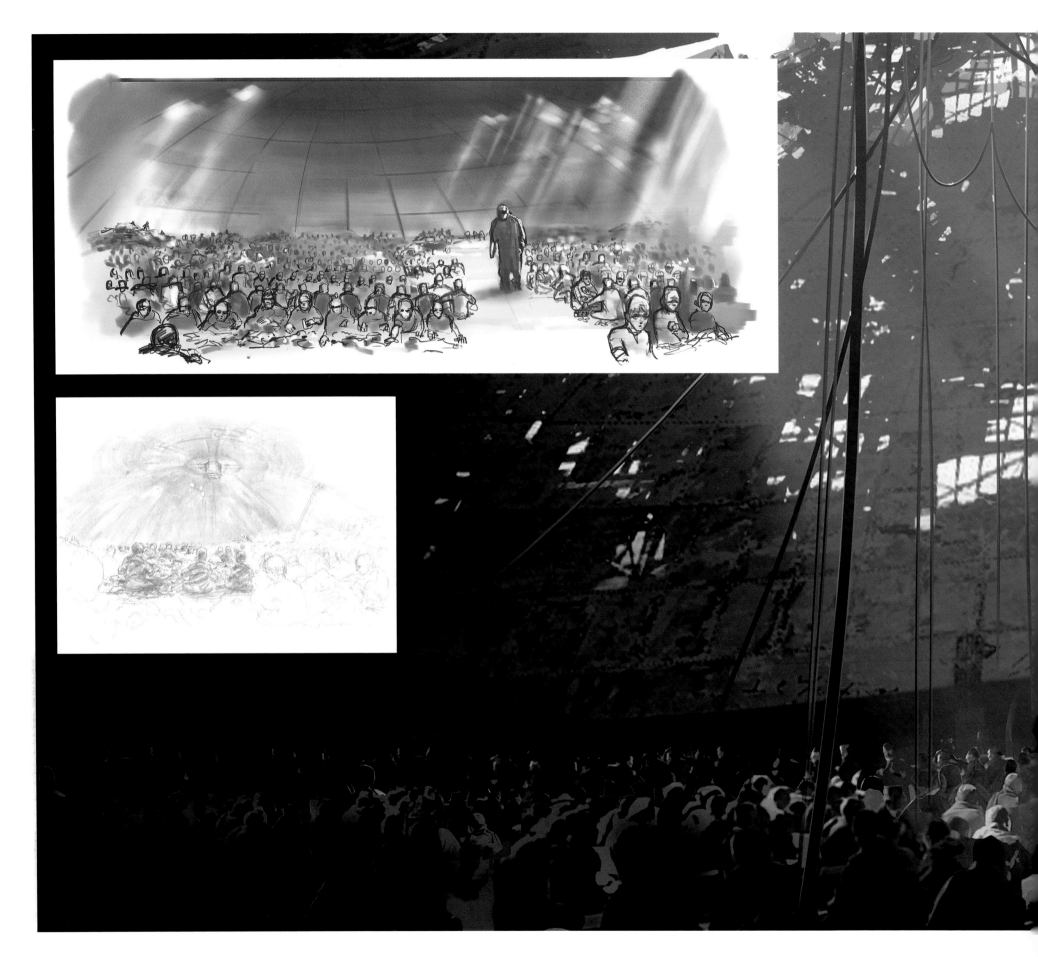

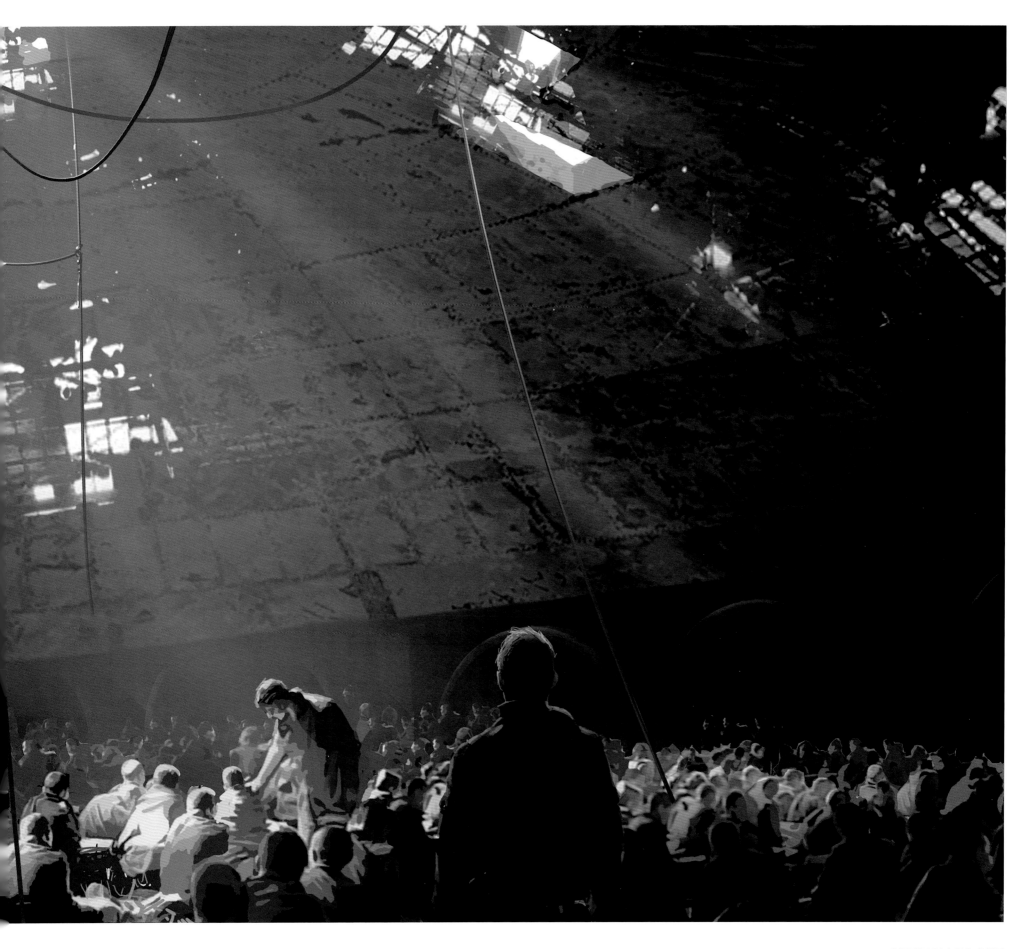

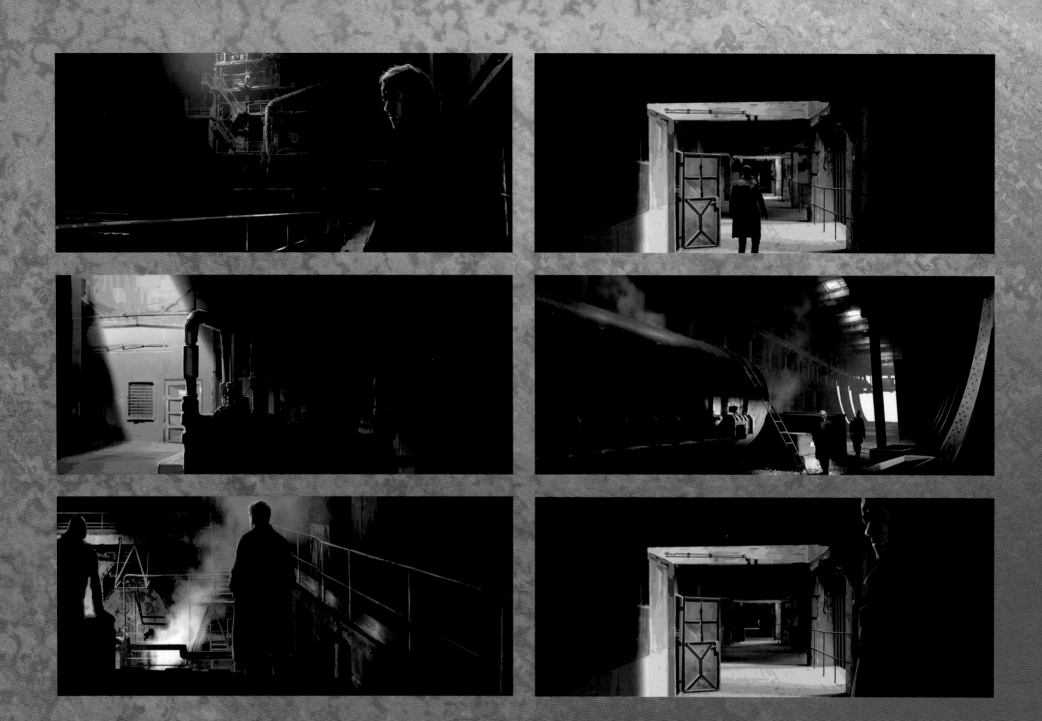

"So-called keyframe illustrations show different lighting and camera angles on an existing location. An experimental storyboard really, exploring the possibilities of how to turn a power station into the interior of a scrapped freighter ship. Some of the ideas are still visible in the furnace sequence, shot exactly on that location in Hungary. "
Peter Popken

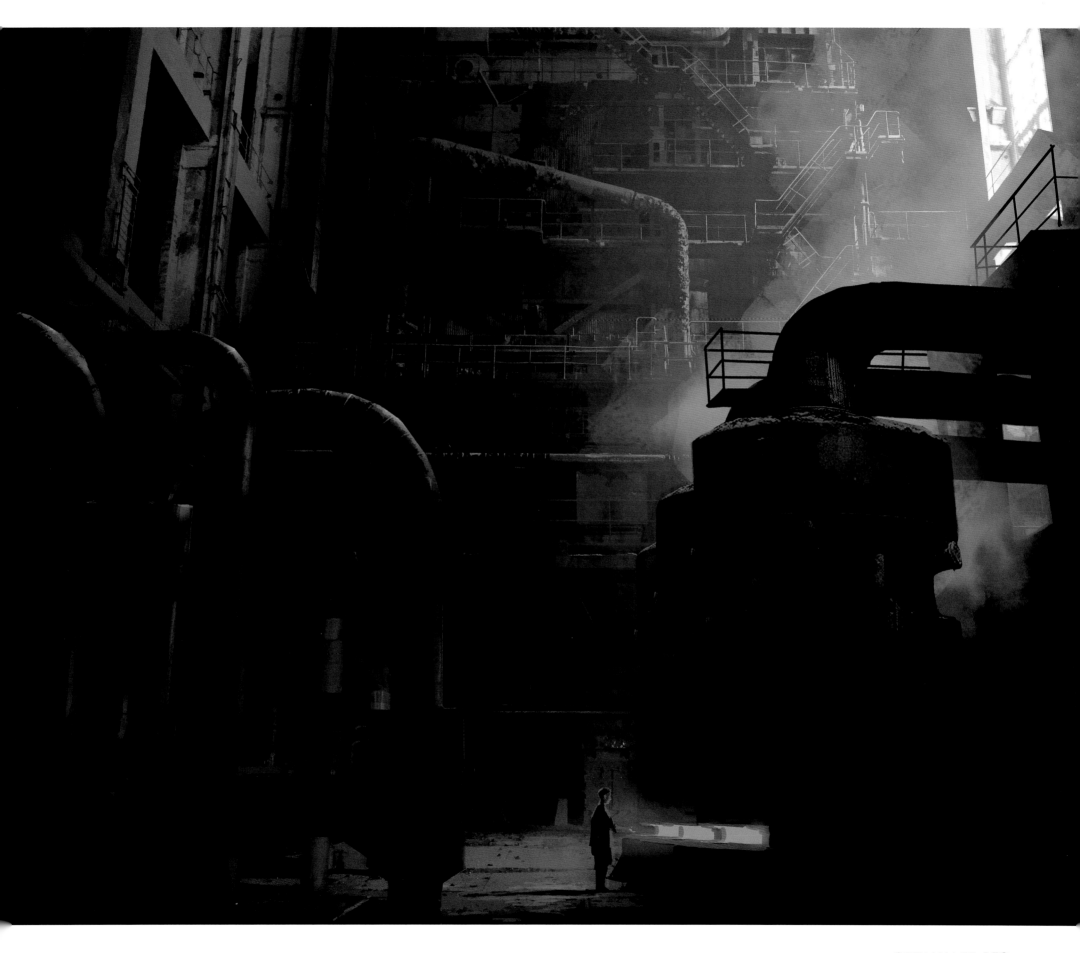

COTTON'S OFFICE

"In an early effort to design Cotton's office we attempted to make use of one very special location we discovered in Hungary, an abandoned power station, but design and lighting did not quite resonate with the sets in the preceding sequence. Then I remembered that the set was called 'captain's quarters' in an earlier version of the script. That's why I decided to bring it home to the initial idea of a cabin-type room."

Peter Popken

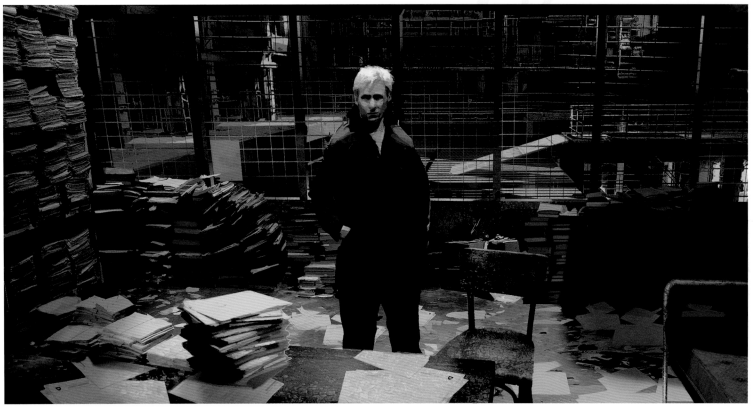

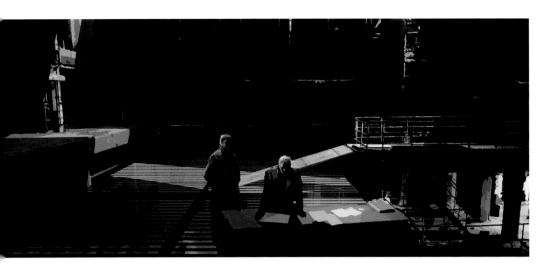
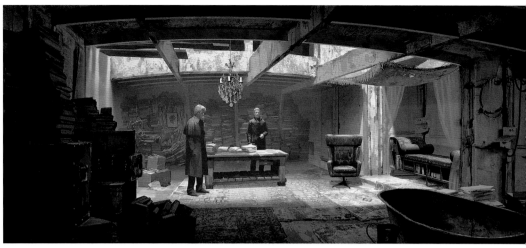
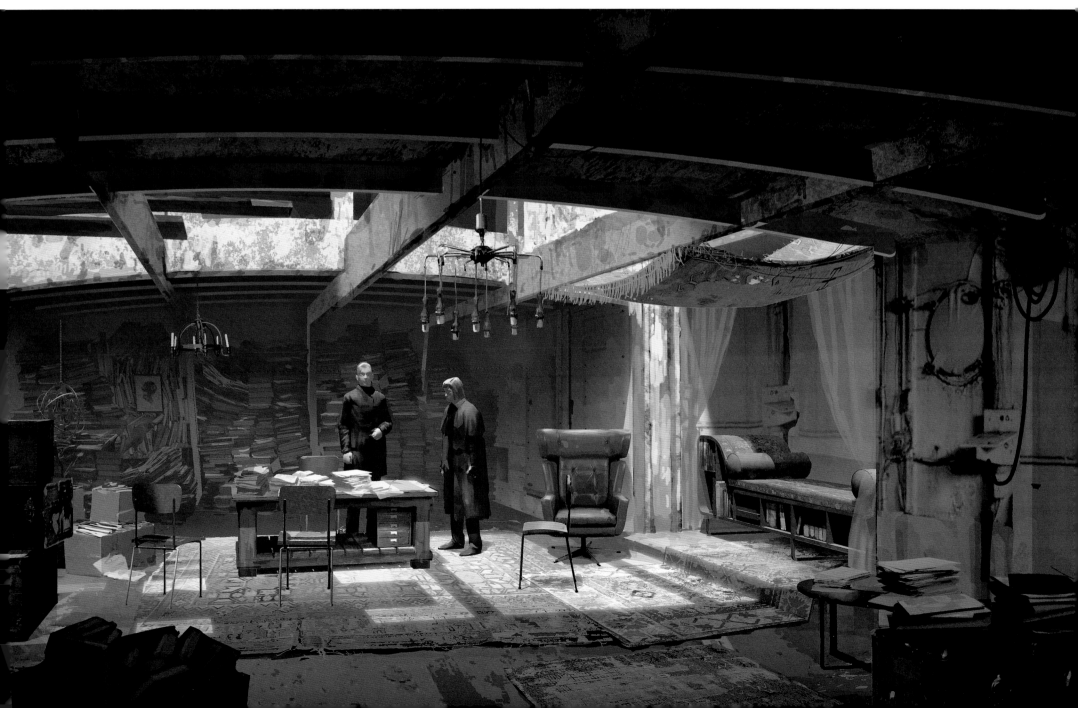

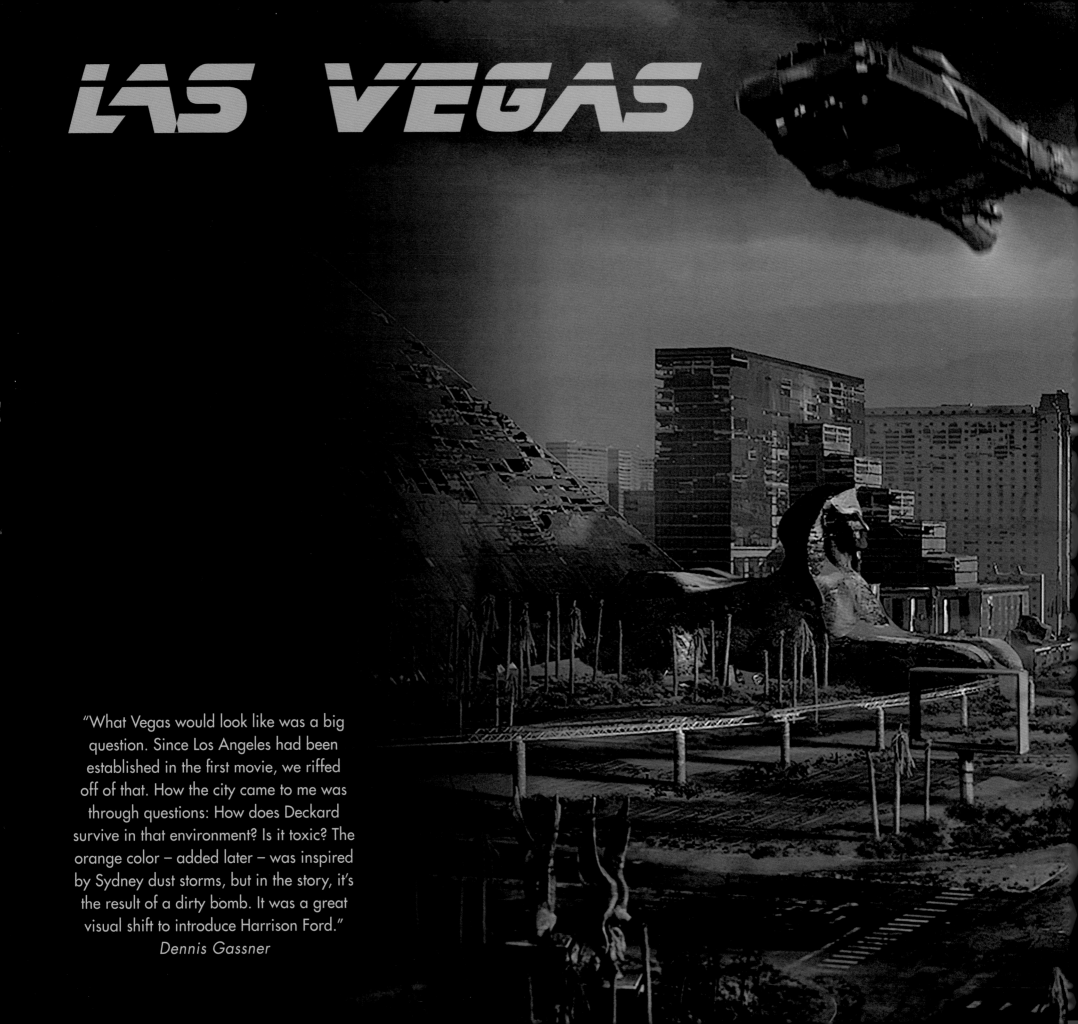

LAS VEGAS

"What Vegas would look like was a big question. Since Los Angeles had been established in the first movie, we riffed off of that. How the city came to me was through questions: How does Deckard survive in that environment? Is it toxic? The orange color – added later – was inspired by Sydney dust storms, but in the story, it's the result of a dirty bomb. It was a great visual shift to introduce Harrison Ford."

Dennis Gassner

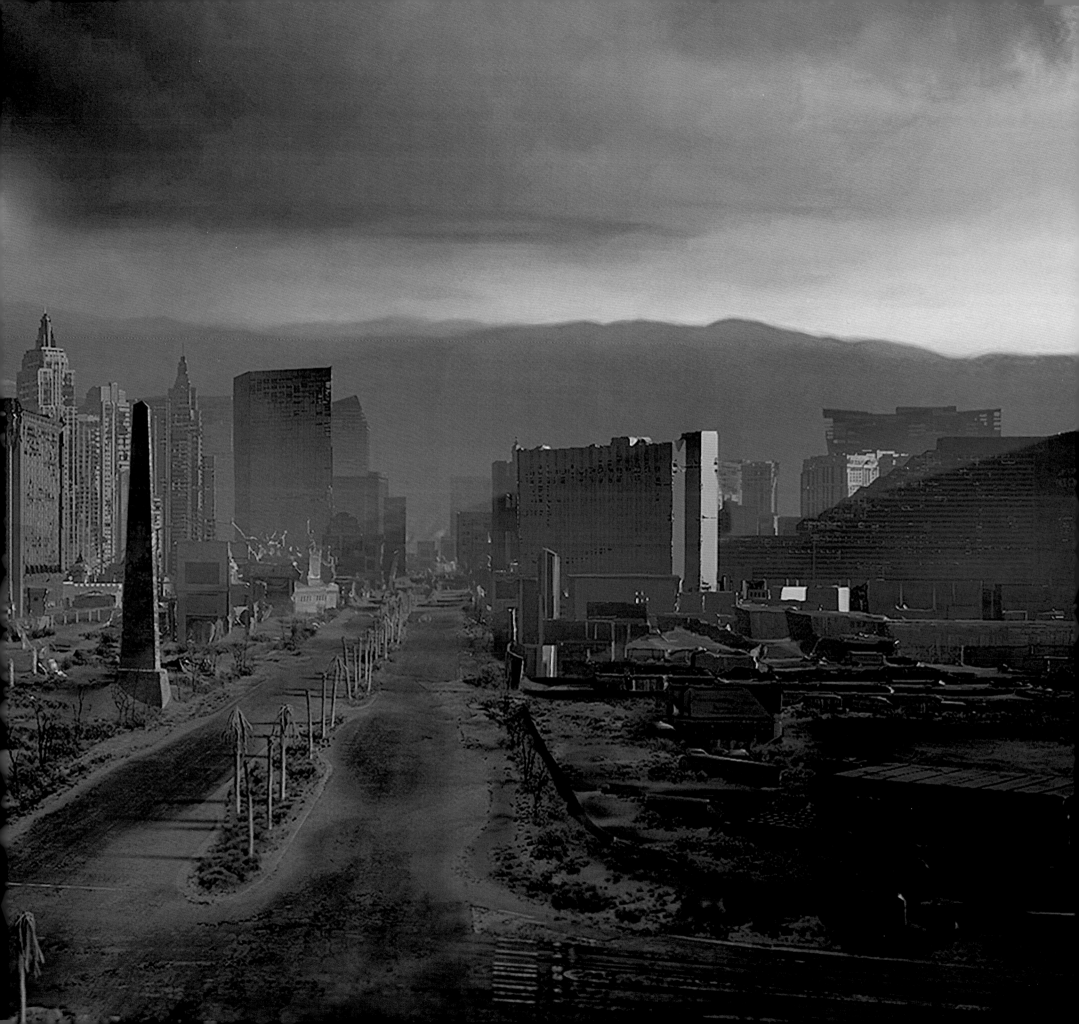

"We had almost a whole week to come up with ideas for a combined cover or shield for the city. All of the concept artists and some of the art directors had to design some of these. In the end it wasn't a particularly successful idea, so it slowly disappeared."
Kamen Anev ▶

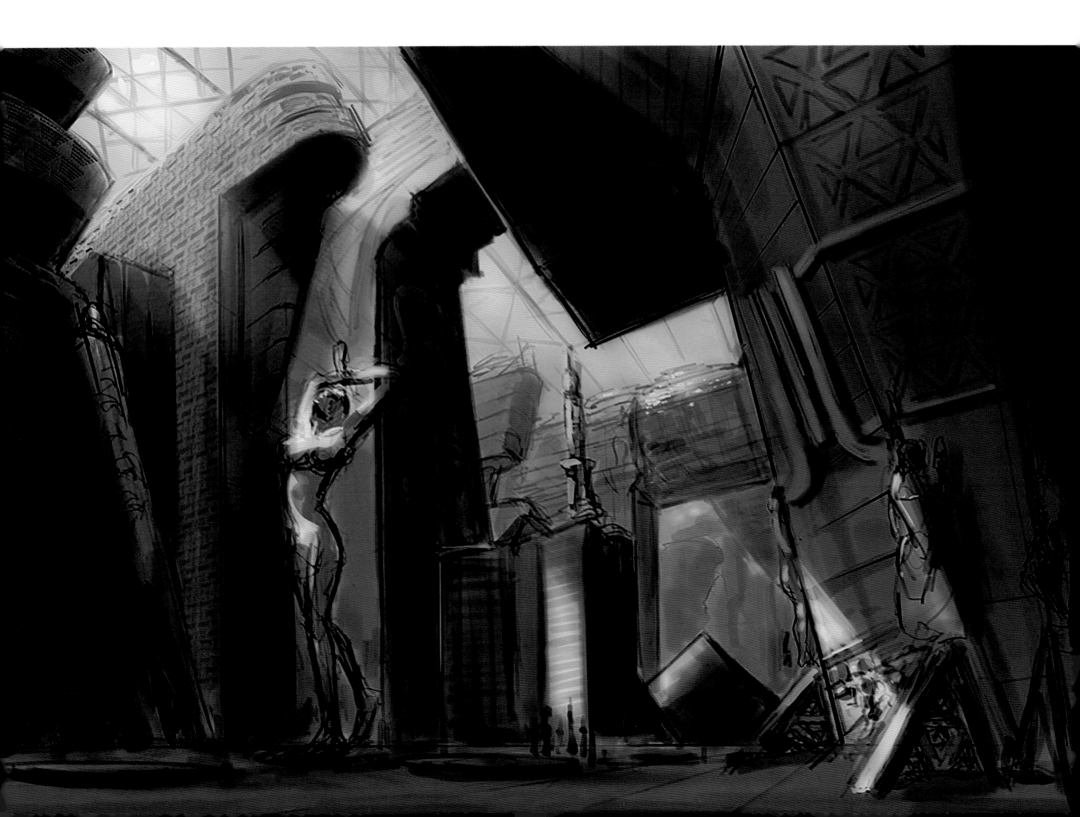

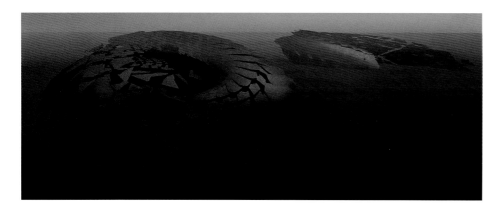

"In an earlier version of the script there was a shot where K arrives in Las Vegas and looks across to the city from a rocky cliff [next spread]. Our supervising art director, Paul Inglis, thought that we could have big concrete beacons that show that the area is radioactive."

▼ *Kamen Anev*

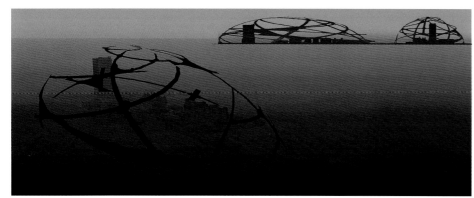 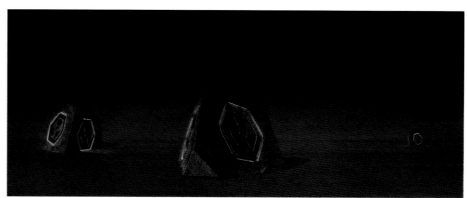

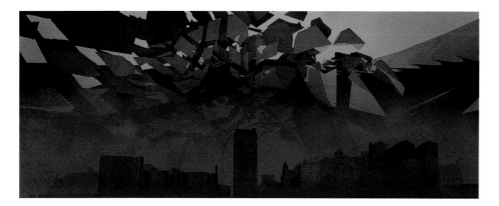 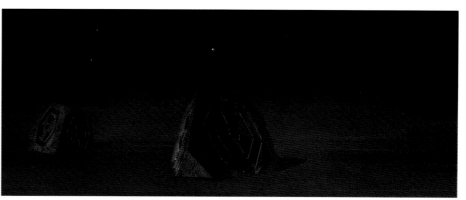

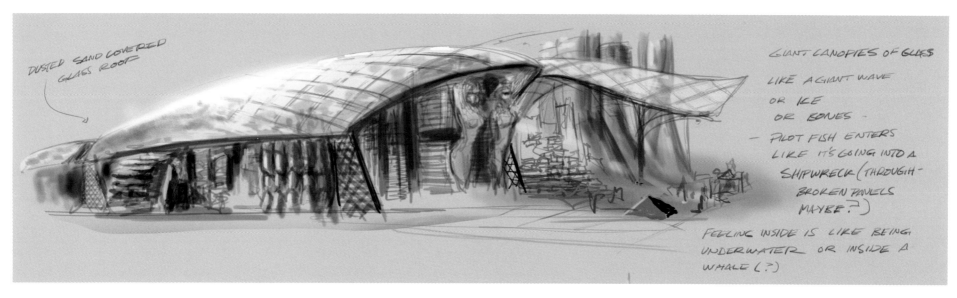

DUSTED SAND COVERED GLASS ROOF

GIANT CANOPIES OF GLASS

LIKE A GIANT WAVE OR ICE OR BONES

— PILOT FISH ENTERS LIKE IT'S GOING INTO A SHIPWRECK (THROUGH BROKEN PANELS MAYBE?)

FEELING INSIDE IS LIKE BEING UNDERWATER OR INSIDE A WHALE (?)

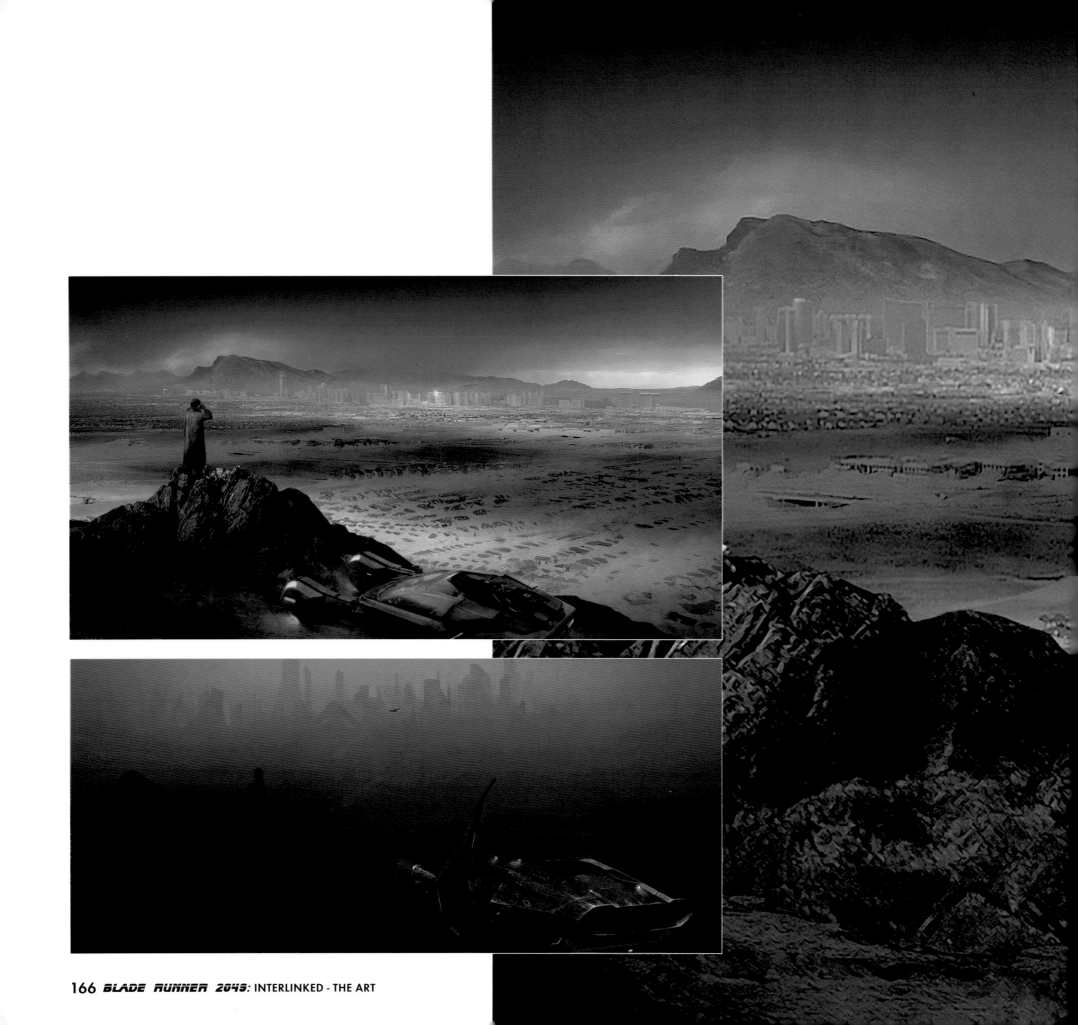

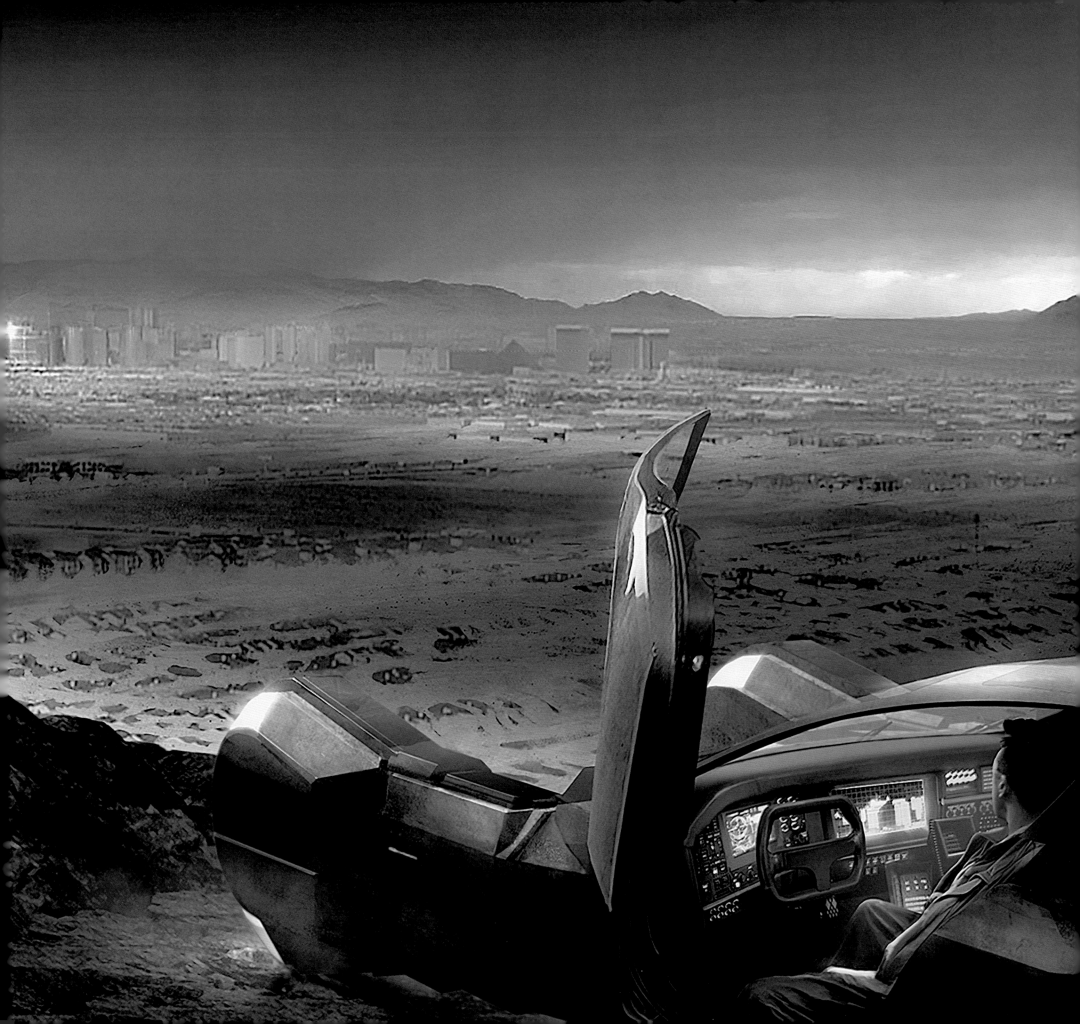

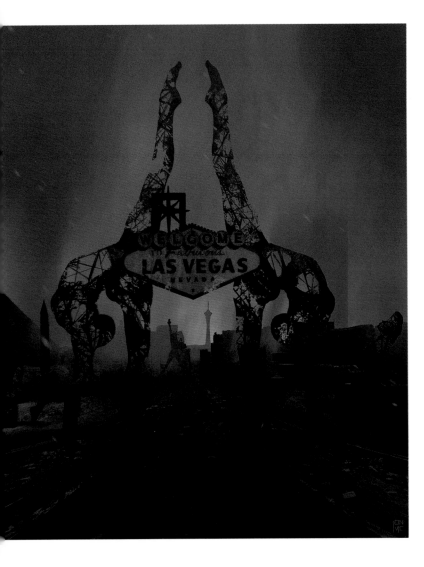
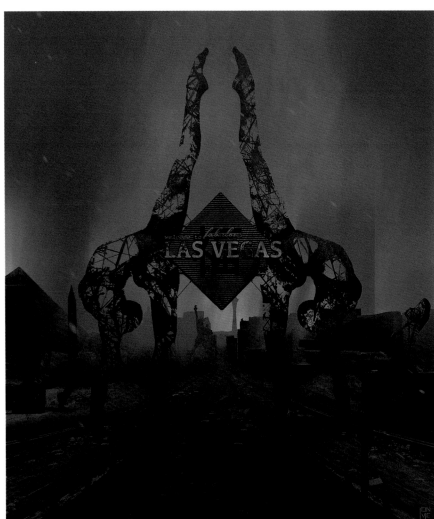
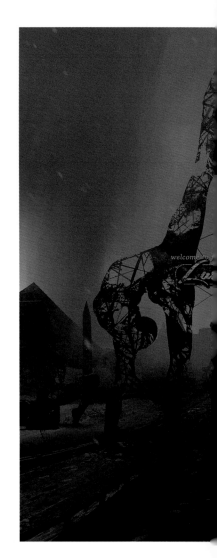

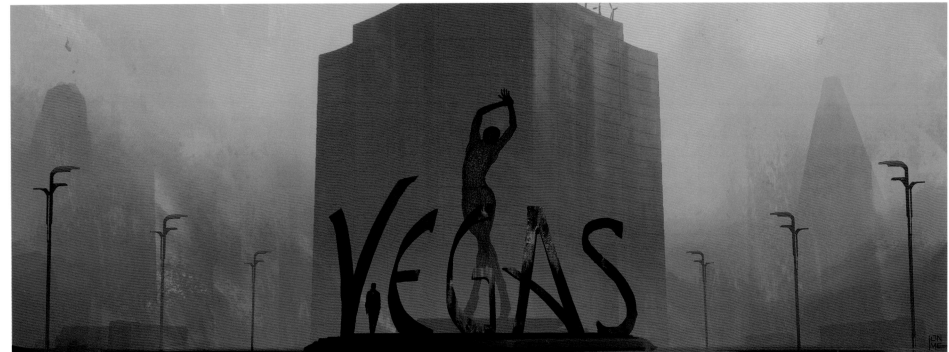

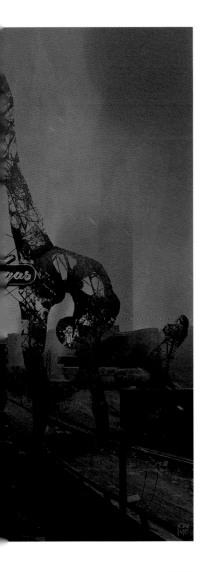
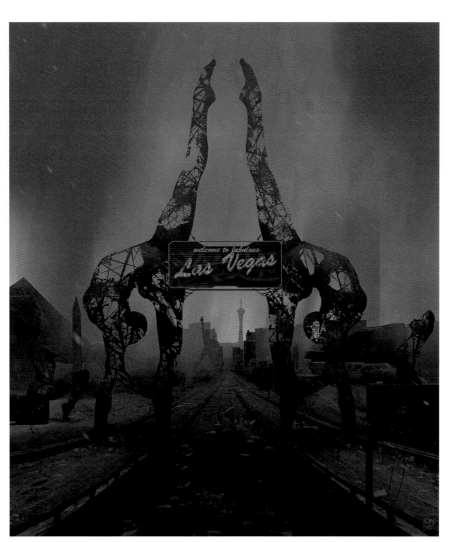
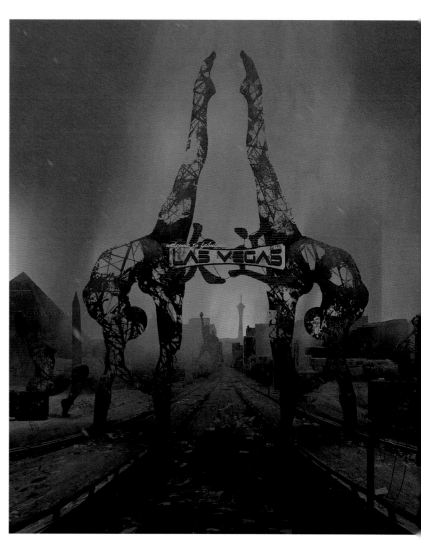
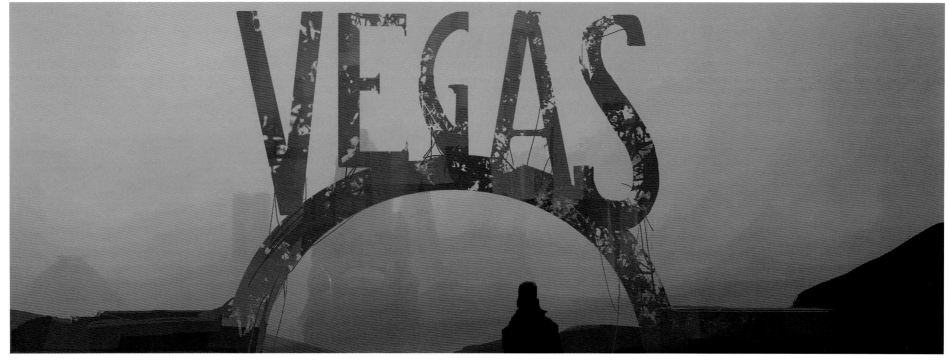

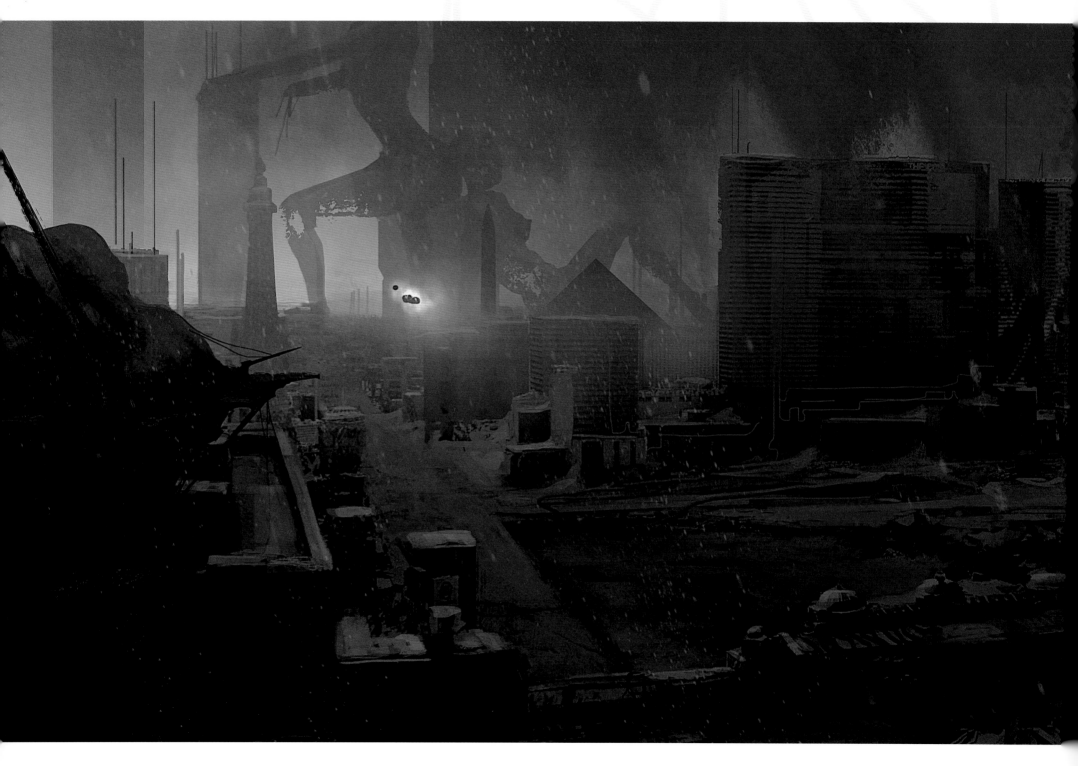

"One of the early ideas for how Deckard survives here, was for him to farm in a concrete-clad Las Vegas."
Scott Lukowski ▶

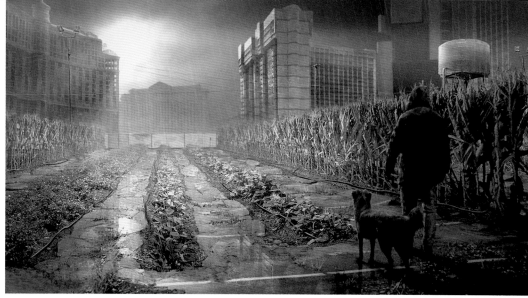

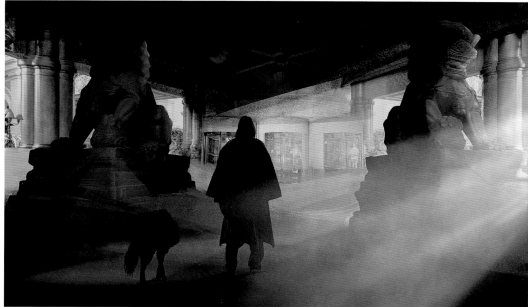

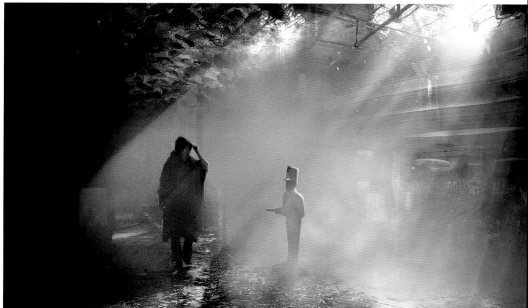

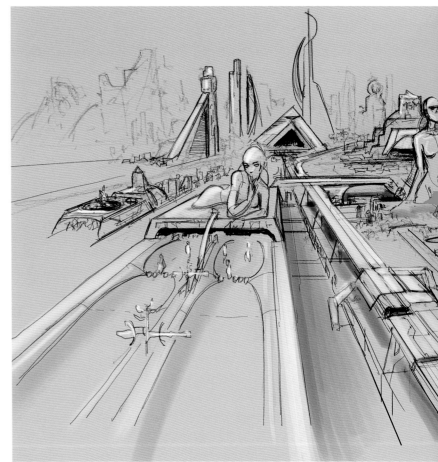
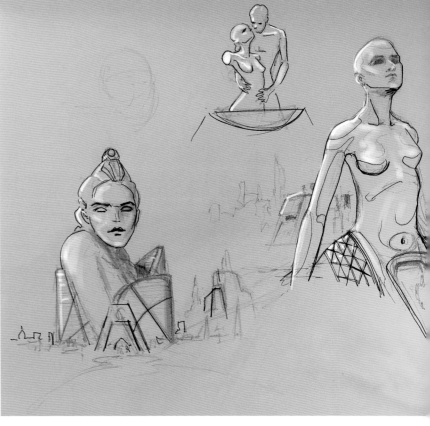

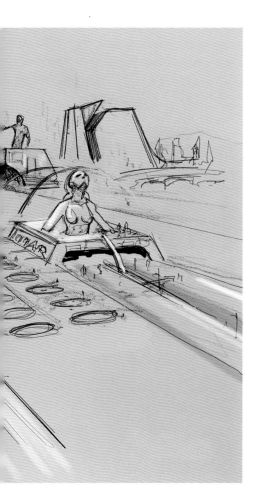

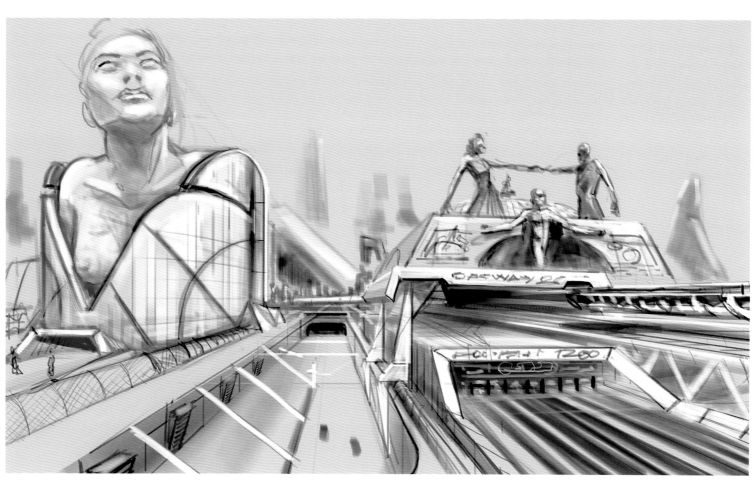

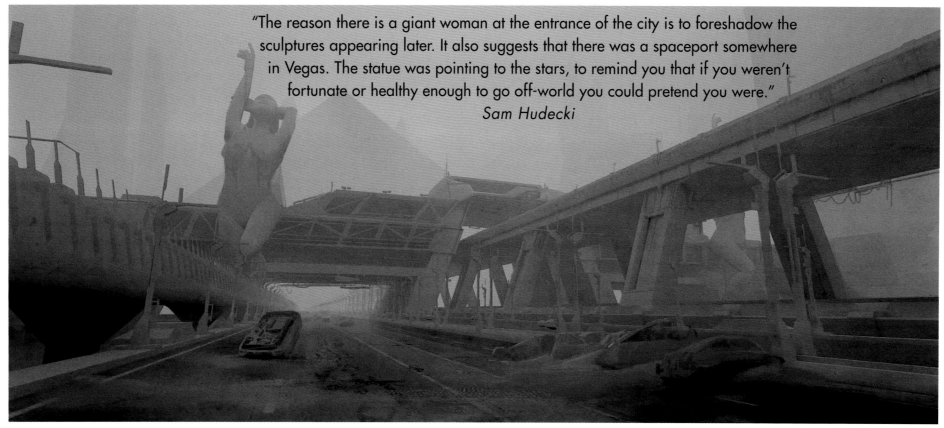

"The reason there is a giant woman at the entrance of the city is to foreshadow the sculptures appearing later. It also suggests that there was a spaceport somewhere in Vegas. The statue was pointing to the stars, to remind you that if you weren't fortunate or healthy enough to go off-world you could pretend you were."
Sam Hudecki

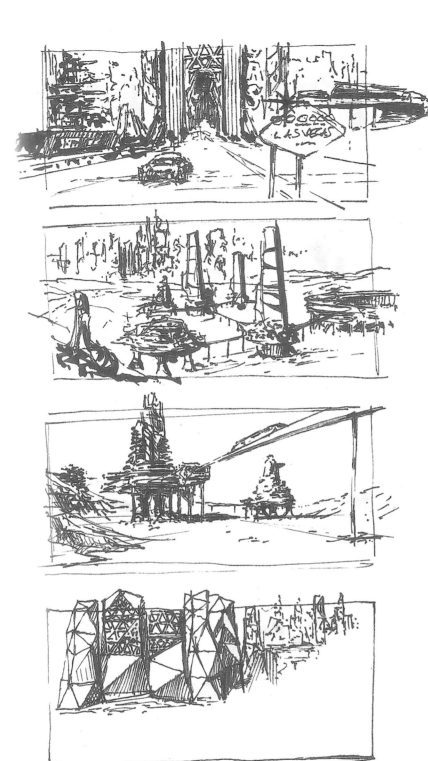

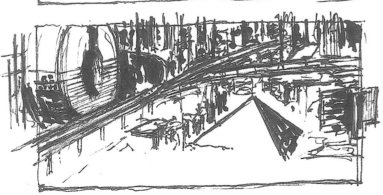

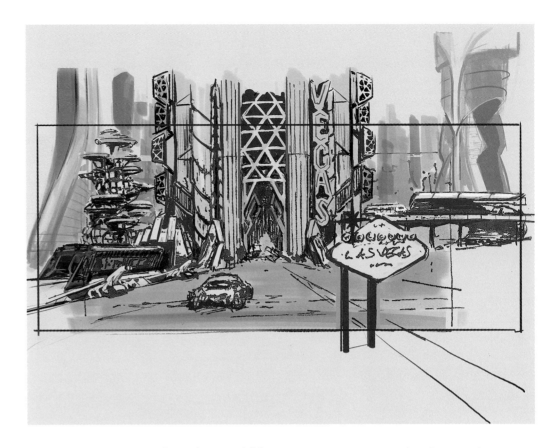

"I was expanding the world but staying in tune with what Syd Mead had created in the original movie for Los Angeles, and keeping that DNA in Las Vegas."
Sam Hudecki

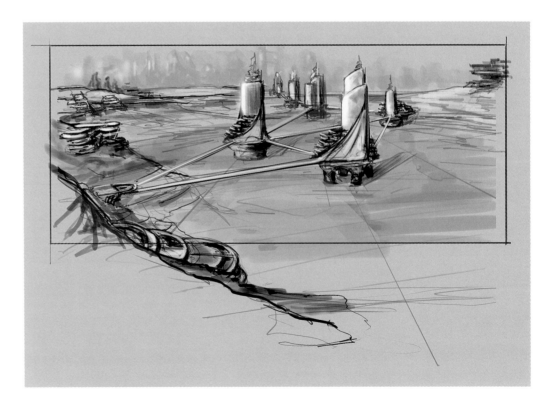

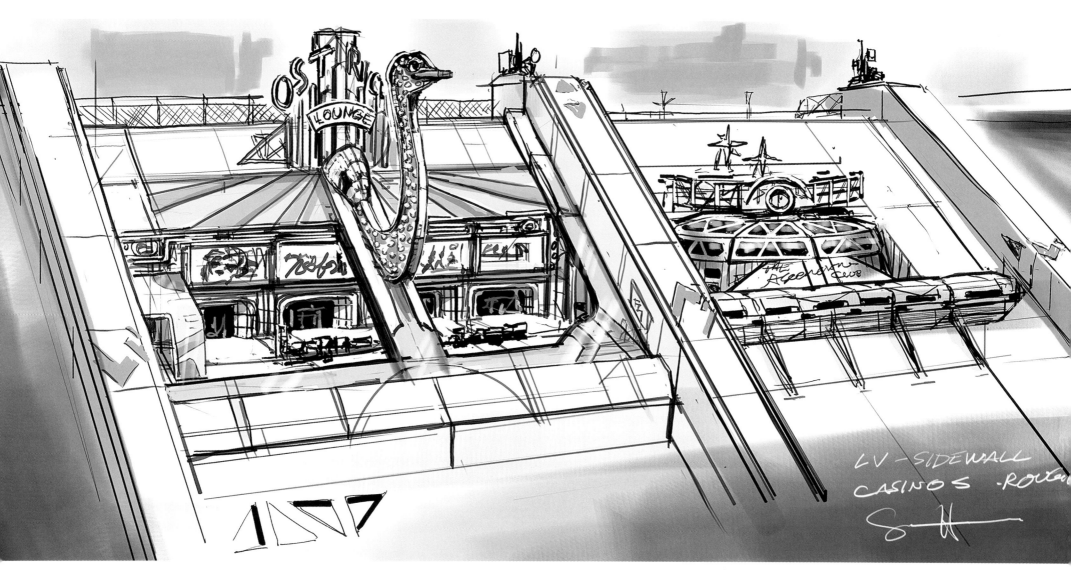

LV-SIDEWALL
CASINOS -ROW

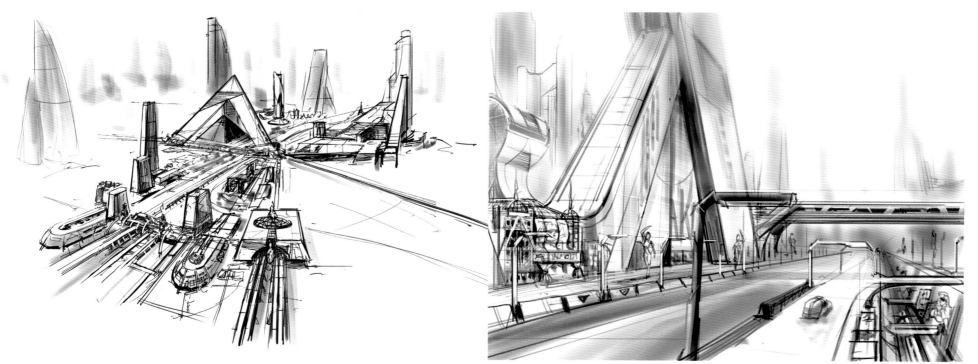

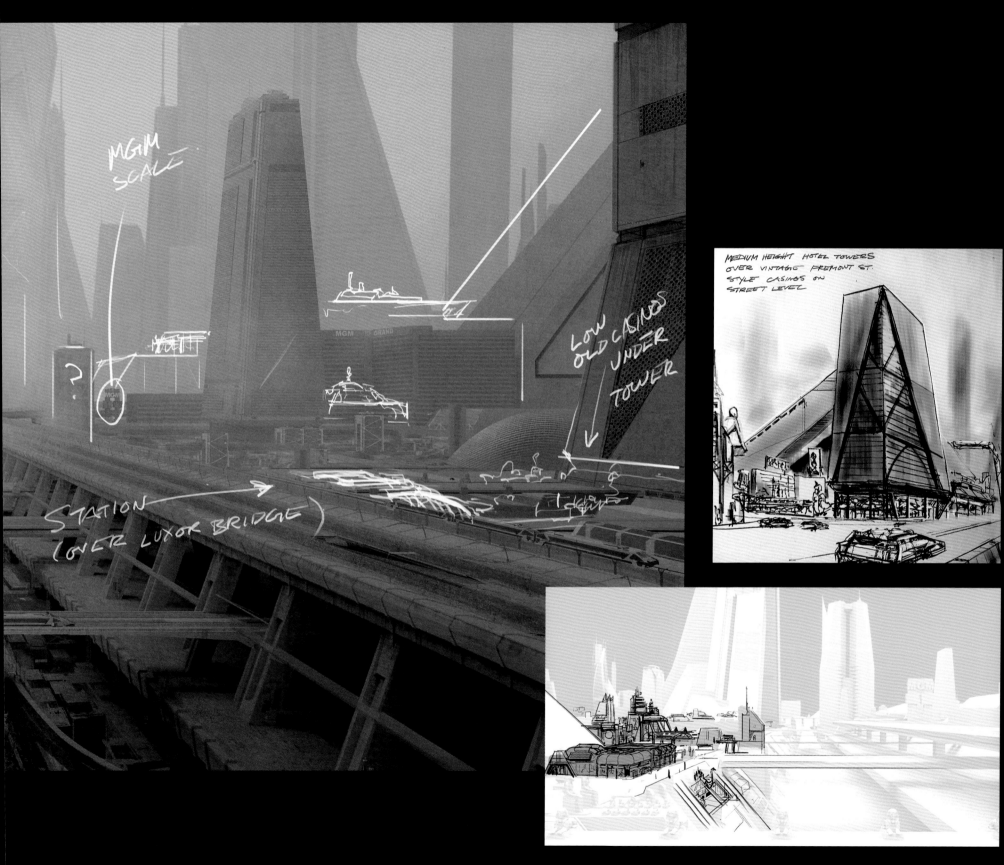

Oct. 13

MGM
SCALE

?

MGM GRAND

MEDIUM HEIGHT HOTEL TOWERS
OVER VINTAGE FREMONT ST.
STYLE CASINOS ON
STREET LEVEL

LOW
OLD CASINOS
UNDER
TOWER

STATION
(OVER LUXOR BRIDGE)

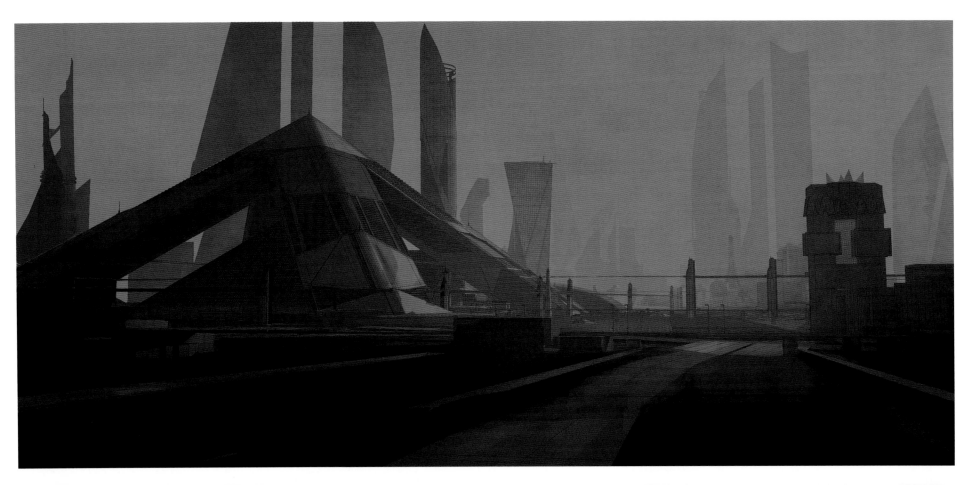

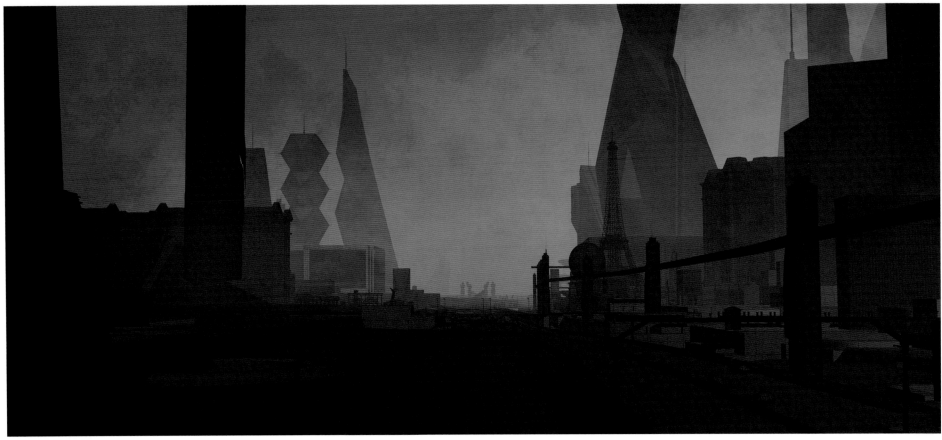

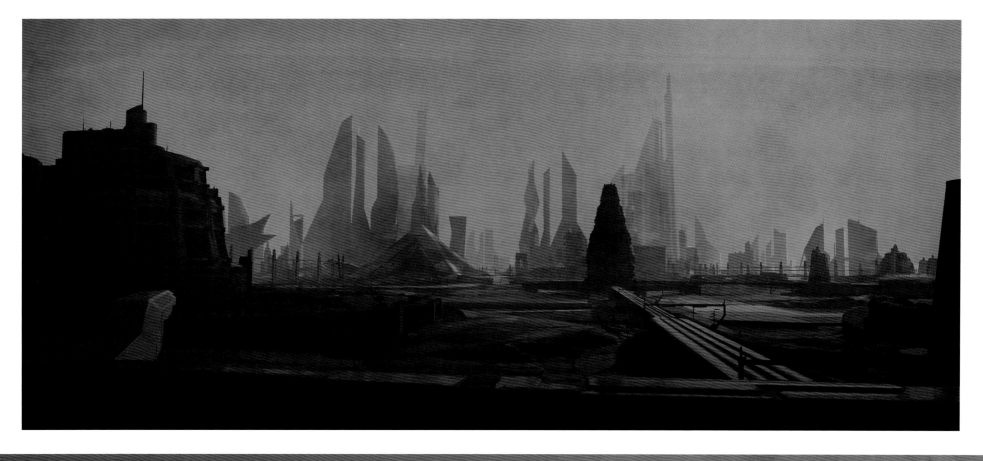

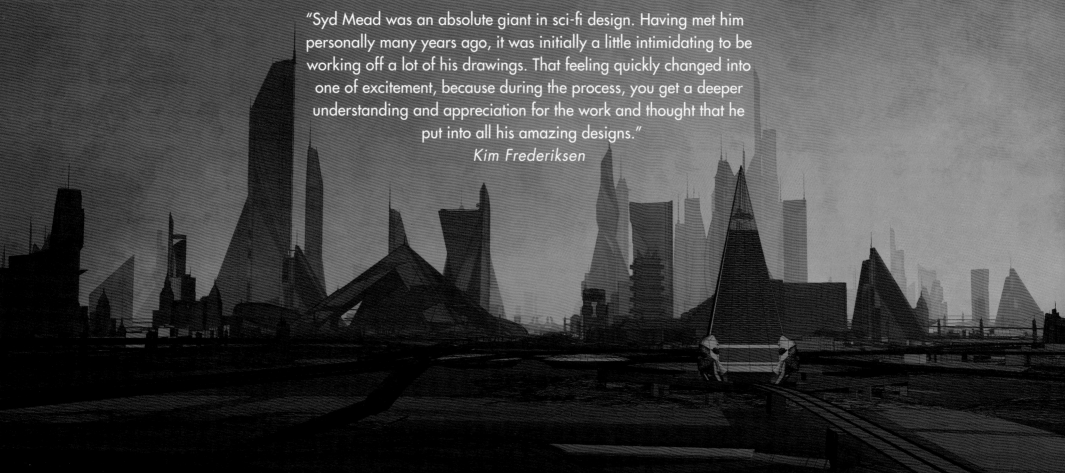

"Syd Mead was an absolute giant in sci-fi design. Having met him personally many years ago, it was initially a little intimidating to be working off a lot of his drawings. That feeling quickly changed into one of excitement, because during the process, you get a deeper understanding and appreciation for the work and thought that he put into all his amazing designs."
Kim Frederiksen

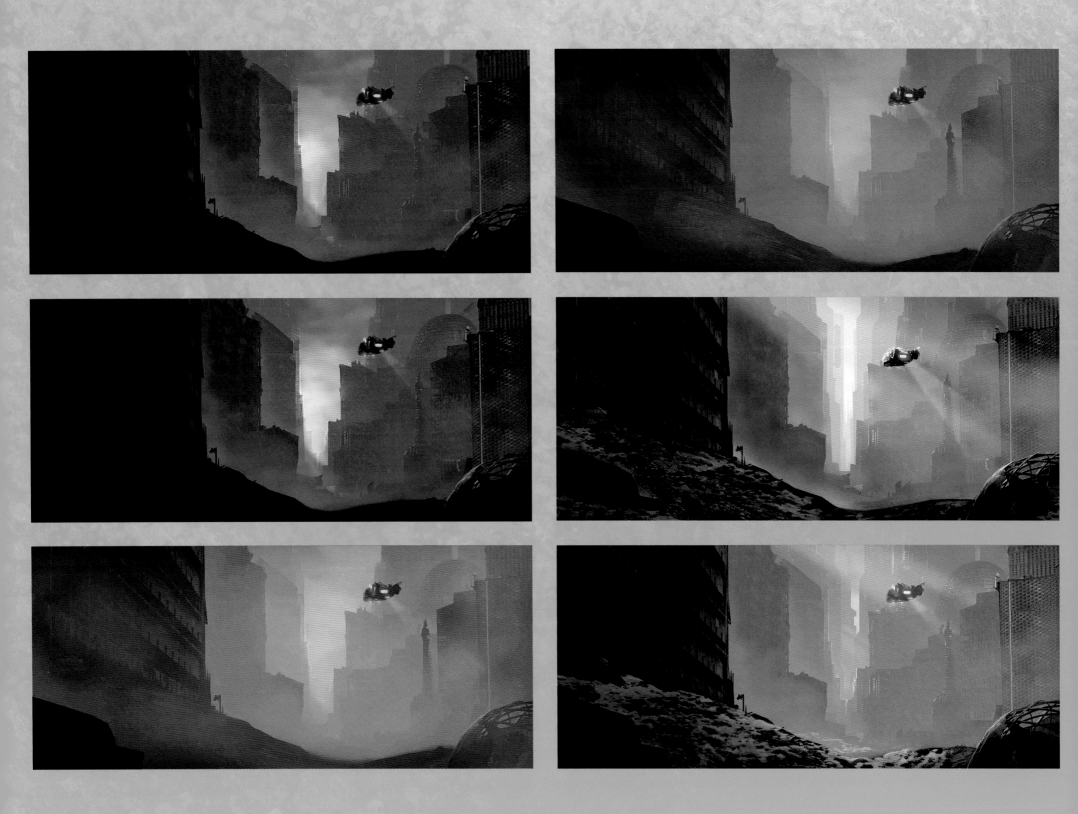

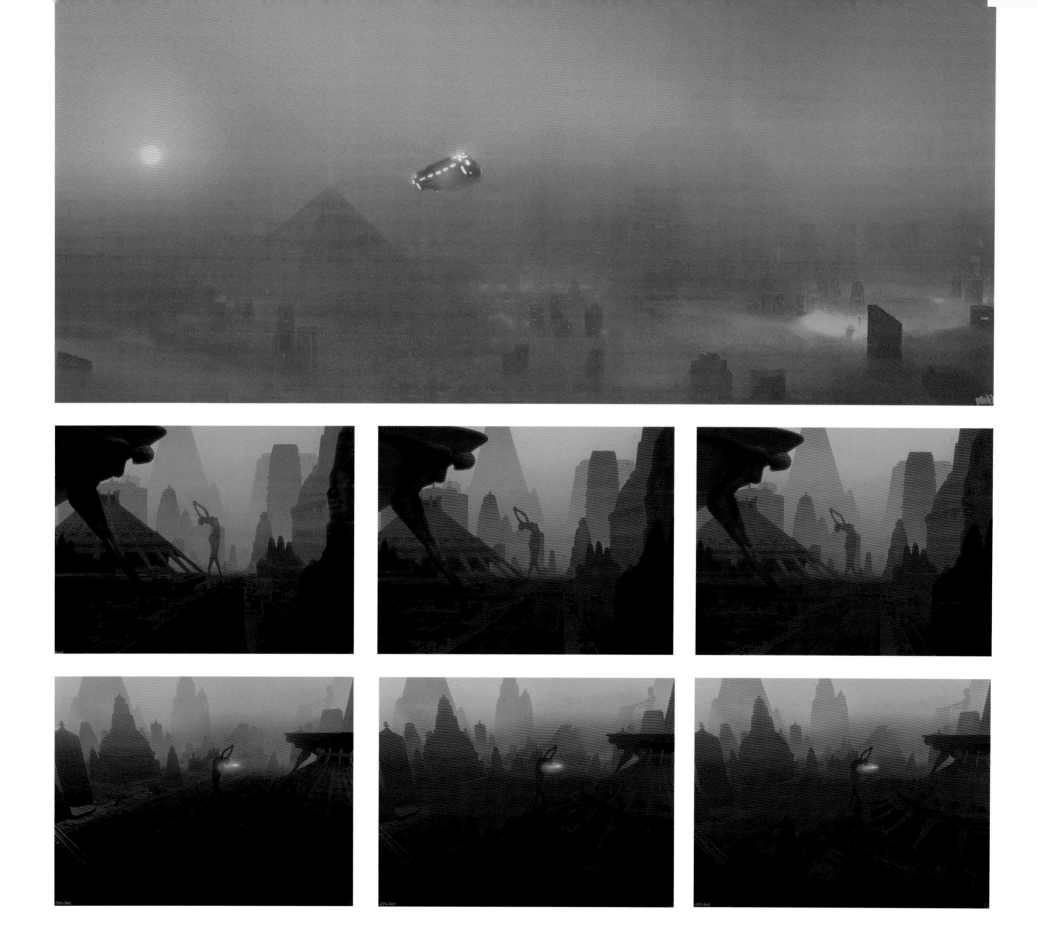

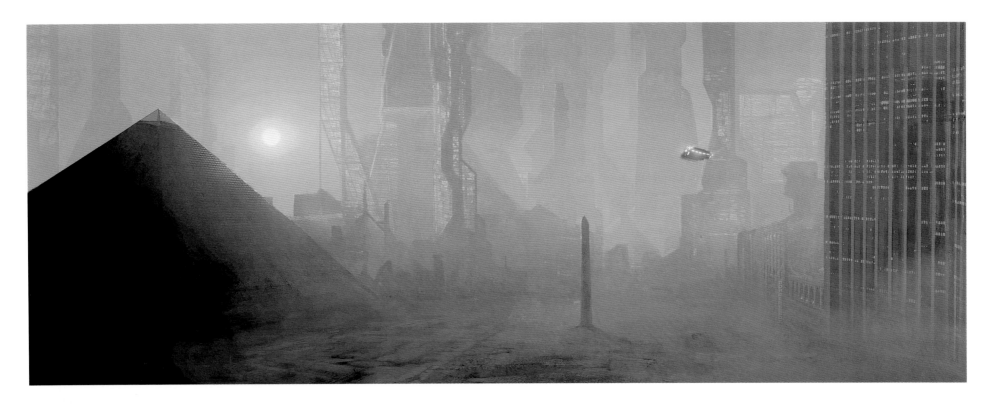

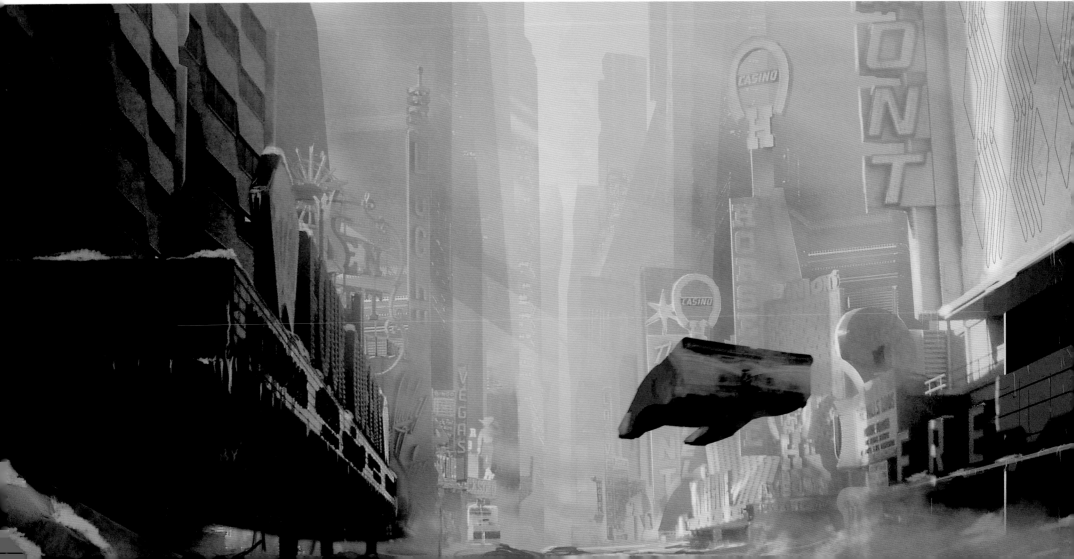

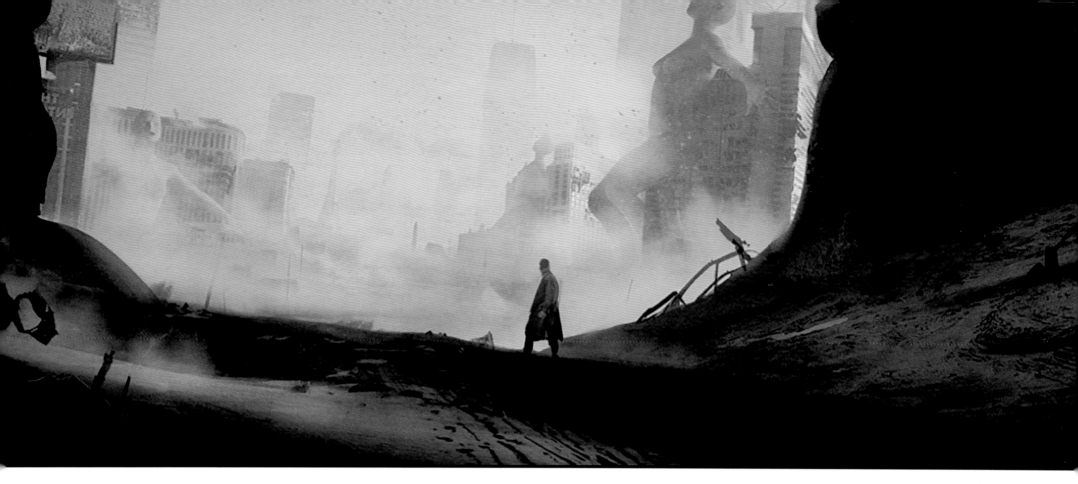

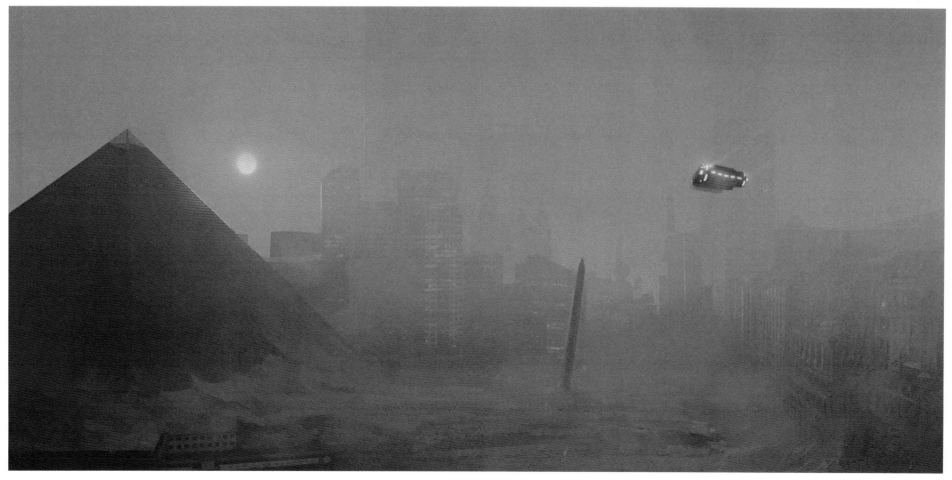

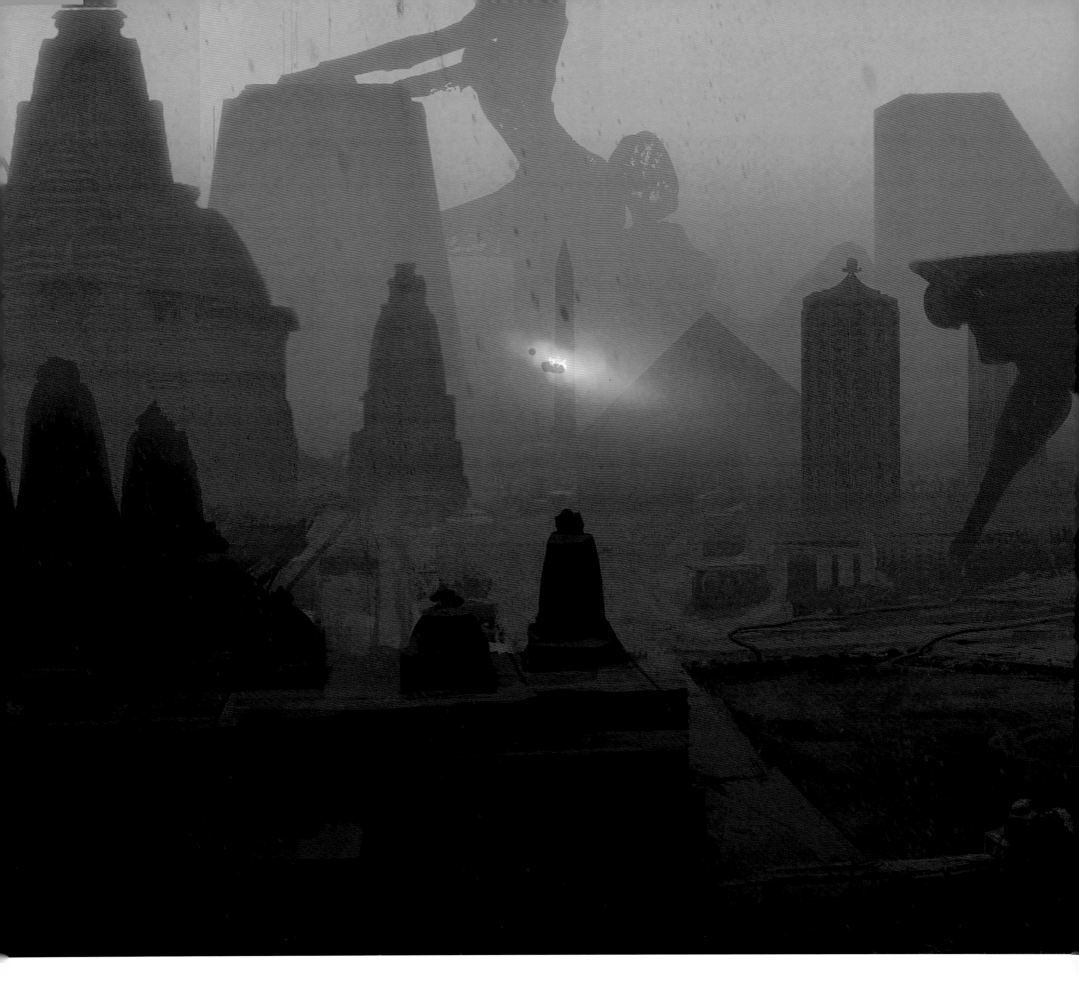

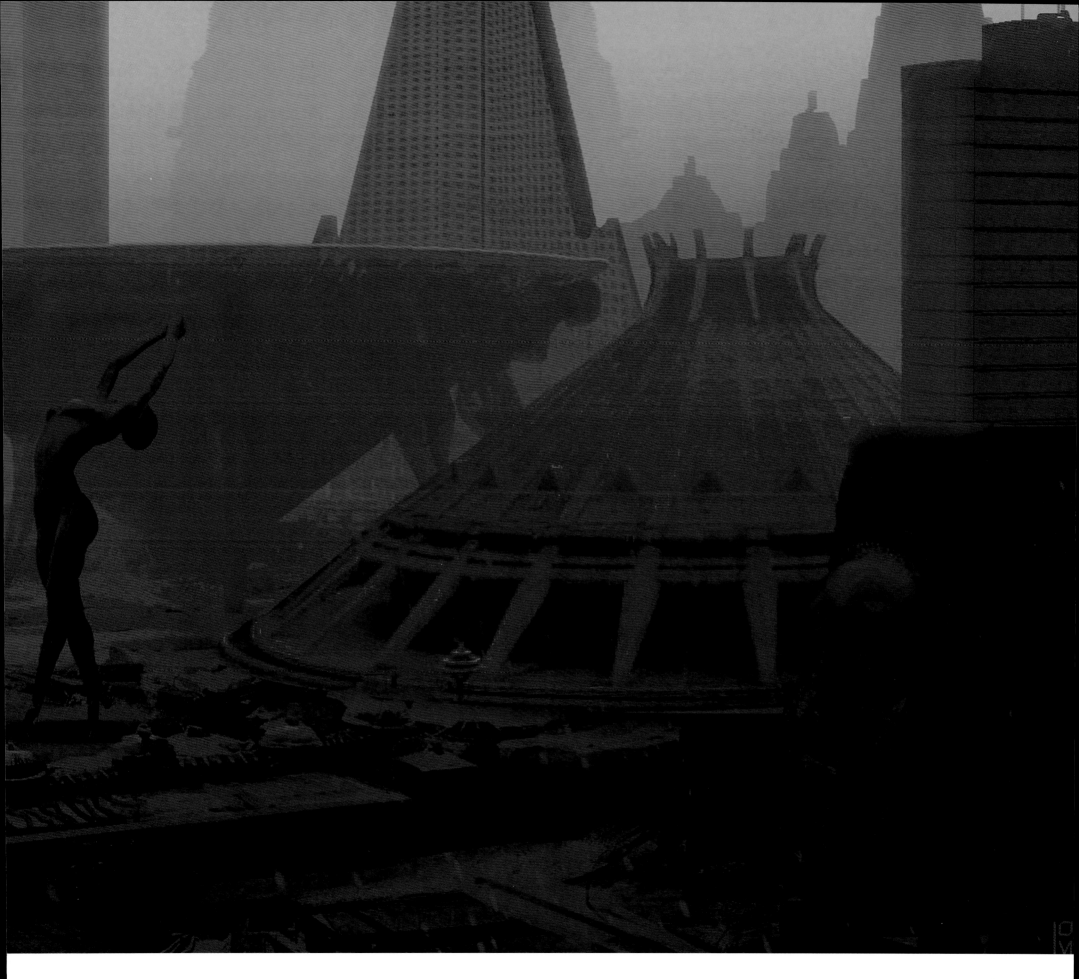

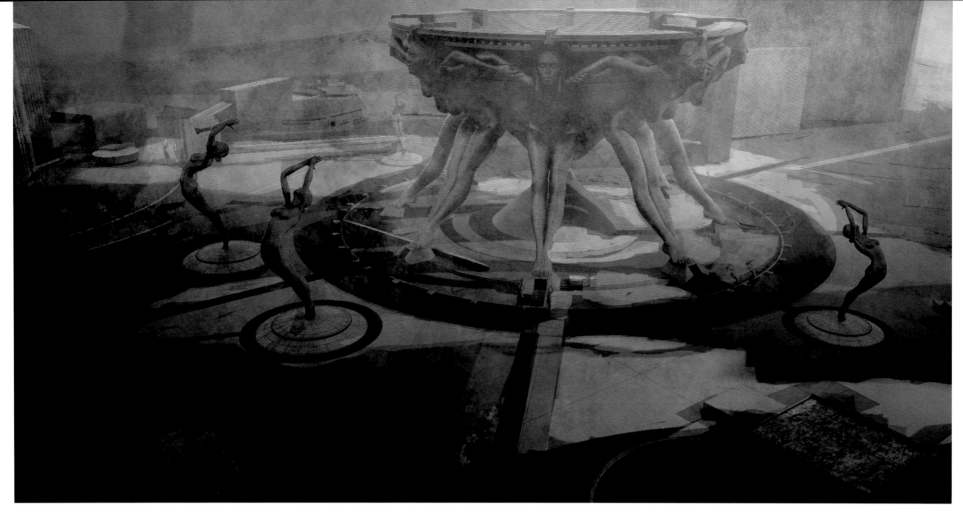

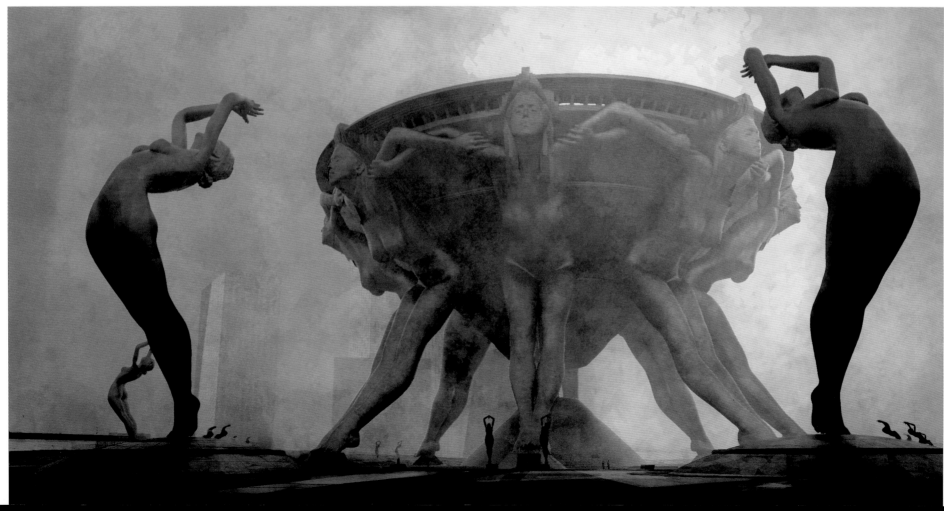

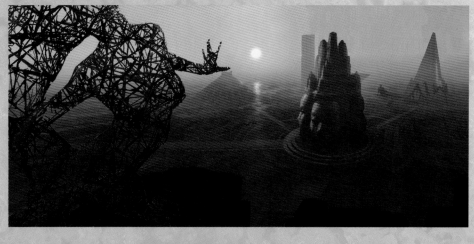

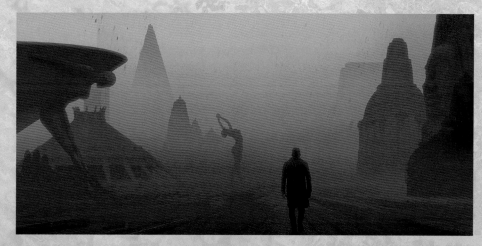

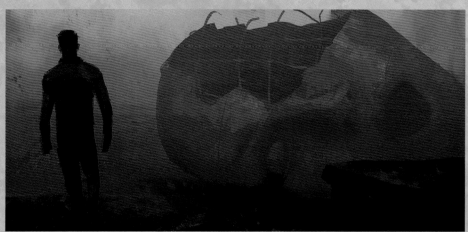

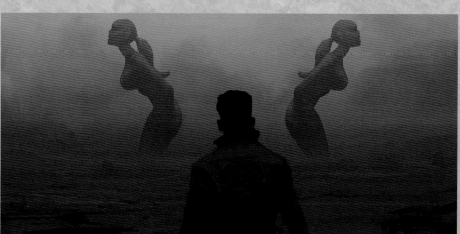

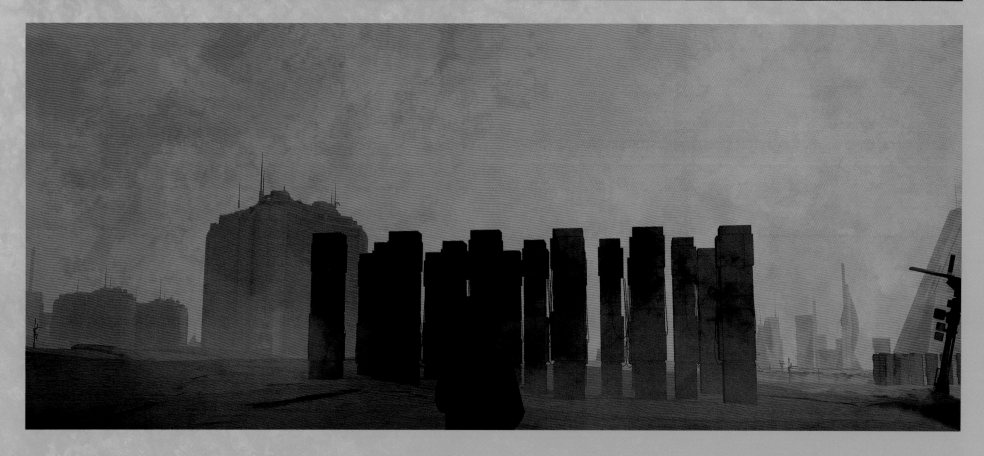

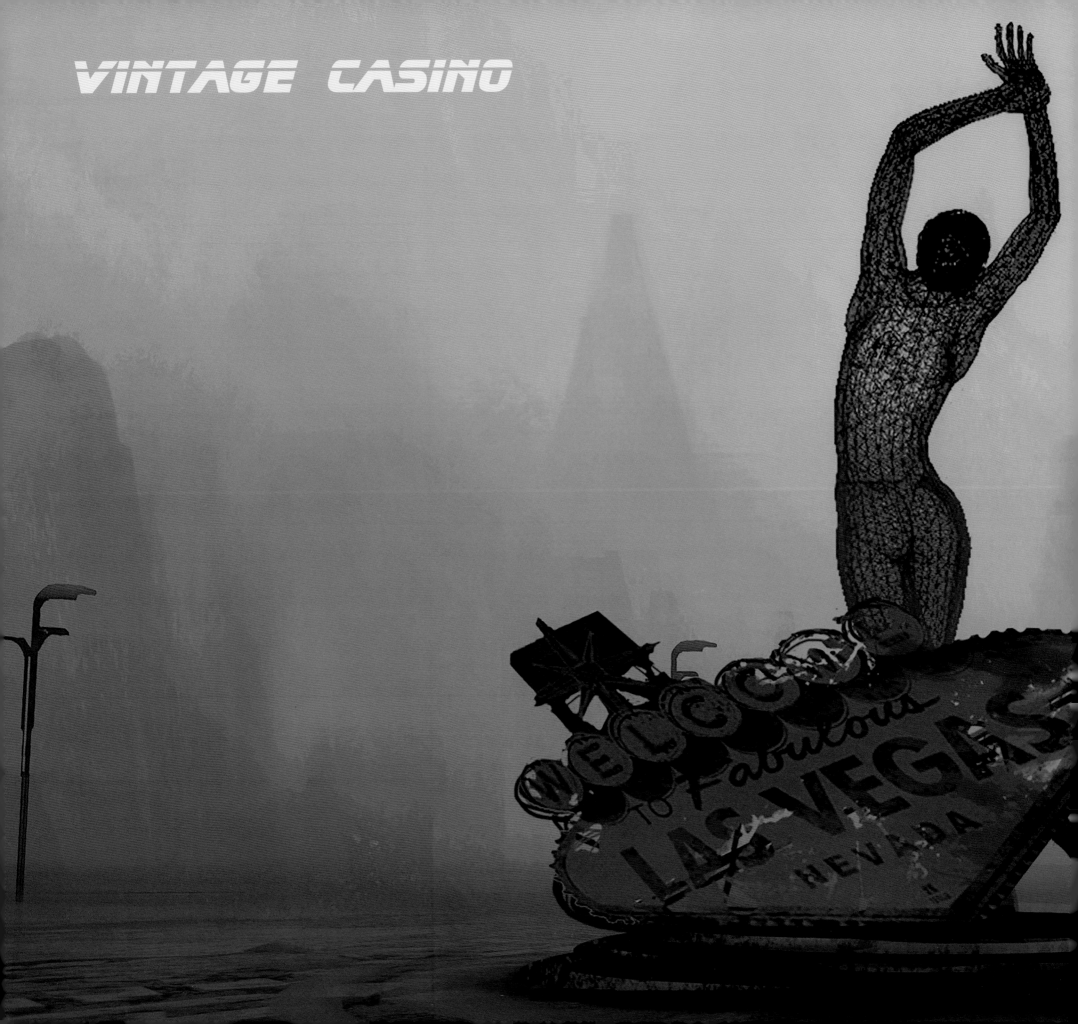

VINTAGE CASINO

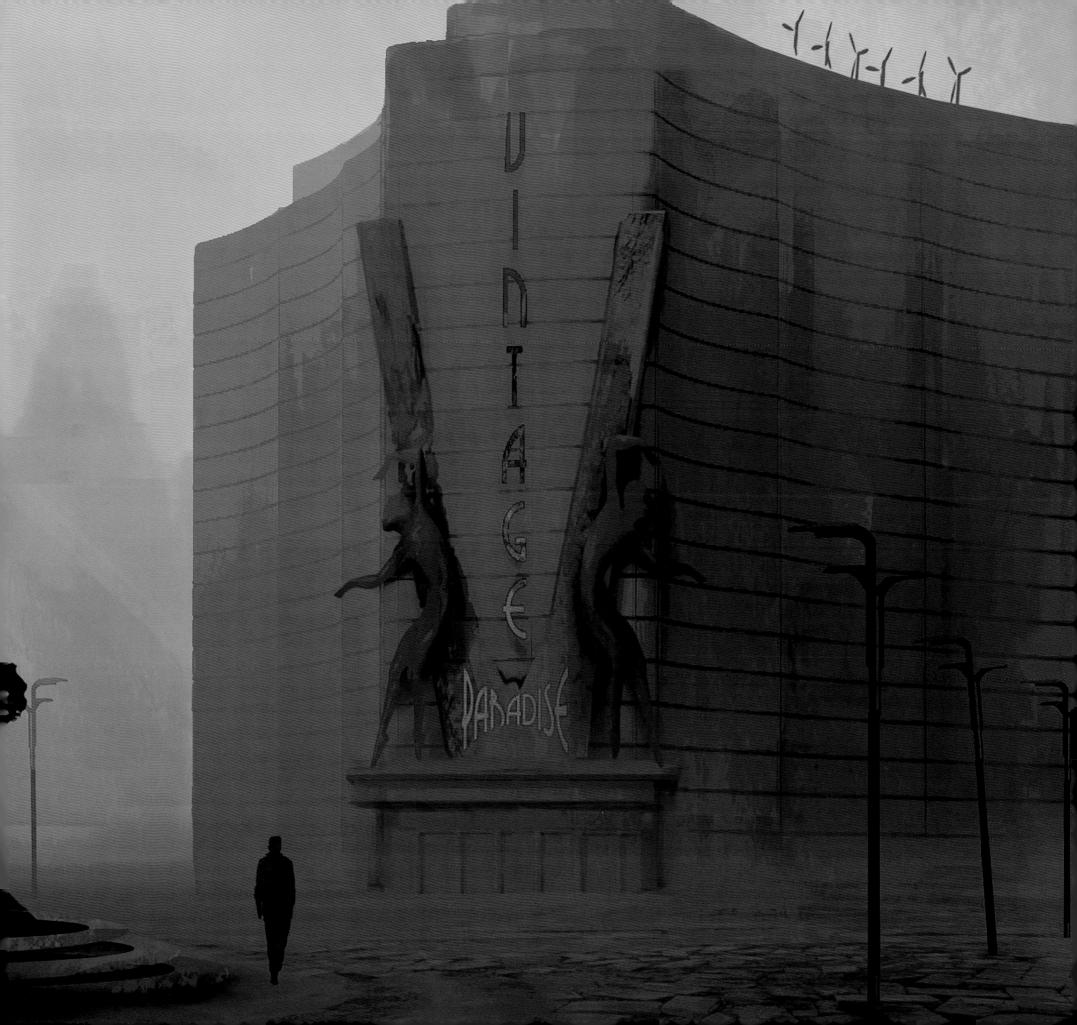

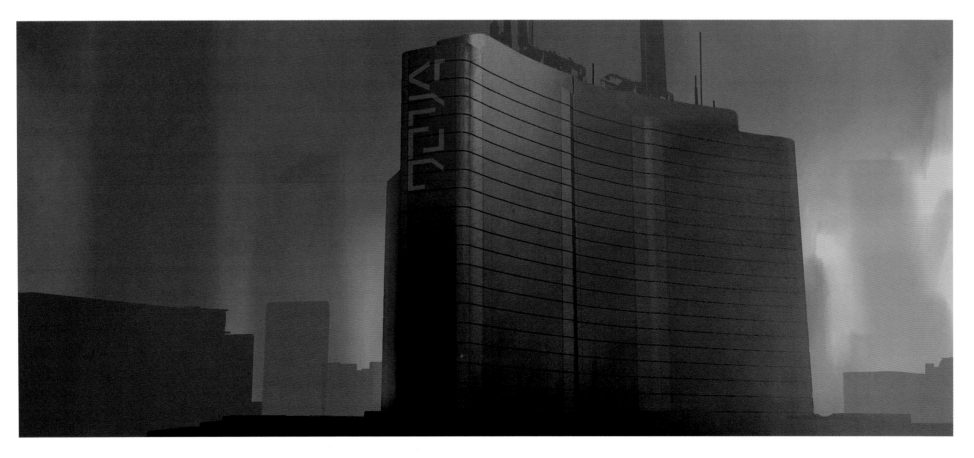

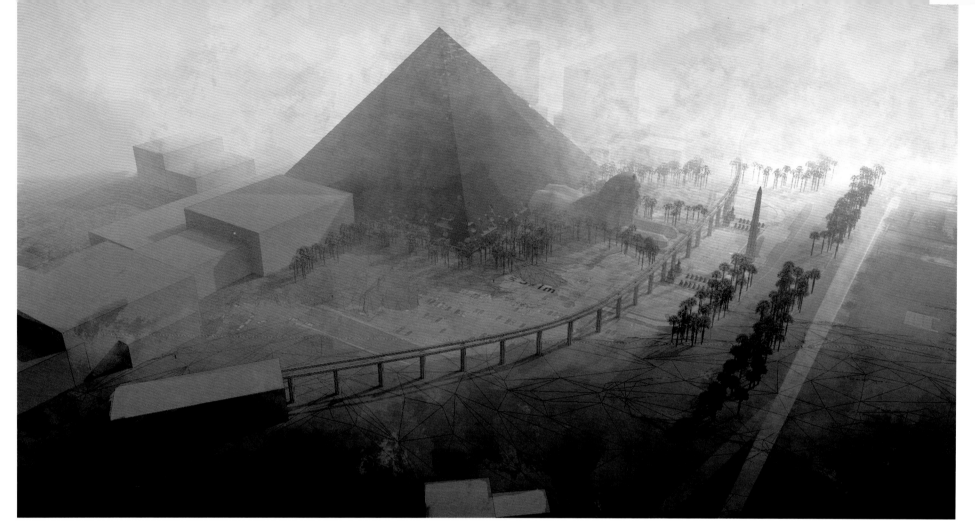
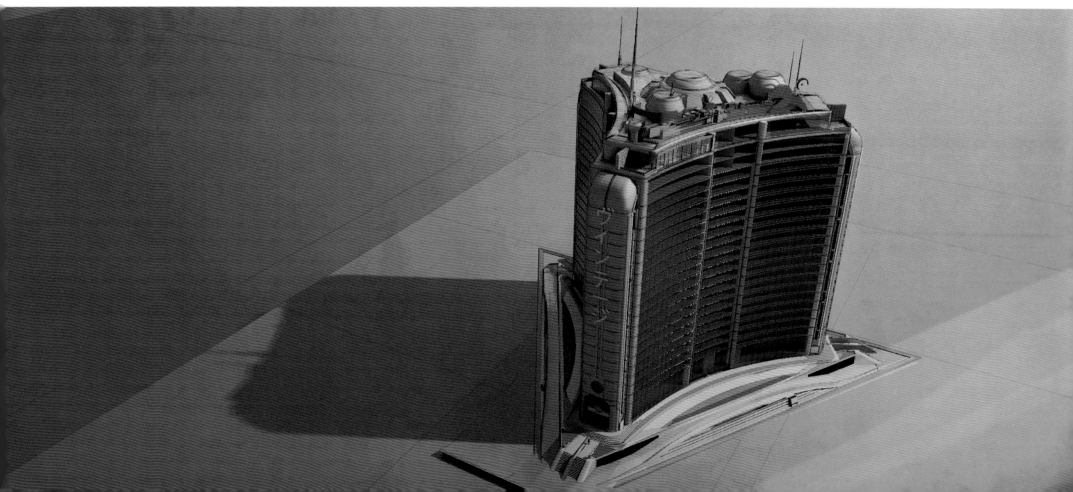

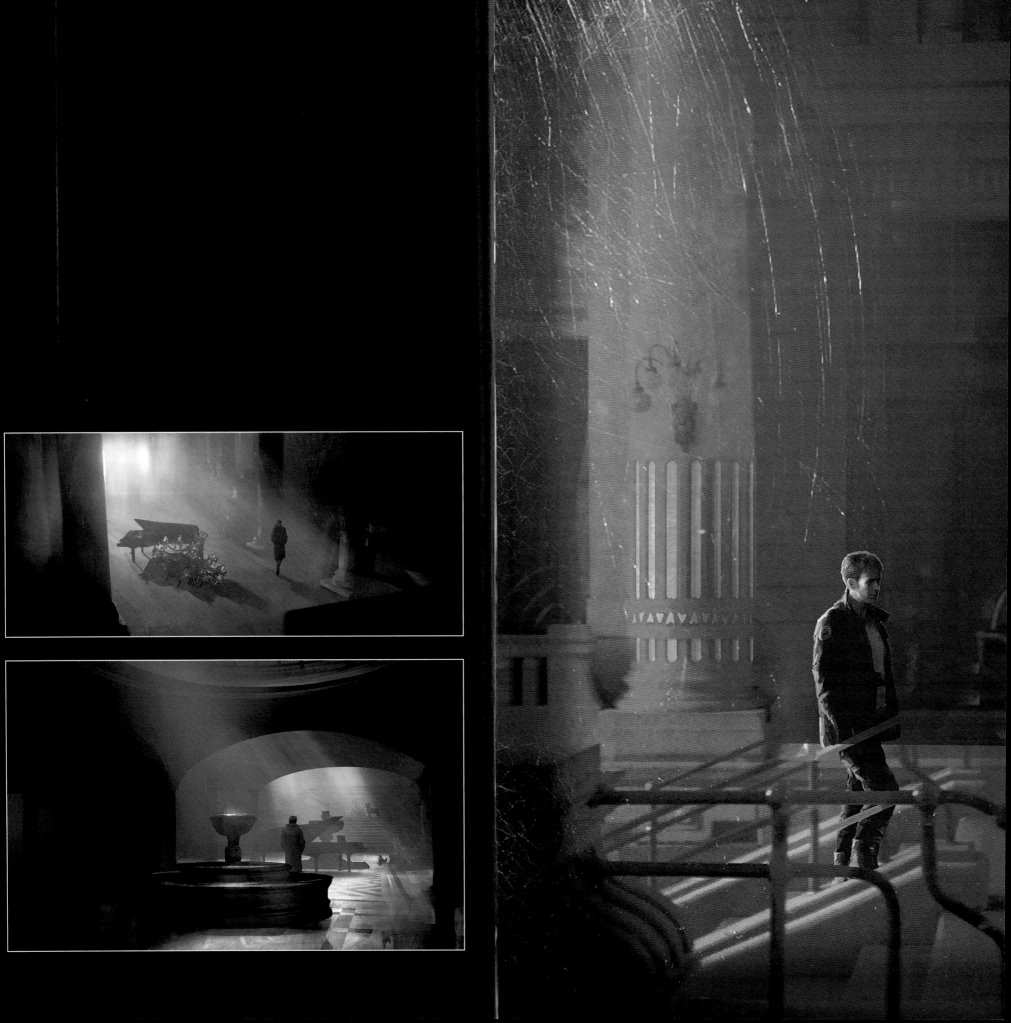

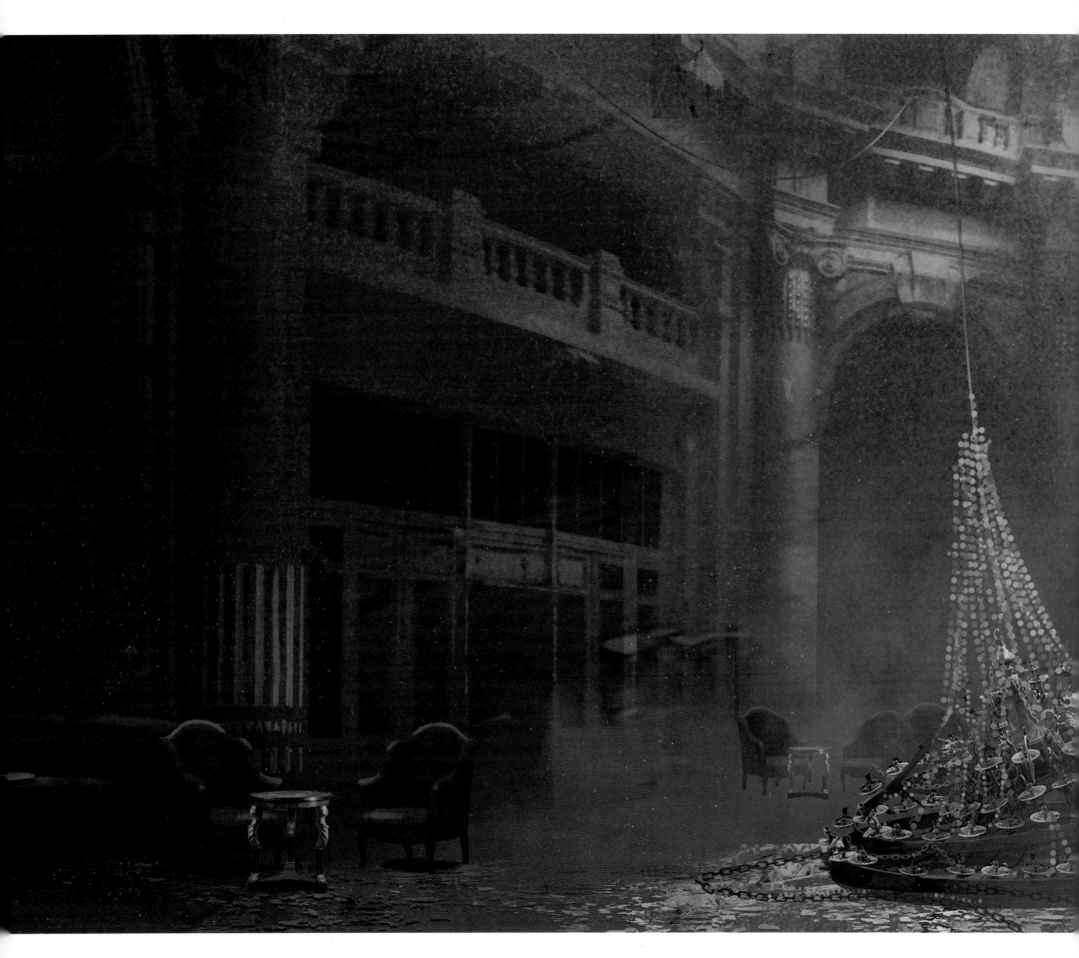

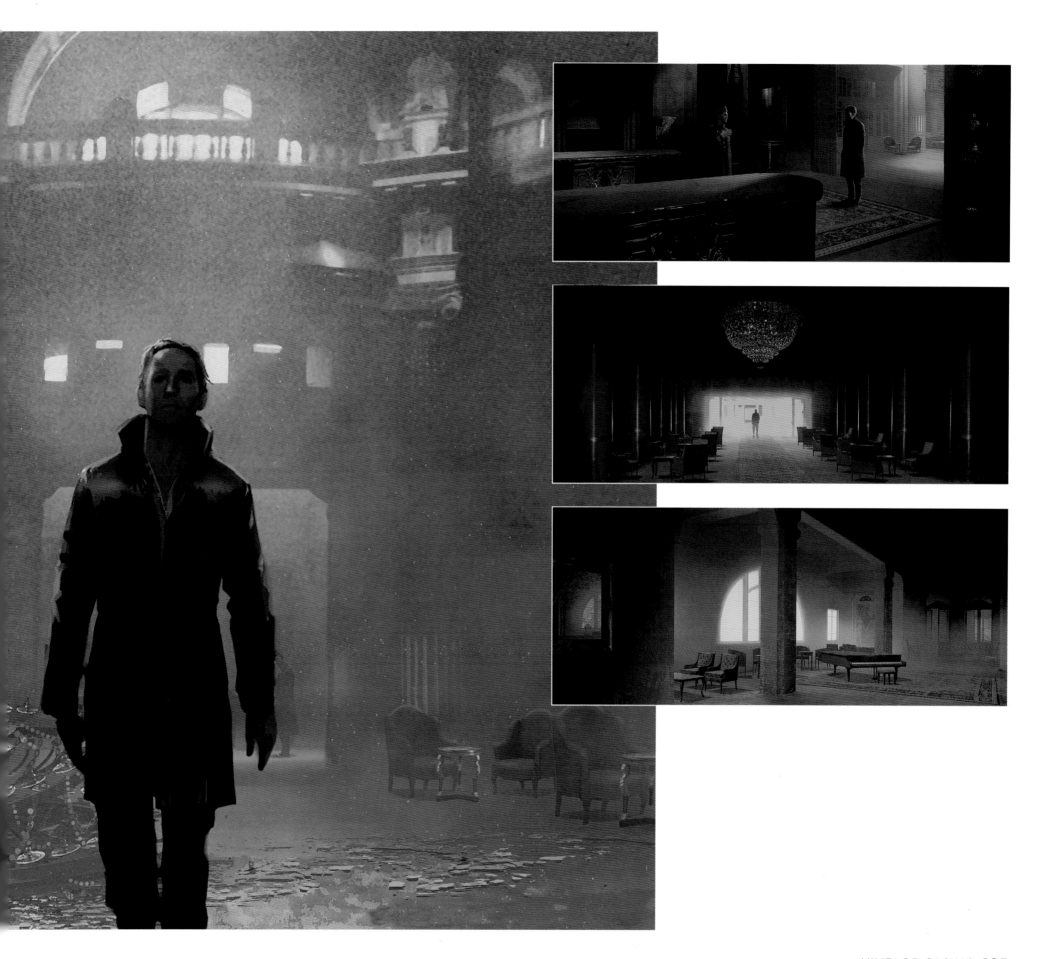

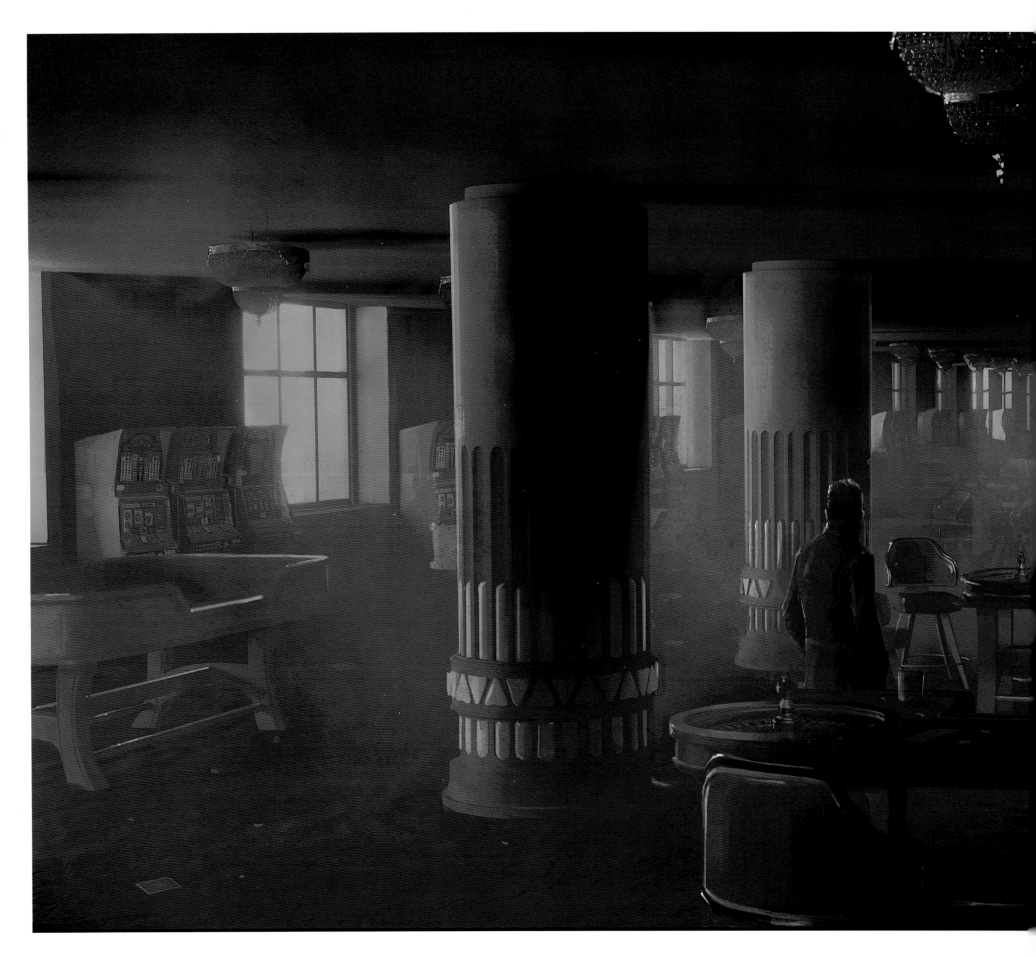

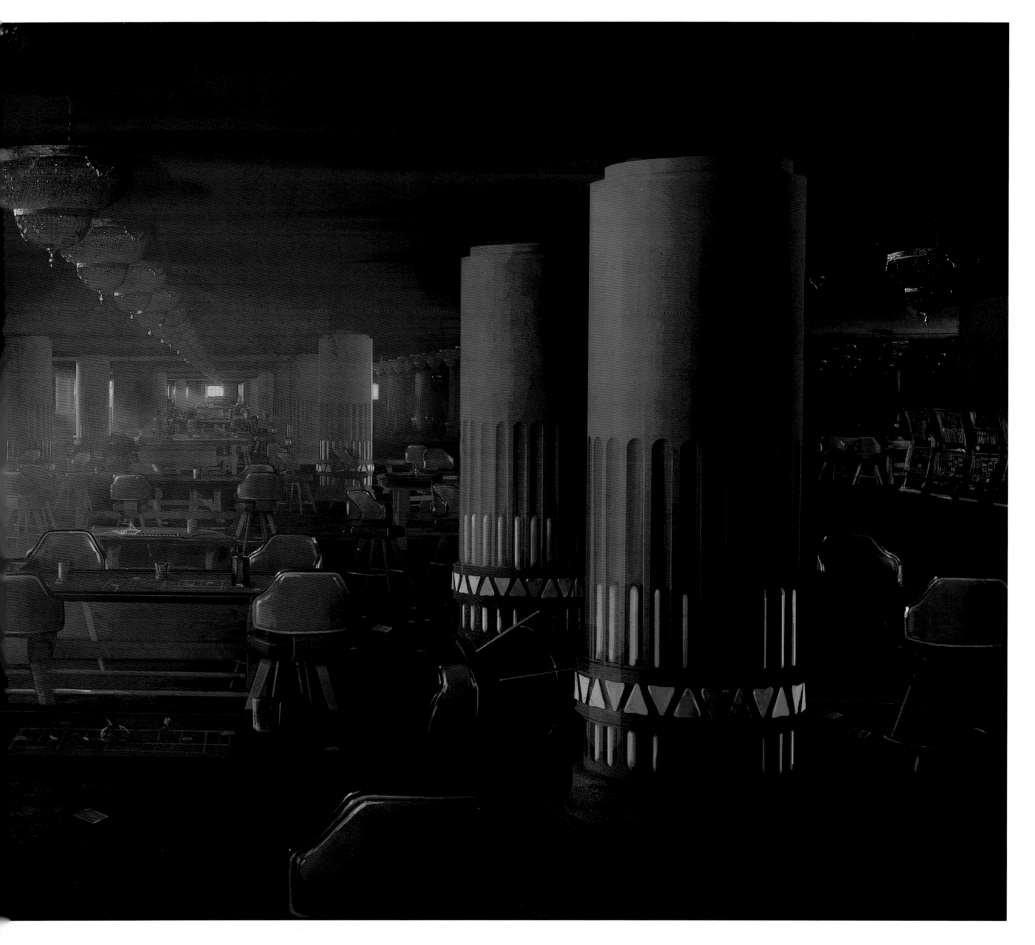

DECKARD'S PENTHOUSE

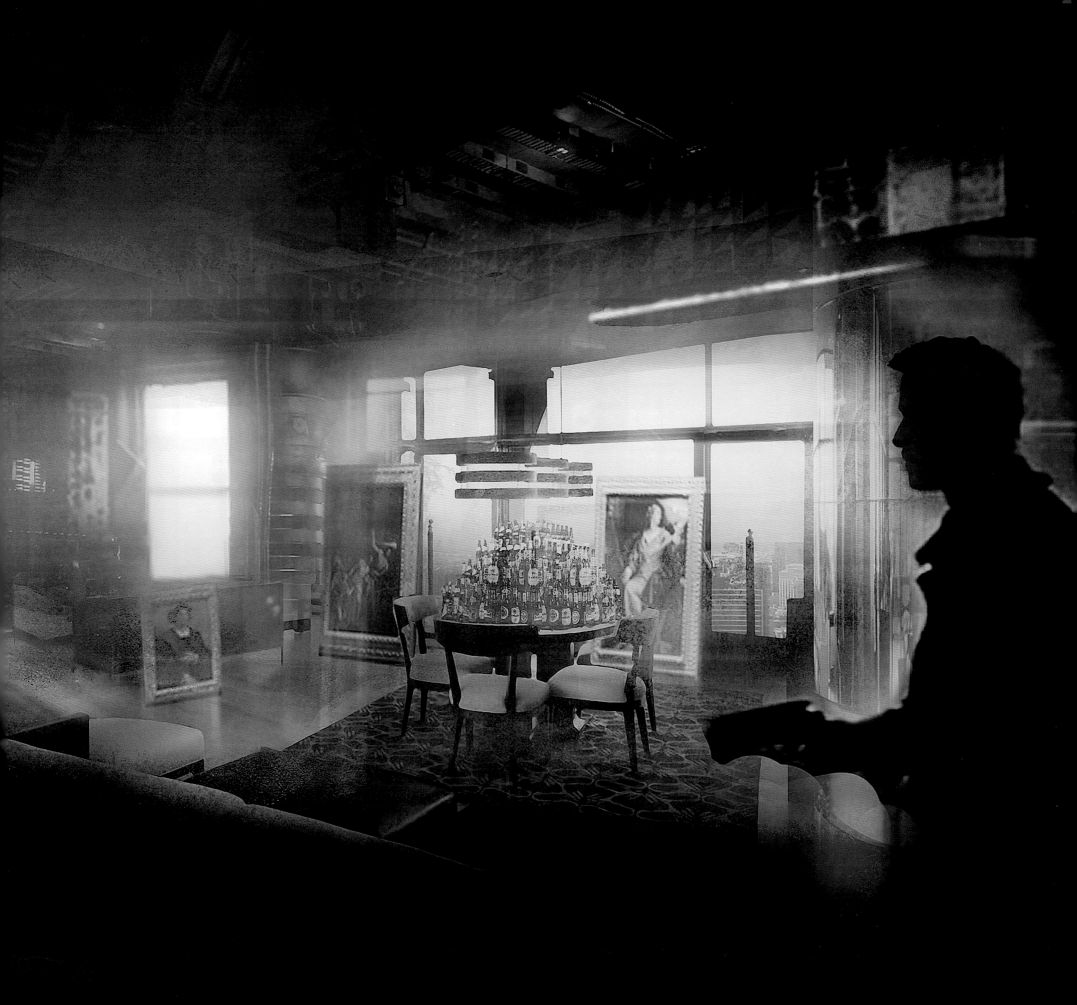

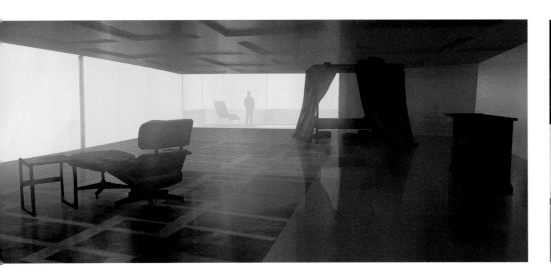

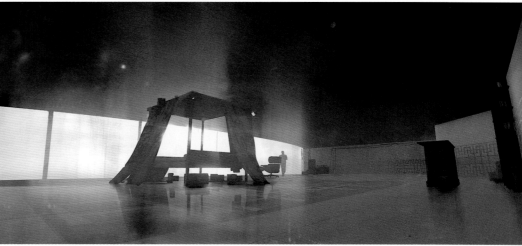

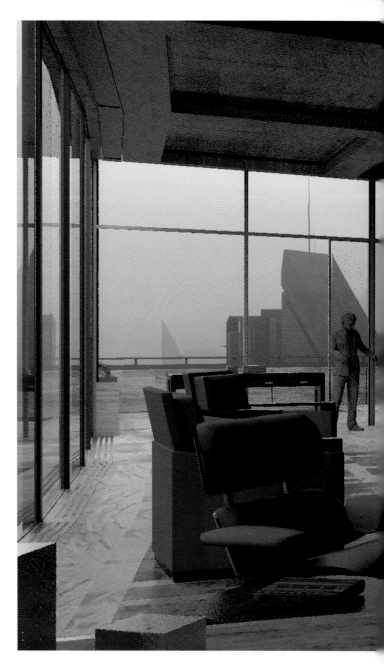

"These concepts were created to help Denis Villeneuve, Dennis Gassner, and Roger Deakins visualize to a very high level of detail the finished set. They used it to try out different approaches for how to dress the set. In the end, it was about showing Deckard as a collector of paintings and other objects that evoke memories or feelings of a time past. The single biggest purpose of this 3D model/concept was to allow us to plan and design the Las Vegas skyline as seen from Deckard's flat. Having already built a 3D model of the main strip of our version of Las Vegas, it allowed us to quickly evaluate the correct position of the penthouse within the city. If you compare the exterior of Deckard's building with the interior of his penthouse, you will realize that the interior is much more elevated than if it matched the exterior, but it was an acceptable cheat. The important thing is to get the desired emotional impact."

Kim Frederiksen ▶

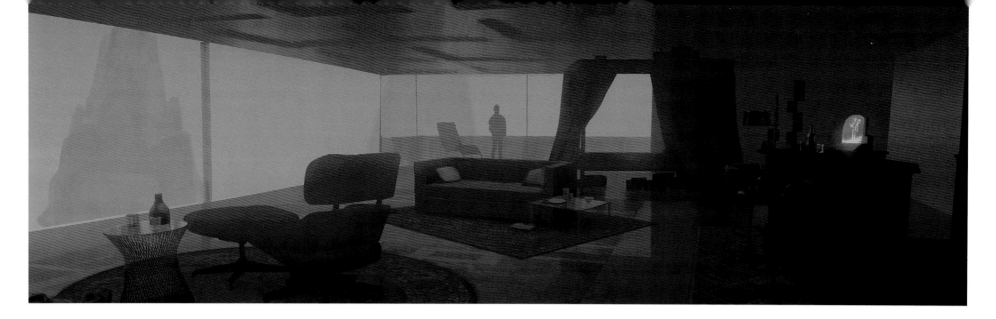

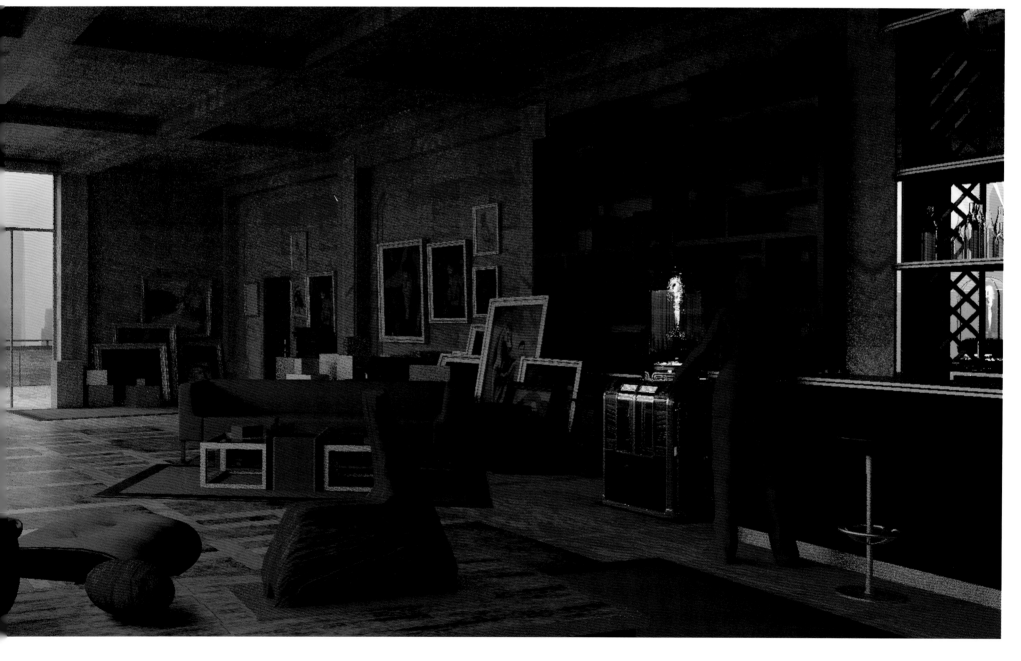

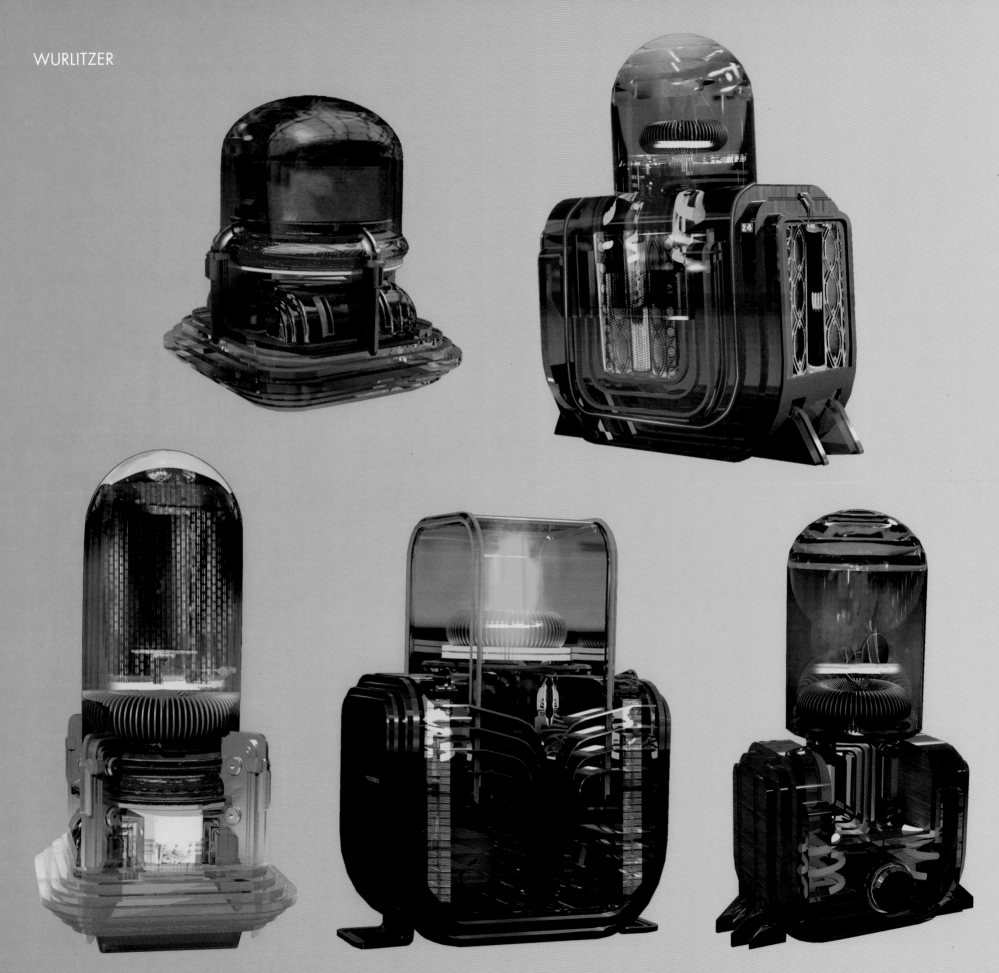

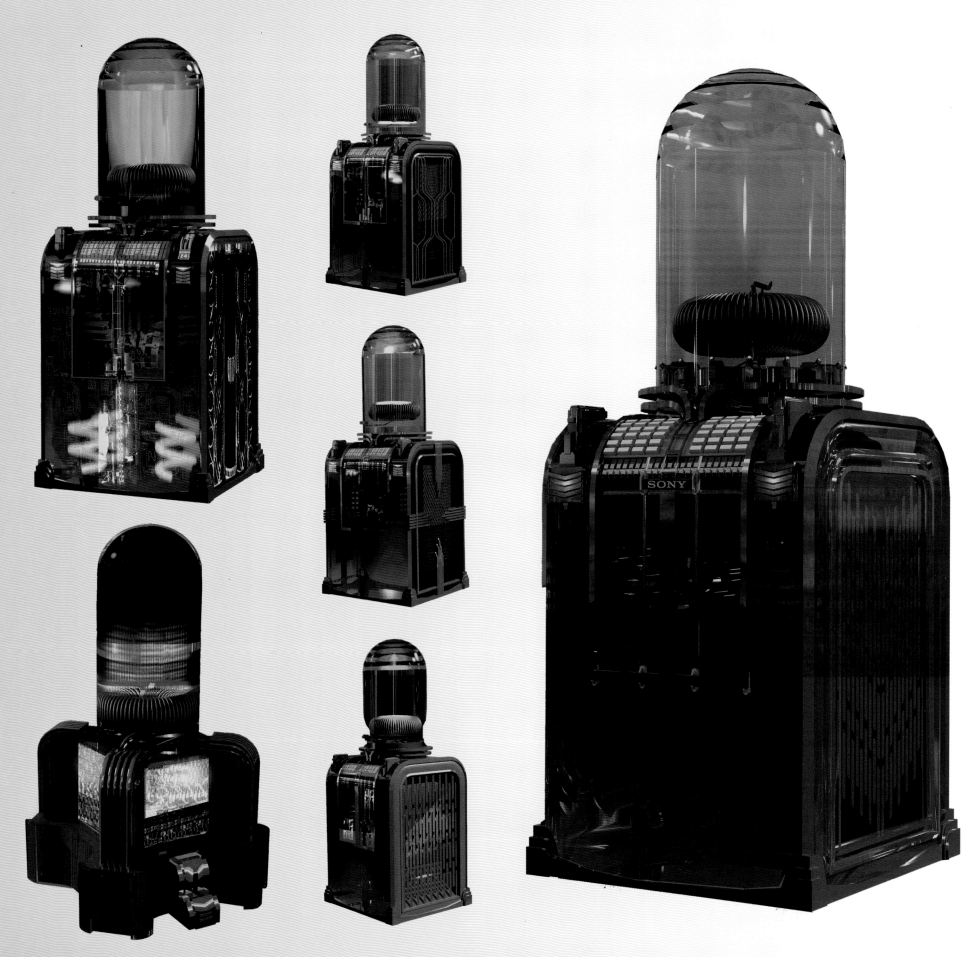

UNREALIZED LOCATIONS

"This scene, cut early in the development process, involved a meeting between K and the head of a trading post. The initial design of the trading post was a small desolate colony just outside of the Las Vegas quarantine zone. The structures in this settlement were composed of the depleted remains of prior generations. In contrast, a more advanced version was also realized, which incorporated basic telecommunications, solar cells, and the ability to mobilize."

▼ *Scott Lukowski*

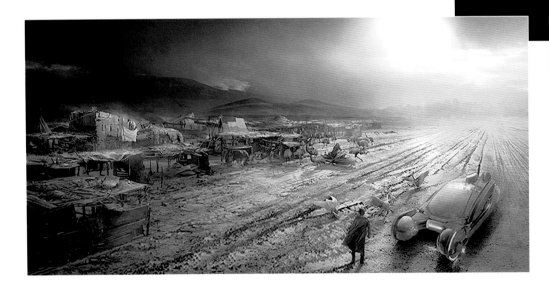

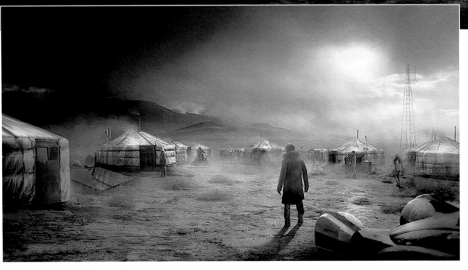

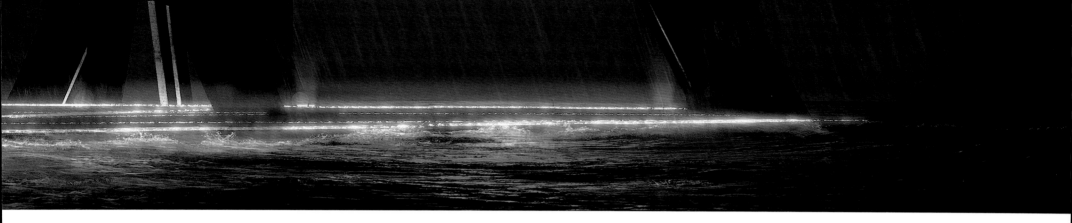

"The Los Angeles spaceport was one of my favorite concepts for multiple reasons. It was great to work on a Brutalist building that stands completely alone in the environment. The underwater lights, for me, recall the design of Wallace's office. I also like it because we've heard so much about the off-world colonies, but we never see how mankind can get there."

▲ *Kamen Anev*

"I still remember getting this assignment from Aaron Haye. He told me about the sea wall and what role it played in the script, so I designed the structure way above the clouds to give it scope, but I still felt it was lacking something. I recall then needing to go out and run some errands. As soon as I got out of my house, I saw the mountain behind me, with fog rolling in. I stopped, took a photo, and used it in the illustration to finish it!"
Emmanuel Shiu ▶

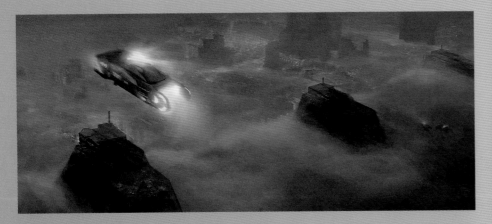

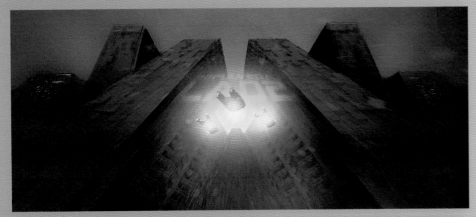

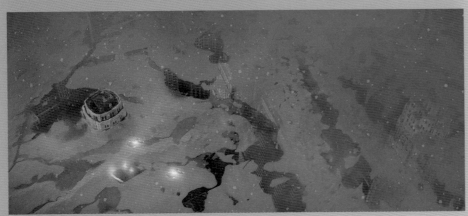

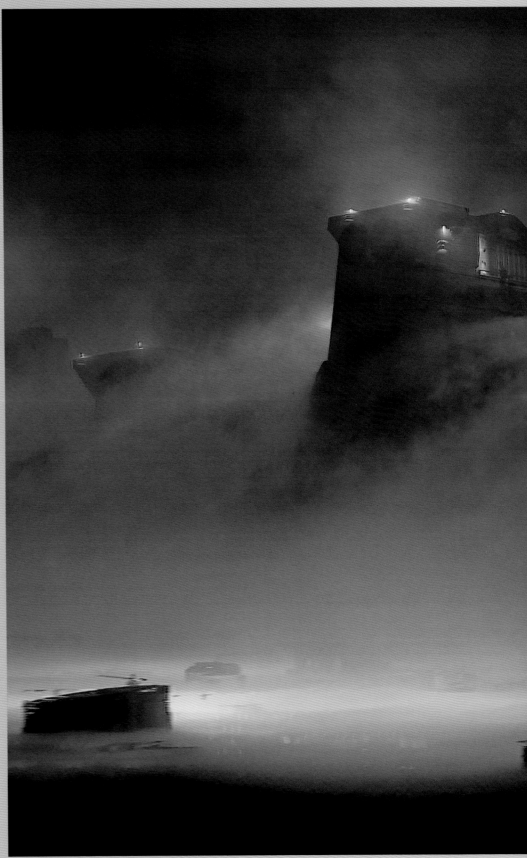

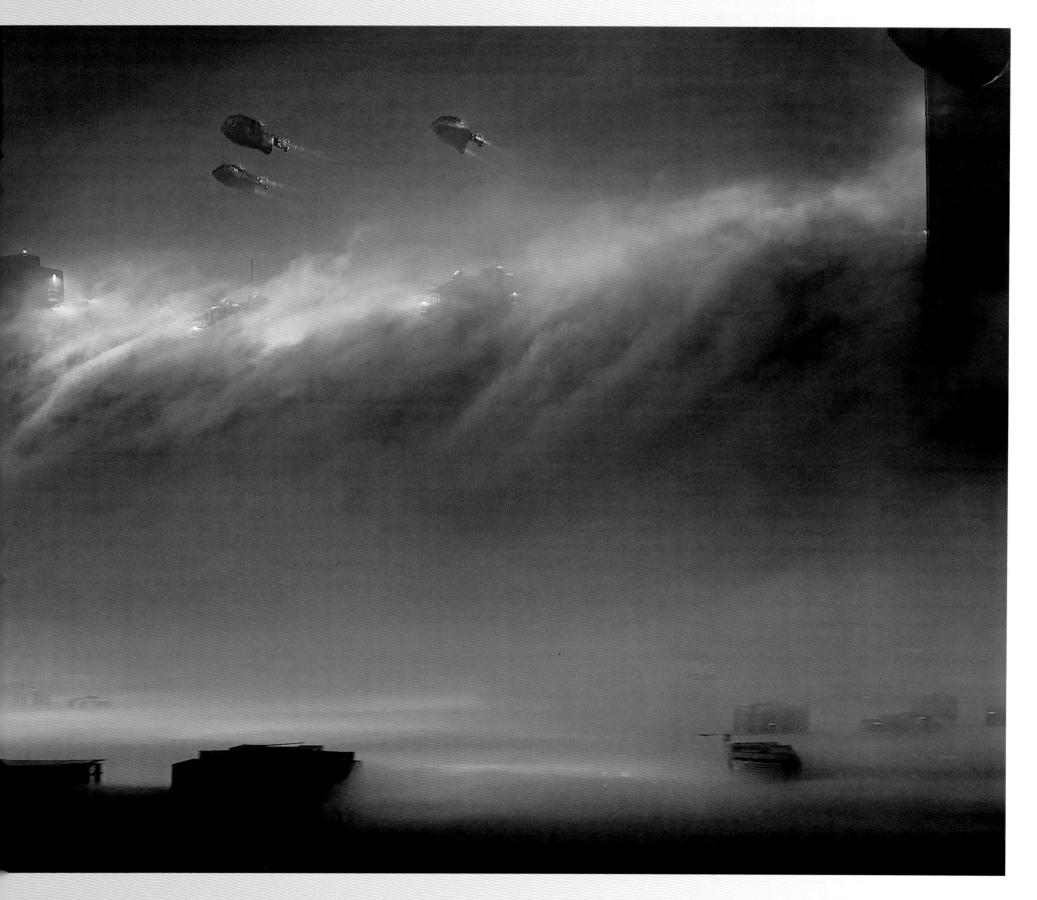

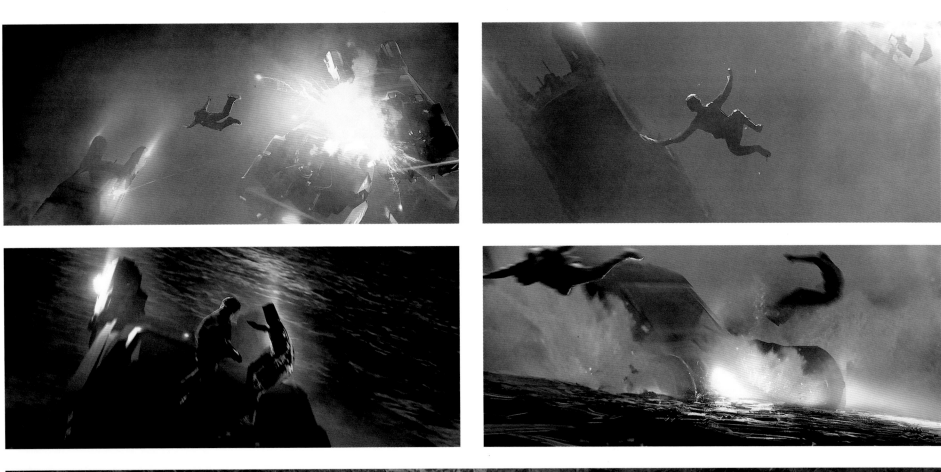

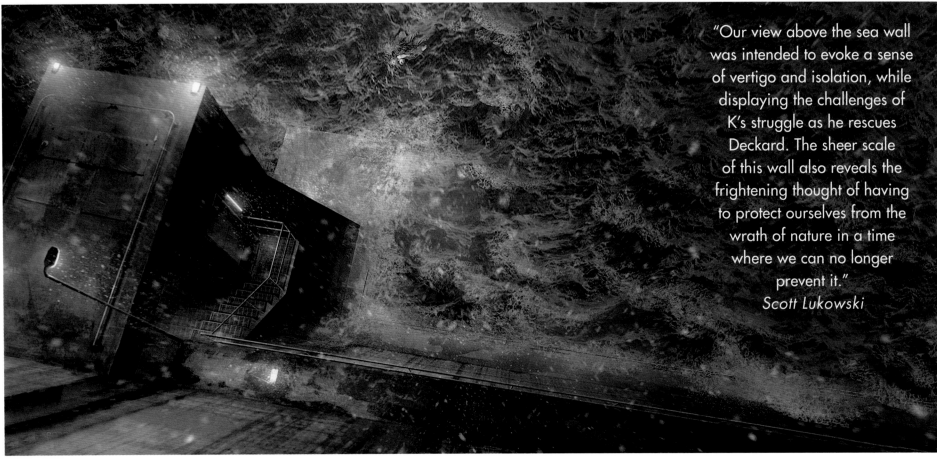

"Our view above the sea wall was intended to evoke a sense of vertigo and isolation, while displaying the challenges of K's struggle as he rescues Deckard. The sheer scale of this wall also reveals the frightening thought of having to protect ourselves from the wrath of nature in a time where we can no longer prevent it."
Scott Lukowski

"I was asked to come up with a bunch of quick illustrations and mood studies for the final chase and crash. I kept thinking that atmosphere would play a very important role in this sequence. I wanted to keep it simple and tell the story. These actually turned out a lot better than I originally intended!"

◄ *Emmanuel Shiu*

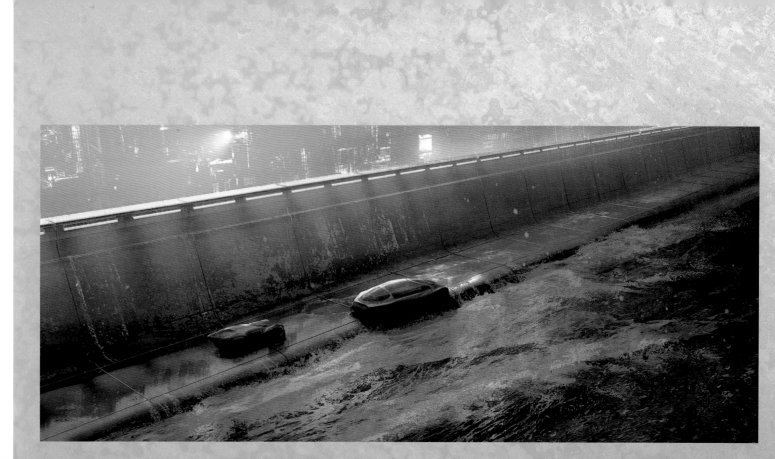

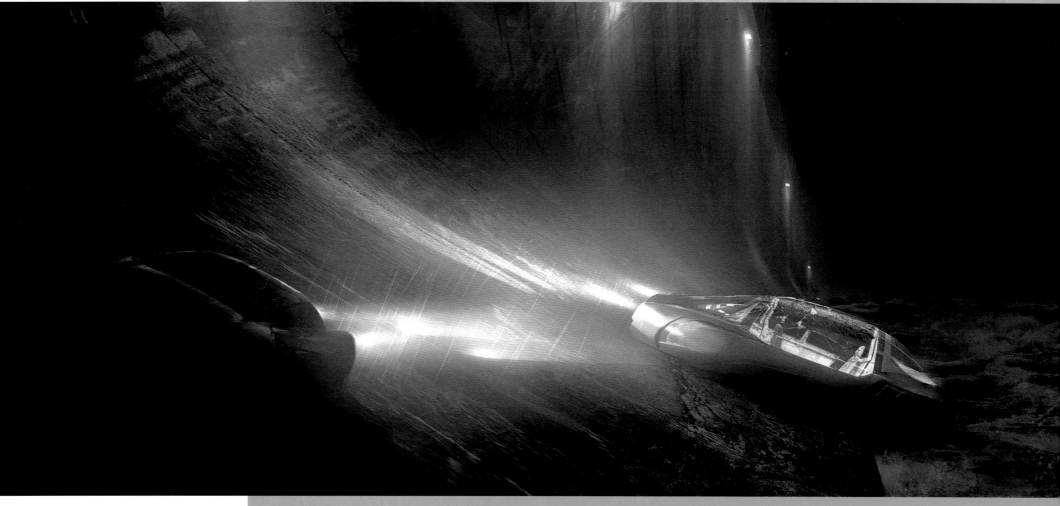

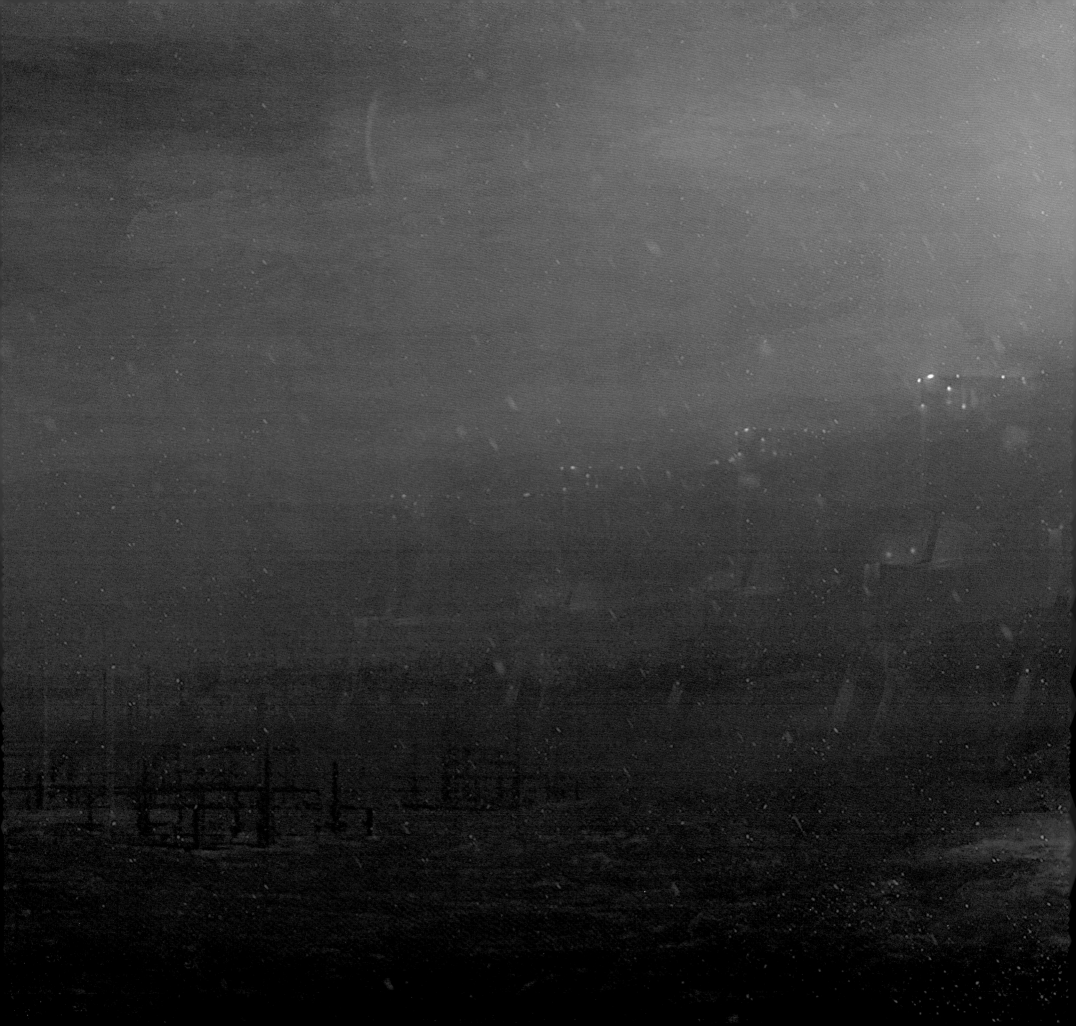

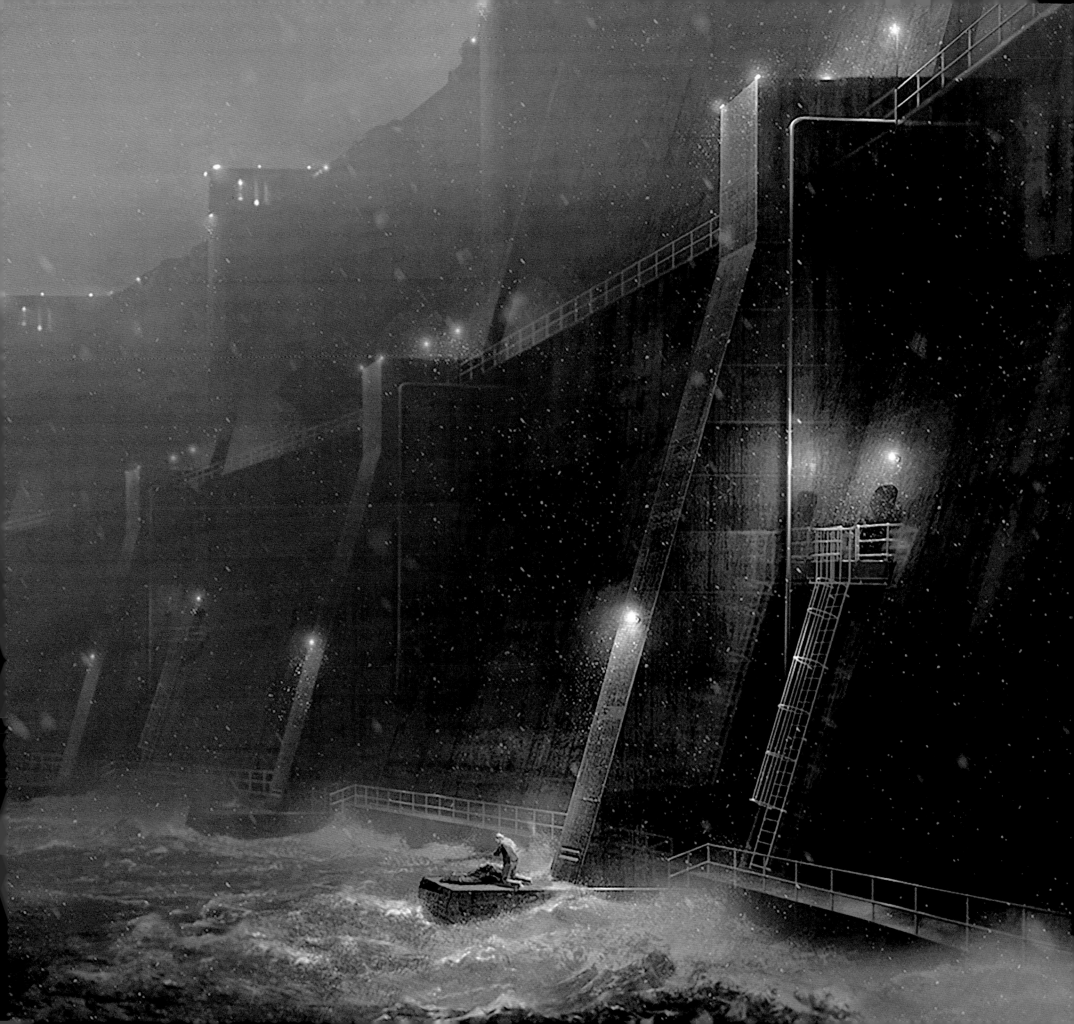

MEMORY LAB

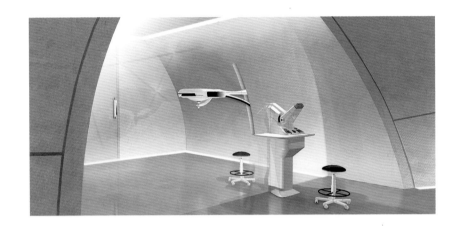

"Dr. Ana Stelline's lab equipment was absolutely a team effort. Gabor Szabo and myself worked closely with Sam Hudecki, who already had some sketches. I only had to define the details, joint points, and connection to the wall. Denis Villeneuve wanted something reminiscent of the opened mouth of a deep-sea fish, but in a very clean design that fits the set. The biggest challenge was to fit it into the small waiting area."
◄ *Kamen Anev*

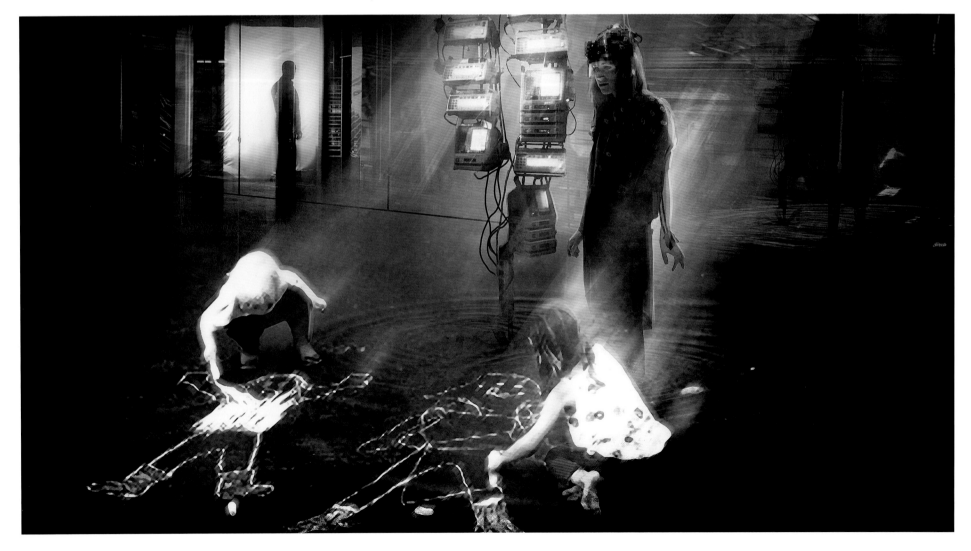

"This was very much meant to be reminiscent of the original [*Blade Runner*] Voight-Kampff machine. This was a one-off, very quick alternative direction for the new machine, developed in just a couple hours. The brief for this particular piece had a few additional requirements: It had to be more like a 'cradle' for the face (hence the chin support and the dual eye-pieces). Also, [have] some tech that would allow more interaction/adjustment with the machine (hence the bulk around the eye pieces), almost like the dial on an phoropter."
Kim Frederiksen ▼

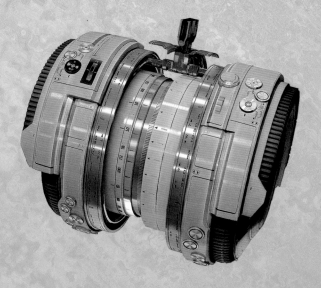

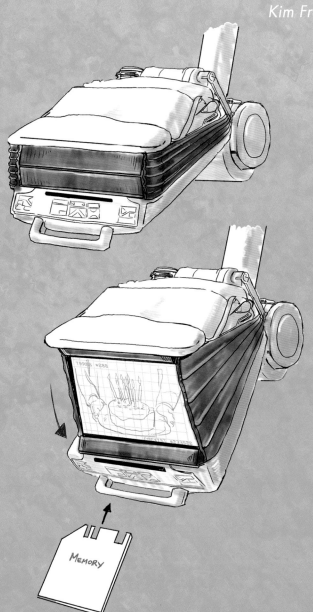

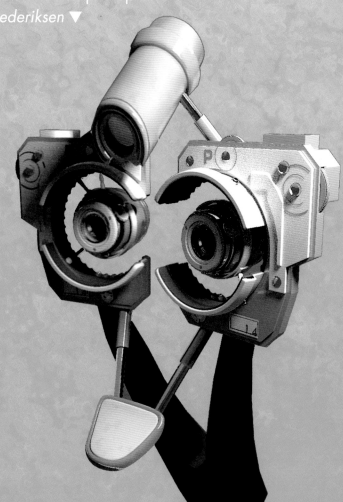

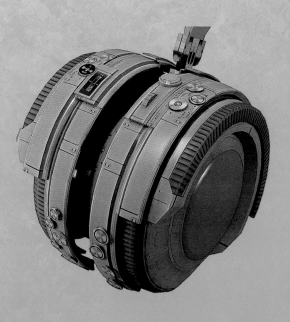

"We had to figure out how Ana saw these dreams she was making. We ruled out 3D goggles. She instead uses a handheld orb reminiscent of camera equipment."
Sam Hudecki ▶

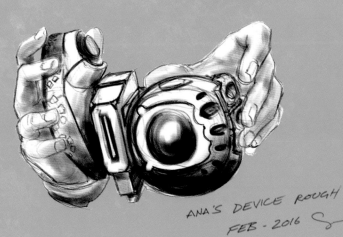

ANA'S DEVICE ROUGH
FEB - 2016

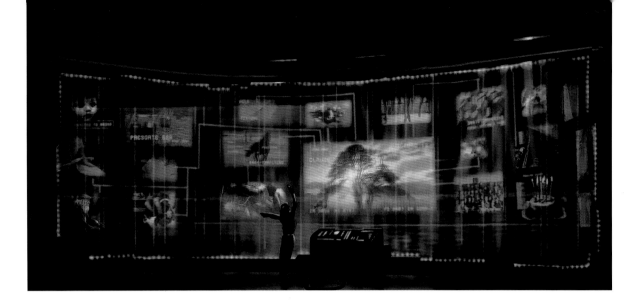

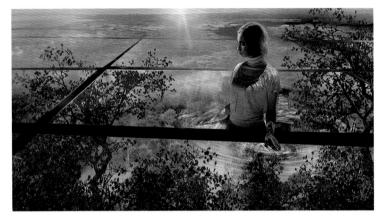

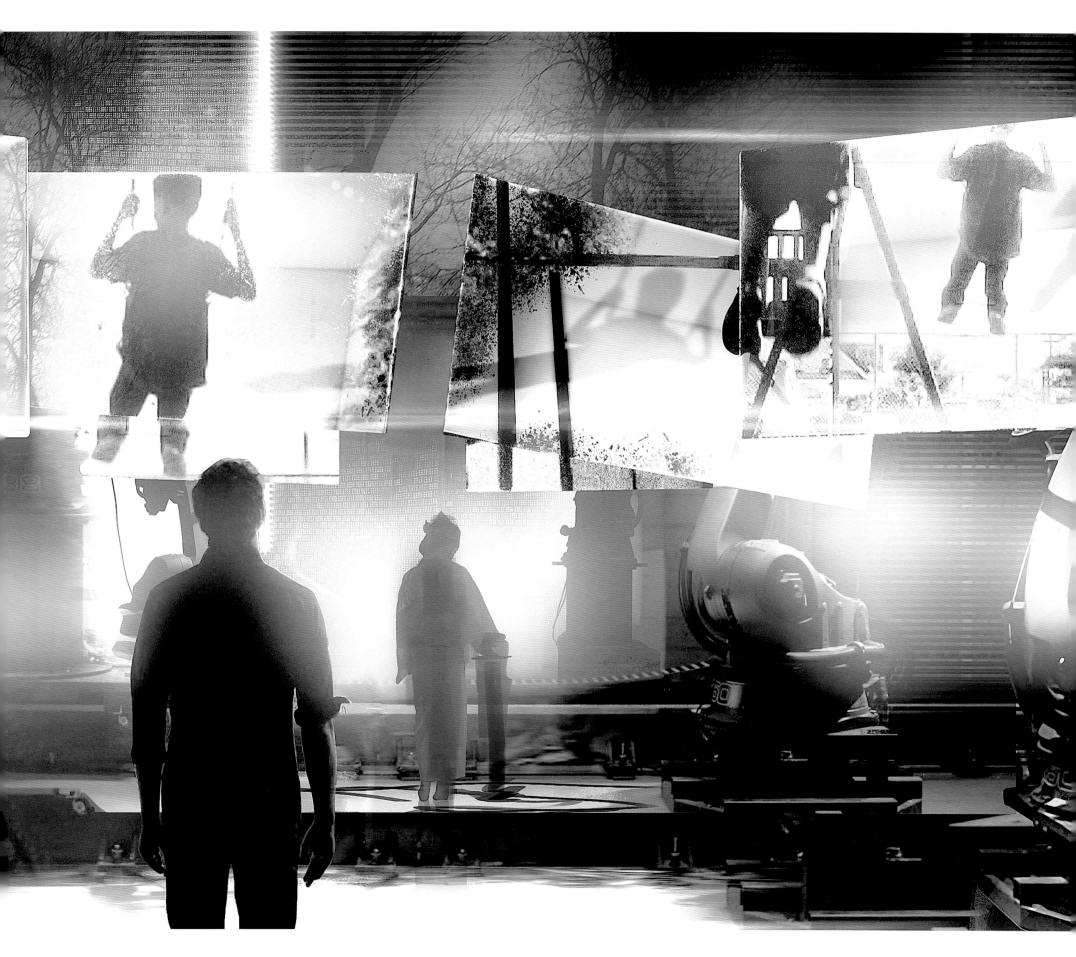

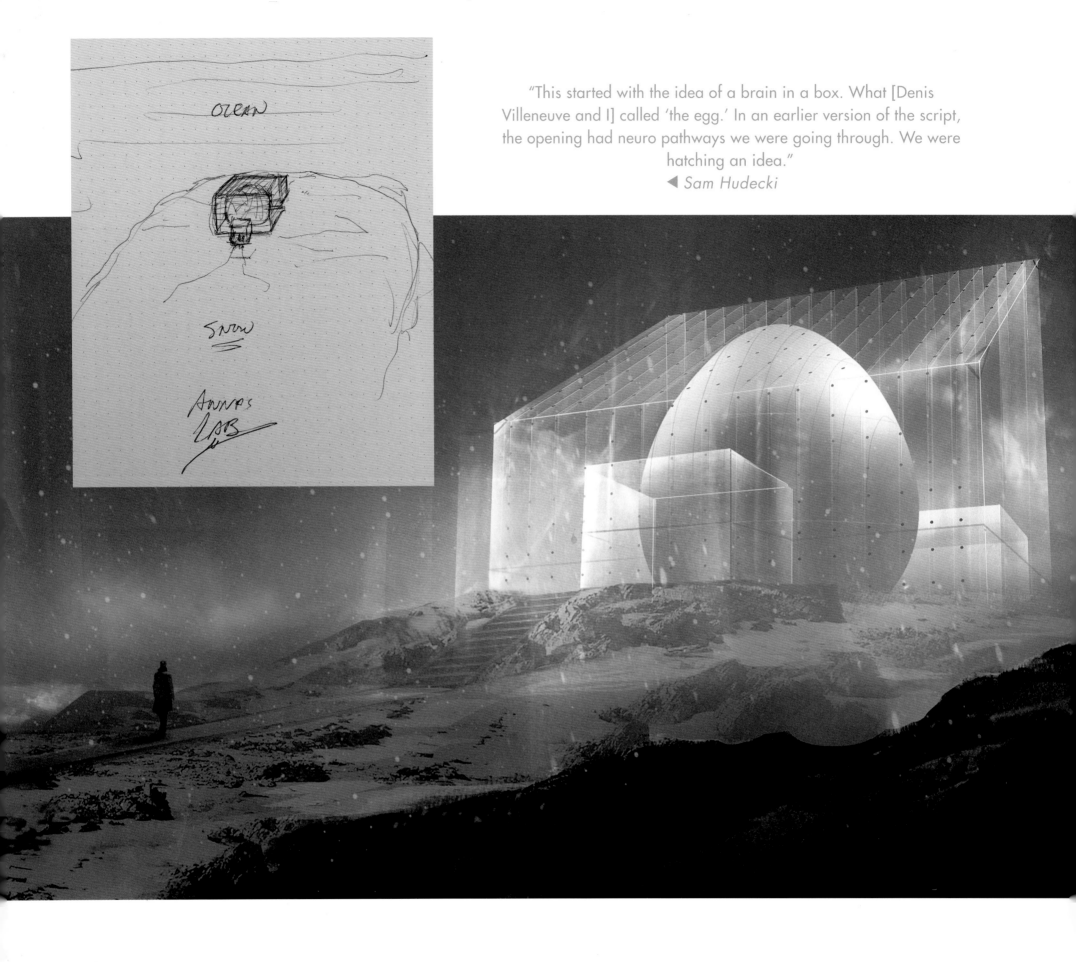

"This started with the idea of a brain in a box. What [Denis Villeneuve and I] called 'the egg.' In an earlier version of the script, the opening had neuro pathways we were going through. We were hatching an idea."

◀ *Sam Hudecki*

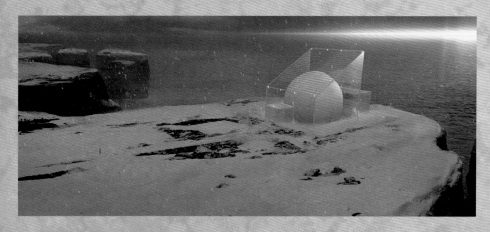
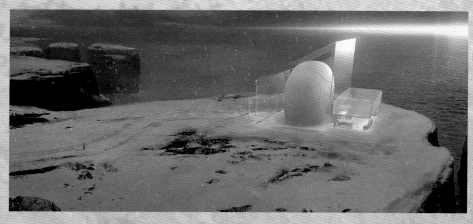
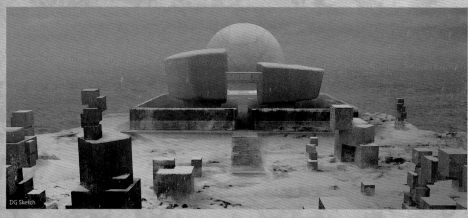
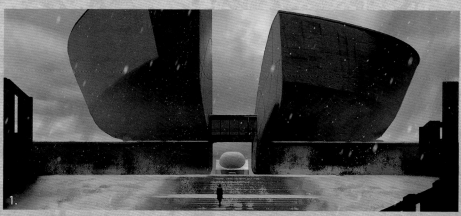

1.

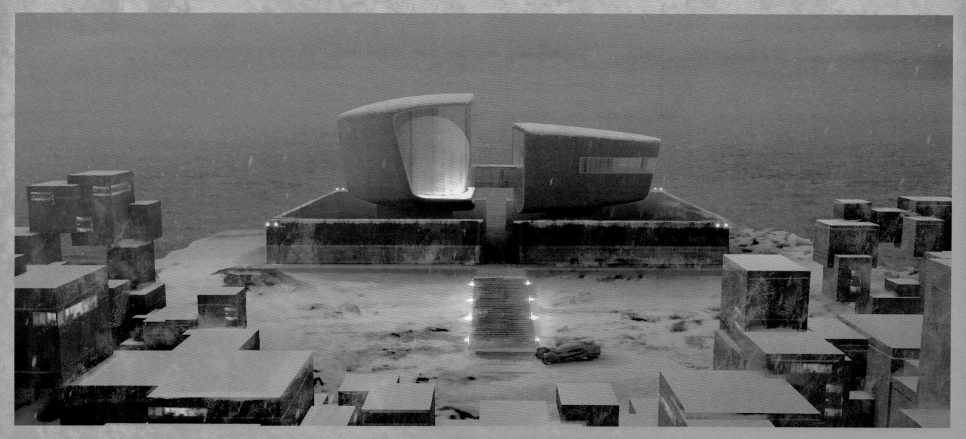

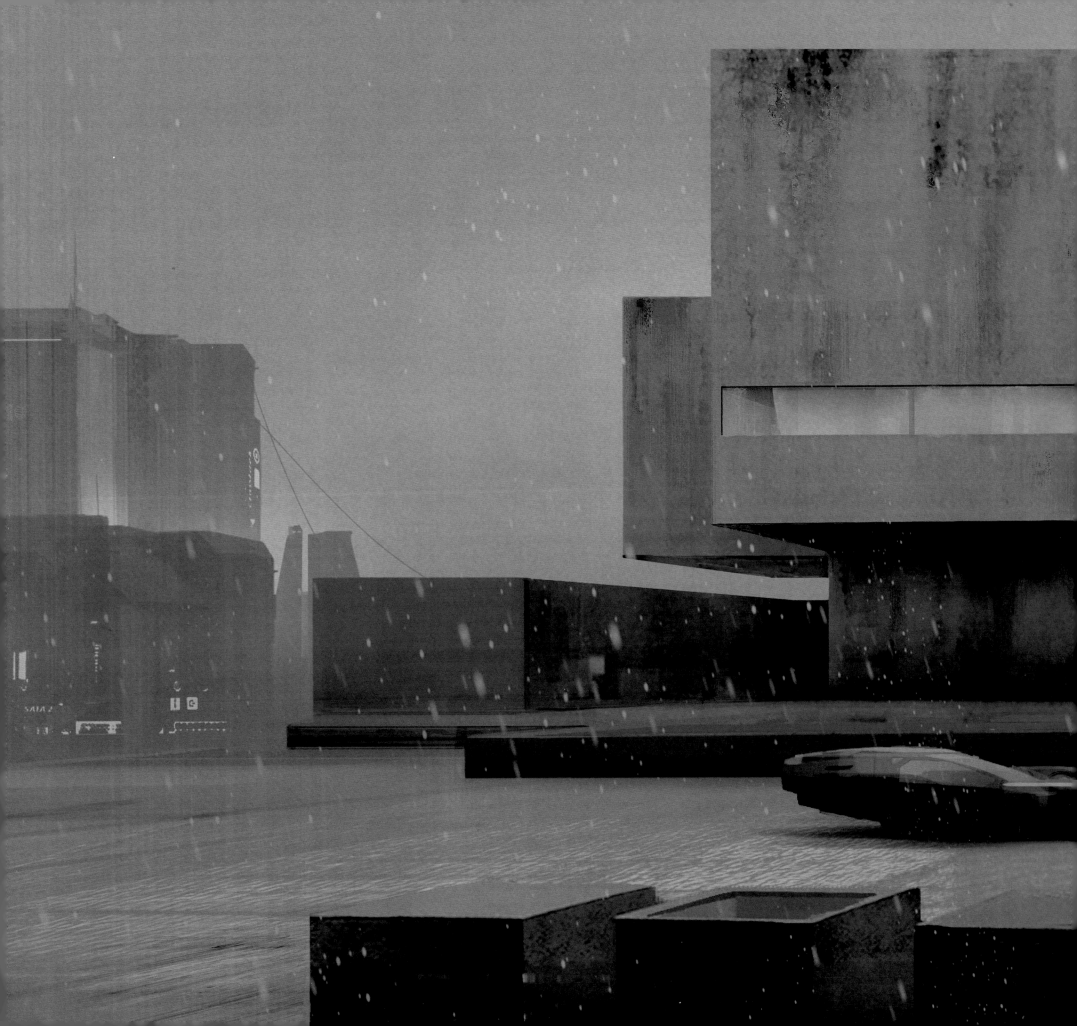

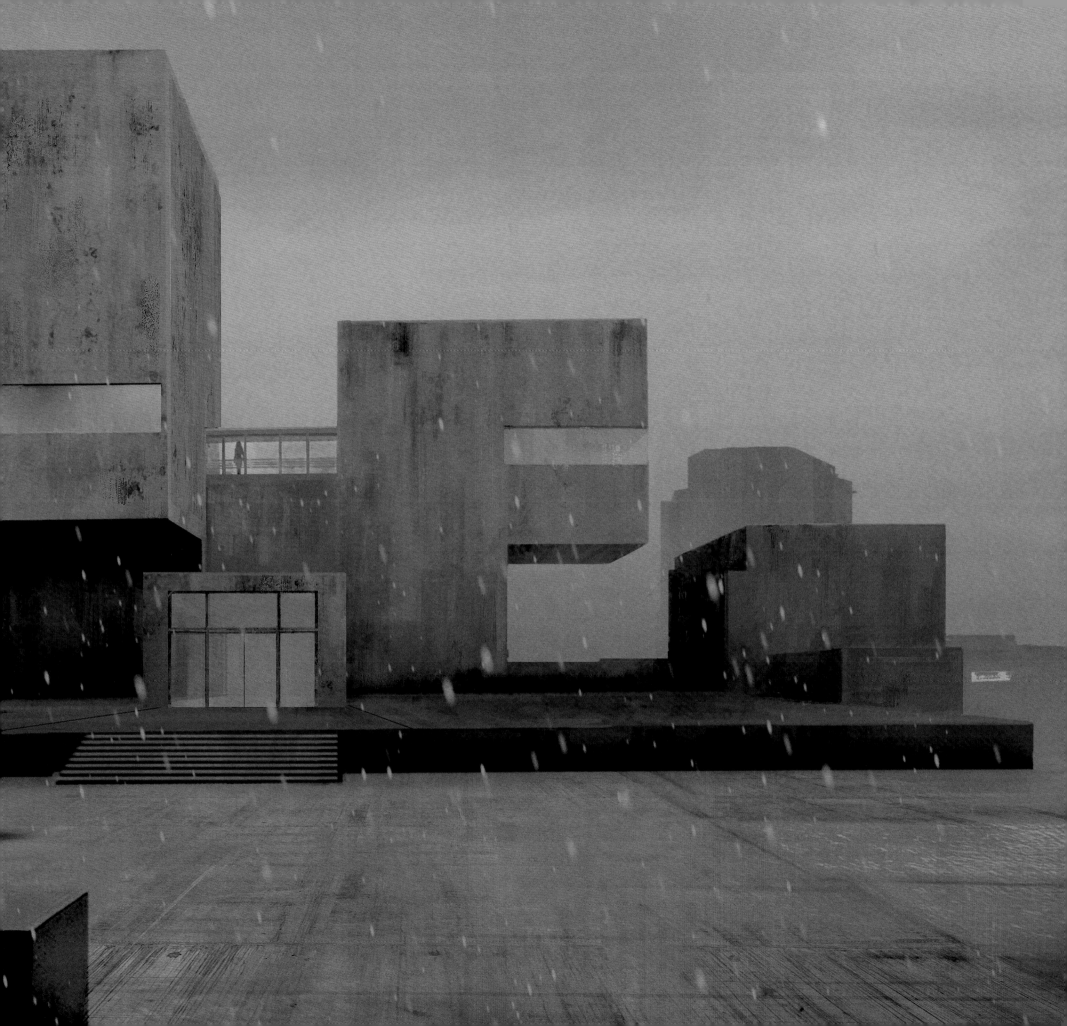

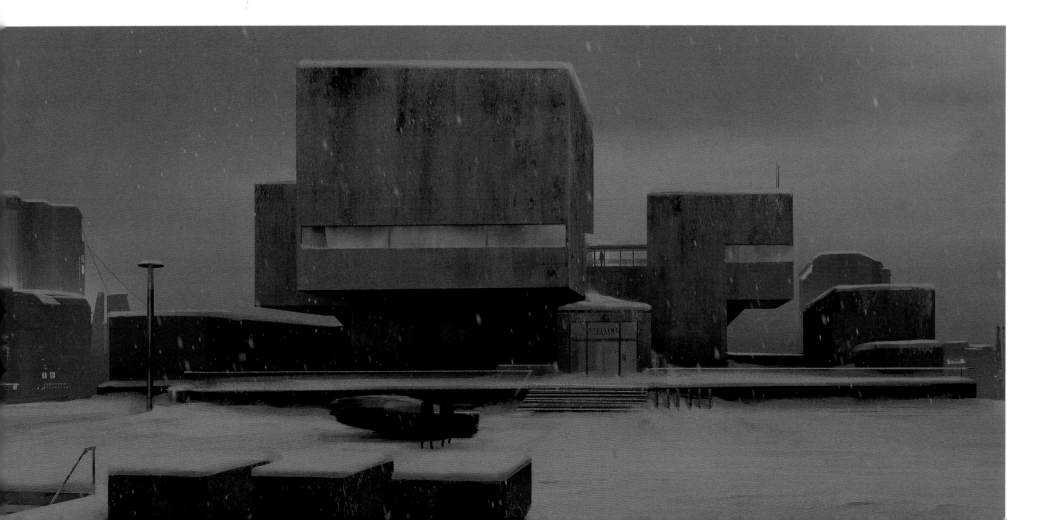